Photographic Analysis

Photographic Analysis

A TEXTBOOK OF PHOTOGRAPHIC SCIENCE

BY JEROME KATZ
FORMERLY ASSISTANT PROFESSOR
ROCHESTER INSTITUTE OF TECHNOLOGY

SIDNEY J. FOGEL
INDUSTRIAL CONSULTANT

MORGAN & MORGAN, INC., PUBLISHERS
HASTINGS-ON-HUDSON, N.Y. 10706
FOUNTAIN PRESS, LONDON, AGENTS FOR GREAT BRITAIN

Copyright 1971 by Jerome Katz and Sidney J. Fogel
First Edition, 1971

MORGAN & MORGAN, Inc., Publishers
400 Warburton Avenue, Hastings-on-Hudson, N.Y. 10706

Standard Book Number 87100-015-6
Library of Congress Catalog Card Number 75-122515

Printed in U.S.A.

Design: Rostislav Eismont
Composition: Morgan Press Incorporated
Printing: Murray Printing Company
Binding: Charles H. Bohn & Co., Inc.

Foreword

Within the past few years, the particular nature of the advances in understanding of the photographic process has focused attention on the bases of this once rather specialized branch of science in the more fundamental disciplines. The definitive experimental investigations in this area have come to employ more sophisticated modern techniques and to probe more basic properties than did the traditional, purely photographic studies which characterized earlier research efforts. Furthermore, a number of phenomena once thought of as unique to the photographic process have been recognized to have close counterparts in other technologies. For these and other reasons, it has now become possible to formulate the mechanisms of many photographic effects largely from elemental concepts, using a terminology of more general applicability.

One can, of course, cite examples of fundamental concepts whose relation to the photographic process have been long realized. The decade of the 60's, however, has been impressive in emphasizing the connections between photographic science and fundamental physical and chemical principles.

During this period there has not appeared a book-length treatment of the subject which is suitable for use as a text. The several excellent reference works in this area must necessarily cover such an extensive collection of published work that they tend to confuse a beginning student of the subject, and have not proved to be very good texts.

The authors of this volume have obviously chosen as their approach to place emphasis on the fundamental foundations of photographic science. Many of the concepts treated are introduced and derived from first principles. As a text for an undergraduate college course, therefore, it is relatively self-contained, and requires only a minimum of background in physics and chemistry. Such a stance may in fact be a necessary one, for a text at this level, owing to the very diverse fundamental areas on which the subject matter is based.

Obviously it is not possible to provide as much background material as they have done and at the same time to be comprehensive of the many aspects of the process, the many approaches to its study, and the many discoveries which appear to be significant. Selection of the subject matter has clearly involved their judgment of the concepts which will continue to be important as future developments unfold. Only time will tell how valid their judgments have been. Regardless of that, it can be said that the serious student of this volume will understand where the principles have originated, and will be able to place them in context relative to broader scientific studies or reading.

Rochester
4–16–70

J. F. Hamilton
Research Laboratories, Eastman Kodak Co.
Rochester, New York

Table of Contents

TO OUR PARENTS

Preface

Through the years the photographic science literature has steadily responded to publications that require the reader to be adept in areas of chemistry, physics and mathematics. The nature of these publications is to present results and conclusions rather than derivations. In the past decade many profound publications have appeared in the literature. The work of Freiser and Klein, Hamilton and Bayer, James, Bird, Trautweiler, Tani and Kikuchi, Tong and Glesmann are outstanding among other profound publications. These cited works have laid the cornerstone to digital simulations of the latent image process, a first quantum model for photographic development, the mathematical derivation of the characteristic curve, the first plausible mechanism for dye sensitization with all its ramifications, an empirical equation that is useful in classifying dye aggregates, and the mechanism and kinetics of color coupling.

These classical works that are the very foundation of photographic science are presented in this text with derivation from first principles.

From a quantitative standpoint the photographic process can be presented only as a branch of physics and chemistry.

The depth and broad spectrum background requirements for understanding of these classical works make them obscure for most readers and difficult for even the advanced student. With these facts in mind and the realization that further advances in the field must use these publications as a cornerstone, it became clear that a textbook had to be written with four aims in mind.

1. The results of these classical works must be presented.
2. The material should be presented in a manner such that an undergraduate or first year graduate student would not find it difficult.
3. The broad spectrum scientific background requirement for the understanding of these works necessitated the inclusion of background material such as thermodynamics, radiation processes, etc., written as either review or for the student who has not

studied these topics. The inclusion of this background material is aimed at making the book as self contained as possible.

4. Photographic science should be taught as a branch of physics and chemistry.

Any photographic worker, scientist or engineer interested in theory, photo-optical applications or photographic systems engineering cannot ignore the need to understand the scientific principles that underlie the photographic process. To ignore these principles is equivalent to ignoring past and future developments that will require the understanding of the basic fundamentals presented in this textbook.

We acknowledge with gratitude the help and stimulation given by J. F. Hamilton and John Thirtle of the Research Laboratories, Eastman Kodak Co., Rochester, New York. These men read and commented on various portions of the book. Their critical comments led to the refinement of this book.

We acknowledge with pleasure the helpful discussions with Linus Pauling, T. H. James, Brice Bayer, H. Spencer and Kenneth Norland.

The authors are grateful to their students for many helpful comments, criticisms and discussions, especially Robert Uzenoff, Michael De Santis, Duane Dutton among others.

We are extremely grateful to Miss Marion L'Amoreaux for proofreading the manuscript, Robert Indorf for his artwork, and Alice McKittrick for checking proofs.

We thank Mrs. Norma Katz for typing the manuscript.

It is a pleasure to acknowledge the excellent cooperation of Anthony Alterio of Morgan Press Incorporated.

Any errors that appear are the responsibility of the authors. They will appreciate having these brought to their attention.

J.K.
S.J.F.

1 Topics in Photographic Science

This chapter discusses photochemical reactions, quantum yield, excitons, the calculus of variation, the calculation of the lattice energy of a silver bromide crystal and a quantum model for photographic development.

It was necessary to derive Fermi-Dirac statistics in order to clarify the quantum model for photographic development.

1.1 Preliminaries

PHOTOCHEMICAL REACTIONS

The photographic process is initiated by the interaction of radiation and matter.

This type of interaction is often termed a photochemical process.

More specifically we can define the *primary process* in photography as the absorption of a photon by a silver halide grain.

Effective absorption of radiation excites the silver halide grain producing an electron hole pair. The hole may be a bromine atom and/or the absence of an electron from a state that is ordinarily occupied by an electron that maintains the neutrality of charge.

According to Dirac (the originator of the hole concept), electrons may exist in both positive and negative energy states. The negative energy states are almost entirely filled whereas the positive energy states are almost entirely empty.

Both the negative and positive energy states are termed energy bands and there is a gap between these states. When an electron in the negative energy state absorbs sufficient energy to traverse the band gap and appear with positive energy, a hole is simultaneously created and appears as the absence of an electron in one of the negative states.

In the case of silver halide crystals, the electronic energy bands result from the complex movement of the electrons in the ordered atomic structure of the crystal. When a photon is absorbed by the crystal, the electron appears in the energy band called the *conduction band* and the hole appears simultaneously in the *valence band* (Figure 1.1.1).

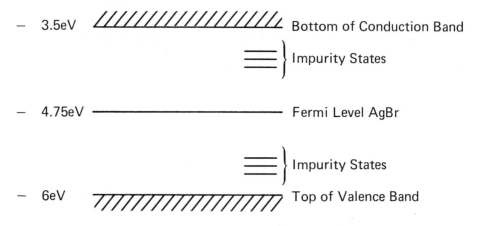

Fig. 1.1.1 *Shows schematically the relative* *level and impurity states are discussed*
 positions of the valence and conduction *in Section 1.3.*
 bands of silver bromide: The Fermi

The valence band consists of closely spaced electronic energy levels that originate from the atomic electronic energy levels of silver and the halide atom. Electrons in the valence band are closely associated (bound) with the silver halide in the crystal and are not free to explore the crystal.

However, electrons that appear in the conduction band are free to explore the envelope of the crystal, and simultaneously the conjugate hole gains some mobility.

It is convenient to quantify the number of electrons and holes formed during the absorption of a photon by a mathematical expression called the *quantum efficiency*, symbolized as Φ, and we write

$$\Phi = \frac{\text{The number of electron hole pairs formed}}{\text{The number of quanta absorbed}}$$

$$(1.1.1)$$

When the quantum efficiency is defined according to equation 1.1.1, it is termed the quantum yield of the *primary process.*

The total *quantum yield* can be defined as the number of moles of silver formed per number of einsteins absorbed, and we may write

$$\Phi_T = \frac{\text{The number of moles of Ag formed}}{\text{The number of einsteins of radiation absorbed}}$$

$$(1.1.2)$$

where an einstein of radiation is equal to the energy of 1 mole of quanta at the specified wavelength.

Since the energy of a quantum of light is written as

$$E = h\nu$$

(1.1.3)

where h $= 6.623 \times 10^{-27}$ erg-sec
$c/\lambda = \nu =$ frequency of radiation in cycles/sec

equation 1.1.3 can be rewritten as

$$E = \frac{hc}{\lambda}$$

(1.1.4)

where $c = 2.99 \times 10^{10}$ cm/sec
$\lambda =$ wavelength of radiation in cm

The value of the einstein is given by

$$E_{einstein} = \frac{Nhc}{\lambda}$$

where N $= 6.023 \times 10^{23} \frac{quanta}{mole}$

(1.1.5)

An analysis of equations 1.1.1 and 1.1.2 can be made by reference to the *Grotthuss-Draper Law* and the Einstein Law of the photochemical equivalence. The Grotthuss-Draper Law, sometimes called the riciprocity law, states that *only radiation that is absorbed by the reacting system can produce a chemical reaction.*

According to the *Einstein law of photochemical equivalence,* each molecule or atom taking part in a chemical reaction, which is a direct result of the absorption of light, takes 1 and only 1 quantum of the radiation causing the reaction. The influence of the Grotthuss-Draper Law is evidenced in both equations 1.1.1 and 1.1.2 by the appearance of the word 'absorbed' in the denominator of both these expressions. In terms of the Einstein law of photochemical equivalence, we should expect the quantum efficiency for the primary process to be 1.

A series of classical papers by Eggert and Noddack [Ref: J. Eggert and W. Noddack, Sitzungsber Preuss. Akad. Wiss., 1921, p. 631; Ibid., 1923, 116; Ibid., 1925, 31, 922; Ibid., 1927, 43, 222; Ibid., 1929, 58, 861]

established Einstein's law of photochemical equivalence for certain silver bromide and silver chloride emulsions. They showed by photolysis that the number of silver atoms produced was equal to the number of quanta absorbed by the silver halide of the emulsions under test.

Mutter [Ref: R. Mutter, Z. w. P., **26**, 193 (1929)] also confirmed this law by measuring the bromine production per quanta of light absorbed by silver bromide precipitates. In actual photographic emulsions the quantum efficiency can be less than one (Figure 1.1.2).

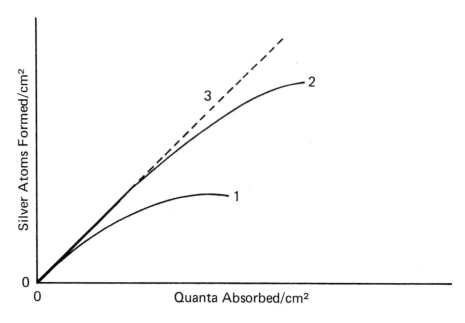

Fig. 1.1.2 Shows schematically two effects that are responsible for quantum efficiency deviations from Einsteins law. Curve 1 shows the effect resulting from recombination of the hole electron pair in a photographic emulsion.

Curve 2 shows the effect in the presence of a halogen acceptor. Curve 3 represents a quantum efficiency of one corresponding to the Einstein law.

If a halogen acceptor is not present in a photographic emulsion during exposure, the probability of recombination of free electrons and holes is greater at the surface of the grain, decreasing the number of silver atoms formed as illustrated in Figure 1.1.2 (also see Section 2.3 IN-EFFICIENCY IN NUCLEATION). On the other hand, when the halogen acceptor is present, the quantum efficiency remains at a value of one over a wider range of exposure. However, at high exposure levels, the quantum efficiency decreases. This decrease can be attributed to hole electron re-combination in the interior of the grain where no halogen acceptor is present.

The primary process in silver halide photography may be represented as

$$h\nu + AgBr \longrightarrow Ag^+ + e + Br \qquad (1.1.6)$$

$$Ag^+ + e \longrightarrow Ag^\circ \qquad (1.1.7)$$

After the formation of the latent image schematically represented by equation 1.1.7, an amplification process of the latent image must be accomplished in order to observe the image.

Conventionally, the latent image is amplified by a developer solution that contains a reducing agent that is a source of electrons.

During photographic development, the latent image silver nuclei serve as catalytic sites for the reduction and deposition of silver ions. Thus a latent image aggregate consisting of three or more silver atoms can grow by the addition of a million or more silver atoms. Consequently, the total quantum yield for silver halide emulsions after development is of the order of 10^6 or more.

The secondary process or amplification due to photographic development may be written as

$$kAg^\circ_{(s)} + nAg^+_{(s)} + nDA_{(l)} \longrightarrow (n+k) Ag^\circ_{(s)} + nDA^+_{(l)}$$
$$(1.1.8)$$

$$
\begin{aligned}
(n+k)Ag^\circ &= \text{the number of silver atoms produced as a}\\
&\quad \text{consequence of latent image formation and}\\
&\quad \text{subsequent development}\\
kAg^\circ &= \text{the number of silver atoms per latent image aggregate}\\
s &= \text{solid state}\\
l &= \text{liquid state}\\
n\,DA &= \text{number of moles of developing agent}\\
n\,DA^+ &= \text{number of moles of oxidized developing agent}\\
nAg^+ &= \text{the number of silver ions that become}\\
&\quad \text{reduced due to development}\\
k/n &\approx 10^{-6}
\end{aligned}
$$

EXAMPLE CALCULATION OF THE QUANTUM YIELD

An emulsion layer received 9.1 ergs of radiation/cm² of wavelength 436 nanometers. It was determined that the average area of each emulsion grain in the layer was 10^{-8} cm² with a corresponding grain volume of 1 x 10^{-13} cm³.

The absorbance of this layer was found to be 5%. Subsequent development resulted in all grains being developed. The calculation of total quantum yield in terms of developed silver follows:

a) Determine the energy in ergs of the quanta of wavelength 436 nanometers.

$$E \; = \; \frac{h\,c}{\lambda} \; = \; \frac{6.625 \times 10^{-27} \text{ erg sec} \times 2.99 \times 10^{10} \text{ cm/sec}}{436 \times 10^{-7} \text{ cm}}$$

(1.1.9)

$$E \; = \; 4.55 \times 10^{-12} \text{ ergs/quanta}$$

(1.1.10)

b) Determine the number of absorbed quanta/cm^2 of emulsion layer.

$$\frac{.05 \times 9.1}{4.55 \times 10^{-12} \text{ erg/quanta}} \; = \; 10^{11} \; \frac{\text{quanta absorbed}}{\text{cm}^2}$$

(1.1.11)

c) Determine the number of silver bromide molecules/cm^2, molecular weight of silver bromide = 187.8 gram/mole, density of AgBr = 6.47 gram/cm^3, average volume of AgBr = 10^{-13} cm^3.

$$\frac{6.47 \frac{\text{gram}}{\text{cm}^3} \times 10^{-13} \frac{\text{cm}^3}{\text{grain}} \times 6.02 \times 10^{23} \frac{\text{molecules}}{\text{mole}}}{187.8 \frac{\text{gram}}{\text{mole}}}$$

$$= \; 2.08 \times 10^9 \; \frac{\text{molecules}}{\text{grain}}$$

(1.1.12)

d) Since all grains develop, the number of silver atoms produced per cm^2 is written as

$$\frac{2 \times 10^9 \text{ Ag atoms/grain}}{10^{-8} \text{ cm}^2/\text{grain}} = 2 \times 10^{17} \frac{\text{Ag atoms}}{\text{cm}^2}$$

(1.1.13)

and the quantum yield is written as

$$\Phi = \frac{2 \times 10^{17} \text{ Ag atoms produced/cm}^2}{10^{11} \text{ quanta absorbed/cm}^2} = 2 \times 10^6$$

(1.1.14)

EXCITONS

If the energy of the quanta absorbed by a silver halide grain is greater than the energy gap E_g of the crystal, then a free electron hole pair is produced.

On the other hand, when the energy of the photon is less than E_g, then it is possible for an electron hole pair to be formed in a stable bound state. The stable electron hole pair bound state results from the attractive coulomb interaction between these two particles. This state is termed an *exciton*. The exciton can travel throughout the crystal, giving up its energy of formation on recombination. Since the exciton is a neutral particle, it produces no electrical conductivity. A tightly bound exciton (Frenkel exciton) has an electron hole inter-particle distance of the order of the nearest neighbor distance of the crystal (Figure 1.1.3).

(1)

$h\nu \longrightarrow$

```
     +   −   +   −   +   −   +   −
     −   +   −   +   −   +   −   +
     +   −   +   −   +   −   +   −
```

(2)
```
+     −   +   −
  ⊖
0     +   −   +          ⟶
+     −   +   −
```

(3)
```
+     0   +   −
  ⊖
−     +   −   +
+     −   +   −
```

(4)
```
+   0     +   −
      ⊖
−     +   −   +          ⟶
+     −   +   −
```

(5)
```
+     −     +   −
        ⊖
−     +   0   +
+     −   +   −
```

(6)
```
+   −   +     −
          ⊖
−   +   0     +          ⟶
+   −   +     −
```

(7)
```
+   −   +     0   +
          ⊖
−   +   −     +   −
+   −   +     −   +
```

(8)
```
+   −   +   0     +   −
              ⊖
−   +   −   +     −   +
+   −   +   −     +   −
```

Fig. 1.1.3 *Shows a schematic diagram of the movement of a Frenkel exciton moving through a crystal.*

Conversely, the Mott exciton has a large average electron hole distance with respect to the nearest neighbor distance (Figure 1.1.4).

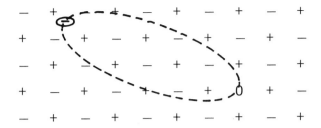

Fig. 1.1.4 *Shows a schematic diagram of a Mott exciton.*

A Frenkel exciton is considered to be a moving excited state of a single atom. That is, the atom has absorbed sufficient energy to excite one of the valence electrons. This excitation energy can be transferred from atom to atom in the lattice.

In silver bromide crystals the negative bromide ions contain the excitons of lowest energy because the positive ions have higher excitation energy levels.

Since a Frenkel exciton is the moving excited state of a bromide ion, it is expected that the optical absorption characteristics of these excitons should be closely related to the spectroscopic properties of an isolated bromide ion.

The absorption spectrum of the bromide ion shows a characteristic twin peak in the untraviolet region.

This characteristic twin peak (doublet) is also found in silver bromide. Thus we can conclude that a Frenkel exciton is a moving excited state of a bromide ion.

Since the average distance between the electron and the hole is large for a Mott exciton, they are weakly bound. Furthermore, the Mott exciton can be treated as a two particle system where the negatively charged particle is orbiting a positively charged particle. When the equations for this system are solved, a series of discrete exciton levels lying close to the bottom of the conduction band are found (Figure 1.1.5).

The Mott exciton is fundamental to latent image formation and the photographic process. On the other hand, the tightly bound Frenkel exciton is of lesser importance to the photographic process.

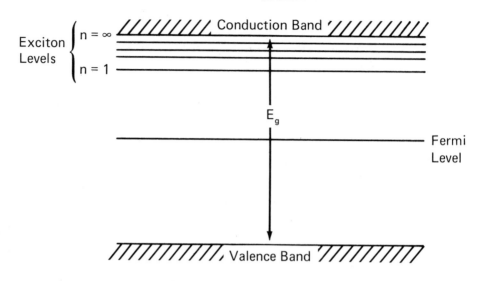

Fig. 1.1.5 *Shows schematically the weakly bound*
Mott exciton energy levels in a crystal.

The Mott exciton can decay into the unbound hole electron pair. This free electron can then be trapped and either participate in the formation of a silver atom or it can recombine with a hole, which results in an inefficiency event (see Sections 2.2 and 2.3).

CALCULUS OF VARIATION

This section will briefly develop the concepts of the calculus of variation.

We consider a simple but fundamental problem. That is, finding an extremum of the integral

$$I = \int_{x_1}^{x_2} \psi(x, y, y') \, dx$$

(1.1.15)

$$\text{where } y = f(x)$$

(1.1.16)

$$y' = \frac{dy}{dx} = f'(x)$$

(1.1.17)

We assume that $f(x)$ and all its derivatives are finite, continuous and single valued.

In general, the integral I is a line integral along some path γ between the end points

$$(x_1, y_1)$$
(1.1.18)

and

$$(x_2, y_2)$$
(1.1.19)

Since the integral is a definite integral, it becomes a number when the path is defined.

However, if we vary the path between the end points, then the integral I will vary as a function of the path.

Our immediate task is to determine how the integral varies as a function of the path chosen.

We choose a reference path Γ°, which is defined as

$$y \;=\; y(x) \text{ from } x_1 \text{ to } x_2$$
(1.1.20)

$$y_1 \;=\; y(x_1)$$
(1.1.20a)

$$y_2 \;=\; y(x_2)$$
(1.1.21)

Any variation in Γ° can be written as

$$Y(x) \;=\; y(x) \;+\; \epsilon v(x)$$
(1.1.22)

where ϵ is equal to a small constant
v is an arbitrary function that is zero at the end points

$$v(x_1) \;=\; v(x_2) \;=\; 0$$
(1.1.23)

The variation of the path Γ° is defined symbolically as

$$\delta y = \epsilon \nu(x)$$

$$(1.1.24)$$

If ϵ is small, then equation 1.1.24 is termed a *weak variation.*
Using this definition, we may write

$$Y(x) = y(x) + \delta y(x)$$

$$(1.1.25)$$

This text will treat only the weak variations.
The variation $\delta y(x)$ corresponds to the distance ab (Figure 1.1.6).

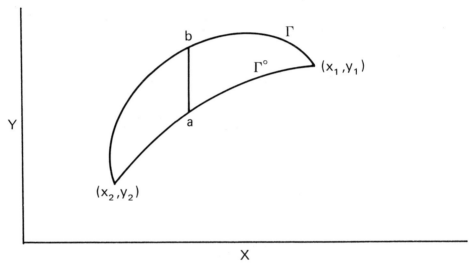

Fig. 1.1.6 *Shows the reference path $\Gamma°$ and the variation path Γ.*

If we take the derivative of equation 1.1.22, we may write

$$Y'(x) = y'(x) + \epsilon \nu'(x)$$

$$(1.1.26)$$

Analyzing equation 1.1.24, we see that

$$\delta y'(x) = \epsilon \nu'(x)$$

$$(1.1.27)$$

14

Therefore we may write

$$Y'(x) = y'(x) + \delta y'(x)$$

(1.1.28)

Since the derivative with respect to x commutes with the variation, we may write

$$\frac{d}{dx} \delta y = \frac{d}{dx} \epsilon \nu(x)$$

(1.1.29)

$$\epsilon \nu'(x) = \delta y'(x)$$

(1.1.30)

$$\frac{d}{dx} \delta y = \delta y'(x)$$

(1.1.31)

We now define the integral I along the reference path as

$$I = \int_{x_1}^{x_2} \psi(x, y(x), y'(x)) \, dx$$

(1.1.32)

Replacing y and y' by Y and Y' in equation 1.1.32, we write the integral for the varied path as

$$J = \int_{x_1}^{x_2} \psi \left\{ x, \underbrace{y(x) + \delta y(x)}_{Y}, \underbrace{y'(x) + \delta y'(x)}_{Y'} \right\} dx$$

(1.1.33)

Expanding the ψ function in a Taylor's series around the point $\epsilon = 0$, we obtain

$$\psi \left\{ x, y(x) + \delta y(x), y'(x) + \delta y'(x) \right\} = \psi(x, y(x), y'(x))$$

$$+ \left(\frac{\partial \psi}{\partial y}\right)_{\epsilon = 0} \delta y + \left(\frac{\partial \psi}{\partial y'}\right)_{\epsilon = 0} \delta y' + \quad \begin{array}{l} \text{terms of order } \epsilon^2 \\ \text{and higher} \end{array}$$

(1.1.34)

Neglecting the terms of higher power in equation 1.1.34, we may write

$$\psi(x, y + \delta y, y' + \delta y') \quad - \quad \psi(x,y,y')$$

$$= \frac{\partial \psi}{\partial y} \delta y + \frac{\partial \psi}{\partial y'} \delta y'$$

(1.1.35)

We now define the left hand side of equation 1.1.35 as $\delta \psi$ and write

$$\delta \psi = \frac{\partial \psi}{\partial y} \delta y + \frac{\partial \psi}{\partial y'} \delta y'$$

(1.1.35a)

Thus

$$\delta J = \int_{x_1}^{x_2} \delta \psi \, dx$$

(1.1.36)

and

$$\delta J = \int_{x_1}^{x_2} \left\{ \frac{\partial \psi}{\partial y} \delta y + \frac{\partial \psi}{\partial y'} \delta y' \right\} dx$$

(1.1.36a)

Integration of the second term of 1.1.36a by parts yields

$$\int_{x_1}^{x_2} \underbrace{\left(\frac{\partial \psi}{\partial y'} \right)_{\epsilon = 0}}_{u} \underbrace{\delta y' \, dx}_{dv}$$

(1.1.37)

$$\frac{\partial \psi}{\partial y'} \delta y \bigg|_{x_1}^{x_2} - \int_{x_1}^{x_2} \delta y \frac{d}{dx}\left(\frac{\partial \psi}{\partial y'}\right) dx$$

(1.1.38)

$$\delta J = \frac{\partial \psi}{\partial y'} \cdot \delta y \bigg|_{x_1}^{x_2} + \int_{x_1}^{x_2} \delta y \left\{\frac{\partial \psi}{\partial y} - \frac{d}{dx}\left(\frac{\partial \psi}{\partial y'}\right)\right\} dx$$

(1.1.39)

Since

$$\delta y = \epsilon \nu(x)$$

(1.1.40)

and

$$\nu(x_1) = \nu(x_2) = 0$$

(1.1.41)

then the first term vanishes at the end points and we write

$$\delta J = \int_{x_1}^{x_2} \delta y \left\{\frac{\partial \psi}{\partial y} - \frac{d}{dx}\left(\frac{\partial \psi}{\partial y'}\right)\right\} dx$$

(1.1.42)

If we choose the reference path Γ° as giving the extremum of the integral I for all variations of path Γ, then all variations vanish and we write

$$\delta J = 0$$

(1.1.43)

and

$$\int_{x_1}^{x_2} \delta y \left\{ \frac{\partial \psi}{\partial y} - \frac{d}{dx} \left(\frac{\partial \psi}{\partial y'} \right) \right\} dx = 0$$

(1.1.44)

This implies that for arbitrary variations (δy is arbitrary) we have

$$\frac{\partial \psi}{\partial y} - \frac{d}{dx} \left(\frac{\partial \psi}{\partial y'} \right) = 0$$

(1.1.45)

Equation 1.1.36 shows that it is natural to define the weak variation of any function as

$$\delta \phi(x_1, x_2, x_3, \dots) = \frac{\partial \phi}{\partial x_1} \delta x_1 + \frac{\partial \phi}{\partial x_2} \delta x_2 + $$

$$\frac{\partial \phi}{\partial x_3} \delta x_3 + \dots$$

(1.1.46)

Equations 1.1.45 and 1.1.46 are the fundamental equations of the calculus of weak variations.

Equation 1.1.45 indicates that if one desires to minimize the integral of a function ψ with respect to a weak variation then one merely solves equation 1.1.45 for the function ψ. This equation is called the Euler-Lagrange equation.

Equation 1.1.46 shows that the variation $\delta \phi$ has a form identical to the differential $d\phi$ of ordinary calculus. However the variations δx_i of course cannot be interpreted as the differential dx_i.

On the other hand, the fact that the calculus of variation is equivalent to the ordinary calculus in terms of formalism means that we do not have to learn anything new. We must remember that the differential of a function is not the same as the variation of a function.

These quantities must be used in the appropriate physical case.

1.2 Lattice Energy

This section shows how to calculate the binding energy of a silver bromide crystal in terms of the covalent repulsion energy and the electrostatic binding energy of the ions in the lattice structure of the crystal.

This calculation is important when considering the effective charge of latent image aggregates at the surface of a crystal.

MADELUNG ENERGY

The *Madelung energy* is the electrostatic binding energy of ionic crystals.

We may write the energy of interaction between any two ions, where a is the reference ion and j is any other ion; thus the total energy of any one ion a is

$$E_a = \sum_{j \neq a} E_{aj}$$

(1.2.1)

We assume that E_{aj} may be written as

$$E_{aj} = \lambda \exp(-r_{aj}/\rho) \pm \frac{|q_a||q_j|e^2}{r_{aj}}$$

(1.2.2)

The first term $\lambda \exp(-r_{aj}/\rho)$ represents a *repulsive potential* where λ and ρ are parameters to be determined by experiment, q_a is the charge of the reference ion in units of e and q_j is the charge of the ion in units of e at the distance r_{aj}, and where e is the charge on the electron.

This repulsive potential represents the fact that filled electronic shells tend to repel neighboring ions in such a manner that there is a resistance to the overlapping of the electron distribution of neighboring ions. This is a result of the Pauli exclusion principle.

The term $\pm|q_a||q_j|e^2/r_{aj}$ is the coulomb potential where the negative sign refers to unlike charges and the positive sign to like charges, q being magnitude of the charges.

It is possible to characterize the repulsive potential as

$$\frac{A}{R^{12}}$$

(1.2.3)

where A = a constant

R = the distance of nearest neighbors

This form of the repulsive potential is not used in this text because the authors consider the exponential form which contains 2 empirical constants as a more accurate representation of the repulsive interaction.

The sodium chloride type crystal structure, i.e., silver chloride and silver bromide, is composed of positively charges silver ions and negatively charged halide ions at alternate points of a simple cubic lattice (Figure 1.2.1).

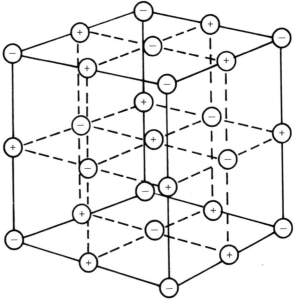

Fig. 1.2.1 *Shows schematically a silver chloride or silver bromide crystal lattice structure. This structure represents the unit cell with the positively charged ion arbitrarily placed at the center of coordinates. This simple cubic lattice structure is generally referred to as the sodium chloride type crystal.*

The E_a of the silver halide crystal is independent of the choice of reference ion. As a first approximation, we neglect the surface effects; due to the charge ending at a surface or a corner. This approximation is equivalent to assuming that the crystal is infinite in extension while containing a finite number of ions.

Utilizing this approximation, we write for an appropriate silver halide system containing N molecules (equivalent to 2N ions)

$$E_{total} = \frac{1}{2} \sum_a E_a$$

(1.2.4)

where the sum is taken over all the ions of the crystal and the factor ½ is introduced so that paired interactions are not counted twice; i.e., as the reference ion is changed to the next neighboring ion, the interaction between the new and former reference ion is not counted.

Since the crystal is assumed to be infinite in extent in all directions, there are no surface effects; thus the value of E_a is the same regardless of where the reference ion is chosen.

Hence we may write

$$E_1 = E_2 = E_3 = \cdots E_a = \cdots E_{2N}$$

(1.2.5)

Thus using equation 1.2.5, we have

$$\sum_a E_a = 2NE_a$$

(1.2.6)

Substituting equation 1.2.6 into equation 1.2.4, we write

$$E_{total} = \frac{1}{2} 2NE_a = NE_a$$

(1.2.7)

Equation 1.2.7 represents the amount of energy required to separate the ions of the crystal into single ions which are at an infinite distance from each other.

If we measure the distance r_{aj} in equation 1.2.2 in terms of the nearest neighbor distance R, we may write

$$r_{aj} \equiv n_{aj}R \tag{1.2.8}$$

where n_{aj} is a conversion factor.

This conversion is made in order to express the results in terms of the easily measurable quantity R (by X-ray diffraction techniques).

Since the repulsive interaction is a short range force, we may include its effect only for nearest neighbors without appreciable loss of accuracy. Thus we may write for nearest neighbor repulsive interaction

$$\lambda\exp(-R/\rho) \tag{1.2.9}$$

Therefore the contribution of the short range repulsive term to E_{aj} is

$$Z\lambda\exp(-R/\rho) \tag{1.2.10}$$

where Z is equal to the number of nearest neighbors.

Since the coulomb term includes all interactions, we may write

$$E_a = \underbrace{Z\lambda\exp(-R/\rho)}_{\substack{\text{Nearest}\\\text{Neighbor}\\\text{Interact-}\\\text{ions}}} + \underbrace{\sum_j \pm \frac{|q_a||q_j|e^2}{r_{aj}}}_{\substack{\text{All Other Inter-}\\\text{actions}}} \tag{1.2.11}$$

Substituting 1.2.8 into equation 1.2.11, we write

$$E_a = Z\lambda\exp(-R/\rho) + \frac{e^2}{R}\sum_j \pm \frac{|q_a||q_j|}{n_{aj}} \tag{1.2.12}$$

The quantity

$$M = \sum_{j} \pm \frac{|q_a||q_j|}{n_{aj}}$$

(1.2.13)

is known as the Madelung constant.

After substitution of equation 1.2.13 into equation 1.2.12, we may write

$$E_a = Z\lambda\exp(-R/\rho) + \frac{Me^2}{R}$$

(1.2.14)

The total lattice energy can now be written as

$$E_{total} = N\left(Z\lambda\exp(-R/\rho) + \frac{Me^2}{R}\right)$$

(1.2.15)

Conventionally the sign within the bracketed term of equation 1.2.15 is taken as negative.

This simply changes all the signs of the summation terms M.

Applying this convention, we may write

$$E_{total} = N\left(Z\lambda\exp(-R/\rho) - \frac{Me^2}{R}\right)$$

(1.2.16)

In this convention the minus sign in the Madelung constant refers to like charges whereas a positive sign refers to unlike charges.

Ions in a lattice vibrate around a fixed equilibrium distance $R_0(T)$ that is easily measured at very low temperature by X-ray diffraction methods (Figure 1.2.2).

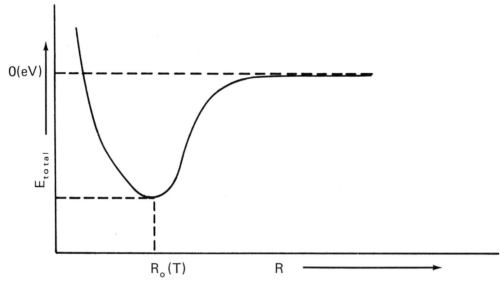

Fig. 1.2.2 Shows a plot of E_{total} distance for the ions and
 versus R where R_o is the equilibrium is a function of temperature.

In order to obtain the value of E_{total} in terms of R_o, it is necessary to take the derivative of equation 1.2.16 with respect to R. According to Figure 1.2.2, when R is equal to R_o, the derivative is equal to zero.

Thus we may write

$$\frac{dE_{total}}{dR} = NZ\lambda(-\frac{1}{\rho})\exp(-R/\rho) + \frac{NMe^2}{R^2}$$

$$(1.2.17)$$

at $R = R_o$ we have

$$\left(\frac{dE_{total}}{dR}\right)_{R = R_o} = 0 = \frac{-NZ\lambda}{\rho}\exp(-R_o/\rho) + \frac{NMe^2}{R_o^2}$$

$$(1.2.18)$$

Solving, we write

$$R_o^2 \exp(-R_o/\rho) = \frac{\rho Me^2}{Z\lambda}$$

$$(1.2.19)$$

and

$$\lambda = \frac{\rho Me^2}{ZR_o^2} \exp(R_o/\rho)$$

(1.2.20)

At the equilibrium distance the total energy is

$$E_{total} = N\left(Z\lambda\exp(-R_o/\rho) - \frac{Me^2}{R_o}\right)$$

(1.2.21)

Substituting equation 1.2.20 into equation 1.2.21, we write

$$E_{total(R_o)} = N\left(\frac{\rho Me^2}{R_o^2} - \frac{Me^2}{R_o}\right)$$

(1.2.22)

$$E_{total(R_o)} = -\frac{NMe^2}{R_o}\left(1 - \frac{\rho}{R_o}\right)$$

(1.2.23)

where the term $-NMe^2/R_o$ is called (after Madelung who first calculated the value of M) the *Madelung energy*. [Ref: E. Madelung, *Physik. Z.* 19, 524 (1918).]

EXERCISE:

1. Define the Madelung energy.
2. If b represents the reference ion and k is any other ion in a system containing 20 ions, write the expression for the total energy of any one ion b.
3. Consider the relative size of an ion with respect to the volume of a crystal. Choose an arbitrary spherical crystal having a diameter of 1 micron.
4. Discuss why we may make the assumption that a crystal is infinite in extension while containing a finite number of ions.
5. Verify equation 1.2.15.

EXAMPLE CALCULATIONS OF THE MADELUNG CONSTANT

For a one-dimensional line of ions

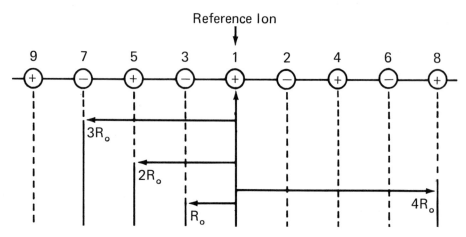

Fig. 1.2.3 *Shows a one-dimensional line of ions with
alternating charge. The reference charge is
arbitrarily chosen as a positive ion.*

Applying the definition of the Madelung constant in the convention
of 1.2.16, we may calculate the Madelung constant for the line of ions in
Figure 1.2.3 as

$$M = \sum_{j=2}^{9} \pm \frac{1}{n_{1j}} = +\frac{1}{n_{12}} + \frac{1}{n_{13}} - \frac{1}{n_{14}} - \frac{1}{n_{15}} + \frac{1}{n_{16}}$$
$$+ \frac{1}{n_{17}} - \frac{1}{n_{18}} - \frac{1}{n_{19}}$$

(1.2.24)

where + = two ions of unlike charge
 − = two ions of like charge

Since

$$\left\{ \begin{array}{llll} n_{12} = n_{13} = 1 & n_{16} = n_{17} = 3 \\ n_{14} = n_{15} = 2 & n_{18} = n_{19} = 4 \end{array} \right\}$$

(1.2.25)

then

$$M = 1 + 1 - \frac{1}{2} - \frac{1}{2} + \frac{1}{3} + \frac{1}{3} - \frac{1}{4} - \frac{1}{4}$$

(1.2.26)

and

$$M = 2(1 - \frac{1}{2} + \frac{1}{3} - \frac{1}{4})$$

(1.2.27)

If the line of ions is extended to infinity in both directions, then we have the infinite series

$$M = 2(1 - \frac{1}{2} + \frac{1}{3} - \frac{1}{4} + \frac{1}{5} - \frac{1}{6} \cdots)$$

(1.2.28)

Since

$$\log(1 + X) = \frac{X^2}{2} + \frac{X^3}{3} - \frac{X^4}{4} + \frac{X^5}{5} \cdots$$

(1.2.29)

then if X = 1, we have

$$\log(2) = 1 - \frac{1}{2} + \frac{1}{3} - \frac{1}{4} + \frac{1}{5} \cdots$$

(1.2.30)

Comparison of equations 1.2.28 and 1.2.30 enables us to write

$$M = 2(\log 2) = 1.38$$

(1.2.31)

Therefore the Madelung constant is dependent only upon the lattice structure and the arrangement of the ions in the lattice.

For a three-dimensional lattice, it is convenient to arrange the summation in terms of neutral or nearly neutral groups of ions by dividing ions into fractional charges according to their lattice position. This method of summation of charges was originally given by Ewald, Evjen and Frank [Ref: P.P. Ewald, *Ann. Physik.*, **64**, 253 (1921); H.M. Evjen, *Phys. Rev.*, **39**, 675 (1932); F.C. Frank, *Phil. Mag.*, **41**, 1287 (1950)].

The particular example of the calculation of the Madelung constant for silver halides which have the NaCl structure is due to Evjen (Figure 1.2.4).

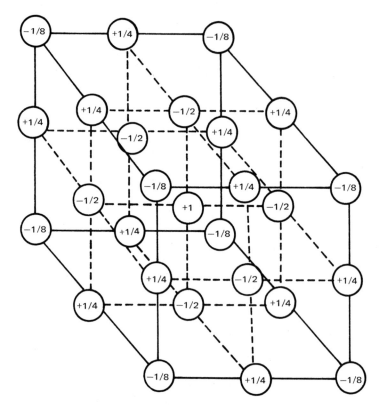

Fig. 1.2.4 *Shows the partial charges assigned to the positive and negative ions, according to Evjen.*

Since the Madelung constant is independent of the ionic specie, the calculation given in this text is applicable to silver chloride and silver bromide as well as to many other ionic crystals having a face centered cubic structure.

The unit cell shown in Figure 1.2.4 assigns 1/8 of the charge of the chloride or bromide ions at each corner. This assignment arises from the fact that we may construct 8 unit cells that will share the same ion.

The assignment of ¼ and ½ of the charge of the chloride or bromide ions which are located on an edge and face of the crystal respectively is based on the number of unit cells that can share the same ion (Figure 1.2.5).

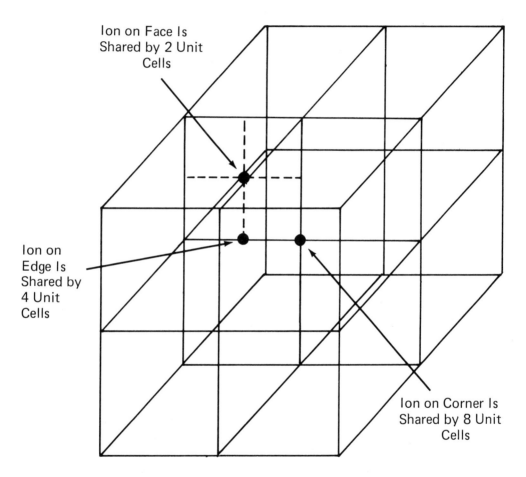

Ion on Face Is Shared by 2 Unit Cells

Ion on Edge Is Shared by 4 Unit Cells

Ion on Corner Is Shared by 8 Unit Cells

Fig. 1.2.5 *Shows the sharing of face edge and corner ions by the surrounding unit cells.*

In order to calculate the Madelung constant, we must determine the distances in terms of R_o from the reference ion to the corner, edge and face ion (Figure 1.2.6).

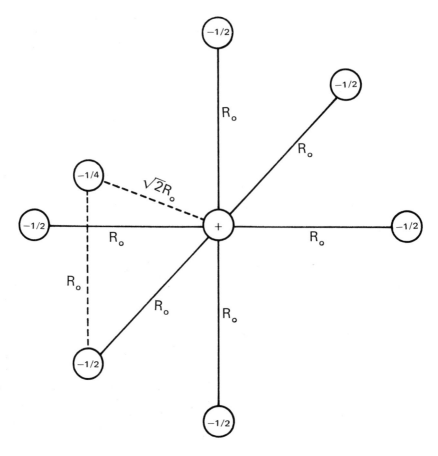

Fig. 1.2.6 *Shows schematically the reference positively nearest neighbors, and at a distance of $\sqrt{2}R_o$*
charged ion at a distance of R_o from its 6 from an edge ion.

EXERCISE

Show that the distance from the reference ion to a corner ion is $\sqrt{3}\ R_o$.

The calculation of the Madelung constant for the silver bromide lattice having a charge distribution similar to the structure shown in Figure 1.2.4 may be performed for this first unit cube. The cube surrounding the positively charged reference ion intercepts eight $(-1/8)$ charges at the cube corner, twelve $(+1/4)$ charges at the cube edges and six $(-1/2)$ charged ions at the cube faces.

Thus the calculation of the contribution to the Madelung constant for the first cube is

$$M = \frac{6 \times 1/2}{1} - \frac{12 \times 1/4}{2^{1/2}} + \frac{8 \times 1/8}{3^{1/2}}$$

(1.2.32)

$$M = 1.46$$

(1.2.33)

Since the experimentally determined value of the Madelung constant for either silver chloride or silver bromide is 1.747558, it is evident that we must sum up the fractional charges for the next larger cube (Figure 1.2.7).

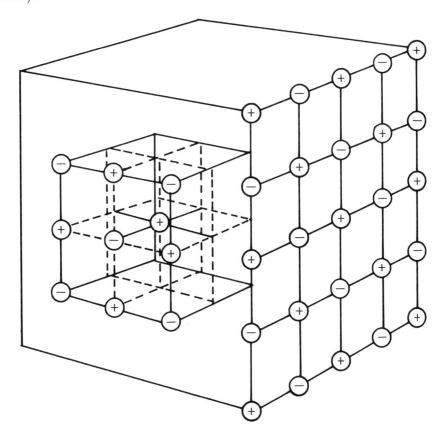

Fig. 1.2.7 *Shows the charges on one face and the reference positively charged ion of the original cube of Figure 1.2.4 surrounded by the next larger cube. The length of the smaller cube is $2R_o$, whereas the length of the larger cube is $4R_o$ For simplicity, only one face is depicted with charges.*

In this summation, the fractional charges of the outer cube include the remainder of fractional charges excluded from the original summation.

The calculation of the contribution to the Madelung constant from the charges in the next larger cube is divided into two parts. The first part is the contributions from the residual fractional charges excluded in the original cube (Figure 1.2.4) and the second part is the contribution from the charges of the surface of the larger cube.

Thus the contribution from part one is written as

$$M = \frac{6 \times 1/2}{1} - \frac{12 \times 3/4}{\sqrt{2}} + \frac{8 \times 7/8}{\sqrt{3}}$$

(1.2.34)

$$M = + .676$$

(1.2.35)

The contribution from the second part includes the summation of 98 charges on the surface of the larger cube.

This summation can be conveniently arranged by the systematic consideration of the ions in the corners, edge and face positions of the larger cube (Figure 1.2.8).

EXERCISE

1. Apply the definition of the Madelung constant and calculate the Madelung constant for the line of ions shown in Fig. 1.2.3.
2. Discuss how the assignment of fractional charge for face, edge and corner ions is made.
3. Verify the signs in equation 1.2.32 according to the earlier convention.

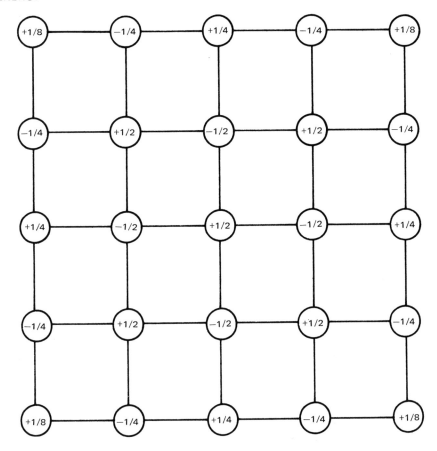

Fig. 1.2.8 *Shows schematically the charges assigned to the edge, corner and face ions for one face of the next larger cube.*

FACE CHARGE CALCULATION FOR LARGE CUBE

The first ion to be considered is the center face ion, which is a distance of $2R_o$ from the reference ion (Figure 1.2.9). Since there are a total of six of these ions, we write

$$\frac{-6 \times 1/2}{2} = -1.5$$

(1.2.36)

The second group of ions to be considered are the negatively charged face ions. Since there is a total of twenty-four of these ions at a distance of $\sqrt{5}R_o$ from the reference ion, we write

$$\frac{24 \times 1/2}{\sqrt{5}} = 5.369$$

(1.2.37)

Since there is a total of twenty-four positive charged face ions at a distance of $\sqrt{6}R_o$ from the reference ion, we have

$$\frac{-24 \times 1/2}{\sqrt{6}} = -4.902$$

(1.2.38)

This completes the calculation for the fifty-four face charges.

EDGE CHARGE CALCULATION

Since there is a total of twelve positively charged edge ions at a distance of $2\sqrt{2}R_o$ from the reference ion, we may write

$$\frac{-12 \times 1/4}{2\sqrt{2}} = -1.061$$

(1.2.39)

For the remaining twenty four negatively charged edge ions at a distance of $3R_o$ from the reference ion, we find

$$\frac{24 \times 1/4}{3} = 2$$

(1.2.40)

CORNER CHARGE CALCULATION

For the eight corner charges at a distance of $2\sqrt{3}R_o$ from the reference ion, we write

$$\frac{-8 \times 1/8}{2\sqrt{3}} = -.2887$$

(1.2.41)

Summing all contributions, we write

$$M = 1.753$$

(1.2.42)

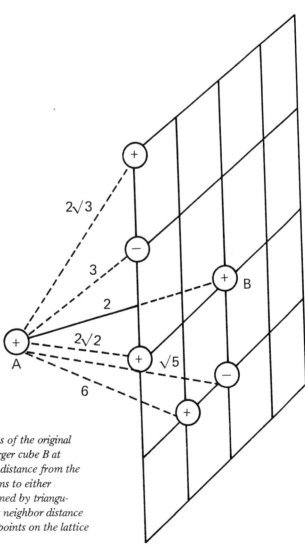

Fig. 1.2.9 *Shows the reference ions of the original cube A, and the next larger cube B at a distance of $2R_o$. The distance from the corner, edge and face ions to either reference ion is determined by triangulation where the nearest neighbor distance from any two adjacent points on the lattice is R_o.*

Since each cube is practically neutral, this method of summing the coulomb interactions leads to rapid convergence.

It is of photographic interest to calculate the Madelung constant with respect to a reference ion at the surface of a silver bromide crystal (see Section 1.3). In order to simplify the calculation, we consider a two-dimensional model (Figure 1.2.10).

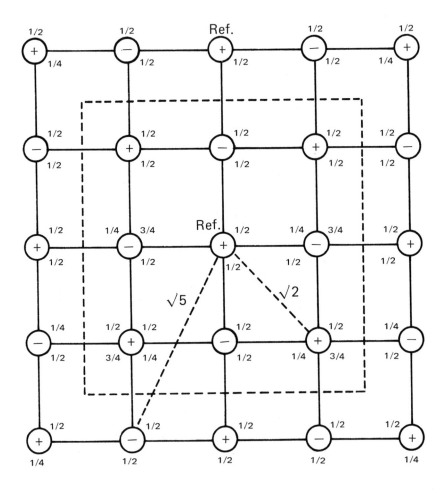

Fig. 1.2.10 *Shows schematically in two dimensions a lattice having two reference charges. Charges ascribed above the lattice positions are relative to the surface reference ion* *while those charges shown below the lattice positions are relative to the center face reference ion.*

The small lattice contribution with respect to the reference ion at the center is

$$\frac{-4 \times 1/4}{\sqrt{2}}, \quad \frac{-4 \times 3/4}{\sqrt{2}}, \quad \frac{4 \times 1/2}{1}, \quad \frac{4 \times 1/2}{1}$$

(1.2.43)

The large lattice contribution with respect to the reference ion at the center is

$$\frac{-4 \times 1/2}{2}, \quad \frac{8 \times 1/2}{\sqrt{5}}, \quad \frac{-4 \times 1/4}{2\sqrt{2}}$$

(1.2.44)

Summing all contributions, we write

$$M = 1.607$$

(1.2.45)

This two-dimensional calculation approximates the earlier three-dimensional calculation.

Using Figure 1.2.10 and calculating the Madelung constant with respect to the positively charged ion at the surface of the crystal, after summing all contributions, we find

$$M = 0.403$$

(1.2.46)

This calculation shows that an ion or charge at the surface is bound less strongly than in the interior of the crystal.

The loss of binding energy is equivalent to a loss of effective electronic charge.

This *partial coulombic force* effect at the surface (see Conclusion to Section 1.3) is responsible for the presence of an effective charge on silver aggregates containing no ions.

EXERCISE

Using Figure 1.2.10, verify the Madelung constant with respect to the positively charged ion at the surface of the crystal (M = 0.403).

(See below.)

1.3 Quantum Model of Development

INTRODUCTION

The environment of the silver halide grains during photographic chemical development consists of a solution of electrolytes at an interface with an ionic crystalline solid. This solution contains a chemical reducing agent which can reduce the silver ions of an *exposed* silver halide grain to metallic silver at a faster rate than the rate that the reducing agent can develop an *unexposed* grain.

It is the purpose of this section to discuss a quantum model for photographic development in qualitative terms. This model shows how Fermi-Dirac statistics can be applied to the quantum states of the latent image and how these states are related to conventional photographic development.

The treatment in this section is based upon the model of F. Trautweiler. [Ref: F. Trautweiler, *Phot. Sci. Eng.,* 12,138 (1968).]

Although the Trautweiler model is speculative in nature, it represents the first plausible attempt to describe photographic development in the terms of quantum mechanics.

Other workers have applied quantum mechanics to explain the mechanism of spectral sensitization and desensitization (see Chapter 4).

Since photographic development is a microscopic process, ultimately it will have to be described by quantum mechanics.

Thus this section presents an elementary and speculative model with the realization that it will be refined by later investigators.

By presenting this model at this time the authors hope to stimulate the reader to think and integrate Fermi-Dirac statistics and the covalent bond with latent image states and developability of silver halide grains.

INTERFACIAL PROPERTIES OF UNEXPOSED GRAINS

We are considering the interfacial properties between an unexposed silver halide grain and the developing agent. The only systems under consideration are those to which a redox potential can be ascribed (see Chapter 3).

The unexposed silver halide grain has a valence band that is characterized by a complete lack of holes

$$[h_f] \;+\; [h_t] \;=\; 0$$

(1.3.1)

The conduction band of the unexposed grain may be characterized by the equation

$$[\epsilon_t] \;+\; [\epsilon_f] \;=\; 0$$

(1.3.2)

where

$[h_f]$ = the concentration of free holes
$[h_t]$ = the concentration of trapped holes
$[\epsilon_t]$ = the concentration of trapped electrons
$[\epsilon_f]$ = the concentration of free electrons

The isolated surface of the unexposed grains also has a concentration of ionic defects(see Section 1.1) which come to thermal equilibrium with the bulk of the crystal. At thermal equilibrium, the state of the isolated surface of the grain has a difference in electrical potential relative to the remainder of the grain, maintained by *diffuse space charge.*

Trautweiler points out [Ref: F. Trautweiler, *Phot. Sci. Eng.,* 12, 98 (1968)] that there are at least two theoretical reasons for the layer of diffuse space charge initially derived by Frenkel and Lehovec and by Grimly and Mott [Ref: J. Frenkel, *Kinetic Theory of Liquids,* Oxford University Press, New York (1946), p-36; K. Lehovec, *J. Chem. Phys.,* 21, 1123 (1953); T.B. Grimly and N.F. Mott, *Disc. Faraday Soc.,* 1, 3 (1947); T.B. Grimly, *Proc. Roy. Soc.,* 8201, 40 (1950).]

The Frenkel and Lehovec theory assumes that there are a sufficient number of surface sites (kink sites, jogs etc.) with which the vacancies and interstitials are in a dynamic equilibrium. If there is a *Frenkel defect* (cation moves into an interstitial position near the surface of the crystal)

near the surface of the crystal, the interstitial positive ion can be compensated for by an adsorbed negative charge. On the other hand, the vacancy can be formed at the surface(cation becomes interstitial moving away from the surface) and the vacancy is compensated for by an adsorbed positive charge. (Shottky defect)

The free energies of formation for these two processes are different. At thermal equilibrium the thermodynamic requirement that the total change in the free energy of the process be equal to zero results in a different concentration of vacancies and interstitials at the surface (see Chapter 3). For crystals containing only intrinsic defects (Shottky, Frenkel) the concentration of vacancies and interstitials is equal in the bulk of the crystal. A difference in potential results due to this inequality in concentration of the vacancies and interstitials with respect to the surface and the bulk of the crystal.

The charges that maintain this difference in potential extend to several tenths of a micron into the interior [Ref: V.I. Saunders, R.W. Tyler and W. West, *Phot. Sci. Eng.*, **12**, 90 (1968).] This extended charge layer is called a diffuse space charge. On the other hand, the compensating charged surface is not diffuse (see Figure 1.3.1).

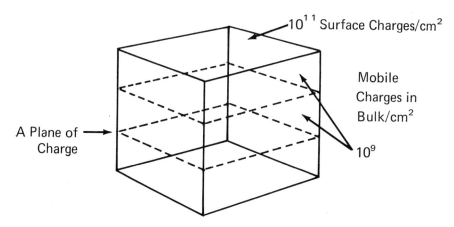

Fig. 1.3.1 *Shows the planar surface charge the planes of diffuse space charge extending*
of a portion of a silver bromide crystal and into the bulk of the crystal.

The measurements of Saunders, Tyler and West cited previously were analyzed by Trautweiler, who derived the density of surface charges to be $2(+3-1) \times 10^{11}$ negative charges/cm^2 and the concentration of mobile positive charges in the bulk to be $(5 \pm 2)10^{14}$ positive charges/cm^3. Thus an isolated silver bromide crystal can be thought of as a body with a negatively charged surface that is compensated by a positive diffuse space charge extending into the interior of the grain.

EXERCISE

> Given that the concentration of mobile positive charges in the bulk of the crystal is $5 \times 10^{14}/cm^3$, determine the approximate planar density within the bulk of the crystal.

As shown in Figure 1.3.1, an intrinsic property of a silver halide crystal is that the surface is negatively charged whereas the interior has a positive diffuse space charge.

Although the micro crystals of a photographic emulsion are too small to allow the full development of the potential difference between the surface and the interior which is characteristic of larger crystals, a small potential difference between the surface and the interior does exist. This potential field is repulsive to electrons moving toward the negatively charged surface.

On the other hand, this surface condition attracts positive holes. Since a chemically unsensitized grain surface has a deficiency in silver ions whereas the sub surface region has a preponderance of silver ions, the effect is to favor low surface sensitivity and high internal sensitivity for the unsensitized emulsion. (Also see 2.3.135, 2.3.155.)

Slifkin *et al.* [Ref: L. Slifkin, W. McGowan, A. Fukai and J. S. Kim, *Phot. Sci. Eng.,* **11**, 79 (1967)] suggest for an unsensitized silver chloride grain that:

1. The larger potential field in the region of the diffuse space charge separates the electron hole pair, drawing the hole quickly to the surface and preventing recombination.

2. The large concentration of negative surface charges repels the electron, thereby reducing the number of possible electron trapping sites.

3. The surface site, which has an adsorbed positive ion, increases the electron trapping efficiency at that site. Thus photolytic silver would be concentrated at only a few surface sites due to the excess of negative charges at the surface.

4. Due to the large gradient of the electric field near the surface of the grain, *excitons* (see Section 1.1) of large radius might be drawn to the surface, where the field would dissociate them.

5. Due to the tendency for the interstitial ion produced in the Frenkel defect to travel to the interior, there will be a large concentration of interstitial ions just below the surface in the region of diffuse space charge.

Thus we may conclude from statement five that *the ionic process for latent image formation and the growth of silver aggregates is faster in the interior for unsensitized silver halide grains.*

Although Slifkin *et al.* offered suggestions 1 thru 5 only as speculations, it is apparent that the work of Slifkin *et al.*, Saunders *et al.* and Trautweiler gives further insight into the observed low surface and high internal sensitivity associated with many unsensitized emulsions.

These surface effects are significant to the photographic process.

In order to treat the Trautweiler model, "Implications of a Quantum Model of the Latent Image" [Ref: F. Trautweiler, *Phot. Sci. Eng.*, 12, 138 (1968)] it is necessary to understand Fermi-Dirac statistics. Therefore before proceeding further, we will derive the Fermi-Dirac distribution function and relate this function to chemical potential.

DERIVATION OF FERMI-DIRAC DISTRIBUTION

Particles such as electrons with spin ±½ or particles with spin ± $(2n+1)/2$ where n = 0, 1, 2, 3, . . . , are constrained by the Pauli principle. This principle states that no two electrons can have the same set of quantum numbers. This fact is equivalent to placing each electron at an energy level ϵ_i into g_i distinguishable boxes. Each box represents the set of possible quantum numbers for the electron, at energy ϵ_i. The electrons are indistinguishable relative to each other.

Thus we are faced with the problem of placing N_i indistinguishable electrons into g_i distinguishable boxes. We must calculate the number of different ways that this placement can be done (also see DERIVATION OF MAXWELL BOLTZMANN DISTRIBUTION Section 2.3).

We shall number the boxes 1, 2, 3, . . . , g_i. Each time we place N_i electrons into the g_i boxes where $N_i < g_i$ we choose a particular combination of the numbers 1 through g_i taken N_i times.

For example, if $g_i = 5$ and $N_i = 3$, then a placement of the 3 electrons may be written 1, 3, 5. Other possible placements are 1, 2, 3; 1, 4, 5; and so on. These examples show that the total number of different placements that can be made is equal to the number of combinations of g_i boxes taken N_i times.

Thus the thermodynamic probability (see Section 2.3) for the i^{th} energy state may be written as

$$W_i = \frac{g_i!}{(g_i - N_i)! \, N_i!}$$

$$(1.3.3)$$

The total theromodynamic probability is given by the total number of ways that we can place N particles among all the ϵ_i energy levels where

$i = 0, 1, 2, 3, \ldots$, and where

$$N = \sum_i N_i$$

(1.3.4)

Since expression 1.3.3 gives the number of ways that N_i particles can be placed among g_i boxes at energy ϵ_i, then the total number of ways of placing N particles over all energy levels is given by

$$\Pi_i \frac{g_i!}{(g_i - N_i)!N_i!}$$

(1.3.5)

Thus the total thermodynamic probability may be written as

$$W = \Pi_i \frac{g_i!}{(g_i - N_i)!N_i!}$$

(1.3.6)

At this point the reader should see the derivation of the Maxwell-Boltzmann distribution in Section 2.3.

Taking the log of expression 1.3.6 and remembering that the log of a product is a sum of logs, we write

$$\ln W = \sum_i \left\{ \ln g_i! - \ln (g_i - N_i)! - \ln N_i! \right\}$$

(1.3.7)

In photographic systems of interest, g_i and N_i are very large numbers. For instance, in one grain of silver bromide of the volume approximating (10^{-13} cm^3) the number of molecules of silver bromide is of the order of 10^9 molecules.

EXERCISE

Verify that a silver bromide crystal of volume 10^{-13} cm^3 having a density of 6.47 grams/cm^3 contains approximately 10^9 molecules.

Since N_i and g_i are large, we may apply Stirling's approximation in the form

$$\ln X! = X \ln X - X$$

(1.3.8)

$$\ln g_i! = g_i \ln g_i - g_i$$

(1.3.9)

$$\ln (g_i - N_i)! = (g_i - N_i) \ln (g_i - N_i) - (g_i - N_i)$$

(1.3.10)

$$\ln N_i! = N_i \ln N_i - N_i$$

(1.3.11)

Substituting expressions 1.3.9, 1.3.10 and 1.3.11 into equation 1.3.7, we may write

$$\ln W = \sum_i \left\{ g_i \ln g_i - (g_i - N_i) \ln (g_i - N_i) - N_i \ln N_i \right\}$$

(1.3.12)

In a manner identical to the derivation of the Maxwell-Boltzmann distribution (see Section 2.3) we subtract the constraints

$$N = \sum_i N_i$$

(1.3.13)

45

$$E = \sum_i E_i N_i$$

(1.3.14)

after the variations are taken and they are multiplied by the undetermined multipliers α and β respectively. We take the variations and the results are

$$\delta N = \sum_i \delta N_i = 0$$

(1.3.15)

$$\delta E = \sum_i E_i \delta N_i = 0$$

(1.3.16)

Equations 1.3.15 and 1.3.16 are equal to zero and have the given forms because N, E, g_i, E_i are constants.

With these facts in mind, we may take the variations of ln W and find

$$\delta \ln W = \sum_i \left\{ -g_i \frac{\delta(g_i - N_i)}{(g_i - N_i)} + \delta N_i \ln(g_i - N_i) \right.$$

$$+ N_i \frac{\delta(g_i - N_i)}{(g_i - N_i)} - \delta N_i \ln N_i - N_i \frac{\delta N_i}{N_i} \right\}$$

$$= \sum_i \left\{ \frac{g_i \delta N_i}{g_i - N_i} + \delta N_i \ln(g_i - N_i) - \frac{N_i \delta N_i}{(g_i - N_i)} - \delta N_i \ln N_i - \delta N_i \right\}$$

(1.3.17)

By rearranging terms and removing the common factor δN_i we can eliminate three terms in the sum. After rearrangement and factoring, we may write

$$\delta \ln W = \sum \left\{ \frac{g_i}{g_i - N_i} - \frac{N_i}{g_i - N_i} - 1 + \ln(g_i - N_i) - \ln N_i \right\} \delta N_i$$

(1.3.18)

The first three terms in equation 1.3.18 sum to zero since

$$\frac{g_i}{g_i - N_i} - \frac{N_i}{g_i - N_i} - 1 = \frac{g_i - N_i}{g_i - N_i} - 1 = 0$$

(1.3.19)

Using relation 1.3.19, we have

$$\delta \ln W = \sum_i \left\{ \ln(g_i - N_i) - \ln N_i \right\} \delta N_i$$

(1.3.20)

Multiplying equations 1.3.15 and 1.3.16 by α and β respectively, and subtracting the result from equation 1.3.20, we find

$$\delta \ln W - \alpha \delta N - \beta \delta E = \sum_i \left\{ \ln (g_i - N_i) - \ln N_i - \alpha - \beta E_i \right\} \delta N_i$$

(1.3.21)

The maximum value of W is found (see Section 2.3) by letting the quantity in the brackets go to zero and we write

$$\ln (g_i - N_i) - \ln N_i - \alpha - \beta E_i = 0$$

(1.3.22)

or

$$\ln \left(\frac{g_i}{N_i} - 1 \right) = \alpha + \beta E_i$$

(1.3.23)

Solving equation 1.3.23 for N_i, we have

$$N_i = \frac{g_i}{e^{\alpha + \beta E_i} + 1}$$

(1.3.24)

Equation 1.3.24 is the *Fermi-Dirac distribution law.*

DETERMINATION OF THE VALUES OF α AND β

In order to determine the values of α and β we shall divide the system composed of N molecules given by equation 1.3.13 and the energy E given by equation 1.3.14 into the part containing N_j molecules at energy E_j from the remainder of the system.

The N_j molecules occupy some or all of the g_j degenerate states and the total volume of the system (see Figure 1.3.2).

The remainder of the molecules also occupy the total volume of the system.

We define the N_j molecules at energy E_j as the j portion of the system where j is a number equal to one of the numbers i in equation 1.3.14.

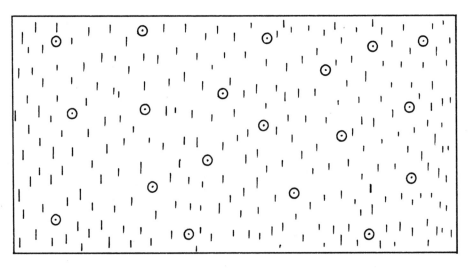

\odot = One of the filled g_j degenerate states of energy E_j

I = Remainder of the system

Fig. 1.3.2 *Shows the division of a system into two parts coexistent in the same volume. The part of the system consisting of the N_j molecules is represented by circles containing dots; the remainder of the system is represented by lines.*

Essentially this division of the system into two parts (Fig. 1.3.2) is equivalent to choosing one term out of the sum in equation 1.3.14.

We can calculate the entropy (see Chapter 3) of the j portion by use of the relation

$$S_j = k \ln W_j$$

(1.3.25)

where

$$W_j = \frac{g_j!}{(g_j - N_j)! \, N_j!}$$

(1.3.26)

the thermodynamic probability for the j^{th} portion of the Fermi-Dirac distribution (see equation 1.3.3).

Substituting equation 1.3.26 into 1.3.25, we have

$$S_j = k \left\{ \ln g_i! - \ln (g_i - N_i)! - \ln N_i! \right\}$$

(1.3.27)

We assume that the j^{th} portion is large so that the factorials in equation 1.3.27 can be approximated by Stirling's approximation.

Making this approximation and the appropriate cancellations, we find

$$S_j = k \left\{ g_j \ln g_j - (g_j - N_j) \ln (g_j - N_j) - N_j \ln N_j \right\}$$

(1.3.28)

By multiplying out the factor $(g_j - N_j)$ in 1.3.28, we have

$$S_j = k \left\{ g_j \ln g_j - g_j \ln (g_j - N_j) + N_j \ln (g_j - N_j) - N_j \ln N_j \right\}$$

(1.3.29)

The total derivative of equation 1.3.29 with respect to N_j (remembering that g_j is a constant) is

$$\frac{dS_j}{dN_j} = k \left\{ -g_j \frac{(-1)}{g_j - N_j} + \ln(g_j - N_j) + N_j \frac{(-1)}{g_j - N_j} \right.$$

$$\left. -\ln N_j - N_j \frac{1}{N_j} \right\}$$

$$(1.3.30)$$

Since the first, third and fifth terms in equation 1.3.30 sum to zero (see equation 1.3.19) we may write

$$\frac{dS_j}{dN_j} = k \ln \left(\frac{g_j}{N_j} - 1 \right)$$

$$(1.3.31)$$

At constant total energy, if a system is at equilibrium with respect to the transfer of particles from the j^{th} portion to the remainder, then the entropy for such a process must have a maximum value. Thus when a particle is added from the j^{th} portion, the increase in entropy of the remainder of the system is given by equation 1.3.31.

The addition of a j^{th} portion particle to the remainder also involves the simultaneous addition of an amount of energy dE_j/dN_j to this region. The change in entropy of the remainder of the system after the addition of a j^{th} portion particle is given as

$$-\frac{dS_R}{dN_j}$$

$$(1.3.32)$$

Since the remainder is much larger than the j^{th} portion, and the entropy of the remainder is approximately equal to the entropy of the total system, we write

$$S_R \approx S$$

$$(1.3.33)$$

From Chapter 3, the differential of S_R can be written as

$$dS_R = \left(\frac{\partial S}{\partial N}\right)_{E,V} dN_R + \left(\frac{\partial S}{\partial E}\right)_{N,V} dE_R$$

(1.3.34)

where dN_R and dE_R are very small quantities.

Since the total number of particles are constant and we are transferring particles from the j^{th} portion to the remainder, we may write

$$dN_R = -dN_j$$

(1.3.35)

$$dE_R = -dE_j$$

(1.3.36)

Therefore substituting 1.3.35 and 1.3.36 into equation 1.3.34, we have

$$dS_R = \left(\frac{\partial S}{\partial N}\right)_{E,V} (-dN_j) + \left(\frac{\partial S}{\partial E}\right)_{N,V} (-dE_j)$$

(1.3.37)

Expression 1.3.37 implies that S_R can be expressed as a function of N_j and E_j with respect to the transfer of a particle from the j^{th} portion to the remainder of the system.

Thus we may write

$$-\frac{dS_R}{dN_j} = \left(\frac{\partial S}{\partial N}\right)_{E,V} + \left(\frac{\partial S}{\partial E}\right)_{N,V} \frac{dE_j}{dN_j}$$

(1.3.38)

From Chapter 3, page 340

$$\left(\frac{\partial S}{\partial N}\right)_{E,V} = -\frac{\mu}{T}$$

(1.3.39)

TOPICS IN PHOTOGRAPHIC SCIENCE

$$\left(\frac{\partial S}{\partial E}\right)_{N,V} = \frac{1}{T}$$

(1.3.40)

where μ is the chemical potential.

Since we are concerned with the transfer of particles from the j^{th} region to the remainder of the system, the energy associated with the transfer of one particle is E_j and we may write

$$\frac{dE_j}{dN_j} = E_j$$

(1.3.41)

Substituting equations 1.3.39, 1.3.40 and 1.3.41 into equation 1.3.38, we have

$$-\frac{dS_R}{dN_j} = -\frac{\mu}{T} + \frac{E_j}{T}$$

(1.3.42)

For the transfer of one particle from the j^{th} region to the remainder, equation 1.3.42 can be equated with equation 1.3.31 and we have

$$k\ln\left(\frac{g_j}{N_j} - 1\right) = -\frac{\mu}{T} + \frac{E_j}{T}$$

(1.3.43)

Solving equation 1.3.43 for N_j

$$N_j = \frac{g_j}{e^{-(\mu - E_j)/kT} + 1}$$

(1.3.44)

Comparing equation 1.3.44 with equation 1.3.24, we see that

$$\alpha = \frac{-\mu}{kT}$$

(1.3.45)

$$\beta = \frac{1}{kT}$$

(1.3.46)

This is a general result which holds for all of quantum statistics. The Fermi-Dirac discrete distribution is sometimes written as

$$\frac{N_j}{g_j} = \frac{1}{e^{(E_j - \mu)/kT} + 1}$$

(1.3.47)

When written in the form of equation 1.3.47, the ratio N_j/g_j is the probability that one of the degenerate energy states g_j at energy E_j will be occupied by an electron.

FERMI LEVEL

If the Fermi-Dirac distribution is applied to the solid state, i.e., silver halide crystals, semiconductors, etc., the chemical potential μ is sometimes called the *Fermi level*. In such cases the particles are electrons and holes. When these particles are located in the conduction band they are considered to have continuous energy states so that the ratio in equation 1.3.47 can be replaced by the continuous function

$$f(E) = \frac{1}{e^{(E - \mu)/kT} + 1}$$

(1.3.48)

Equation 1.3.48 represents a free electron Fermi gas. The *Fermi level,* or *chemical potential* for both the discrete or continous Fermi-Dirac distribution, is given by μ.

The Fermi-Dirac distribution function $f(E)$ can be plotted versus E/μ.

We are interested in finding the shape of the curve T=0 when $E < \mu$ and when $E > \mu$.

Examining the case where $E/\mu > 1$, in the case $E > \mu$, we write

$$\lim_{T \to 0} f(E) = \lim_{T \to 0} \frac{1}{e^{A/kT} + 1} = \frac{1}{e^{\infty} + 1} = \frac{1}{\infty + 1} = 0$$

(1.3.49)

Examining the case where $E < \mu$, in this case $E/\mu < 1$, we have

$$\lim_{T \to 0} f(E) = \lim_{T \to 0} \frac{1}{e^{-A/kT} + 1} = \frac{1}{e^{-\infty} + 1} = 1$$

(1.3.50)

From these two limits we can conclude that the continous Fermi-Dirac distribution is discontinous at E=μ when T=0. Figure 1.3.3 shows a plot of the Fermi-Dirac distribution function when T=0.

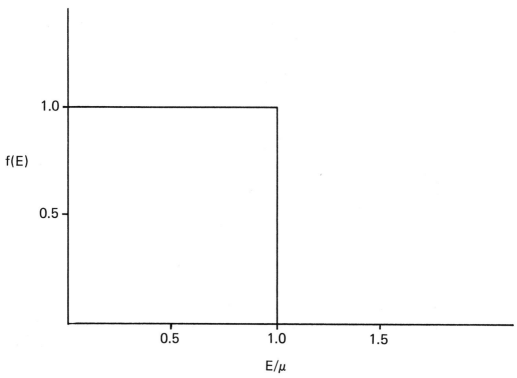

Fig. 1.3.3 *Indicates that the function f(E) changes* *energy level) to the value 0 (an empty*
 discontinuously from the value 1 (a filled *energy level) when E = μ.*

The question arises as to the value of f(E) when T is not zero. This question is immediately answered in the case where E=μ since the term in the exponent $(E-\mu)/kT$ becomes zero. Thus we may write

$$f(E) = \frac{1}{e^\circ + 1} = \frac{1}{2}$$

(1.3.51)

Equation 1.3.51 shows that the value E=μ at any temperature results in the fact that ½ of the degenerate energy levels are filled at the Fermi level (see Figure 1.3.4).

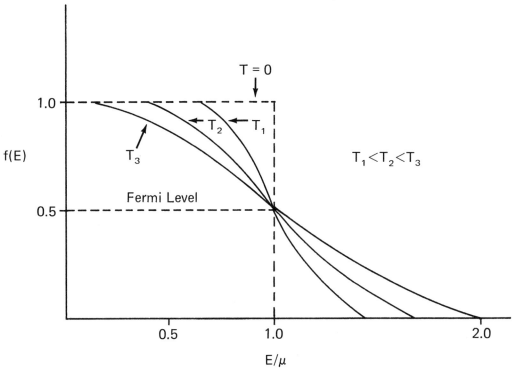

Fig. 1.3.4 *Shows a plot of the continuous Fermi-Dirac* *to E/μ at T=0 and at three other tempera-*
 distribution function f(E) with respect *tures where $T_1{<}T_2{<}T_3$.*

As the temperature increases, Figure 1.3.4 shows that the higher energy states become more populated, the lower energy states become less populated, while the population of the Fermi level remains constant at ½ (see Figure 1.3.5).

EXERCISE

The Fermi level or chemical potential applies to semi conductors and silver halide crystals. Describe why photographic development of silver halide grains can be assigned quasi-Fermi levels.

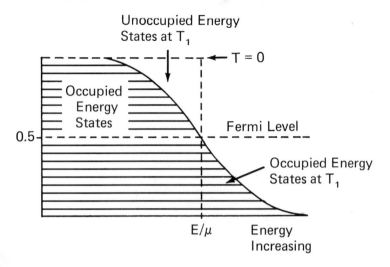

Fig. 1.3.5

Shows that as the temperature increases from T=0 to an arbitrary temperature T_1, the higher energy states become occupied with a corresponding lessening in occupation of lower energy states.

The *Fermi energy* is defined as the highest filled energy state at T=0. Since at T=0, the highest filled energy state is reached when E=μ, then by definition μ is equal to the Fermi energy E_F at T=0.

A silver halide crystal has energy bands that consist of bound electrons in the valence band and free electrons in the conduction band.

The electrons in the valence band are said to be bound because they move in the atomic and molecular orbitals of the silver and halide ions.

The continuous form of the Fermi-Dirac distribution function applies to the valence and conduction band.

a) In the valence band the overlapping of electron wave functions causes a smearing and broadening of the discrete electron energy states, requiring a continous representation of the distribution function.

b) In the conduction band, free electrons may occupy a continuum of energy states which require the continuous form of the Fermi-Dirac distribution function.

The valence band and the conduction band are separated by an energy gap that may contain trap levels when there are imperfections in the silver halide crystal. These traps can capture electrons or holes that may be re-emitted at a later time [Ref: Charles Kittel, *Introduction to Solid State Physics*, 3rd ed., John Wiley & Sons, New York, 2nd corrected Printing, (Nov. 1967) p. 551]. In most cases there will be a trap level that will coincide with the Fermi level.

These energy states existing in the forbidden gap are called surface states of the crystal (see Figure 1.3.6).

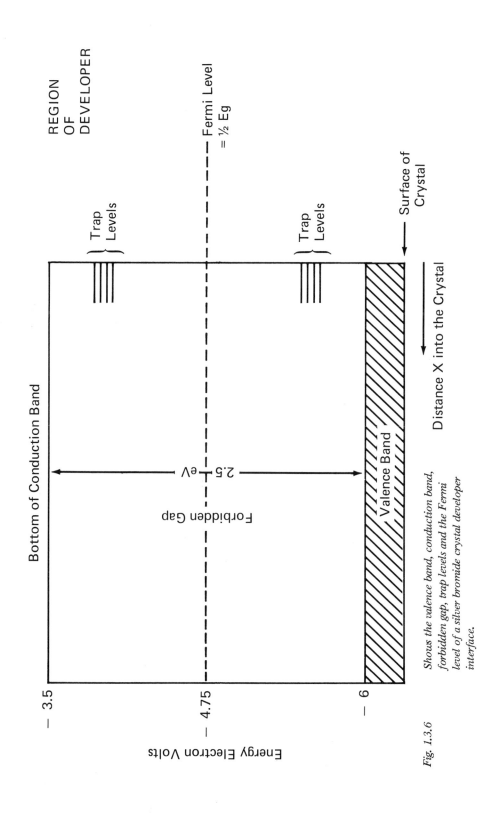

Fig. 1.3.6

Shows the valence band, conduction band, forbidden gap, trap levels and the Fermi level of a silver bromide crystal developer interface.

Prior to exposure, a silver halide crystal contains surface states that lie in the forbidden gap. These states arise from either the intrinsic or impurity controlled ionic concentration.

The trap levels lying closest to the valence band of the surface of the crystal are filled with electrons due to the negative surface charge, but the higher trap levels will be empty.

The electrons in the trap levels are in thermal equilibrium with the particles in the energy states of the valence band. When the surface of the crystal contacts a developer solution (an electrolytic solution that has a redox potential) *the Fermi level of the surface* (see Figure 1.3.6) becomes equal to the Fermi level of the electrolyte by the process of the transfer of electrons from the electrolyte to some of the empty surface states.

The Fermi level of the electrolyte is defined by Trautweiler as that energy level of any quantized system, solid, liquid or gaseous, that has a probability of ½ being filled with an electron at the thermodynamic conditions of the system.

In general a quasi-Fermi level of molecules can be defined by the relationship [Ref: T. Tani, *Phot. Sci. Eng.,* 14, 72 (1970)]

$$\mu = -\frac{(E_I + E_A)}{2}$$

(1.3.52)

where E_I = the ionization potential (energy required to ionize the molecule).

E_A = the electron affinity (amount of energy given off when an electron in the vacuum state is captured by a neutral molecule.)

The new electrostatic fields that are formed force the ions in the developer-crystal system to thermally equilibrate in such a manner that energy is conserved and a dynamic equilibrium is established between the newly filled surface states and the developer solution.

The actors that take part in establishing this dynamic equilibrium are the mobile ions of the crystal and of the electrolyte. After the system reaches thermal equilibrium, a new potential difference between the surface of the crystal and the bulk of the electrolyte is maintained by a balance between concentration gradients of ions in the electrolyte with the charged particles in the crystal.

Thus an unexposed silver bromide grain is in a relatively stable state. When a grain contains latent image silver, these latent image sites represent a special surface state which have an unfilled level below the Fermi-level of the developer. When the developer interfaces with the crystal containing the latent image, the unfilled level is filled with an electron that is transferred from the developer. To compensate for the increased negative charge at the latent image site, a positively charged interstitial silver ion moves into the site, neutralizing the charge in such a manner than an additional empty state appears at or below the initial unfilled level.

On the other hand, the relaxation of charge can be achieved by interstitial ions moving in, vacancies moving out, Br^- ions moving away or by several of these species occurring simultaneously within a fraction of a lattice spacing.

According to Trautweiler, the significant effect is that by this process silver ions are enabled to perturb the electronic wave function of the latent image such that another empty state appears that can accept another electron. This new state is at or below the initial state that accepted the first electron. This process of electron transfer, ionic relaxation followed by the formation of an empty state, continues until the entire grain is reduced.

CALCULATED AND EXPERIMENTAL EVIDENCE
RELEVANT TO THE MODEL

A speculation must proceed from existing experimentally collected data.

The experimental data which are relevant to this model are as follows.

1. It was found by Hedges & Mitchell [Ref: J.M. Hedges and J.W. Mitchell, *Phil. Mag.*, (7) 44, 223, 357 (1953)] that in silver halides at room temperature a one-electron center (a single atom of silver) is thermally unstable.

2. Webb showed by low intensity reciprocity failure experiments [Ref: J.H. Webb, *J. Opt. Soc. Am.*, 40, 3 (1950)] that a two-atom aggregate is thermally stable but does not render a grain developable.

3. Marriage [Ref: *J. Phot. Sci.*, 9, 93 (1961)] found that emulsion grains having absorbed three photons could be rendered developable at 10 minute development times, while grains that absorbed 4, 5 and more quanta required shorter development times.

Since at least three quanta have to be absorbed per grain in order to form a three silver atom aggregate, we may interpret these data to mean that a three silver atom aggregate is the smallest aggregate that can render

a grain developable. Although there is no assurance that three absorbed quanta will produce a three-atom aggregate of silver due to the inefficiencies in nucleation as described in Sections 2.2 and 2.3, these facts set the minimum size of the aggregate for significant contribution to normal development.

It is likely that in the course of normal development a few two-atom aggregates are developed but these two-atom aggregates cannot be considered the minimum criterion for developability.

4. The stability of a three-atom aggregate is approximately 180 millivolts below the stability of bulk silver metal. [Ref: F.Trautweiler, *Phot. Sci. Eng.,* 12, 138 (1968)].

The *sequence of steps from the growth of a silver atom to a two, three or more silver atom aggregate has not been described by either experiment or quantitative calculation.*

Thus the model presented in this section is no more speculative than the variations of either of the two principal mechanisms proposed by Gurney and Mott and Mitchell. [Ref: R.W. Gurney and N.F. Mott, *Proc. Roy. Soc.,* (London), Ser. A, 164, 151 (1938); J.W. Mitchell, *Rept. Progr. Phys.,* 20, 433 (1957); J.W. Mitchell and N.F. Mott, *Phil. Mag.,* (8) 2, 1149 (1957)].

According to Mitchell and Trautweiler, the single silver atom speck cannot act as a center for the capture of a photo electron until it has first captured a positively charged silver ion, resulting in the formation of the positively charged ion Ag_2^+.

Thus we may write for the first stage of growth during latent image formation

$$Ag \ + \ Ag^+ \rightleftharpoons Ag_2^+$$

$$(1.3.53)$$

The Trautweiler model departs from all other speculations with regard to latent image formation in that it considers *covalent bonds* as the *major contributor to the chemical stability of the latent image aggregates of silver.*

At this juncture the reader should skim the Hamilton and Bayer Computer Model for latent image formation in Sections 2.2 and 2.3.

The events of the Trautweiler model are governed by probabilities for growth and decay of a silver atom aggregate as described in Sections 2.2, 2.3 and as modified by the following probability contributors.

1. **Growth**

The charge of the aggregate with respect to the AgBr lattice is the

major contributor to aggregate growth.

(a) The conduction band electrons have a high probability for combining with a positive silver ion due to the large cross-section of these ions with respect to the electron.

(b) A positively charged silver ion is strongly attracted to a negatively charged silver aggregate.

2. Decay

Since the coulomb law of attraction is governed entirely by the charge and the distance between the charges, we may write

$$F = \frac{AZ_1 Z_2}{r_{12}^2}$$

(1.3.54)

where A = Constant
 Z_1 and Z_2 = The charges on the two particles
 r_{12} = The distance between the centers of charge

Since the denominator in equation 1.3.54 is the distance squared between the centers of charge, equation 1.3.54 is independent of speck size.

Furthermore, the coulomb force is a long range force that can extend over many atomic diameters. These two facts (independent of speck size and that the force extends over many Angstroms) are important in distinguishing between coulomb and covalent forces with respect to aggregates of silver.

The primary contributor to the magnitude of the probability of decay is a *short range covalent force*. During the first growth steps, the covalent force is strongly dependent upon the aggregate size. This force does not extend beyond the aggregate. Thus the distinction between growth and decay of the latent image centers is that growth depends upon the coulomb force while decay depends upon the force associated with covalent bonding (see Figure 1.3.7).

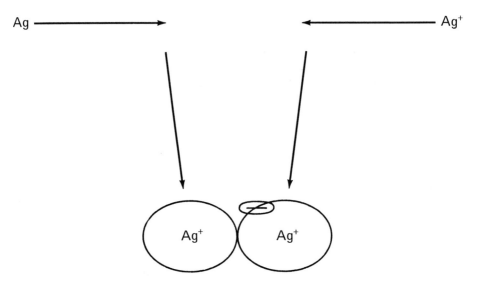

Fig. 1.3.7 *Shows how a silver atom and a positively* *single electron comes from the 5s orbital*
charged silver ion form a covalent bond *of the neutral silver atom.*
by the sharing of a single electron. The

EXERCISE

Show by diagram the electronic structure of both the neutral silver atom and the positively charged silver ion.

Since the aggregate can decay by either the *loss of an electron* (into the conduction band of the solid) *or loss of a positively charged ion* (at room temperature) both of these processes do not require the breaking of the covalent bond. However, the energy associated with these two processes cannot be the same.

The energy required to separate the electron from the aggregate (Figure 1.3.8) is called the ionization energy, while the energy required to break this bond by removal of a positively charged ion is called the bond energy or energy of dissociation. When the positively charged aggregate loses an electron, two positively charged centers result and the coulomb force of repulsion weakens the covalent bond.

Conversely, when the postively charged aggregate decays due to the loss of a positively charged ion, a neutral silver atom and a positively charged ion result. These two processes yielding a doubly charged ion and a conduction band electron in one case and a neutral silver atom and an ion in the other must have different energies (law of conservation of energy).

ELECTRON AFFINITY AND IONIZATION ENERGY

The electron affinity (E_A) in the solid state can be defined as the amount of energy absorbed in order to produce the reaction

$$Ag_2 \longrightarrow Ag_2^+ + e$$

(1.3.55)

Thus we may write

$$E_A(2) + Ag_2 \longrightarrow Ag_2^+ + e_{CB}$$

(1.3.56)

where e_{CB} represents the electron released to the conduction band. The comparable ionization (E_I) energy can be defined similarly as

$$E_I(2) + Ag_2^+ \longrightarrow 2Ag^+ + e_{CB}$$

(1.3.57)

Thus we may write the general expressions

$$E_A(n) + Ag_n \longrightarrow Ag_n^+ + e_{CB}$$

(1.3.58)

$$E_I(n) + Ag_n^+ \longrightarrow Ag_{n-1}^+ + Ag^+ + e_{CB}$$

(1.3.59)

where $n = 2, 3, 4, 5, \ldots$

Equations 1.3.58 and 1.3.59 enable us to compare the stability of a species after it has trapped an electron with the same species respectively, ready to accept an electron as a function of aggregate size.

Analyzing equations 1.3.58 and 1.3.59, we may interpret Ag_n as a species lying at a trap level in the forbidden gap $E_A(n)$ electron volts below the conduction band. Similarly Ag_n^+ is a species lying at a trap level in the forbidden gap $E_I(n)$ electron volts below the conduction band.

The ionization energy and electron affinity that represent the different aggregate species must be related to the Fermi level of the developer (μ_D) when the center is at the AgBr − developer interface.

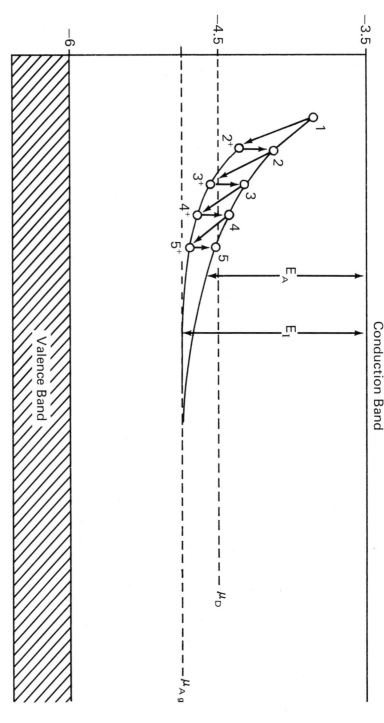

Electron Volts

Conduction Band

−3.5

−4.5

−6

Valence Band

E_A

E_I

μ_D

μ_{Ag}

Fig. 1.3.8

Shows the latent image specks as special surface states of the crystal. The running indices 1, 2, 3, 4, 5 and 2^+, 3^+, 4^+, and 5^+, represent silver aggregates Ag, Ag_2, Ag_3, Ag_4, Ag_5, and Ag_2^+, Ag_3^+, Ag_4^+, Ag_5^+, respectively. The Fermi levels of the developer and metallic silver are μ_D and μ_{Ag} respectively. E_A is the electron affinity and E_I is the ionization energy (After Trautweiler.)

If $E_I>0$, then the latent image speck lies at a trap level having an energy of $-E_I$. When $E_A>0$, then the speck lies at a trap level having an energy of $-E_A$. If $-E_I$ is more negative than the Fermi level of the developer, then the speck is stable with respect to decay.

When $-E_A<\mu_D$ where μ_D is the Fermi level of the developer, the speck can take an electron from the developer and the subsequent growth proceeds by negatively charged species.

The probability for growth decreases due to an activation energy barrier.

When a center lies at a trap level such that $-E_A>>\mu_D$, then this center will not render a grain developable.

The speck can lose an electron to the conduction band when $-E_I>\mu_D$ (see Figure 1.3.9).

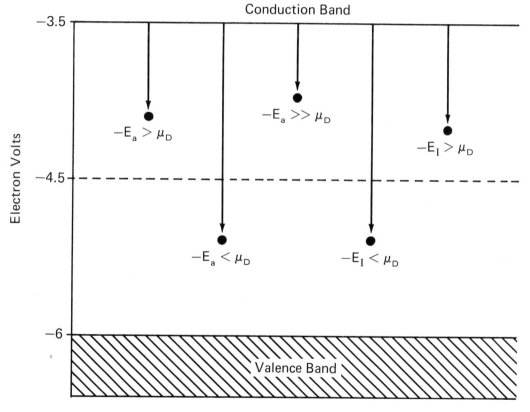

Fig. 1.3.9 Shows arbitrarily chosen occupied levels where the electron affinity and the ioniza- tion energies are given with reference to the Fermi level of the developer.

EQUATIONS OF LATENT IMAGE GROWTH AND DECAY

The growth of the latent image aggregate according to the Trautweiler model proceeds as follows:

	Reversible Growth				Decay				

1. Ag^+ + e_P \rightleftharpoons Ag

2. Ag + Ag^+ \rightleftharpoons Ag_2^+ ; $Ag_2^+ \rightarrow 2Ag^+$ + e

3. Ag_2^+ + e_P \rightleftharpoons Ag_2 ; $Ag_2 \rightarrow Ag^-$ + Ag^+

4. Ag_2 + Ag^+ \rightleftharpoons Ag_3^+ ; $Ag_3^+ \rightarrow Ag_2^+$ + Ag^+ + e

5. Ag_3^+ + e_P \rightleftharpoons Ag_3

6. Ag_3 + Ag^+ \rightleftharpoons Ag_4^+

7. Ag_4^+ + e_P or e_D \rightleftharpoons Ag_4

8. Ag_4 + Ag^+ \rightleftharpoons Ag_5^+

9. Ag_5^+ + e_P or e_D \rightleftharpoons Ag_5

Absorption of photo electrons (e_P) is required until Ag_3 is formed, at which time either photo electrons or electrons donated by the developer (e_D = electron donated by the developer), continue the growth process. As larger aggregates are formed (4 or more silver atom aggregates) the developer solution plays a greater role in contributing to the silver forming electrons.

The three, four and five-atom aggregates release electrons back to the developer many times before growth continues (inefficiency). As the aggregates grow more stable, the growth stage is almost completely efficient in the neighborhood of Ag_6.

The rate of growth then becomes proportional to the size of the silver speck and thus follows an exponential curve

$$\frac{dV_{sp}}{dt} = kV_{sp}$$

(1.3.60)

where V_{sp} is the volume of the speck and k is the constant of proportionality.

EXERCISE

If the rate of growth of the speck (in terms of volume of the speck) is proportional to the volume of the speck at any instant, then we may write

$$\frac{dV_{sp}}{dt} = kV_{sp}$$

Show that this equation predicts an exponential rate of growth of specks with respect to volume.

If for an emulsion developer system the atom aggregates exhibit an inefficiency of growth (release electrons many times prior to growth) a pronounced induction period will result.

The rate of aggregate growth shows an exponentially increasing rate until depletion of the reactants in the neighborhood of the growing speck, and the exponential curve changes to a diffusion controlled curve since the speck can grow only when reactants diffuse to the speck.

JUSTIFICATION OF THE TRAUTWEILER MODEL

The neutral and positively charged aggregates of silver located at various energy levels in the forbidden gap (see Figure 1.3.8) must be justified with respect to their existence and placement.

We shall show that the existence of the species shown in Figure 1.3.8 is more plausible than the existence of other species.

If the three species Ag^+, Ag and Ag^- are considered, we may conclude that: Since Ag is thermally unstable in a silver halide crystal at room temperature, then it must occupy a trap level very close to the conduction band.

Brandt measured optical absorption bands in silver bromide which he could attribute to an electron in the coulomb field of a positive charge (the Ag atom). From the edge of the band he was able to determine the E_I of the Ag atom in AgBr as 0.24 electron volts below the conduction band. [Ref: R.C. Brandt, *Infra Red Absorption by Localized Polarons in the Silver Halides,* Thesis, University of Illinois (1967)].

Gurney and Mott [Ref: R.W. Gurney, N.F. Mott, *Proc. Royal Soc.,* 164A, 151 (1938); and N.F. Mott and R.W. Gurney, *Electronic Processes in Ionic Crystals,* 2nd ed., Oxford University Press (1948) pp-108, 136] had earlier indicated a trap level 0.25 electron volts below the conduction band and also at 0.50 electron volts below the bottom of the conduction

band. The upper level at 0.25 electron volts when occupied by an electron will eject the electron into the conduction band in 10^{-6} to 10^{-7} seconds. The injection time for the lower level is 10^{-2} to 10^{-3} seconds.

Thus we may anticipate that the upper level corresponds to the stability of a neutral silver atom formed by the reaction of an interstitial silver ion with a trapped electron at that level (see Figure 1.3.8).

The formation of Ag^- has a low probability according to Trautweiler since the neutral silver atom is relatively unstable and must compete with many interstitial ions for an electron. Therefore we do not consider Ag^- as a significant contributor to the formation of the latent image at this point.

The distinction between Ag_2^+, Ag_2 and Ag_2^- to significant latent image growth is analyzed as follows:

a) It is known that the H_2^+ ion is a very stable ion with considerable binding energy. [Ref: G. M. Barrow, *Physical Chemistry*, 2nd ed., McGraw-Hill, Inc., New York (1966), p-289]. The quantum mechanical explanation for this fact is that a hydrogen atom with an electron in the ls orbital approaches a hydrogen ion that has an unfilled ls orbital. Although there is no coulomb force of attraction between these species, when they become sufficiently close together their ls orbital combine to form a bonding σ orbital and an antibonding σ orbital (also see Chapter 4), where the σ^* orbital lies at a higher energy than the σ orbital (see Figure 1.3.10).

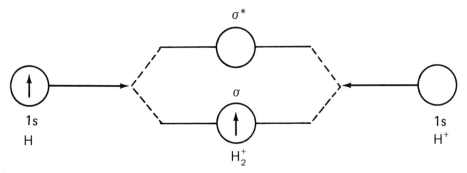

Fig. 1.3.10 *Shows how the 1s orbitals of two protons combine to form the bonding σ-molecular orbital and the σ*-molecular orbital. The electron that was originally in the 1s orbital now finds itself in a more stable (lower energy) σ orbital.*

Both the σ and the σ^* molecular orbitals of the H_2^+ molecule ion can contain a maximum of two paired electrons (paired electrons, see Section 2.1).

The 5s valence electron of the silver atom moves from the 5s state to the bonding σ state of the Ag_2^+ molecule. By analogy with the H_2^+ ion, which has a large binding energy, we expect the Ag_2^+ ion to also have a

large binding energy and thus be an intermediate step in the growth of the latent image (see Figure 1.3.11).

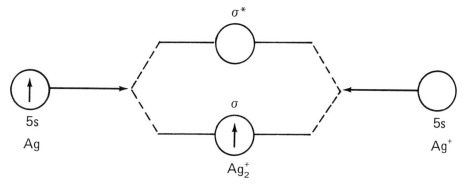

Fig. 1.3.11 Shows how the 5s orbitals of two silver σ-molecular orbital and the σ* molecular
 cores combine to form the bonding orbital of the Ag_2^+ molecule ion.

In the earlier section, *Calculated and Experimental Evidence Relevant to the Model,* it was cited that a one-electron center was found to be thermally unstable. This fact means that both the Ag and the Ag_2^+ species are thermally unstable. In order to justify this model with respect to this experimental evidence, Trautweiler chose a value for the binding of Ag_2^+ to be 0.6 electron volts. The binding energy is the negative of the amount of energy required to dissociate the Ag_2^+ ion into an Ag and Ag^+ ion.

In terms of stability this places the Ag_2^+ ion 0.6 electron volts below the Ag atom as shown in Figure 1.3.8. Therefore with respect to the loss of an electron to the conduction band, the Ag_2^+ ion is at an energy level of -0.85 electron volts. This means that the Ag_2^+ ion is more stable toward the loss of an electron than it is to the loss of a silver ion.

b) The σ bonding orbital of the Ag_2^+ molecule ion can accept a second electron, as shown in Figure 1.3.12, and form the stable Ag_2 molecule.

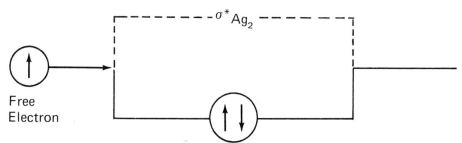

Fig. 1.3.12 Shows the formation of the stable Ag_2
 molecule by the addition of a free electron
 into sigma bonding orbital of the Ag_2^+ ion.

The only other state available for an additional electron in the Ag_2 molecule is the σ^* antibonding moleculer orbital. Since the σ^* orbital is at a higher energy than the σ molecular orbital, it would tend to give up this electron to the conduction band, thus making the formation of Ag_2^- unlikely. The stability of the negative ion species is discussed in the next subsection.

The three species Ag_3^+, Ag_3 and Ag_3^- may be analyzed as follows:

a) Hirschfelder [Ref: J.O. Hirschfelder, *J. Chem. Phys.*, **6**, 795 (1938)] has calculated the energy states for the H_3 molecule. He found that in the lowest energy state, the H_3 molecule is linear with respect to the orientation of the three protons, whereas the lowest energy state for H_3^+ is a right to equilateral triangle with a degeneracy of two in the σ molecular orbital.

The Jahn and Teller theorem states that except for unlikely numerical coincidences, all non-linear nuclear configurations are unstable for an orbitally degenerate electronic state (degeneracy see Section 2.3) of a neutral polyatomic molecule [Ref: H.A. Jahn and E. Teller, *Proc. Royal Soc.*, **A161**, 220 (1937)].

This means that although the H_3^+ molecule ion is doubly degenerate in its σ molecular orbital and can accept up to four electrons in the lowest energy state, it is stable in a triangular configuration with respect to the three protons. On the other hand, the polyatomic molecule H_3 is unstable in the triangular configuration so that the lowest energy state is in the doubly-degenerate linear configuration. However, when an electron is added to H_3, it will revert to the triangular doubly degenerate configuration forming a stable H_3^- ion (see Table 1.3.1).

TABLE 1.3.1

STABLE SPECIES	MOLECULAR ORBITAL DEGENERACY	SPATIAL CONFIGURATION
H_3^+	2	Triangular
H_3	2	Linear
H_3^-	2	Triangular

Reasoning in analogy with the results obtained by Hirschfelder, we can go on to discuss the Ag_3^+, Ag_3 and Ag_3^- species.

The 5s electrons of the two Ag atoms in the Ag_3^+ molecular ion would occupy the degenerate energy states in a triangular configuration (see Table 1.3.1) as shown in Figure 1.3.13.

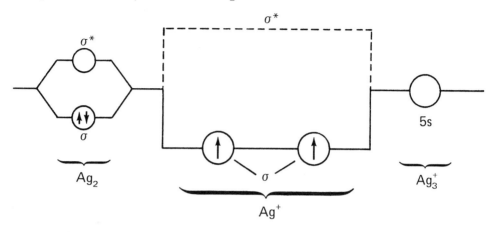

Fig. 1.3.13 *Shows the 5s electrons occupying the degenerate energy levels in the σ bonding molecular orbitals. The Ag_2 molecule has* *reacted with a positively charged silver ion to form a triangular Ag_3^+ ion.*

b) The addition of an electron to Ag_3^+ results in the formation of Ag_3. Due to the Jahn-Teller effect, the lowest doubly degenerate state of Ag_3 occurs when the spatial configuration is linear.

Thus the triangular spacial configuration of Ag_3^+ spontaneously reverts to a linear configuration when an electron is captured and Ag_3 is formed (see Figure 1.3.14).

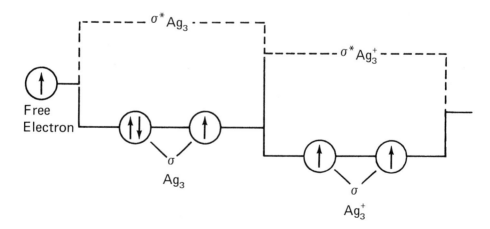

Fig. 1.3.14 *Shows a free electron combining with an Ag_3^+ ion and occupying one of the* *doubly degenerate states and producing the linear Ag_3 molecule.*

c) Since the sigma bonding molecular orbital of the Ag_3 molecule can accept an additional electron, the formation of this stable Ag_3^- ion is possible as shown in Figure 1.3.14.

The Ag_3^- ion represents the first relatively stable negative ion that can act as an intermediate in aggregate growth of latent image formation.

DEVELOPABILITY AS A FUNCTION OF FERMI LEVEL OF THE DEVELOPER AND THE AGGREGATE SPECIES

In order to render a grain developable, a latent image speck must either be a trap for the third electron, i.e., Ag_3^+ ion, or be a neutral molecule aggregate, positively charged aggregate or negatively charged site having acquired three or more electrons so that it can lie below the Fermi level of the developer.

The Quantum Model for development considers the aggregate size and species, Fermi level of the developer as follows:

1. According to Trautweiler, [Ref: F. Trautweiler, *Implications of a Quantum Model of the Latent Image, Phot. Sci. Eng.*, 12, 138, (1968)] it is unlikely that the Ag_3^+ ion species would receive an electron from the developer since this latent image center does not lie far enough below the Fermi-level of the developer and consequently the energy barrier for the formation of the Ag_3 center would require too high an activation energy (see Figure 1.3.8).

Therefore the Ag_3^+ ion captures a photo electron in order to form Ag_3.

2. Growth of the Ag_3 aggregate proceeds either by capturing an interstitial positive ion forming Ag_4^+ or by trapping an electron and forming Ag_3^-. From an activation energy standpoint, the formation of Ag_4^+ would be more likely. However, if the Ag_3^- ion is formed, it is sufficiently stable to capture an Ag^+ and grow. Probabilistically the formation of Ag_4^+ is greater than the Ag_3^-.

The formation of Ag_4 can proceed by the Ag_4^+ site receiving an electron from the developer or by absorption of a photo electron. Since, according to Trautweiler, the Ag_4 aggregate may decay, thereby releasing an electron back to the developer a number of times before the growth event takes place, an induction period will be observed. The transfer of an electron from the developer for the formation of the Ag_4 aggregate also involves an activation barrier (see Figure 1.3.8).

Growth continues by the trapping of an interstitial ion, followed by the transfer of an electron from the Fermi level of the developer. Since the larger neutral aggregates formed during latent image growth lie on or below the Fermi level of the developer, the growth stage at this point

becomes very efficient with respect to stability to the loss of an electron.

CONCLUSION

The Trautweiler model clearly points out that the formation of a covalent bond between silver atoms and positively charged interstitial ions is more probable at the early stages of latent image formation.

The major limitation of the Trautweiler model is that it is not quantitative. It merely establishes concepts and ideas that will be necessary for the quantification of the latent image and photographic development processes.

The effective charge of an ion or speck at the surface of a silver halide crystal is considerably smaller than the effective charge within the crystal, as shown by the Madelung constant calculation in Section 1.2. Thus the partial coulombic force on the aggregate tends to hold the electron less strongly at the surface of the silver halide crystal. It must not be inferred from the Trautweiler model that ions have the same characteristics at the surface as they have in the interior of a silver halide crystal.

The Hirschfelder calculation for the energy states of the H_3 molecule neglected molecule substrate interactions. Therefore, although Figure 1.3.11 is a useful analogy of the Hirschfelder model, since the effects of adsorption have been neglected, a sigma bonding molecular orbital of the Ag_2^+ molecule ion will probably deviate from that of the Hirschfelder model. On the other hand, the concepts and ideas presented by use of this analogy can lead to the refinement which is necessary in order to completely solve this problem.

The reader has the final task of learning the Fermi-Dirac statistics, the implications of the Trautweiler model, the Hirschfelder analogy to the Ag_2^+ aggregate ion, and relating this material to the future publications that will appear in the literature with the realization that he must be sufficiently flexible so that he can build a background for further understanding based on early models that may themselves not have a high degree of certainty with respect to the actual process.

Chapter 2, Sections 2.2 and 2.3 considers a computer model for latent image formation, nucleation, growth, inefficiences of nucleation and growth that are treated quantitatively only for the negative ion and neutral aggregate species.

The authors feel that a further investigation of the growth and development of photolytic silver can be investigated with the inclusion of the parameters relating to the positive ion, the negative ion and the Fermi level of the developer. As the reader proceeds through the digital simula-

tions in Sections 2.2 and 2.3, he should keep in mind how this model could be digitally simulated using the assumptions and parameters discussed in this section.

Since it has not been shown experimentally that the probability for the rate of decay of the negative ion aggregate species is equal to the probability of the rate of decay of positive ion aggregate species, and since these two processes probably require different energies, then we have no justification in saying that these two processes are equivalent. This section offers the Trautweiler model and its thesis that in the early stages of aggregate growth the positive ion species are more probable (based on the covalent bonding) in hope that it will stimulate critical thinking and further experimentation that will solve this dilemma. It seems apparent that the Trautweiler approach, the use of Fermi-Dirac statistics and quantitative quantum mechanical calculations will be required to solve this problem. Therefore this text takes the viewpoint that student preparation in these areas is extremely important.

Appendix 1A
Stability of
Negative
Ion Species

If the covalent bonding between silver atom aggregates and a positively charged silver ion does indeed drop the site to a lower energy level than the neutral silver aggregate, then *the authors propose the following:*

a) The negatively charged aggregates Ag_2^-, Ag_4^- Ag_5^- ..., must lie above the energy levels of their respective neutral aggregates Ag_3, Ag_4, Ag_5 Thus for the stability series for the loss of an electron to the conduction band, we may write

$$Ag_n^+ > Ag_n > Ag_n^-$$

$$(1.3.61)$$

b) Let us analyze the species Ag_2 and Ag_3^-, in terms of their relative stability. Since Ag_3^- is already negatively charged, it is unlikely that it can accept another electron. Also if Ag_2 accepts an electron, it must be less stable than Ag_3^-. If Ag_2 were more stable than Ag_3^-, then when Ag_2 gained an electron it could still remain more stable than Ag_3^- and this contradicts the *fact* that Ag_2^- must be less stable than Ag_3^-. Thus we can conclude that the stability of Ag_3^- is less than or equal to the stability of Ag_2 (see Figure 1.3.15).

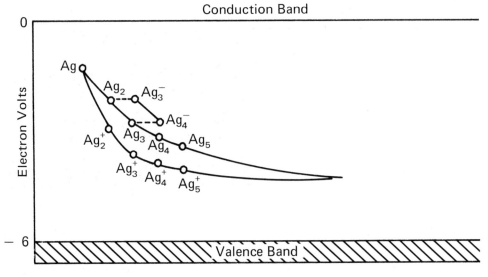

Fig. 1.A.1 *Shows the relative position of the negative, positive and neutral silver aggregates.*

In other words, the limit of stability of the specie Ag_n^- is given by the stability of Ag_{n-1}.

Therefore in terms of stability we may write

$$Ag_n^+ \geqslant Ag_{n-1} \geqslant Ag_n^-$$

(1.3.62)

where n is equal to 1, 2, 3, 4, 5, . . . , bulk metal.

PROBLEM SET 1.2

1. Discuss the Frenkel and Lehovec theory for the layer of diffuse space charge.

2. Why does the work of L. Slifkin suggest that the ionic process for latent image formation and growth is faster in the interior of the grain for an unsensitized emulsion?

3. Derive equation 1.3.3.

4. What is chemical potential and how may it be derived?

5. When T=0 and E=μ, show that the continuous form of the Fermi-Dirac distribution is discontinuous.

6. Explain why ½ of the degenerate energy levels are filled at the Fermi level at any temperature when E=μ.

7. Explain why latent image centers are located in the forbidden gap region of the silver halide crystal.

8. According to the Trautweiler model, discuss the relation between the covalent bond and the assumption that in the early stages of latent image formation growth is characterized by metallic silver combining with a positively charged silver ion prior to the trapping of a photo electron or developer electron.

9. For an unexposed silver halide crystal where do $-E_A$ and E_I lie with reference to the Fermi level of the developer?

9a If a crystal contains a latent image aggregate Ag_8, why does the value of $-E_A$ approach the value of $-E_I$? (See Figure 1.3.8).

10. Discuss the induction period associated with development in terms of the development model.

11. Explain the analogy between the H_2^+ and Ag_2^+ ions.

12. Why should the Ag_3^- ion be more unstable than either the Ag_3 or Ag_3^+ species? (Unstable with reference to the loss of electrons to the conduction band.)

13. Explain why the Ag_3^- ion is probably the smallest negatively charged aggregate that can participate in aggregate growth.

14. Discuss the developability criteria for a silver halide grain with respect to the Fermi level of the developer.

15. If a silver halide grain has 5 trap levels at the same energy level in the forbidden gap, then calculate the number of trap levels occupied at $-3.7eV$; $-4.75eV$ and $-5.7eV$ when $\mu = -4.75eV$ and where T=$300°$K.

16. What are the major limitations of the Trautweiler model?

2 Photographic Physical– Chemical Topics

This chapter treats kinetics, the latent image and the theory of the characteristic curve.

Over the years many workers have contributed to these topics. Other photographic books have discussed experiments and theories from a qualitative descriptive or survey standpoint.

The authors chose to treat the majority of these topics from a quantitative standpoint by selecting the classical theoretical papers which lend themselves to digital simulation.

We found it necessary to integrate basic chemical kinetics, elements of probability theory and quantum statistics in order to clarify these photographic topics.

2.1 Chemical Kinetics

Chemical kinetics is the study of reaction rates. This study includes both experimental methods and the theoretical interpretation of the experimental results. The results of chemical kinetics are the quantitative understanding of chemical (and sometimes physical) photographic processes in terms of the nature of the reactions. This understanding of the nature of the reactions allows us to generate theories which can be utilized in the research and development of new photographic processes. This understanding can be a powerful tool in the hands of engineers who may wish to build kinetic models for various systems.

Reactions that take place during the photographic process are either homogeneous or heterogeneous. In a homogeneous reaction all the reactants and products are in the same phase, solid, liquid or gaseous. A heterogeneous reaction is characterized by the fact that at least one of the reactants or products is in a different phase relative to the other components.

During photographic development a typical homogeneous reaction is the oxygen oxidation of hydroquinone in the presence of sodium sulfite. This reaction is written as

$$\text{(hydroquinone)} + 2\,Na_2SO_3 + O_2 \longrightarrow \text{(product with } SO_3Na\text{)} + Na_2SO_4 + NaOH$$

$$(2.1.1)$$

In reaction 2.1.1 the oxygen is initially in the gaseous phase but it must be absorbed by the water before a reaction can occur. (Since the other components are dissolved in the water.)

Reaction 2.1.1 is a total stoichiometric reaction. A stoichiometric reaction indicates the number and kind of molecules reacting and the

number and kind of molecules produced. A stoichiometric reaction must proceed exactly as it is written.

A total stoichiometric reaction is actually the sum of a sequence of other reactions. These other reactions may be *parallel* or *consecutive*. A pair of parallel reactions may be symbolized as

$$A \ + \ B \longrightarrow C \ + \ D \tag{2.1.2}$$

$$E \ + \ B \longrightarrow F \ + \ G \tag{2.1.3}$$

A pair of consecutive reactions may be written as

$$A \ + \ B \longrightarrow C \ + \ \boxed{D} \tag{2.1.4}$$

$$\boxed{D} \ + \ E \longrightarrow F \ + \ G \tag{2.1.5}$$

The product D in reaction 2.1.4 becomes one of the reactants in reaction 2.1.5 (as denoted by the dotted lines).

In many cases both consecutive and parallel reactions are occurring simultaneously in a reacting system.

A sequence of parallel and consecutive reactions that add up to form a total stoichiometric reaction is called a *network*.

The network for reaction 2.1.1 is composed of the reactions [Ref: L. Storch, *Ber*, **27**, Ref. 77 (1894), T. H. James, J. M. Snell and A. Weissberger, *J. Am. Chem. Soc.*, **60**, 2084 (1938)].

$$\tag{2.1.6}$$

$$H_2O_2 \ + \ Na_2SO_3 \longrightarrow Na_2SO_4 \ + \ H_2O \tag{2.1.7}$$

QUINONE

(2.1.8)

EXERCISE

(a) Using reactions 2.1.6, 2.1.7 and 2.1.8 write the parallel and consecutive pairs of reactions.

(b) Show that reactions 2.1.6, 2.1.7 and 2.1.8 sum to give reaction 2.1.1.

If reaction 2.1.1 goes to completion in the presence of sufficient O_2 and sodium sulfite is in excess, two other reactions occur.

HYDROQUINONE

QUINONE
MONOSULFONATE

(2.1.9)

HYDROQUINONE
DISULFONATE

(2.1.10)

Reactions 2.1.1 thru 2.1.10 are typical reactions that occur prior to film being placed into the developer solution. When the film is placed into the developer solution, the silver halide in the emulsion serves as the oxidizing agent in preference to the oxygen.

Since the silver halide exists in the solid phase, the development reaction is a heterogeneous reaction. To indicate a solid or liquid phase in the following reactions we will utilize the following notation:

(s) for solid phase when written under the appropriate molecule in a reaction.

(l) for liquid phase when written under the appropriate molecule in a reaction.

Heterogeneous reactions take place at the interface between the two phases.

A possible sequence of reactions representing the *network of development* are given by the heterogeneous reaction 2.1.11 and the homogeneous reaction 2.1.12.

$$(2.1.11)$$

$$(2.1.12)$$

The total reaction is written as

$$H_2O \; + \; 2AgBr \; + \; Na_2SO_3 \longrightarrow H_2QSO_3Na \; + \; 2Ag$$

$$+ \; 2Br^- \; + \; H^+ \; + \; Na^+$$

$$(2.1.13)$$

As an example of an active center we write equation 2.1.7 in ionic form,

$$H_2O_2 + SO_3^= \longrightarrow SO_4^= + H_2O$$

$$(2.1.14)$$

Equation 2.1.14 shows only the reactive species in aqueous solution. This equation is entirely equivalent to 2.1.7 since the sodium sulfite and sulfate ionize in solution to produce Na^+ sodium ion, sulfite ions $SO_3^=$, and $SO_4^=$ sulfate ions. The sodium ions take no part in the reaction and are omitted from the net equation 2.1.14.

It is often more accurate to write reactions that occur in aqueous media in ionic form. The sequence of reactions for reaction 2.1.14 is

$$2H_2O_2 \longrightarrow 2H_2O + O_2$$

$$(2.1.15)$$

$$O_2 + SO_3^- \longrightarrow SO_5^-$$

$$(2.1.16)$$

$$SO_3^= + SO_5^- \longrightarrow SO_5^= + SO_3^-$$

$$(2.1.17)$$

$$SO_5^= + SO_3^= \longrightarrow 2SO_4^=$$

$$(2.1.18)$$

Equations 2.1.15 thru 2.1.18 represent a network of reactions for the individual reaction 2.1.14, where SO_3^- and SO_5^- are the active centers.

EXERCISE

Verify that reaction 2.1.13 is the sum of reactions 2.1.11 and 2.1.12. Balance reaction 2.1.9.

INTERMEDIATES

As a reacting system proceeds from reactants to products, different types of molecules appear which are called *intermediates*. Initially these

intermediates increase in concentration, then decrease in concentration and vanish if the reaction goes to completion. Intermediates are classified as

(1) Stable intermediates or synonymously intermediates.
(2) Active centers.
(3) Transition states.

The intermediates are the molecules that appear in the reactions of the network for the total stoichiometric reaction. However, they do not appear in the total stoichiometric equation. For example, in equations 2.1.6, 2.1.7 and 2.1.8 the intermediates are quinone and hydrogen peroxide. These intermediates do not appear in the total stoichiometric reaction 2.1.1.

The second type of intermediate, the active center, appears in the sequence of reactions for an individual reaction of the network. The active centers have the following characteristics when compared to the intermediates:

(1) They are usually present in much smaller concentrations.
(2) They have shorter lifetimes.
(3) They are more reactive.

The active center is a species that can be determined spectroscopically. If the active center is a free radical, electron spin resonance methods can be used to determine whether these centers exist. Ordinarily the sequence of reasoning used to hypothesize the existence of active centers is based on an understanding of how reactions may proceed.

For example, an atom or a molecule placed into a reacting system may form stable intermediates or active centers. The worker may hypothesize the formation of stable intermediates which he may determine experimentally. On the other hand, the worker may hypothesize the formation of active centers. This worker can test his hypothesis using optical and radio frequency spectroscopic techniques.

Having determined that active centers are produced, he can then go on to write very accurate kinetic expressions. The determination of the existence of active centers in a reacting system is based on a procedure of hypothesis testing coupled with a verification by experimental methods.

EXERCISE

(a) Show that reaction 2.1.14 is part of the network of reactions for the total stoichiometric reaction 2.1.1 (hint: this requires rewriting other reactions in ionic form).

(b) Explain how the sequence of reactions 2.1.15 thru 2.1.18 is related to the total stoichiometric equation 2.1.1.

In order to fully understand reactions 2.1.15 thru 2.1.18 we must first analyze the outer shell structures of sulfur and oxygen. Oxygen and sulfur belong to the same group in the periodic table. The valence or outer shell of each of these atoms contain 6 electrons.

Schematically we write

$$\ddot{} \\ :\!S\!: \qquad \text{Sulfur, 6 outer shell electrons}$$

Fig. 2.1.1

$$\ddot{} \\ :\!O\!: \qquad \text{Oxygen, 6 outer shell electrons}$$

Fig. 2.1.2

Schematically, the filling of the shells for oxygen and sulfur is shown by Figures 2.1.1 and 2.1.2.

Fig. 2.1.3

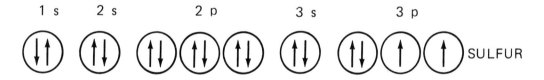

Fig. 2.1.4

The circles in Figures 2.1.3 and 2.1.4 represent the orbitals where the arrows represent the electrons. Each electron can be thought of as being a small magnet having a magnetic moment and a north and south pole.

If arbitrarily we consider the arrow head as the north pole, then paired electrons are represented as ⊕ while unpaired electrons are represented schematically as ⊕ ⊕

Quantitatively this can be expressed by the fact that the electron has an intrinsic angular momentum of magnitude $h/4\pi$, where h is Planck's

constant $(6.624 \times 10^{-27}$ erg-sec). The magnitude of the magnetic dipole moment for the electron is given by

$$\mu = \frac{e\,h}{4\,\pi\,m\,c}$$

(2.1.19)

where

μ = the magnitude of the magnetic moment

e = the charge on the electron = 4.803×10^{-10} esu $(cm^{3/2}\ sec^{-1})$

c = the velocity of light = $2.998 \times 10^{+10}$ cms. sec^{-1}

m = the rest mass of the electron = 9.109×10^{-28} grams

The spin angular momentum was first hypothesized [Ref: S. Goudsmit and G. Uhlenbeck, *Naturwissenschaften*, 13, 953 (1925); R. Bichowsky and H. C. Urey, *Proc. Natl. Acad. Sci.*, 12, 80 (1926)] to explain the fact that in energy level diagrams for atoms which have one or more valence electrons, the levels appear in closely spaced groups. This hypothesis was probably a direct result of earlier experimental work [Ref: O. Stern and W. Gerlach, *Z. Physik*, 8, 110; 9, 349 (1922)] where the magnetic moment of the electron was measured experimentally. Stern and Gerlach found that when a beam of silver atoms was passed through a strong non-uniform magnetic field, the beam divided into two sharply separate beams.

The beams were deflected as if each atom were a magnetic dipole of magnitude eh/4π mc oriented in the direction of the field. Both beams were deflected like a magnetic dipole of similar strength but oriented in different directions. This experiment gave a direct measure of the intrinsic magnetic moment of the valence electron of the silver atom [Ref: *Quantum Chemistry*, H. Eyring J. Walter, G.E. Kimball, John Wiley & Sons, Inc., New York, Thirteenth Printing, (1965); G. Uhlenbeck and S. Goudsmit, Nature 117, 264 (1926)].

The structure shown in Figures 2.1.3 and 2.1.4 is what is commonly called the ground state or lowest energy state of these atoms. Analogous structures can be drawn for the excited states of these atoms; i.e., the states that occur after these atoms absorb energy. When an atom absorbs energy in discrete packets called quanta, the following examples show some of the excited states that may occur in the electronic configurations depending on the amount of energy absorbed.

The minimum amount of energy that the oxygen atom or any atom in the ground state with an unpaired electron can absorb to affect the electronic structure and produce a measurable result is that energy required to flip the spin on an unpaired electron.

Schematically for oxygen this is shown as

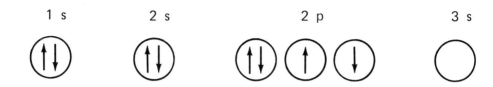

Fig. 2.1.5

Figure 2.1.5 shows one of the 2p unpaired electrons flipped. This configuration shows the oxygen atom in an unstable excited state. The excited oxygen atom returns to the ground state after it loses this energy.

Another excited state requiring more energy than shown in Figure 2.1.5 is represented by Figure 2.1.6.

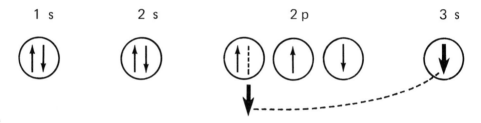

Fig. 2.1.6

This excited state shows four unpaired electrons.

A forbidden excited state is one where the electronic structure is not consistent with the Pauli exclusion principle. This principle can be expressed by the statement that electrons must have different spins to be in the same orbital. A forbidden state for oxygen is schematically represented by

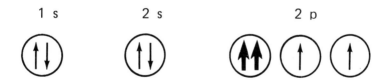

Fig. 2.1.7

The *forbidden* excited state represented by Fig. 2.1.7 shows two electrons having the same spin in the same orbital. This atomic configuration cannot exist.

EXERCISE

Show schematically three excited and three forbidden states for the sulfur atom.

A *free radical* is defined as a non-metal atom or a molecule that contains one or more unpaired electrons. Thus oxygen, sulfur and $\cdot CH_3$ are free radicals.

The presence of a free radical can be detected by a method which measures the amount of energy that is absorbed when an unpaired electron is flipped in a magnetic field. This method is called electron spin resonance (esr) or electron paramagnetic resonance (epr).

A radical is defined as any atom or molecule that contains unpaired electrons. Metal radicals such as sodium, lithium, potassium, and silver form ionic crystal structures when they react with non-metals such as halogens to form AgBr, AgCl and AgI.

$$\boxed{\cdot \ddot{\underset{..}{O}} \cdot} \;+\; \boxed{:\ddot{S}:} \;+\; \boxed{\cdot \ddot{\underset{..}{O}} \cdot} \;+\; \boxed{\cdot \ddot{\underset{..}{O}} \cdot} \;+\; 2 \text{ electrons} \longrightarrow SO_3^=$$

Fig. 2.1.8

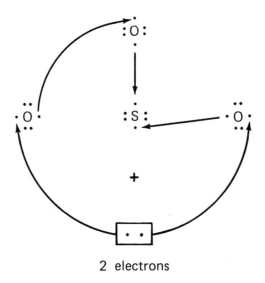

2 electrons

Fig. 2.1.9

Fig. 2.1.10

Figure 2.1.8 shows 3 oxygen atoms, one sulfur atom and two electrons combining to form $SO_3^=$.

A schematic diagram showing how unpaired electrons in atomic orbitals pair up to form molecular orbitals in the $SO_3^=$ structure is represented in Figure 2.1.9. The resultant structure as shown in Figure 2.1.10 represents the ground state of the $SO_3^=$ ion and has no unpaired electrons; it is called a Lewis structure. (In honor of G. Lewis.)

The active center SO_3^- is formed when the $SO_3^=$ loses an electron. This resultant structure has one unpaired electron and is a free radical ion. The SO_5^- active center (see 2.1.16) is also a free radical ion.

EXERCISE

Draw the Lewis structure analagous to Figure 2.1.9 for the SO_3^- and SO_5^- ions.

A *closed sequence* is one in which an active center is a reactant in one reaction of the sequence and a product in a later reaction of the sequence. In reactions 2.1.16 and 2.1.17, the SO_3^- serves as a reactant and a product respectively. Therefore reactions 2.1.15 thru 2.1.18 form a closed sequence.

These reactions do not show the *initial* production of the active center SO_3^- since it is always present in minute quantities in an aqueous solution of sodium sulfite. It is probable that the SO_3^- active center is produced initially by the ubiquitious gamma ray.

A closed sequence produces a repetitious cyclic reaction pattern which allows a large amount of molecules of products to be produced from one active center. For example, the SO_3^- active center which is produced in reaction 2.1.17 can react with more oxygen O_2 as shown by reaction 2.1.16. As long as sufficient oxygen and sulfite $SO_3^=$ are present, the reactions 2.1.16 and 2.1.17 can go on using only one active center SO_3^-.

A *catalyst* is a substance that participates in a reaction to change the rate of the reaction but is itself not changed. All reactions showing a closed sequence may be defined as catalytic reactions with the repeating active center acting as the catalyst. However, in the case where the active center is produced within the system and may not survive long, the sequence of reactions is said to be a chain reaction. Since SO_3^- is produced within the sequence of reactions 2.1.15 to 2.1.18, this sequence is a chain reaction.

A truly catalytic reaction is characterized by a catalyst which is a separate entity having a long life and which produces the active centers.

An *open sequence* is easily distinguished from a closed sequence

since the active center does not appear as a product in any other step in the sequence.

An example of an open sequence is the stepwise ionization of hydroquinone in basic solution to form quinone.

$$(2.1.20)$$

$$(2.1.21)$$

SEMIQUINONE

$$(2.1.22)$$

$$(2.1.23)$$

QUINONE

(2.1.24)

Reaction 2.1.22 shows the formation of the semiquinone which is the active center. The semiquinone active center appears only once as a product in the sequence of steps 2.1.20 thru 2.1.24.

The final intermediate to be considered is the *transition state*. The transition state is defined as an intermediate which cannot be isolated. It is a complex formed during collision of the reactants which immediately breaks up and becomes products. For example, in reaction 2.1.17 the reactants $SO_3^=$ and SO_5^- have to approach close enough to transfer an electron from the $SO_3^=$ to the SO_5^-.

It is probable that the transition state for this reaction is a complex consisting of an SO_3^- molecule and an SO_5^- molecule coupled together by an electron vibrating between them. When the two molecules move away from each other to form products, the electron is preferentially captured by the SO_5^- molecule, resulting in the formation of SO_3^- and $SO_5^=$. This transition state can be schematically represented by the linear array in Figure 2.1.11.

$$[SO_3^- ---------\ e\ --------- SO_5^-]$$

Fig. 2.1.11

A complete reaction including the transition state can be written as follows:

$$SO_3^= + SO_5^- \longrightarrow [SO_3^- ----- e ----- SO_5^-] \longrightarrow SO_3^- + SO_5^=$$

(2.1.25)

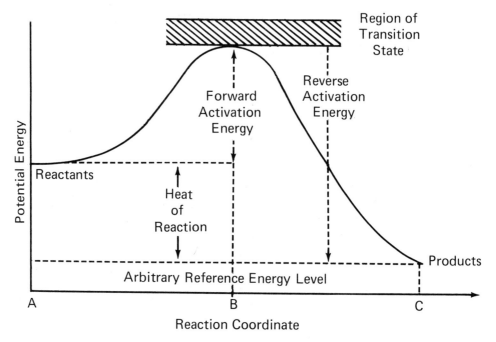

Fig. 2.1.12 *Represents a potential energy diagram for a reaction.*

The reaction coordinate in Fig. 2.1.12 represents the internuclear distance between the reactants in the interval A to B and the internuclear distance between the products in the interval B to C. The magnitude of A and C are quite large with respect to B.

For example, in the reaction

$$R + S \rightleftharpoons X + Z$$

$$(2.1.26)$$

as we move along the reaction coordinate from point A toward point B, the internuclear distance between R and S becomes smaller. When the reaction proceeds and the products X and Z are formed, the internuclear distance is smallest at point B and becomes larger as we proceed toward point C. The forward activation energy is the amount of energy required to bring the reactants to the transition or *activated complex* state. At this point the activated complex may either form products or return to reactants. The theory of the transition state was formulated in great part

by H. Eyring and his co-workers. [Ref: *The Theory of Rate Processes* by S. Glasstone, K.J. Laidler and H. Eyring, McGraw-Hill Book Company, Inc., New York (1941).]

DEFINITION OF KINETIC TASKS

A kinetic study generally proceeds at four well-defined tasks of investigation. *The first task* is to determine the total stoichiometric reaction.

This level of the study is concerned only with determining the number and kind of molecules of reactants and the number and kind of products. An example of the result of this task is given by reaction 2.1.1.

The second task is the determination of the stoichiometric reaction of the network. In this case the number and kind of intermediates that appear in the network are determined. Reactions 2.1.6 thru 2.1.8 represent the results of this task. A sequence of reactions for an individual step of a network is the result of the *third task* of a kinetic study. These reactions are called the *elementary steps* of a network and they result in the determination of the number and kind of active centers which participate in the elementary steps of the network. Reactions 2.1.15 thru 2.1.18 are an example of the results of this phase of the kinetic study.

The condition that sets the definition of an *elementary step* is that it be irreducible.

A reaction is irreducible when one cannot detect intermediates anywhere in the interval from reactants to products. Many so-called elementary steps may be broken down into two, three or more simpler steps. When a step is encountered that cannot be broken down into a sequence of simpler steps that contain intermediates, then, by definition, this is an elementary step.

The basic principle that determines whether an elementary step is irreducible is that the reaction involve the least change in structure.

When considering a candidate for an elementary step from a structural viewpoint—for example—if the reaction involves the transfer of an electron (as shown in Fig. 2.1.11) from one molecule to another, then the reaction is certainly an elementary step. However, if the reaction involves the transfer of two electrons from one molecule to one or two other molecules, it probably proceeds in two elementary steps.

Other types of reactions which involve the breaking and making of bonds can be considered along these lines. In these cases an elementary step is the breaking of one bond and the making of another.

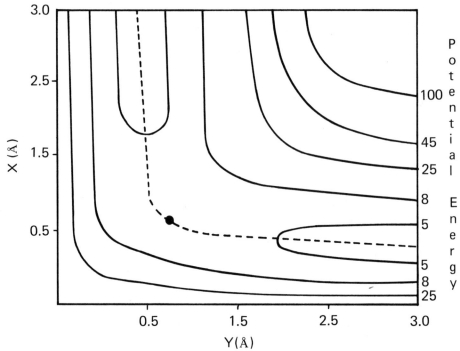

Transition State (2.1.27)

Reaction 2.1.27 shows the sulfonation of quinone that results in the breaking of a carbon hydrogen bond and the making of a bond between the carbon and the $^-SO_3Na$.

When elementary steps involve the breaking of two bonds and the making of two bonds, this specific reaction is called a *four center reaction*. The *four center reaction* and other more complicated reactions involving a series of concerted rearrangements are not within the scope of this text.

The fourth and final task of a kinetic study is concerned with the *transition state.*

Although the transition state cannot be isolated, it represents the highest energy along the lowest energy reaction path. The dotted line in Fig. 2.1.13 shows such a reaction path.

Fig. 2.1.13 *Shows the lowest energy reaction path on a potential energy surface for the hypo-* *thetical reaction 2.1.28. The black dot represents the region of the transition.*

$$\underset{B}{\overset{\cdots\cdots X\cdots\cdots}{}} \quad C-D \longrightarrow \left[B\ ----\ C\ ----\ D\right] \longrightarrow B-C \quad \underset{D}{\overset{\cdots\cdots Y\cdots\cdots}{}}$$

<div align="center">
Transition
State
</div>

<div align="right">(2.1.28)</div>

Equation 2.1.28 represents an atom B at a distance X from the system C–D, proceeding to the transition state and finally going to the system BC, which is at a distance Y from atom D.

Potential energy surfaces of the type shown in Figure 2.1.13 are calculated by the methods of quantum mechanics. Presently computers are enabling this phase of the study to become more practical [Ref: Enrico Clementi, *J. Chem. Phys.,* **49**, 4916 (1968); R. N. Porter and M. Karplus, *J. Chem. Phys.,* **40**, 2358 (1964)].

The kinetic investigator must determine which phase or phases are important to his study. However, the knowledge of the elementary steps, active centers and transition states represents the highest attainment in the study of chemical reactivity.

Some classical examples of photographic kinetic investigations are considered later in this chapter. Portions of the publications of T.H. James and J.F. Hamilton will be expanded and discussed from a kinetic viewpoint.

EXTENT OF REACTION

All of the reactions involved in the various phases of a kinetic study can often be written as a stoichiometric equation. For mathematical convenience, equation 2.1.1 can be written in the form

$$O = \text{[benzene ring with OH, SO}_3\text{Na, OH]} + Na_2SO_4 + NaOH - \text{[benzene ring with OH, OH]} - 2Na_2SO_3 - O_2$$

<div align="right">(2.1.29)</div>

For any stoichiometric equation, a general form can be written as

$$O = \sum_i \nu_i C_i$$

<div align="right">(2.1.29a)</div>

where C_i = i^{th} component (atom, molecule or ion)

ν_i = i^{th} stoichiometric coefficient, which is positive for products and negative for reactants

For example in equation 2.1.1 we can write

$$\nu_1 = 1, \qquad \nu_2 = 1, \qquad \nu_3 = 1, \qquad \nu_4 = -1,$$

$$\nu_5 = -2, \qquad \nu_6 = -1$$

$$C_1 = \quad , \quad C_2 = Na_2SO_4, \quad C_3 = NaOH,$$

$$C_4 = \quad , \quad C_5 = Na_2SO_3, \quad C_6 = O_2$$

$$(2.1.30)$$

The *law of definite proportions* states that when elements react to form a compound they react in a definite proportion by weight. We may also apply this law to molecules: When molecules react to form new molecules they react in a definite proportion by weight.

The quantification of these laws is obtained by considering a reaction taking place in a closed system; i.e., a system which does not exchange mass with its surroundings.

In such a system there are initially n_i^o moles of component C_i with stoichiometric coefficient ν_i at the initial time t_o. At some later time t, we have n_i moles of component C_i since a reaction has taken place. The *extent of reaction* can now be defined by the relation

$$\frac{n_i - n_i^o}{\nu_i} = X$$

$$(2.1.31)$$

Simple algebraic manipulation allows us to rewrite equation 2.1.3 as

$$n_i = n_i^o + \nu_i X$$

(2.1.32)

The variable X has a value of 0 at time t_o and it is always positive at any later time.

EXERCISE

Prove that X is always 0 or positive.

In the case where several simultaneous reactions are taking place in a closed system, the extent of reaction for the i^{th} component in the j^{th} reaction is defined as

$$n_{ij} = n_{ij}^o + \nu_{ij} X_j$$

(2.1.33)

For example, the equations 2.1.34 and 2.1.35 as written in the form of the equation 2.1.33 where the component numbers under each molecule are

1st Reaction

| Components | 1 | 2 | 3 | 4 |

(2.1.34)

2nd Reaction

$$0 = Na_2SO_4 + H_2O - H_2O_2 - Na_2SO_3$$

| Components | 1 | 2 | 3 | 4 |

(2.1.35)

The extent of reaction expression for 1st Reaction is written as

$$n_{11} = n_{11}^o + \nu_{11}\, X_1 \qquad \text{(quinone)}$$

$$n_{21} = n_{21}^o + \nu_{21}\, X_1 \qquad (H_2O_2)$$

$$n_{31} = n_{31}^o + \nu_{31}\, X_1 \qquad \text{(hydroquinone)}$$

$$n_{41} = n_{41}^o + \nu_{41}\, X_1 \qquad \text{(oxygen)}$$

$$(2.1.36)$$

The analogous expressions for the 2nd Reaction are

$$n_{12} = n_{12}^o + \nu_{12}\, X_2 \qquad (Na_2SO_4)$$

$$n_{22} = n_{22}^o + \nu_{22}\, X_2 \qquad (H_2O)$$

$$n_{32} = n_{32}^o + \nu_{32}\, X_2 \qquad (H_2O_2)$$

$$n_{42} = n_{42}^o + \nu_{42}\, X_2 \qquad (Na_2SO_3)$$

$$(2.1.37)$$

In both equations 2.1.36 and 2.1.37, $\nu_{11}, \nu_{21}, \nu_{12}, \nu_{22}$ are all equal to 1 while $\nu_{31}, \nu_{41}, \nu_{32}, \nu_{42}$ are all equal to -1.

EXERCISE

Prove that the extent of reaction expression is a form of the law of definite proportions.

For convenience, reactions are not usually started with the reactants in stoichiometric proportions. Thus the reactant present in the smallest amount called the *limiting reactant* determines the *maximum extent* of the reaction.

The maximum extent of the reaction X_{max} can be derived by taking the number of moles of limiting reactant n_L as zero.

This is expressed as

$$0 = n_L^o + \nu_L X_{max}$$

(2.1.38)

Equation 2.1.38 can be written as

$$X_{max} = \frac{-n_L^o}{\nu_L}$$

(2.1.39)

When the number of moles of limiting reactant is not zero, we write

$$X = \frac{n_L - n_L^o}{\nu_L}$$

(2.1.40)

The extent of reaction is not convenient for comparing two reacting systems because it is proportional to the mass of the system.

A new variable which is independent of the mass of the system is the fractional conversion f.

This variable is defined as

$$f = \frac{X}{X_{max}}$$

(2.1.41)

Substituting equations 2.1.39 and 2.1.40 into equation 2.1.41, we find

$$f = 1 - \frac{n_L}{n_L^o}$$

(2.1.42)

The fractional conversion

$$\boxed{f = 1 - \frac{D}{D_{max}}}$$

(2.1.43)

can be used as a measure of the rate of photographic development where D is the optical transmission density. In this case, n_L° represents the number of moles of silver formed in the limit as developing time becomes large. Development times of 20-30 minutes for most film systems can be regarded as very large.

EXERCISE

Prove that the fractional conversion takes on the values

$$0 \leqslant f \leqslant 1$$

We may define *irreversible* and *reversible* reactions by the extent of reaction. If a reaction takes place such that X_{max} is never reached and X approaches an equilibrium value X_E, then the reaction is said to be a reversible reaction. On the other hand, if $X_E = X_{max}$ then the reaction is said to be an irreversible reaction. Also the efficiency of the reaction ξ is defined as

$$\xi = \frac{X_E}{X_{max}}$$

(2.1.44)

THE MATHEMATICS FOR KINETICS

The rate of change of the extent of the reaction defines the rate in this text.

$$\frac{dX}{dt} = \text{Rate}$$

(2.1.45)

Recalling that all stoichiometric reactions can be written in the form

$$0 = \sum_i \nu_i C_i$$

(2.1.46)

we may take the derivative of equation 2.1.32 and write

$$\frac{dn_i}{dt} = \frac{dn_i^\circ}{dt} + \nu_i \frac{dX}{dt}$$

(2.1.47)

Since n_i° is equal to a constant, the derivative vanishes and we have

$$\frac{1}{\nu_i} \frac{dn_i}{dt} = \frac{dX}{dt} = \text{Rate}$$

(2.1.48)

When the worker is interested in determining the rate of change of the total particles in a given system, the left hand side of expression 2.1.48 is utilized.

An expression for the concentration of particles at constant volume v is written as

$$\frac{1}{\nu_i} \frac{d\frac{n_i}{v}}{dt} = \frac{d\frac{X}{v}}{dt}$$

(2.1.49)

If we define the concentration by using brackets, 2.1.49 becomes

$$\frac{n_i}{v} = [i]$$

(2.1.50)

After substitution of equation 2.1.50 into equation 2.1.49 we obtain

$$\frac{1}{\nu_i} \frac{d[i]}{dt} = \frac{d\frac{X}{v}}{dt}$$

(2.1.51)

Kinetic equations are generally written in the following form:

$$n_1 A + n_2 B \underset{k_{-1}}{\overset{k_1}{\rightleftharpoons}} n_3 C + n_4 D$$

(2.1.52)

where k_1 is called the rate constant for the forward reaction and k_{-1} is the rate constant for the reverse reaction. The stoichiometric coefficients are designated by n_1, n_2, n_3 and n_4. By convention, the rate constants are always taken as positive quantities.

Guldberg and Waage first suggested in 1867 by their Law of Mass Action that the rate of a reaction of the type shown in equation 2.1.52 could be expressed as

$$\text{Rate} = k_1 [A]^{n_1} [B]^{n_2}$$

(2.1.53)

Later investigators found that the exponents were rarely equal to the values of the stoichiometric coefficients n_1 and n_2. Thus the rate would be expressed as:

$$\text{Rate} = k_1 [A]^{\alpha_1} [B]^{\alpha_2}$$

(2.1.54)

$$\text{where} \quad \alpha_1 \neq n_1, \quad \alpha_2 \neq n_2$$

(2.1.55)

However when it was realized that the reaction could be an equilibrium reaction (see Eq. 2.1.52) the investigators were able to derive a new rate law by including the backward force of the reactants in a negative term.

The rate expression for Eq. 2.1.52 then became

$$\text{Rate} = k_1 [A]^{n_1} [B]^{n_2} - k_{-1} [C]^{n_3} [D]^{n_4}$$

(2.1.56)

Equation 2.1.56 is more theoretically sound since the stoichiometric coefficients are now present in the expression. In fact, as a first hypothesis, the rate expression for each reaction of a sequence is always written in this form.

If we follow the reaction by measuring the rate of change of the extent of the reaction for component A, the equation then becomes

$$\frac{1}{-n_1} \frac{d[A]}{dt} = k_1 [A]^{n_1} [B]^{n_2} - k_{-1} [C]^{n_3} [D]^{n_4}$$

(2.1.57)

Since the concentration of component A is decreasing as a function of time, its rate of change is negative, and it must be multiplied by -1 to satisfy the initial conditions of the reaction. To see this more clearly we

must consider that when the reaction first starts, the concentration of C and D is zero. Also all variables and constants are positive quantities except $d[A]/dt$, which is negative. Thus we must multiply by -1 to maintain the equality. However, if we follow the course of the reaction by measuring the rate of change of any one of the products, we may write for component C

$$\frac{1}{n_3} \frac{d[C]}{dt} = k_1 [A]^{n_1} [B]^{n_2} - k_{-1} [C]^{n_3} [D]^{n_4}$$

(2.1.58)

EXERCISE

Show why equation 2.1.58 is written without a negative sign in front of the derivative.

At equilibrium the rate of change of any component is zero and we may write

$$\frac{k_1}{k_{-1}} = \frac{[C]^{n_3} [D]^{n_4}}{[A]^{n_1} [B]^{n_2}} = K_{eq}$$

(2.1.59)

where K_{eq} is the familiar equilibrium constant.

An example of the use of equation 2.1.51 is its application to an experiment on the inhibition of the auto-oxidation of hydroquinone. [Ref: T.H. James and A. Weissberger, *J. Am. Chem. Soc.*, **61**, 442 (1939).]

The rate defining equations in this case are

$$H_2Q + O_2 \xrightarrow{k_o} Q + H_2O_2$$

(2.1.60)

$$H_2Q + O_2 + Q \xrightarrow{k_1} 2Q + H_2O_2$$

(2.1.61)

$$H_2O + Q + Na_2SO_3 \xrightarrow{k_2} \text{(quinone-SO}_3\text{Na structure)} + NaOH$$

(2.1.62)

This sequence of reactions is a simplified limiting case where the quinone concentration remains very low during the course of the reaction.

If the sequence of reactions 2.1.60, 2.1.61 and 2.1.62 are valid in the region of approximation, then we expect that the rate of change of the quinone concentration for reaction 2.1.60 is written as

$$\underbrace{\frac{d\,[Q]}{dt}}_{} = k_o\,[H_2Q]\,[O_2]$$

Rate of formation
of quinone

(2.1.63)

for reaction 2.1.61 we write

$$\underbrace{\frac{d\,[Q]}{dt}}_{} = k_1\,[H_2Q]\,[O_2]\,[Q]$$

Rate of formation
of quinone

(2.1.64)

and for 2.1.62

$$\underbrace{\frac{d\,[Q]}{dt}}_{} = -\,k_2\,[Q]\,[Na_2SO_3]\,[H_2O]$$

Rate of disappear-
ance of quinone

(2.1.65)

In the differential equations 2.1.63 and 2.1.64, the rates are positive because quinone is being produced in these two reactions. Differential equation 2.1.65 is written with a negative sign since the rate is expressing the disappearance of quinone as the reaction proceeds.

In equations 2.1.60, 2.1.61 and 2.1.62, the stoichiometric coefficients are 1. Thus the quantity $1/v_i$ is 1 in expressions 2.1.63, 2.1.64 and 2.1.65.

Equation 2.1.65 may be simplified by combining the factor H_2O with k_2 since water is in large excess and its concentration is essentially constant in this reaction.

Rewriting equation 2.1.65 with this assumption, we have

$$\frac{d[Q]}{dt} = - k_2 [Q] [Na_2 SO_3]$$

(2.1.66)

The total rate of change of quinone will be the sum of the rate of change as it is produced in equations 2.1.63 and 2.1.64 and the equation 2.1.65 which expresses its consumption.

Summing these equations, we write

$$k_o [H_2 Q] [O_2] \; + \; k_1 [H_2 Q] [O_2] [Q] \; - \; k_2 [Q] [Na_2 SO_3]$$

(2.1.67)

If it is assumed that the quinone is consumed at the same rate that it is being produced, then its total rate of change is equal to zero.

Thus equation 2.1.67 is equal to zero.

$$\text{EQUATION (2.1.67)} \; = \; 0$$

(2.1.68)

Equation 2.1.68 is an expression of the *steady state approximation*. Utilizing equation 2.1.68, it is possible to solve for the steady state concentration of quinone.

By algebraic manipulation of equation 2.1.68 we obtain

$$[Q] \; = \; \frac{k_o [H_2 Q] [O_2]}{k_2 [Na_2 SO_3] \; - \; k_1 [H_2 Q] [O_2]}$$

(2.1.69)

Equation 2.1.69 represents the steady state concentration of quinone.

The total rate of change of oxygen in the system expressed by equations 2.1.60, 2.1.61 and 2.1.62 consists of the sum of the rate of oxygen uptake in equations 2.1.60 and 2.1.61; the resulting equation is

$$\frac{d\,[O_2]}{dt} = k_0\,[H_2Q]\,[O_2] + k_1\,[H_2Q]\,[O_2]\,[Q]$$

(2.1.70)

Substituting equation 2.1.69 into equation 2.1.70, we write

$$\frac{d\,[O_2]}{dt} =$$

$$k_0\,[H_2Q]\,[O_2]\left[\,1 + \frac{k_1}{k_2}\,\frac{k_2}{k_2}\,\frac{[H_2Q]\,[O_2]}{[Na_2SO_3] - k_1\,[H_2Q]\,[O_2]}\,\right]$$

(2.1.71)

Equation 2.1.71 implies that the rate of uptake of oxygen will depend on the concentration of hydroquinone and oxygen raised to a power between 1 and 2. This can be verified by multiplying out all the terms in equation 2.1.71.

Although equation 2.1.71 predicts that as the initial concentration of sulfite is increased the rate of oxygen uptake decreases (everything else being held constant), it was found experimentally [Ref: T.H. James and A. Weissberger, *J. Am. Chem. Soc.*, **61**, 442 (1939)] that this prediction did not hold.

On the other hand, these experiments showed that the rate of oxygen uptake depended upon the concentration of hydroquinone and oxygen raised to a power between 1 and 2.

We can conclude that the series of reactions 2.1.60, 2.1.61 and 2.1.62 do not represent the real situation. One of the problems appears to be that the active centers such as semiquinone SO_3^-, etc., have not been considered.

If we did not have any alternate possibilities for the reactions 2.1.60, 2.1.61 and 2.1.62, we could not make any definite conclusions. For instance, we might conclude that there is no steady state representation for such a system, so that the kinetic equations 2.1.69 thru 2.1.71 are incorrect. On the other hand, we are faced with the possibility that there is another sequence of reactions which is correct. Faced with this quandary, we cannot come to a definite conclusion. Thus we must continue to test hypotheses until the model, kinetic equations, and the experimental data are in good agreement.

The reader should be well aware of the pitfalls that are associated with an incomplete kinetic investigation.

Now that we have somewhat destroyed your faith and confidence in chemical kinetics, we can go on, hoping that we will obtain sufficient maturity to distinguish the false from at least the more accurate hypotheses.

THE ORDER OF REACTIONS

In the cases where we are dealing with simple kinetic equations, that is equations which contain only one term of factors, the total *order* of such equations can be defined as the sum of the exponents in the term.

Example:

Consider the rate equation of the form

$$\frac{1}{n_1} \frac{d[A]}{dt} = k[A]^{n_1}[B]^{n_2}$$

$$\text{Order} = n_1 + n_2$$

$$(2.1.72)$$

When the rate equations consist of a number of terms of factors, it is more appropriate to define the order with respect to one component than to consider the total order of such a complex equation.

$$\frac{1}{2} \frac{d[A]}{dt} = \frac{k_1[A]^2[B] - k_{-1}[C]^2[D]}{k_2[E]^{1/2}[F]^{3/2}}$$

$$(2.1.73)$$

Equation 2.1.73 is second order with respect to components A and C, first order with respect to components B and D, $-1/2$ order with respect to component E, and $-3/2$ order with respect to component F.

Equations of this type (also see equation 2.1.71) generally arise from an analysis of a sequence of reactions in which the steady state assumption is made.

RATE EXPRESSIONS FOR CATALYTIC SEQUENCE

Let us consider the free radical ionic catalytic closed sequence

$$\text{Sequence} \begin{cases} SO_3^- + O_2 \; \underset{k_{-1}}{\overset{k_1}{\rightleftharpoons}} \; SO_5^- & (2.1.74) \\[2em] SO_5^- + SO_3^= \; \underset{k_{-2}}{\overset{k_2}{\rightleftharpoons}} \; SO_5^= + SO_3^- & (2.1.75) \\[2em] SO_5^= + SO_3^= \; \underset{k_{-3}}{\overset{k_3}{\rightleftharpoons}} \; 2\,SO_4^= & (2.1.76) \end{cases}$$

$$\text{Total Reaction} \begin{cases} 2\,SO_3^= + O_2 \rightleftharpoons 2\,SO_4^= \end{cases}$$

(2.1.77)

In this sequence the SO_3^- and the SO_5^- are the active centers. This type of sequence discussed earlier (see equations 2.1.15 thru 2.1.18) was characterized as a chain reaction. The rate constants are omitted from the total reaction because they are not used in the final analysis.

We proceed to analyze equations 2.1.74 and 2.1.75 in terms of the rate of change of the active centers and we write

$$\frac{d\,[SO_3^-]}{dt} = -k_1\,[SO_3^-]\,[O_2] + k_{-1}\,[SO_5^-]$$

(2.1.78)

$$\frac{d\,[SO_5^-]}{dt} = -k_2\,[SO_5^-]\,[SO_3^=] + k_{-2}\,[SO_5^=]\,[SO_3^-]$$

(2.1.79)

A final equation 2.1.80 is written for the rate of change of the $SO_5^=$, which is not an active center.

$$\frac{d\,[SO_5^=]}{dt} = -\,k_3\,[SO_5^=]\,[SO_3^=] + k_{-3}\,[SO_4^=]^2$$

(2.1.80)

Since active centers appear only in the equations 2.1.74 and 2.1.75, they are very fast reactions and reach a state of equilibrium rapidly. These reactions to which the steady state approximation can be applied do not determine the rate of the total reaction. The slow reaction 2.1.76 actually determines the total rate of the reaction. In this type of sequence reaction 2.1.76 represents the *rate determining step*.

We proceed with the analysis by applying the steady state approximation to equations 2.1.78 and 2.1.79 and we have

$$-\,k_1\,[SO_3^-]\,[O_2] + k_{-1}\,[SO_5^-] =$$
$$-\,k_2\,[SO_5^-]\,[SO_3^=] + k_{-2}\,[SO_5^=]\,[SO_3^-]$$

(2.1.81)

Inspection of the differential equation 2.1.80 representing the rate determining step shows that we may solve equation 2.1.81 for either $[SO_3^=]$ or $[SO_5^=]$. Arbitrarily we shall solve for $[SO_5^=]$.

Solving for $[SO_5^=]$ we have

$$[SO_5^=] = \frac{-\,k_1\,[SO_3^-]\,[O_2] + k_{-1}\,[SO_5^-] + k_2\,[SO_5^-]\,[SO_3^=]}{k_{-2}\,[SO_3^-]}$$

(2.1.82)

Using algebraic manipulation, we may write

$$[SO_5^=] = \frac{\dfrac{[SO_5^-]}{[SO_3^-]}\left(k_{-1} + k_2\,[SO_3^=]\right) - k_1\,[O_2]}{k_{-2}}$$

(2.1.83)

We can evaluate the ratio $[SO_5^-]/[SO_3^-]$ as follows. Since the concentration of these active centers is at equilbrium at the steady state we can write the equilibrium expression:

$$K_{eq(1)} = \frac{k_1}{k_{-1}} = \frac{[SO_5^-]}{[SO_3^-][O_2]}$$

(2.1.84)

and

$$\frac{[SO_5^-]}{[SO_3^-]} = \frac{k_1}{k_{-1}}[O_2]$$

(2.1.85)

Substituting equation 2.1.85 into equation 2.1.83, we have

$$[SO_5^=] = \frac{\dfrac{k_1}{k_{-1}}[O_2]\left(k_{-1} + k_2[SO_3^=]\right) - k_1[O_2]}{k_{-2}}$$

(2.1.86)

Simplifying equation 2.1.86, we write

$$[SO_5^=] = \frac{\cancel{k_1[O_2]} + \dfrac{k_1 k_2}{k_{-1}}[O_2][SO_3^=] - \cancel{k_1[O_2]}}{k_{-2}}$$

(2.1.87)

and

$$[SO_5^=] = [O_2][SO_3^=]K_{eq(1)}K_{eq(2)}$$

(2.1.88)

where $K_{eq(1)}$ is the equilibrium constant for reaction 2.1.74 and $K_{eq(2)}$ is the constant for reaction 2.1.75

Substituting equation 2.1.88 into equation 2.1.80, we have

$$\frac{d[SO_5^=]}{dt} = -k_3 K_{eq(1)} K_{eq(2)}[O_2][SO_3^=]^2 + k_{-3}[SO_4^=]^2$$

(2.1.89)

Equation 2.1.89 is much simpler than equation 2.1.80 because the concentrations of the active centers SO_3^- and SO_5^- have been eliminated. If equation 2.1.80 were written in terms of the rate of change of $[SO_3^=]$ and if the preceding analysis were made, the result would be

$$\frac{d\,[SO_3^=]}{dt} \;=\; -\,k_3\,K_{eq(1)}\,K_{eq(2)}\,[O_2]\,[SO_3^=]^2 \;+\; k_{-3}\,[SO_4^=]^2$$

(2.1.90)

Equation 2.1.90 represents an example of how one can deduce a kinetic equation from a given series of reactions. In its present form it is difficult to integrate. However, if we consider the state of the system when t is in the neighborhood of zero, we note that the concentration of $SO_4^=$ is extremely small.

Thus the term $k_{-3}\,[SO_4^=]^2$ can be neglected for a first approximation. Equation 2.1.90 can now be written as

$$\frac{d\,[SO_3^=]}{dt} \;=\; -\,k_3\,K_{eq(1)}\,K_{eq(2)}\,[O_2]\,[SO_3^=]^2$$

(2.1.91)

$$\text{If}\quad -\,k_3\,K_{eq(1)}\,K_{eq(2)} \;=\; -\,k_3'$$

(2.1.92)

then we can write

$$\frac{d\,[SO_3^=]}{dt} \;=\; -\,k_3'\,[O_2]\,[SO_3^=]^2$$

(2.1.93)

Equation 2.1.93 can now be integrated. Without any loss of generality, we set the initial conditions as

$$[SO_3^=]_o \;=\; a$$

(2.1.94)

$$[O_2]_o \;=\; \frac{a}{2}$$

(2.1.95)

where $[\;]_o$ represents the initial concentration of a component at time t_o.

If X is the concentration of $SO_3^=$ remaining at any time t in the neighborhood of t_o, then we see in Table 2.1.1 the concentrations of the components remaining and reacted.

This table is based upon the total stoichiometric equation 2.1.77.

TABLE 2.1.1

Component	Amount Remaining	Amount Reacted
$[SO_3^=]$	X	$a - X$
$[O_2]$	$\dfrac{a}{2} - \dfrac{(a - X)}{2}$	$\dfrac{a - X}{2}$

Substituting the quantities X for $[SO_3^=]$ and X/2 for $[O_2]$ in equation 2.1.93, we write

$$\frac{d\,X}{dt} = -k_3'\,X^2\,\frac{X}{2}$$

(2.1.96)

$$\frac{d\,X}{dt} = -k_3'\,\frac{X^3}{2}$$

(2.1.97)

Equation 2.1.97 can now be integrated by the method of separation of variables and we have

$$\int_a^X \frac{d\,X}{X^3} = -\frac{1}{2}\,k_3'\int_{t_o}^t dt$$

(2.1.98)

Evaluating the integral, we find

$$\frac{1}{X^2} = k_3' (t - t_o) + \frac{1}{a^2}$$

(2.1.99)

Since equation 2.1.99 can be placed in the slope intercept form of a straight line, we can write

$$\underbrace{\frac{1}{X^2}}_{y} = \underbrace{k_3'}_{m} \underbrace{(t - t_o)}_{x} + \underbrace{\frac{1}{a^2}}_{b}$$

$$y = m \quad x \quad + \quad b$$

(2.1.100)

where the slope is k_3'.

Slope intercept plots of equation 2.1.99 may now be drawn as shown in Figure 2.1.14.

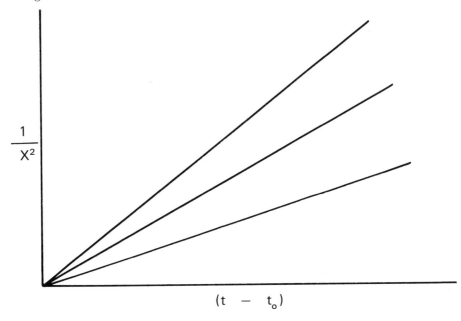

Fig. 2.1.14 Shows slope-intercept plots of equation 2.1.98 for various values of the slope k_3' when b equals zero.

If the experimenter measures the concentration of $SO_3^=$ as a function of time, the resultant plot of these data may verify equation 2.1.99. Since

the approximation that resulted in equation 2.1.99 is valid only in the neighborhood of t_o, then we should expect the experimental plot to approximate a straight line in this neighborhood.

The fact that experimental data do approximate a straight line in this neighborhood is not sufficient proof that the model is correct. Another method of verification for equation 2.1.99 is to change the temperature and measure slope changes as a function of temperature. The change in temperature would tend to change the value of the equilibrium constants $K_{eq(1)}$ and $K_{eq(2)}$. These equilibrium constants affect the slope as factors so that a correlation of the changes of temperature with the resulting slope changes might give sufficient information to validate the model. On the other hand, equation 2.1.76 may not be an equilibrium reaction; i.e., it may be irreversible. In this case, the rate constant k_{-3} would be equal to zero and the term containing this constant would vanish and the results would then be valid outside the neighborhood of t_o.

TEMPERATURE DEPENDENCE OF RATE CONSTANTS

In 1889, S. Arrhenius [Ref: S. Arrhenius, Z. *Physik. Chem.*, 4, 226 (1889)], first recognized that before a reaction could proceed, some high energy species must first be formed prior to breaking down into products. These high energy species are now called the activated complex.

Contemporary with Arrhenius, J.C. Maxwell and L. Boltzmann had theoretically established in the kinetic theory of gases the so-called Maxwell–Boltzmann distribution. This exponential distribution which relates the number of particles at different energy levels by means of the equation

$$\frac{n_2}{n_1} = e^{-(E_2 - E_1)/RT}$$

$$(2.1.101)$$

is based on Newtonian mechanics of particles in a gas phase. The quantity n_i is the number of molecules at the energy E_i, $i = 1, 2$.

Arrhenius reasoned that he could use equation 2.1.101 for particles in the liquid phase. By substituting for n_2 the concentration of activated complex molecules and the concentration of reactant molecules for n_1, he wrote

$$\frac{\text{Concentration of Activated Complex Molecules}}{\text{Concentration of Reactant Molecules}} = e^{-Ea/RT}$$

$$(2.1.102)$$

Where Ea is the energy difference between the reactant and activated complex molecules, R is the Boltzmann gas constant, which is equal to 1.9872 calories per mole degree kelvin, and T is the absolute temperature in degrees kelvin. Of course Arrhenius did not use terms such as activated complex.

Using equation 2.1.102, Arrhenius wrote the rate of the reaction as

$$\text{Rate} \quad = \quad A\,e^{-Ea/RT} \quad [\text{Reactants}]$$

$$(2.1.103)$$

Equation 2.1.103 is based on the assumption made by Arrhenius that the rate is proportional to the concentration of activated complex molecules where A is the constant of proportionality. This is demonstrated by the fact that the concentration of reactants on the right side of equation 2.1.103 cancels out the denominator of the expression 2.1.102.

Expression 2.1.103 was then compared with an ordinary rate expression of the form:

$$\text{Rate} \quad = \quad k_1 \quad [\text{Reactants}]$$

$$(2.1.104)$$

so that the identification

$$k_1 \quad = \quad A\,e^{-Ea/RT}$$

$$(2.1.105)$$

was made.

Equation 2.1.105 is the celebrated Arrhenius expression for the rate constant as a function of temperature.

MODERN TRANSITION STATE THEORY

Even before the development and common usage of large computers reaction parameters such as rate constants were measured more accurately than they could be calculated theoretically. At the present time, common usage of these computer systems is *lending credence* to the concept that reaction parameters may in the future be calculated more accurately than they can be measured. Thus to be fair to the reader we must at the least show him some of the modern theoretical ideas about the calculation of a reaction parameter such as a rate constant from elementary principles.

Presently, reaction parameters in the photographic process such as rate constants are being investigated from a theoretical standpoint with the help of computers.

The modern approach to the theory of the transition state or activated complex is based on many of the notions of Arrhenius.

We consider a reaction that takes place with molecules A and B, which react and set up an equilibrium with the transition state species, which, in turn, subsequently breaks up to form products. This reaction is written as

$$A \ + \ B \ \rightleftharpoons \ (AB)^* \ \longrightarrow \ PRODUCTS$$

(2.1.106)

where (AB)* is the activated complex.

The equilibrium constant for the activated complex can be written as

$$K^* \ = \ \frac{[\,(AB)^*\,]}{[\,A\,]\,[\,B\,]}$$

(2.1.107)

Equation 2.1.107 implies that the concentration of the activated complex can be written as

$$[\,(AB)^*\,] \ = \ K^*\,[A]\,[B]$$

(2.1.108)

We imagine that the activated complex is vibrating in such a manner that when its vibration reaches the limit of elasticity, it breaks up, forming product molecules. We assume that the frequency of these vibrations is equal to the rate at which the complex breaks up.

We also assume that the average energy of this vibrational degree of freedom is equal to the classical expression kT where

$$k \ = \ \frac{R}{6.02 \times 10^{23}}$$

(2.1.109)

and is not to be identified with the rate constant k_i, which always has a subscript to identify it from the Boltzmann constant k.

We can now calculate the frequency of these vibrations by equating the Planck expression with kT and we write

$$h\nu = kT$$

(2.1.110)

Thus the average frequency at which the activated complex is breaking up is written as

$$\nu_{av} = \frac{kT}{h}$$

(2.1.111)

Equation 2.1.111 shows that ν_{av} is a universal frequency characteristic of all matter. That this universal frequency exists is the fundamental assumption of transition state theory.

The rate of the reaction can now be written in terms of transition state theory as

$$-\frac{d[A]}{dt} = \nu_{av}[(AB)^*]$$

(2.1.112)

Equation 2.1.112 is analogous to the reasoning of Arrhenius that the rate of the reaction is proportional to the concentration of activated complex molecules.

Substituting equation 2.1.111 and equation 2.1.108 into equation 2.1.112 we obtain

$$-\frac{d[A]}{dt} = \frac{kT}{h} K^*[A][B]$$

(2.1.113)

If equation 2.1.113 is compared with the standard kinetic expression for the reaction

$$-\frac{d[A]}{dt} = k_1[A][B]$$

(2.1.114)

we see that the following identification can be made

$$k_1 = \frac{k\,T}{h}\,K^*$$

$$(2.1.115)$$

In chapter three it is proven that the standard Gibbs free energy change for an equilibrium reaction can be expressed as

$$\Delta G^\circ = -\,R\,T\,\ln K_{eq}$$

$$(2.1.116)$$

In terms of the activated complex we may write expression 2.1.116 as

$$(\Delta G^\circ)^* = -\,RT\,\ln K^*_{eq}$$

$$(2.1.117)$$

It is also shown in Chapter 3 that

$$\Delta G^\circ = \Delta H^\circ - T\Delta S^\circ$$

$$(2.1.118)$$

For the transition state we have the analogous expression

$$(\Delta G^\circ)^* = (\Delta H^\circ)^* - T(\Delta S^\circ)^*$$

$$(2.1.119)$$

The quantities $(\Delta H^\circ)^*$ and $(\Delta S^\circ)^*$ are called the enthalpy and entropy of activation, respectively.

From the definition of the logarithm we may express equation 2.1.117 as

$$K^* = e^{-(\Delta G^\circ)^*/RT}$$

$$(2.1.120)$$

Substituting equation 2.1.119 into equation 2.1.120, we have

$$K^* = e^{-(\Delta H^\circ)^* - T(\Delta S^\circ)^*/RT}$$

$$(2.1.121)$$

which can be expressed as

$$K^* = e^{-(\Delta H^\circ)^*/RT} \, e^{+(\Delta S^\circ)^*/R}$$

(2.1.122)

Equation 2.1.122 can be substituted into 2.1.115 to obtain the rate constant in the form

$$k_1 = \frac{k\,T}{h} \, e^{-(\Delta H^\circ)^*/RT} \, e^{+(\Delta S^\circ)^*/R}$$

(2.1.123)

Equations 2.1.122 and 2.1.123 provide more insight into the nature of chemical reactivity by showing that before a reaction can proceed, a *free energy barrier* rather than a simple energy barrier must be surmounted. That is, the activation barrier is not a function of energy alone but is also a function of entropy. Furthermore, transition–state theory coupled with statistical quantum mechanics may allow workers to calculate a–priori the rate constants for various reactions [Ref: Enrico Clementi, *J. Chem. Phys.*, **49**, 4916 (1968)].

In order to accomplish this task, the investigator must consider the detailed nature of the system that contains molecules, active centers and activated complexes. This task becomes very complicated when it is applied to the photographic process, since the molecules are solvated, the degrees of freedom associated with all the species involved are difficult to determine, and the molecules are too large to be treated by the methods of exact quantum mechanics. However, by applying the approximate methods of quantum mechanics and by making appropriate assumptions about the degrees of freedom associated with all the various solvated species, some progress may be made.

The kinetics of photographic development must be considered as a heterogeneous autocatalytic system.

The silver formed during development catalyzes the further reduction of silver ions to silver metal.

A first approximation to the *kinetics of photographic development* can be obtained by use of the equation

$$\frac{dD}{dt} = k(D_\infty - D)$$

(2.1.124)

where D = optical density at developing time t

D_∞ = maximum density

D = 0 at time t = 0

D = D_∞ at time t = ∞

Although no one rate equation has been derived that can characterize the kinetics of development over the wide range of developer formulations and film type, the authors have found that equation 2.1.124 accurately represents a surprising number of developer film combinations. However, in many cases the equation represents the rate of development for only a limited range of development times, and generally not in the neighborhood of t = 0.

DETERMINATION OF THE ACTIVATION ENERGY FOR A DEVELOPER FILM COMBINATION

James reported [Ref: T.H. James, *Phot. Sci. Eng.*, 7, 304 (1963)] the activation energy for a sulphur sensitized silver bromide emulsion versus a developer solution containing 2.5 grams of metol, 10 grams of ascorbic acid, 35 grams of Kodak balanced alkali, 1 gram of potassium bromide and 1 gram $Na_2 S_2 O_3 \cdot 5H_2O$ per liter of water was 8 kcal/mole.

It is of interest to show how the activation energy can be determined.

To be completely general, we assume that the rate equation for the system is of the form

$$\text{Rate} \;=\; \frac{dD}{dt} \;=\; kf(D)$$

(2.1.125)

where

$$k \;=\; Ae^{-E_a/RT}$$

$$D \;=\; \text{optical transmission density}$$

(2.1.126)

then we may write

$$\ln \text{Rate} \;=\; \ln k \;+\; \ln f(D)$$

(2.1.127)

Substituting the value of k into equation 2.1.127, we obtain

$$\ln \text{Rate} = \ln A - E_a/RT + \ln f(D)$$

(2.1.128)

By plotting various curves of density versus the time of development at different temperatures as shown in Figure 2.1.15, we can determine the activation energy.

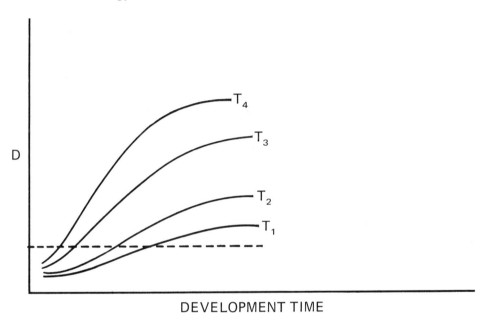

DEVELOPMENT TIME

Fig. 2.1.15 *Shows density versus time of development curves at 4 levels of temperature. The dotted line represents the reference density.*

First a reference density is chosen. A line is drawn from this reference density such that it intersects each curve corresponding to this density. The next step is to determine the rate at each point of intersection by finding the tangent to the curve at the intersection.

Finally these rates are plotted versus temperature and the result should be a straight line if the Arrhenius equation holds. This can be proven by substituting the reference density into equation 2.1.128.

$$\ln \text{Rate at } D_{ref.} = \ln A - \frac{E_a}{RT} + \ln f(D_{ref})$$

(2.1.129)

where the last term in equation 2.1.129 is now a constant.
Combining the constant terms, we may write

$$\text{In Rate at } D_{ref} = \text{In } A' - \frac{E_a}{RT}$$

(2.1.130)

where

$$A' = A \, f(D_{ref})$$

(2.1.131)

Examination of equation 2.1.130 shows that a plot of the left hand side of the equation versus $1/T$ should yield a straight line with a slope

$$-\frac{E_a}{R}$$

(2.1.132)

By measuring the slope and equating it to expression 2.1.132, the value of E_a is calculated.

Another heterogeneous system is the formation of the latent image by the interaction of radiation with the silver halide crystal. This system will be considered in detail in the next section.

The symbols E_a and E_a are used to designate the activation energy.

PROBLEM SET 2.1

1. Discuss two homogeneous and two heterogeneous reactions that take place during photographic development.

2. Write the parallel and consecutive reactions for equation 2.1.1. Show that these reactions sum to give the stoichiometric equation 2.1.1.

3. Write the network of reactions for reaction 2.1.1.

4. Under what conditions can the sequence of reactions 2.1.11, 2.1.12 be written as shown, where the side reaction with oxygen is neglected?

5. Name the active centers and intermediates in reactions 2.1.1 thru 2.1.18.

6. What is a free radical? How can it be detected?

7. Discuss closed and open sequences using reactions 2.1.15 thru 2.1.18.

8. Why is quinone not an aromatic compound? (Hint: Consider the difference between the aromatic compound hydroquinone and quinone in terms of resonance.)

9. Write the sulfonation reaction that results in the weak developing agent hydroquinone monosulfonate.

10. Explain why the developing agent formed in reaction 2.1.27 is very weak under normal development conditions.

11. What determines the maximum extent of a reaction?

12. Write the total rate of change of quinone using equations 2.1.63, 2.1.64 and 2.1.65.

 a) Invoking the steady state approximation, solve for the steady state concentration of quinone.

 b) What assumptions are you making in order to invoke the steady state?

13. Solve equation 2.1.80 for $[SO_3^=]$.

14. Find the integral form of equation 2.1.124.

15. a) After finding the integral form show how one can plot the equation to obtain a straight line relationship between density and time of development.

15. b) What is the value of the slope of this line?

16. What factors contribute to the general inability of equation 2.1.124 to represent the rate of photographic development in the neighborhood of $t = 0$?

17. A number of characteristic curves are drawn representing several developer film combinations at eight levels of development time.

 a) Describe a method for determining rate constants and rate equations derived from the characteristic curve data.

b) Discuss the meaning of the slope and shape of the derived rate curves.

18. Plotting $\ln(1 - D/D_{max})$ against time we arrive at a curve that is linear over the development time range of two to twelve minutes.

a) Discuss the induction period and the non-linearity found in the region zero to two minutes of development.

b) What is the implication of the straight line portion of the rate curve over the development time range of two to twelve minutes?

c) What factors probably cause non-linearaties after twelve minutes of development?

2.2 Surface Latent Image

Latent image formation is such a complex process that mathematical treatments of this process have never been completely successful. J. F. Hamilton and B. E. Bayer [Ref: *J. Opt. Soc. Am.*, **55**, 439 (1965)] applying *Monte Carlo methods* to a relatively simple latent image model have been able to account for many of the observed properties of a hypothetical simple emulsion. The model they chose was based on the theory given by Gurney and Mott [Ref: R. W. Gurney and N. F. Mott, *"Electronic Processes in Ionic Crystals,"* Oxford University Press, New York (1948) 2nd ed., Chap. VII].

The Bayer and Hamilton model yields D log E curves, reciprocity failure curves and the distribution of development center plots. The Hamilton and Bayer treatment does not account for spatial factors. Their model did not consider a complex emulsion probably for the following reasons:

1. Complex emulsions contain tabular grains. Photons arriving at such a grain have a lower probability for arriving at the same center while increasing the probability that the photon will be absorbed forming a new center. Therefore for large grained tabular emulsions the spatial factor cannot be ignored.

2. In large grained emulsions the ionic process is not instantaneous.

3. In large grained tabular emulsions, even if the differences in the projected area are not considered, the variations in grain thickness and defect concentrations are such that the inherent grain differences in complex emulsions cannot be excluded from a more general model.

Thus the Hamilton and Bayer model is not appropriate for large grained tabular emulsions. In spite of the simplifications of the 1965 Hamilton and Bayer analysis of the latent image, this model brings to the reader the fundamental concepts needed for further studies in this area. This type of analysis can serve as a springboard for further investigations of more complex models with all their ramifications.

COMPUTER MODEL ASSUMPTIONS

Hamilton and Bayer used the following assumptions in their 1965 analysis:

1. Unexposed grains contain mobile Ag^+ ions, and either chemical or physical surface imperfections.

2. When a photon is absorbed by a grain, it produces *an electron and a hole.*

3. Crystal imperfections act either as *shallow traps* for electrons or traps for holes.

4. Shallow electron traps may trap an electron; most likely these trapped electrons will escape in a very short time.

5. A recombination center where free electrons can combine with holes is formed when a hole trap captures a hole.

6. The probability of a free hole recombining with an electron at an electron trap is negligible.

7. Holes may be permanently removed from action by some mechanism which makes them no longer available for recombination with an electron.

8. A mobile Ag^+ ion may combine with an electron in a shallow trap to form an atom of silver.

9. A second electron cannot enter an electron trap which is occupied by an electron.

10. If the trapped electron combines with a mobile silver ion to form an atom of silver, the trap is reset and can now accept another electron.

11. The atom formed in the trap can decompose forming an electron in the shallow trap and a mobile silver ion.

12. If decomposition of a silver atom occurs in a shallow trap, the electron will probably escape in a very short time.

13. The formation of a silver atom at a trap deepens the trap.

14. An electron may be trapped at a deep trap which already contains a silver atom.

15. An electron which is trapped at a deep trap (a trap deepened by the formation of a silver atom) does not escape.

16. Another mobile silver ion is captured by the site described in assumption 15. Thus a pair of silver atoms is formed.

17. The process described in assumptions 13, 14, 15, and 16 is repeated a number of times so that the latent image speck grows larger.

18. The probability of escape of an electron from a trap is decreased by sulfur sensitization.

19. Sulfur sensitization decreases the probability of escape of a silver ion from a single atom of silver.

20. To be able to catalyze photographic development a speck must reach some critical size.

21. The critical size is inversely proportional to development time.

22. A grain containing any speck of critical size is developed completely under conditions of normal development (see Figure 2.2.1).

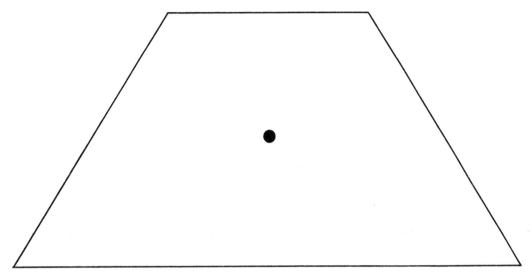

Fig. 2.2.1 *Autocatalysis speck of critical size develops entire grain.*

23. By utilizing the method of arrested development, all specks of critical size are revealed.

24. Exposed grains do not contain internal latent image.

SYMBOLOGY AND DEFINITIONS OF THE COMPUTER MODEL

This model involves a number of different fixed centers and mobile charged particles which were designated as 'actors' by Bayer and Hamilton.

Each actor was given a symbol which is listed in Table 2.2.1. The symbols are used to designate the number of each type of actor within a given grain.

The method of analysis of the model neglects the positions of actors within the grain. However, using a thermodynamic approach, a set of numbers is given to completely describe the state of the grain. As an abbreviation for the state of the grain the symbol Cg is used. The following table gives a list of all other abbreviations.

TABLE 2.2.1

SYMBOL	ACTOR
s_t	shallow electron traps
ϵ_t	trapped electrons
Ag^+	mobile silver ions
Ag	silver atoms
Ag^-	electons trapped at silver atoms
Ag_2	2 silver atom aggregates
Ag_2^-	2 silver atom aggregates with trapped electron
Ag_n	n–silver atom aggregates
Ag_n^-	n–silver atom aggregates with trapped electron
ϵ_f	free electrons
h_f	free holes
h_t	trapped holes

After the absorption of a photon by the system, the random sequence of events which occur in terms of this model is of two types.

Type 1 is a combination that can be written as:

$$A + B \longrightarrow C$$

(2.2.1)

Type 2 is a decomposition that can be written as:

$$C \longrightarrow A + B$$

(2.2.2)

Using standard chemical notation, we write

$$A + B \underset{k_2}{\overset{k_1}{\rightleftharpoons}} C$$

(2.2.3)

where k_1 is the forward rate constant and k_2 is the reverse rate constant.

The rate constants k_1 and k_2 represent the parameters of the model, and the response of the model varies as k_1 and k_2 take on different values.

Bayer and Hamilton chose values for these rate constants so that the

response of the model would approximate the sensitometric character-
istics of the sensitized and primitive emulsions.

A semiemperical method was used where the values of these
parameters were first obtained by approximations to a very simple
analysis and were later readjusted based on trial simulations on a
computer.

The simplified analysis is distinguished by considerations concerning
a developable latent image center which takes place by nucleation and
growth. Nucleation is the formation of a two silver atom aggregate, where-
as growth is the formation of many silver atoms as a function of time.

Burton and Berg [Ref: P. C. Burton and W. F. Berg, *Phot. J.*, **86B**, 2
(1946)] concluded from their experiments that the nucleation stage was
distinguished by low intensity reciprocity failure and that the growth
stage was distinguished by high intensity reciprocity failure.

During the early stages of nucleation, recombination of electrons and
holes competes with the growth of a stable two silver atom nucleus. This
means that a second cycling electron recombines with a hole before the
next photon can be absorbed. Low intensity reciprocity failure is
characterized by this inefficiency in nucleation.

High intensity reciprocity failure is characterized by the growth
stage.

1. In the early stages of nuclei formation, recombination of elec-
trons and holes competes with growth of nuclei. After the first nucleus
forms, the growth stage becomes inefficient for other reasons.

2. Additional formation and growth of nuclei compete against the
growth of nuclei formed earlier. This competition lowers the efficiency of
any one nuclei reaching the critical size of developability.

The two considerations of low and high reciprocity failure resulted in
fixing the values for parameters which were used in the computation of D
log E curves. These parameters will be derived in the next section.

DERIVATION OF PARAMETERS FROM EQUATIONS 2.2.1, 2.2.2, 2.2.3, and TABLE 2.2.1.

The rate equations that can be written for equation 2.2.3 are of the
following form:

$$-\frac{d[A]}{dt} = k(A,B)[A][B] \tag{2.2.4}$$

and

$$-\frac{d[C]}{dt} = k(C)[C] \tag{2.2.5}$$

where the brackets stand for the number of actors.

Example $[\,A\,]$ = the number of A's (2.2.6)

$[\,B\,]$ = the number of B's (2.2.7)

$[\,C\,]$ = the number of C's (2.2.8)

$k(A, B)$ = the rate constant for a combination A and B combining to form C

$$= \frac{\text{Probability of A and B combining to form C}}{\text{Unit Time}}$$

and $k\,(C)$ = the rate constant for C decomposing to form A and B

$$= \frac{\text{Probability of C decomposing to form A and B}}{\text{Unit Time}}$$

The rate constants $k(A,B)$ and $k(C)$ are called the parameters of the model. They can be changed to vary the response of the model. Previously we discussed how high and low intensity reciprocity failure fixed the parameter value $k(x)$, where $k(x)$ can represent any of the possible events.

The analysis of the model was simplified by the requirement that the parameters have values that allow the model to correlate closely with experimental data. This correlation implies that certain events must occur with a higher probability than do other events.

The simplified model contains the following assumptions:

Assumption(a) For values of n encountered in the analysis the parameter $k(\epsilon_f, Ag_n)$ for trapping of an electron at an aggregate of n silver atoms remains constant as n increases.

Assumption (b) The value of $k(\epsilon_t, Ag^+)\,[\epsilon_t]\,[Ag^+]$, which is the rate of capture of a mobile silver ion by a trapped electron after the trapping of an electron, is so large that the time involved can be neglected. This means that an n silver atom aggregate which traps an electron immediately forms an aggregate of n+1 silver atoms, written as Ag_{n+1}.

This sequence of reactions is as follows:

$$\epsilon_t \;+\; Ag^+ \xrightarrow{\;k(\epsilon_t, Ag^+)\;} Ag$$

(2.2.9)

$$Ag \quad + \quad \epsilon_f \quad \xrightarrow{\quad k(Ag, \epsilon_f) \quad} \quad Ag^-$$

$$(2.2.10)$$

$$Ag^- \quad + \quad Ag^+ \quad \xrightarrow{\quad k(Ag^-, Ag^+) \quad} \quad Ag_2$$

$$(2.2.11)$$

$$Ag_n \quad + \quad \epsilon_f \quad \xrightarrow{\quad k(Ag_n, \epsilon_f) \quad} \quad Ag_n^-$$

$$(2.2.12)$$

$$Ag_n^- \quad + \quad Ag^+ \quad \xrightarrow{\quad k(Ag_n^-, Ag^+) \quad} \quad Ag_{n+1}$$

$$(2.2.13)$$

Assumption (c) When a photon is absorbed, a free electron (cycling electron) and a trapped hole (recombination center) are formed almost immediately. Free holes are trapped almost immediately because of their sluggish movement.

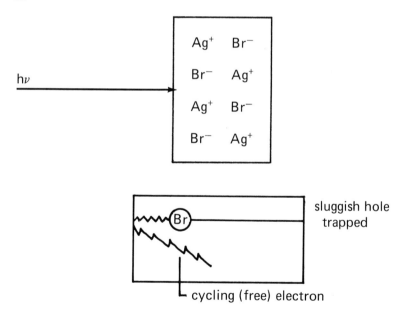

Fig. 2.2.2 *Shows the formation of a free electron and recombination center by lattice absorption of a photon.*

133

Assumption (d) The following events reach equilibrium very quickly.

Event (1) Trapping of an electron at a shallow trap may be written as

$$\epsilon_f \;+\; s_t \;\xrightarrow{\;k(\epsilon_f, s_t)\;}\; \epsilon_t$$

$$(2.2.14)$$

Event (2) Decomposition of an electron and a shallow trap is written as

$$\epsilon_t \;\xrightarrow{\;k(\epsilon_t)\;}\; \epsilon_f \;+\; s_t$$

$$(2.2.15)$$

Event (3) The site of a trapped electron which captures a silver ion to form a silver atom is written as

$$\epsilon_t \;+\; Ag^+ \;\xrightarrow{\;k(\epsilon_t, Ag^+)\;}\; Ag$$

$$(2.2.16)$$

Event (4) The reverse of equation 2.2.16 due to thermal decay is written as

$$Ag \;\xrightarrow{\;k(Ag)\;}\; Ag^+ \;+\; \epsilon_t$$

$$(2.2.17)$$

Utilizing assumptions a,b,c,d, we consider only the total number of electrons in the states where the electrons are free, trapped, and combined with mobile silver ions to form silver atoms. This is given as

$$N \;=\; [\epsilon_f] \;+\; [\epsilon_t] \;+\; [Ag]$$

$$(2.2.18)$$

Now we must calculate the probabilities that the electron is free,

$$P(\epsilon_f)$$

$$(2.2.19)$$

that the electron is trapped,

$$P (\epsilon_t)$$

(2.2.20)

and that the electron combines with a mobile silver ion to form a silver atom

$$P (Ag)$$

(2.2.21)

in terms of the rates,

$$k (\epsilon_t) \quad = \quad \text{rate of decomposition of trapped electrons to form a shallow trap and a free electron}$$

(2.2.22)

$$[s_t] \ k(\epsilon_t, s_t) \quad = \quad \text{rate that an electron is trapped per electron}$$

(2.2.23)

$$[Ag^+] \ k(\epsilon_t, Ag^+) \quad = \quad \text{rate that a trapped electron forms Ag per trapped electron}$$

(2.2.24)

$$k(Ag) \quad = \quad \text{rate that a silver atom decomposes to form a mobile silver ion plus a trapped electron per silver atom}$$

(2.2.24a)

SUMMARY OF EXPRESSIONS

Trapping of an electron at a shallow trap

$$\epsilon_f \quad + \quad s_t \quad \xrightarrow{\ k(\epsilon_f, s_t)\ } \quad \epsilon_t$$

(2.2.25)

Decomposition of an electron and a shallow trap

$$\epsilon_t \xrightarrow{\text{k}(\epsilon_t)} \epsilon_f + s_t$$

(2.2.26)

A trapped electron captures a silver ion to form a silver atom

$$\epsilon_t + Ag^+ \xrightarrow{\text{k}(\epsilon_t, Ag^+)} Ag$$

(2.2.27)

The thermal decay of silver is

$$Ag \xrightarrow{\text{k}(Ag)} Ag^+ + \epsilon_t$$

(2.2.28)

The probability that the electron is free

$$P(\epsilon_f)$$

(2.2.29)

The probability that the electron is trapped

$$P(\epsilon_t)$$

(2.2.30)

The probability that the electron combines with a mobile silver ion

$$P(Ag)$$

(2.2.31)

$$k(\epsilon_t) = \text{rate of decomposition of trapped electrons to form shallow trap and free electron per trapped electron}$$

(2.2.32)

$$[s_t] \; k(\epsilon_f, s_t) \;\; = \;\; \text{rate that an electron is trapped per free electron}$$

$$(2.2.33)$$

$$[Ag^+] \; k(\epsilon_t, Ag^+) \;\; = \;\; \text{rate that trapped electron forms silver atom/trapped electron}$$

$$(2.2.34)$$

$$k(Ag) \;\; = \;\; \text{rate at which silver atom decomposes per silver atom}$$

$$(2.2.35)$$

THE THREE-WAY CYCLE

According to assumption **d**, the electron is restricted to the three-way cycle of being trapped, freed from a trap, or combining with a silver ion while the electron is trapped.

We depict this three way cycle as follows:

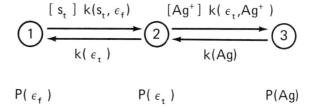

Fig. 2.2.3 *Shows three circles, where circle 1 represents the state where electrons are free with a probability of $P(\epsilon_f)$, circle 2 represents the state where electrons are* *trapped with a probability of $P(\epsilon_t)$, circle 3 represents the state where electrons combine with silver ions to produce silver atoms with a probability of $P(Ag)$.*

The arrows represent the processes taking place in each of their states with the rates per particle written above each arrow.

Equations 2.2.29 to 2.2.32 define these expressions.

The rate of change of the probability that an electron is free is seen to contain only two terms (see Figure 2.2.3) i.e., the positive term represented by the lower arrow $k(\epsilon_t)$ going from state 2 to state 1, and a negative term (going away from the desired state and therefore negative) represented by the upper arrow $[s_t] \; k \; (s_t, \epsilon_f)$ going from state 1 to state 2.

Each of these two processes must be weighted by the respective

reverse probabilities; therefore the differential equation for the rate of change of the probability that an electron will be free is written:

$$\frac{dP(\epsilon_f)}{dt} = P(\epsilon_t)\,k(\epsilon_t) - P(\epsilon_f)\,[\,s_t\,]\,k(s_t,\epsilon_f)$$

(2.2.36)

In the same way we can write the differential equation for the rate of change of the probability that an electron will be trapped.

$$\frac{dP(\epsilon_t)}{dt} = P(\epsilon_t)\,[\,s_t\,]\,k(s_t,\epsilon_f) + P(Ag)\,k(Ag)$$
$$- P(\epsilon_t)\,k(\epsilon_t) - P(\epsilon_t)\,[Ag^+]\,k(\epsilon_t,Ag^+)$$

(2.2.37)

The third equation for the rate of change of the probability that an electron will combine with a silver ion to produce a silver atom is written as

$$\frac{dP(Ag)}{dt} = P(\epsilon_t)\,[Ag^+]\,k(\epsilon_t,Ag^+) - P(Ag)\,k(Ag)$$

(2.2.38)

Since the electron is restricted to the three states as shown in figure 2.2.3, we may write

$$P(\epsilon_f) + P(\epsilon_t) + P(Ag) = 1$$

(2.2.39)

If we take the derivative of equation 2.2.39, we may write

$$\frac{dP(\epsilon_f)}{dt} + \frac{dP(\epsilon_t)}{dt} + \frac{dP(Ag)}{dt} = 0$$

(2.2.40)

Equation 2.2.40 serves as a check for equations 2.2.36, 2.2.37, 2.2.38 since the addition of these equations must produce zero. The reader may verify this check.

At equilibrium the rate of change of the probabilities is equal to zero and we may write:

$$P(\epsilon_t) \, k(\epsilon_t) \; - \; P(\epsilon_f) \, [\, s_t \,] \, k(s_t, \epsilon_f) \;\; = \;\; 0$$

(2.2.41)

$$P(\epsilon_f) \, [s_t] \, k(s_t, \epsilon_f) \; + \; P(Ag) \, k(Ag) \; - \; P(\epsilon_t) k(\epsilon_t)$$

$$- \; P(\epsilon_t) \, [Ag^+] \, k(\epsilon_t, Ag^+) \;\; = \;\; 0$$

(2.2.42)

$$P(\epsilon_t) \, [Ag^+] \, k(\epsilon_t, Ag^+) \; - \; P(Ag) \, k(Ag) \;\; = \;\; 0$$

(2.2.43)

Equations 2.2.41, 2.2.42, and 2.2.43 can be solved for each of the probabilities by the method of successive elimination with the help of equation 2.2.39.

First we rewrite equation 2.2.43 as

$$P(Ag) \;\; = \;\; \frac{P(\epsilon_t) \, k(\epsilon_t, Ag^+) \, [Ag^+]}{k(Ag)}$$

(2.2.44)

Substituting the right side of equation 2.2.44 for the P(Ag) factor in equation 2.2.42, we eliminate the P(Ag) term in equation 2.2.42 and the result is:

$$P(\epsilon_f) \, [s_t] \, k(s_t, \epsilon_f) \; + \; P(\epsilon_t) \, [Ag^+] \, k(\epsilon_t, Ag^+)$$

$$- \; P(\epsilon_t) \, k(\epsilon_t) \; - \; P(\epsilon_t) \, [Ag^+] \, k(\epsilon_t, Ag^+) \;\; = \;\; 0$$

(2.2.45)

Making the same substitution into equation 2.2.39 and rewriting the result as a function of $P(\epsilon_f)$ we find

$$P(\epsilon_f) = 1 - P(\epsilon_t) - \frac{P(\epsilon_t) [Ag^+] k(\epsilon_t, Ag^+)}{k(Ag)}$$

$$(2.2.46)$$

By substituting the right hand side of 2.2.46 back into equation 2.2.41 for the $P(\epsilon_f)$ factor, we write

$$\left\{ 1 - P(\epsilon_t) - \frac{P(\epsilon_t) [Ag^+] k(\epsilon_t, Ag^+)}{k(Ag)} \right\}$$

$$[s_t] k(s_t, \epsilon_f) - P(\epsilon_t) k(\epsilon_t) = 0$$

$$(2.2.47)$$

By dividing equation 2.2.47 by $[s_t] k(s_t, \epsilon_f)$ we can write

$$1 - P(\epsilon_t) - \frac{P(\epsilon_t) [Ag^+] k(\epsilon_t, Ag^+)}{k(Ag)}$$

$$- \frac{P(\epsilon_t) k(\epsilon_t)}{[s_t] k(s_t, \epsilon_f)} = 0$$

$$(2.2.48)$$

A further simplification results when the negative terms are transferred to the right hand side.

$$1 = P(\epsilon_t) + \frac{P(\epsilon_t) [Ag^+] k(\epsilon_t, Ag^+)}{k(Ag)}$$

$$+ \frac{P(\epsilon_t) k(\epsilon_t)}{[s_t] k(s_t, \epsilon_f)}$$

$$(2.2.49)$$

By factoring $P(\epsilon_t)$ from the right hand side of equation 2.2.49 and dividing the equation by the remaining factor, we find

$$P(\epsilon_t) = \cfrac{1}{1 + \cfrac{[Ag^+]\ k(\epsilon_t, Ag^+)}{k(Ag)} + \cfrac{k(\epsilon_t)}{[s_t]\ k(s_t, \epsilon_f)}}$$

(2.2.50)

Equation 2.2.50 expresses the probability of trapping an electron in terms of the parameters of the model.

Substituting the right hand side of 2.2.50 for the $P(\epsilon_t)$ term in the right hand side of equation 2.2.44, we can write

$$P(Ag) = \cfrac{\cfrac{[Ag^+]\ k(\epsilon_t, Ag^+)}{k(Ag)}}{1 + \cfrac{[Ag^+]\ k(\epsilon_t, Ag^+)}{k(Ag)} + \cfrac{k(\epsilon_t)}{[s_t]\ k(s_t, \epsilon_f)}}$$

(2.2.51)

Equation 2.2.51 expresses the probability of forming a silver atom in terms of the parameters of the model.

Using equation 2.2.39, we may write

$$P(\epsilon_f) = 1 - P(Ag) - P(\epsilon_t)$$

(2.2.52)

and

$$P(\epsilon_f) = 1 - \cfrac{1}{1 + \cfrac{[Ag^+]\ k(\epsilon_t, Ag^+)}{k(Ag)} + \cfrac{k(\epsilon_t)}{[s_t]\ k(s_t, \epsilon_f)}}$$

$$- \cfrac{\cfrac{[Ag^+]\ k(\epsilon_t, Ag^+)}{k(Ag)}}{1 + \cfrac{[Ag^+]\ k(\epsilon_t, Ag^+)}{k(Ag)} + \cfrac{k(\epsilon_t)}{[s_t]\ k(s_t, \epsilon_f)}}$$

(2.2.53)

$$P(\epsilon_f) = \frac{\cancel{1} + \dfrac{[Ag^+]\; k(\epsilon_t,\cancel{Ag^+})}{\cancel{k}(Ag)} + \dfrac{k(\epsilon_t)}{[s_t]\; k(s_t\epsilon_f)} - \cancel{1} - \dfrac{[Ag^+]\; k(\epsilon_t,\cancel{Ag^+})}{\cancel{k}(Ag)}}{1 + [Ag^+]\; \dfrac{k(\epsilon_t,Ag^+)}{k(Ag)} + \dfrac{k(\epsilon_t)}{[s_t]\; k(s_t,\epsilon_f)}}$$

(2.2.54)

Simplifying equation 2.2.54, we write

$$P(\epsilon_f) = \frac{\dfrac{k(\epsilon_t)}{[s_t]\; k(s_t,\epsilon_f)}}{1 + \dfrac{[Ag^+]\; k(\epsilon_t,Ag^+)}{k(Ag)} + \dfrac{k(\epsilon_t)}{[s_t]\; k(s_t,\epsilon_f)}}$$

(2.2.55)

Equation 2.2.55 expresses the probability of forming a free electron in terms of the parameters of the model.

Using the probabilities $P(\epsilon_f)$, $P(\epsilon_t)$, $P(Ag)$ previously derived, we may calculate the average number of free electrons as

$$[\epsilon_f] = P(\epsilon_f)\; N$$

(2.2.56)

the average number of trapped electrons as

$$[\epsilon_t] = P(\epsilon_t)\; N$$

(2.2.57)

and the average number of electrons that have combined with silver ions as

$$[Ag] = P(Ag)\; N$$

(2.2.58)

Assumptions a, b, c, and d are accompanied by a final assumption e.

Assumption (e)

1. $[s_t]$ $>$ $>$ $>$ 0 (2.2.59)

2. $[h]$ $>$ $>$ $>$ 0 (2.2.60)

3. $[Ag]$ $>$ $>$ $>$ 0 (2.2.61)

EXERCISE

1. What are the limitations of the three way cycle?
2. Utilizing Figure 2.2.3, write the expression for the rate of change of the probability that an electron will be free.
3. Verify equation 2.2.51.
4. The simplified model utilized the assumption that for values of n encountered in the analysis that the parameter $k(\epsilon_f, Ag_n)$ for the trapping of an electron at an aggregate of n silver atoms remains constant as n increases.
 a) How might this assumption affect the explanation of high intensity reciprocity failure?
 b) How might this assumption be verified by the use of arrested development techniques?
5. Discuss and carefully distinguish between high and low intensity reciprocity failure.

THE FLOW DIAGRAM FOR THE MODEL

The number of silver ions, hole traps and electron traps can be considered as constant since they are in large excess. The flow diagram in Figure 2.2.4 shows how the Hamilton and Bayer simplified latent image model results in the growth of silver atoms which form larger aggregates.

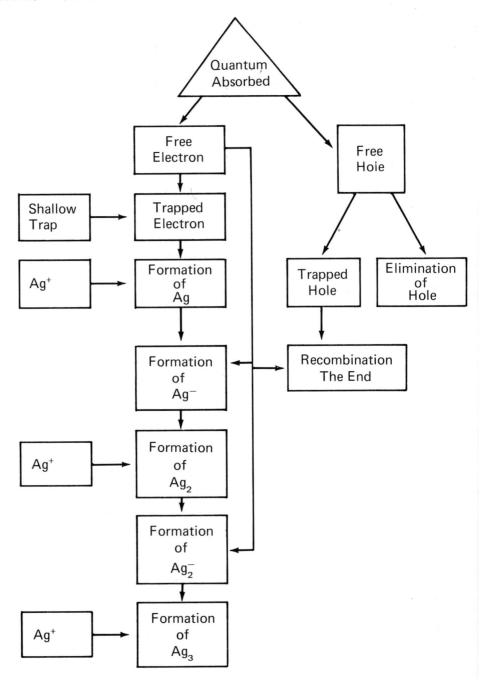

Fig. 2.2.4 *Flow diagram of the process that takes place after the absorption of a photon by a silver halide grain.*

Figure 2.2.4 shows the significant events that take place in this model.

In the left leg of Figure 2.2.4 the probabilities per unit time of the sequence of events are as follows:

a) Absorption of a photon by the silver halide grain is written as

$$k \, (h\nu, \, AgX)I$$

$$(2.2.62)$$

where $k(h\nu, AgX)$ is the rate constant for absorption and I is the intensity in units of the number of photons per grain per second.

b) The sequence of events leading up to the formation of Ag^- as depicted in Figure 2.2.4 is written as the nucleation probability per unit time.

$$[\, \epsilon_f \,] \, [Ag] \, k(\, \epsilon_f, Ag)$$

$$(2.2.63)$$

Remembering to reduce the number of electrons by one and using earlier relations 2.2.56 and 2.2.58, we may write 2.2.63 as:

$$P(\epsilon_f) \, NP(Ag) \, (N-1) \, k(\epsilon_f, \, Ag)$$

$$(2.2.64)$$

c) The probability per unit time for the growth of an n atom aggregate to an n+1 silver aggregate is written as:

$$[\, \epsilon_f \,] \, [Ag_n] \, k(\, \epsilon_f, Ag \,)$$

$$(2.2.65)$$

Using relation 2.2.56, we can rewrite 2.2.65 as

$$P(\, \epsilon_f \,) \, N \, [Ag_n] \, k(\, \epsilon_f, Ag \,)$$

$$(2.2.66)$$

d) Following the right leg of Figure 2.2.4 the probability per unit time of the first significant event, *recombination*, can be written as

$$[\, \epsilon_f \,] \, [h_t] \, k(\epsilon_f, h_t)$$

$$(2.2.67)$$

Using the earlier relations, we can rewrite equation 2.2.67 as

$$P(\,\epsilon_f\,)\ N\ [h_t]\ k(\,\epsilon_f, h_t)$$

(2.2.68)

e) The probability per unit time for elimination of a hole is written as

$$[h_t]\ k(h_t)$$

(2.2.69)

Examination of the preceding equations enables us to define constant factors as being the operational parameters of the model.

The operational parameters are

1. $P(Ag)$ (2.2.70)

2. $P(\epsilon_f)\ k(\epsilon_f, h_t)$ (2.2.71)

3. $P(\epsilon_f)\ k(\epsilon_f, Ag)$ (2.2.72)

4. $k\,(h_t)$ (2.2.73)

Before discussing these operational parameters with reference to the model, it is necessary to discuss the *Monte Carlo* method of calculation.

MONTE CARLO METHOD OF CALCULATIONS

Since the total number of states which must be considered for this model are very large, they cannot be treated by any closed system of equations; the Monte Carlo system was used by Hamilton and Bayer.

First it is necessary to consider one grain in a many grain system at a given time designated as t. The state of this grain at time t is given by the total number of actors (see Table 2.2.1) of all kinds contained by the grain. The next event which takes place in this grain is any of the significant events as shown in Figure 2.2.4 with probabilities of occurrence given by equations 2.2.62 thru 2.2.69.

The relevant equation can be evaluated when the state of the grain and the operational parameters are given some value.

Let X be the rate for **event m** or equivalently the probability per unit time for event m, where m is one of the possible next events which may take place in the grain for the fixed state of the grain.

The total rate X or the total probability per unit time for any event to take place in the grain can now be written as the following sum

$$X = X_{m_1} + X_{m_2} + X_{m_3} + \ldots \tag{2.2.74}$$

$$X = \sum_m X_m \tag{2.2.75}$$

where the state of the grain Cg is written as

$$C_g = F \left([\text{ actor}_1], [\text{ actor}_2], \ldots \right) \tag{2.2.76}$$

where equation 2.2.76 shows a state of the grain as a functional relationship with the number of actors of each type.

The probability of the next event m is written as

$$P(m) = \frac{X_m}{\sum_m X_m} \tag{2.2.77}$$

We calculate the waiting time t for the next event as follows:

The rate of change of the probability of an event taking place $dP(t)/dt$ must be proportional to X, the total probability for any event to take place in a grain. Also the rate of change of the probability must be zero when the probability is 1, and must be a maximum when the probability is zero.

With these considerations in mind, we may now write

$$\frac{d\,P(t)}{dt} = X(1 - P(t)) \tag{2.2.78}$$

By separation of variables, we rewrite equation 2.2.78 as

$$\frac{d\,P(t)}{1 \;-\; P(t)} \;=\; X\,dt$$

(2.2.79)

In order to calculate the probability that the next event will occur before time t, we must integrate 2.2.79 as follows:

$$\int_{0}^{P(t)} \frac{dP(t)}{1 - P(t)} \;=\; X \int_{0}^{t} dt$$

(2.2.80)

$$-\ln(1-P(t)\,)\;\Bigg|_{0}^{P(t)} \;=\; Xt$$

(2.2.81)

$$\ln(1 - P(t)) \;=\; -\,Xt$$

(2.2.82)

$$1 - P(t) \;=\; e^{-\,X\,t}$$

(2.2.83)

$$P(t) \;=\; 1 - e^{-\,X\,t}$$

(2.2.84)

We now use the previous results to define a routine for a digital computer to obtain a randomized sequence of events that approximates latent image formation in simple emulsion systems.

OUTLINE OF THE COMPUTER ROUTINE

A) Give the number and type of actors in an unexposed grain.
B) Consider the state of the grain at the point where this step is reached. As the routine is run again and again thru the computer, latent image formation proceeds and the state of the grain will be different each time, then make a calculation of X_m, the probability per unit time for each possible next event m. Then sum up each of the probabilities for possible next events so as to obtain X where

$$X = \sum_m X_m$$

(2.2.85)

C) Substitute the value of X obtained in Step B into the earlier derived equation (see 2.2.84)

$$P(t) = 1 - e^{-Xt}$$

(2.2.86)

and solve for **t**, by selecting a random number from 0 to 1 for P(t).

$$1 - P(t) = e^{-Xt}$$

$$\ln(1 - P(t)) = -Xt$$

$$t = \frac{-\ln(1 - P(t))}{X}$$

(2.2.86a)

The value of **t** obtained in this calculation is the *random time between two successive events*. The total of these random times is an exposure time.

D) Determine a new state by selecting at random one event X_m according to its relative probability X_m / X. The manner in which this is done in the computer is as follows:

A line of unit length is divided into segments of length corresponding to the magnitude of the relative probability of each event. By use of a random number table a random number between zero and one is chosen; the length of the line corresponding to this random number is then compared to the line composed of segments of length representing the magnitude of each relative probability. If the length of the line representing the random number falls into a segment representing a relative probability X_m / X, then m is chosen as the new event, which is then recorded for the resulting new state (see Figure 2.2.5).

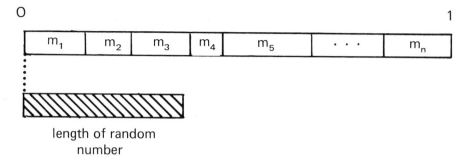

length of random
number

Fig. 2.2.5 *Shows the random number method of picking a new event.*

The relative probabilities of each event $P(m_i)$ are divided into line segments of length corresponding to the magnitude of the relative probability of each event. A random number is then chosen (between zero and one); the magnitude of the random number is then translated into a length. This length establishes the new event. (The figure shows the new event established is m_3.)

E) After the new state has been reached, steps B, C, and D are repeated to converge to a specified exposure time as calculated in step C.

F) After convergence to the specified exposure time, the parameter for photon absorption is set to zero, and steps B and D are repeated until no further changes take place among silver aggregates.

UNEXPOSED STATE Example Calculation

$$[Ag^+] = 10^{14}$$

$$[s_t] = 10^6$$

$$[h_t] \cong 0$$

$$[\epsilon_f] \cong 0$$

$$[Ag] \cong 0$$

$$[Ag_2] = 0$$

$$[Ag_3] = 0$$

$$[Ag_k] = 0$$

Total Number of Electrons \cong 0

(2.2.87)

After absorption of photons by the grain, the next significant events are nucleation, recombination, and hole removal.

EVENTS

1. Rate of
 Absorption $X_{h\nu,AgX}$ = $Ik(h\nu,AgX)$ = $\dfrac{100 \text{ photons}}{\text{grain sec.}}$

 (2.2.88)

2. Rate of
 Nucleation $X_{\epsilon_f,Ag}$ = $NP(\epsilon_f)P(Ag)(N-1)k(\epsilon_f, Ag)$

 (2.2.89)

3. Rate of
 Recombination X_{ϵ_f,h_t} = $NP(\epsilon_f)[h_t]k(\epsilon_f,h_t)$

 (2.2.90)

4. Rate of
 Hole Removal X_{h_t} = $[h_t]k(h_t)$

 (2.2.91)

Hamilton and Bayer used the following estimates for each of the operational parameters that were obtained by trial simulation for a sensitized emulsion.

$P(Ag)$ = 3.3×10^{-1} Probability of silver atom formation

(2.2.92)

$P(\epsilon_f)k(\epsilon_f,Ag)$ = $5.4 \times 10^2 \text{ sec}^{-1}$ Probability of nucleation / sec

(2.2.93)

$P(\epsilon_f)k(\epsilon_f,h_t)$ = $2 \times 10^1 \text{ sec}^{-1}$ Probability of recombination / sec

(2.2.94)

$k(h_t)$ = $5 \times 10^4 \text{ sec}^{-1}$ Probability of hole removal / sec

(2.2.95)

The total number of electrons that are either trapped, free or combined with silver atoms must now be established.

According to the model, whenever a photon is absorbed, it produces a free electron and a trapped hole.

For purposes of calculation we assume that 100 photons were absorbed, producing 100 electrons which are either free, trapped or combined with silver ions.

Using the value given for the operational parameter and since N=100, we write for nucleation

$$X_{\epsilon_{f,Ag}} = 100 \times 5.4 \times 10^2 \times 3.3 \times 10^{-1} \times 99$$

(2.2.96)

$$X_{\epsilon_{f,Ag}} = 1800 \times 10^3 = 1.8 \times 10^6 \ sec^{-1}$$

(2.2.97)

In a similar manner for recombination we write

$$X_{\epsilon_t,h_t} = 100 \times 100 \times 2 \times 10 \ sec^{-1}$$

(2.2.98)

In a similar manner for hole removal we write

$$X_{h_t} = 100 \times 5 \times 10^4 \ sec^{-1}$$

$$= 5 \times 10^6 \ sec^{-1}$$

(2.2.99)

Summing, we find that

$$X = 7.0 \times 10^6$$

(2.2.100)

Going to the next step in the calculation, we write (see Equation 2.2.85).

$$P(t) = 1 - e^{-7.0 \times 10^6 t}$$

(2.2.101)

$$e^{-7.0 \times 10^6 t} = 1 - P(t)$$

(2.2.102)

$$t = \frac{-\ln(1 - P(t))}{X}$$

$$(2.2.103)$$

$$t = (-7.0 \times 10^{-6}) \ln(1 - P(t))$$

$$(2.2.104)$$

$$t = \frac{-2.303 \log(1 - P(t))}{7.0 \times 10^6}$$

$$(2.2.105)$$

choosing a random number 0.9, we obtain:

$$t = \frac{-2.303 \log(1 - .9)}{7.0 \times 10^6} = .33 \times 10^{-6} \text{ sec}$$

$$(2.2.106)$$

This value of t represents the time before the next event. The computer then stores this value of t until the sum of all t's stored equals the pre-set exposure time. However, before the computer makes this comparison, the relative probabilities of the events are calculated.

Now we calculate the relative probabilities for each possible next event as chosen in step B.

Probability of Nucleation

$$\frac{X_{\epsilon f, Ag}}{X} = \frac{1.8 \times 10^6}{7.0 \times 10^6} = .26$$

$$(2.2.107)$$

Probability of Recombination

$$\frac{X_{\epsilon f, h_t}}{X} = \frac{.2 \times 10^6}{7.0 \times 10^6} = .028$$

$$(2.2.108)$$

Probability of Hole Removal

$$\frac{X_{h_t}}{X} = \frac{5 \times 10^6}{7.0 \times 10^6} = .71$$

(2.2.109)

The probability calculations show that hole removal for this model has the largest probability for being the next event with nucleation next and recombination an order of magnitude smaller than either of the other two events.

Placing these events on a line in the order .028, .26, .71, we can go on to pick a random number between 0 and 1 (see Figure 2.2.6).

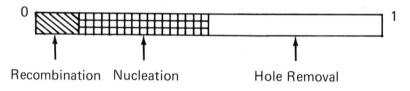

Recombination Nucleation Hole Removal

Fig. 2.2.6 *Shows how to place a random number between 0 and 1.*

The next random number chosen by the computer is .22. Thus the next event is nucleation.

It is necessary to determine the new state that occurs due to the event that took place.

New State of the Grain

The major changes in the new state of the grain are

$$[Ag^-] = 1, \text{without delay} \longrightarrow [Ag_2] = 1$$

$$N = 98$$

(2.2.109a)

It is not necessary to calculate the number of free electrons or trapped electrons or silver atoms, since these quantities can be found from the product of their respective probabilities and N.

The computer repeats steps B, C, and D for each new state until the sum of random times between successive events equals the pre-determined exposure time. The next step is to set the photon absorption parameter to

zero and continuously repeat steps B and D. The convergence criterion at this point for the continous repetition of B and D is the lack of change in the number and type of silver aggregates.

As the process described above is repeated again and again, a final state is reached where there are a number of different kinds of aggregates of silver, i.e., Ag_2, Ag_3, ..., Ag_k.

The number of aggregates above a critical size determines the number of developable centers in the grain.

This procedure yields the number of developable centers in a single grain. The number representing this final state is placed into the memory of the computer; the computer is then programmed to repeat the same procedure again until convergence is again reached. Another number is then stored representing the number of developable centers in another grain. The process is repeated until the number of grains examined is very large. The computer is then programmed to calculate the fraction of grains which have various numbers of development centers (see Figure 2.2.7).

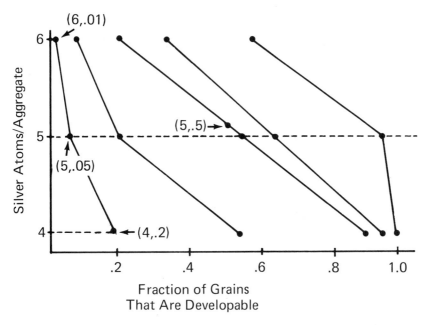

Fig. 2.2.7 Shows the fraction of grains that are develo- from 4 to 6 silver atoms per aggregate at
pable for different critical sizes ranging various high intensity exposures.

This procedure yields D log E curves where the density is proportional to the fraction of grains that are developable, and where log E is in terms of the number of absorbed photons per grain.

Hamilton and Bayer showed a D log E curve for an unsensitized emulsion at an intermediate exposure level and a 6-atom critical size criterion. This curve agreed very well with the experimental results of Spencer and Atwell. They also showed how reciprocity failure was a function of the number of silver atoms, 4, 5, and 6 atoms per aggregate for a sensitized emulsion (sulfur sensitized) The shape of these curves agreed well with experimental results of Spencer and Atwell [Ref: H. E. Spencer and R. E. Atwell, *J. Opt. Soc. Am.*, 54, 498 (1964)].

Before proceeding further we must digress at this point and consider some elementary probability theory that will be useful in the succeeding sections.

In any experiment with a constant probability of sucess p in a single trial and failure q in a single trial, where $p + q = 1$, the probability of obtaining k sucessful events in n trials is

$$P(k) = \frac{n!}{k!(n-k)!} \, p^k q^{n-k}$$

$$= \frac{n!}{k!(n-k)!} \, p^k (1-p)^{n-k}$$

$$(2.2.110)$$

The term on the right hand side of equation 2.2.110 is the k^{th} term of the binomial expansion of $(p + q)^n$. . . and we may write

$$(p+q)^n = \sum_{k=0}^{n} \frac{n!}{k!(n-k)!} \, p^k q^{n-k}$$

$$(2.2.111)$$

Since the sum of $(p + q)^n$ is equal to 1, we can write

$$\sum_{k=0}^{n} \frac{n!}{k!(n-k)!} \, p^k q^{n-k} = 1$$

$$(2.2.112)$$

Equation 2.2.112 verifies the fact that the sum of the probabilities is equal to 1.

$$\sum_{k=0}^{n} P(k) = 1$$

(2.2.113)

Equation 2.2.110 is called the binomial density function, and the distribution determined from this density function is called the binomial distribution.

Derivation of the Poisson Density Function
Expression 2.2.110 may be written as:

$$P(k) = \frac{n!}{k!(n-k)} \left(\frac{\lambda}{n}\right)^k \left(1 - \frac{\lambda}{n}\right)^{n-k}$$

(2.2.114)

where

$$\lambda = np$$

(2.2.115)

Recalling that

$$n! = n(n-1)\,(n-2)\,(n-3) \cdots (n-k+1)\,(n-k)\,(n-k-1) \cdots (1)$$

(2.2.116)

and that

$$(n-k)! = (n-k)\,(n-k-1)\,(n-k-2) \cdots 1$$

(2.2.117)

we may write

$$\frac{n!}{(n-k)!} = \frac{n(n-1)\,(n-2) \cdots (n-k+1)\,(n-k)\,(n-k-1) \cdots 1}{(n-k)\,(n-k-1)\,(n-k-2) \cdots 1}$$

(2.2.118)

$$\frac{n!}{(n-k)!} = n(n-1)(n-2) \cdots (n-k+1)$$

$$(2.2.119)$$

From (eq. 2.2.119), if we assume that

$$k = 1, \text{ 1 factor, } n$$

$$k = 2, \text{ 2 factors, } n(n-1)$$

$$k = 3, \text{ 3 factors, } n(n-1)(n-2)$$

$$k = 4, \text{ 4 factors, } n(n-1)(n-2)(n-3)$$

$$k = k, \text{ k factors, } n(n-1)(n-2) \cdots (n-k+1)$$

$$(2.2.120)$$

Substituting 2.2.118 into 2.2.110, we write

$$P(k) = \frac{n(n-1)(n-2) \cdots (n-k+1)}{k!} \frac{\lambda^k}{n^k} \left(1-\frac{\lambda}{n}\right)^{n-k}$$

$$(2.2.121)$$

Reversing the two terms in the denominator, we write

$$P(k) = \frac{n(n-1)(n-2) \cdots (n-k+1)}{n^k} \frac{\lambda^k}{k!} \left(1-\frac{\lambda}{n}\right)^{n-k}$$

$$(2.2.122)$$

$$= \frac{n(n-1)(n-2) \cdots (n-k+1)}{n \quad n \quad n \cdots \quad n} \frac{\lambda^k}{k!} \left(1-\frac{\lambda}{n}\right)^{n-k}$$

$$(2.2.123)$$

We can now write

$$P(k) = \left(1-\frac{1}{n}\right)\left(1-\frac{2}{n}\right) \cdots \left(1-\frac{k-1}{n}\right) \frac{\lambda^k}{k!} \left(1-\frac{\lambda}{n}\right)^{n-k}$$

$$(2.2.124)$$

$$p(k) \; = \; (1-\frac{1}{n})\,(1-\frac{2}{n}) \; \cdots \; (1-\frac{k-1}{n}) \; \frac{\lambda^k}{k!} \; (1-\frac{\lambda}{n})^n \, (1-\frac{\lambda}{n})^{-k}$$

$$(2.2.125)$$

Let us assume that λ is a constant independent of n where

$$0 < \lambda = np$$

$$(2.2.126)$$

Applying the limit as n goes to infinity we write

$$\lim_{n \to \infty} \left\{ (1-\frac{1}{n})\,(1-\frac{2}{n}) \; \cdots \; \left(1-\frac{k-1}{n}\right) \frac{\lambda^k}{k!} \; (1-\frac{\lambda}{n})^n \, (1-\frac{\lambda}{n})^{-k} \right\}$$

$$= \; 1 \; \frac{\lambda^k}{k!} \qquad \lim_{n \to \infty} \; (1-\frac{\lambda}{n})^n \qquad 1$$

$$(2.2.127)$$

We must now find the value of

$$\lim_{n \to \infty} \; (1-\frac{\lambda}{n})^n$$

$$(2.2.128)$$

The binomial expansion of $(1 - \lambda/n)^n$ yields

$$1 \; - \; \frac{n!}{(n-1)!} \; \frac{\lambda}{n} \; + \; \frac{n!}{2!(n-2)!} \; \frac{\lambda^2}{n^2} \; - \; \frac{n!}{3!(n-3)!} \; \frac{\lambda^3}{n^3}$$

$$+ \; \vdots \; \cdots \; (-1)^k \; \frac{n!}{k!(n-k)!} \; \frac{\lambda^k}{n^k} \; \cdots \; (-1)^n \; \frac{\lambda^n}{n^n}$$

$$(2.2.129)$$

Summing up, we can write equation 2.2.129 as

$$\left(1-\frac{\lambda}{n}\right)^n = \sum_{k=0}^{n} \frac{(-1)^k \, n!}{k!(n-k)!} \frac{\lambda^k}{n^k}$$

(2.2.130)

Examining the k^{th} term of this expansion

$$(-1)^k \quad \frac{n!}{k!(n-k)!} \quad \frac{\lambda^k}{n^k}$$

(2.2.131)

We see that two of the terms in equation 2.2.131 are similar to two of the terms in equation 2.2.114. Performing a similar analysis, we can write 2.2.131 as

$$(-1)^k \quad \frac{n(n-1)\,(n-2)\,\cdots\,(n-k+1)}{n \quad n \quad n \quad \cdots \quad n} \quad \frac{\lambda^k}{k!}$$

(2.2.132)

Equation 2.2.132 can be reduced to

$$\left(-1^k \left(1-\frac{1}{n}\right)\left(1-\frac{2}{n}\right)\cdots\left(1-\frac{k-1}{n}\right) \frac{\lambda^k}{k!}\right.$$

(2.2.133)

Substituting equation 2.2.133 into 2.2.130, we have

$$\left(1-\frac{\lambda}{n}\right)^n = \sum_{k=0}^{n} (-1)^k \left(1-\frac{1}{n}\right)\left(1-\frac{2}{n}\right)\cdots\left(1-\frac{k-1}{n}\right)\frac{\lambda^k}{k!}$$

(2.2.134)

Applying the limit, we write

$$\lim_{n\to\infty} \left(1-\frac{\lambda}{n}\right)^n = \lim_{n\to\infty} \sum_{k=0}^{n} (-1)^k \left(1-\frac{1}{n}\right)\left(1-\frac{2}{n}\right)\cdots\left(1-\frac{k-1}{n}\right)\frac{\lambda^k}{k!}$$

$$(2.2.135)$$

Since the limit of the sum is equal to the sum of the limits, we can write

$$\lim_{n\to\infty} \left(1-\frac{\lambda}{n}\right)^n = \sum_{k=0}^{\infty} (-1)^k \cdot 1 \cdot 1 \cdots \frac{\lambda^k}{k!}$$

$$= \sum_{k=0}^{\infty} (-1)^k \frac{\lambda^k}{k!}$$

$$(2.2.136)$$

A Taylor's expansion of $e^{-\lambda}$ around the point $\lambda=0$ is

$$e^{-\lambda} = \sum_{k=0}^{\infty} (-1)^k \frac{\lambda^k}{k!}$$

$$(2.2.137)$$

If we compare equation 2.136 with equation 2.137, we may write

$$\lim_{n\to\infty} \left(1-\frac{\lambda}{n}\right)^n = e^{-\lambda}$$

$$(2.2.138)$$

By substitution of equation 2.2.138 into equation 2.2.127, we write

$$\lim_{n\to\infty} \left\{\left(1-\frac{1}{n}\right)\left(1-\frac{2}{n}\right)\cdots\left(1-\frac{k-1}{n}\right)\frac{\lambda^k}{k!}\left(1-\frac{\lambda}{n}\right)^n\left(1-\frac{\lambda}{n}\right)^{-k}\right\} = \frac{\lambda^k}{k!}e^{-\lambda}$$

$$(2.2.139)$$

The expression on the right hand side of equation 2.2.139 is called the Poisson density function $(P_{Poi}(k))$.

The Poisson density function is defined as the probability of k successes in an unlimited number of trials where λ is often interpreted as the average number of successes in an unlimited number of trials. One of the requirements for a function to be a probability density function is that when summed over all possible probabilities the sum be equal to 1. Thus for the Poisson probability density function we write

$$\sum_{k=0}^{\infty} \frac{\lambda^k}{k!} \; e^{-\lambda} \; = \; 1$$

(2.2.140)

The average value or equivalently the mathematical expectation for any function or variable associated with a probability is equal to

$$\sum_{k=0}^{n} k \; P(k) \; = \; \begin{array}{l} \text{average number} \\ \text{of successes in} \\ \text{n trials} \end{array}$$

(2.2.141)

Where $P(k)$ = the probability of k successes in n trials.

We now calculate the average value of n successes in k trials for the binomial probability density function and write

$$\sum_{k=0}^{n} k \; \frac{n!}{k!(n-e)!} \; p^k \; q^{n-k} \; = \; \begin{array}{l} \text{average number} \\ \text{of successes in} \\ \text{n trials for the} \\ \text{Binomial Probability} \\ \text{density function} \end{array}$$

(2.2.142)

In order to calculate the average value we must multiply p by e^t in equation 2.2.111. The result is

$$\underbrace{(pe^t \; + \; q)^n}_{\text{Given}} \; = \; \sum_{k=0}^{n} \frac{n!}{k!(n-k)!} \; \underbrace{(pe^t)^k \; q^{n-k}}_{\text{Binomial Expansion}}$$

(2.2.143)

Rearranging terms in the right hand side of equation 2.2.143

$$(pe^t + q)^n = \sum_{k=0}^{n} e^{tk} \left(\frac{n!}{k!(n-k)!} \ p^k \ q^{n-k} \right)$$

(2.2.144)

Taking the derivative with respect to t, we write

$$n(pe^t + q)^{n-1} pe^t = \sum_{k=0}^{n} ke^{tk} \left(\frac{n!}{k!(n-k)!} \right) p^k \ q^{n-k}$$

(2.2.145)

let t = 0, and we can write

$$np(p + q)^{n-1} = \sum_{k=0}^{n} ke^{tk} \left(\frac{n!}{k!(n-k)!} \right) p^k \ q^{n-k}$$

(2.2.146)

Since $p + q = 1$, the average number of successes in n trials is np and we write

$$np = \sum_{k=0}^{n} k \ \frac{n!}{k!(n-k)!} \ p^k \ q^{n-k}$$

(2.2.147)

In a similar manner the average number of failures in n trials is given by nq. Hint: expand $(p + e^t q)^n$

The average number of failures before success is given by the ratio of the average number of failures to the average number of successes.

$$\frac{np}{nq} = \frac{1-p}{p}$$

(2.2.148)

The calculation for the average number of successes in an unlimited number of trials according to the Poisson distribution proceeds as follows. Form the following sum

$$\sum_{k=0}^{\infty} \frac{(\lambda e^t)^k}{k!} \; e^{-\lambda} \;=\; e^{-\lambda} \sum_{k=0}^{\infty} e^{tk} \frac{\lambda^k}{k!}$$

$$(2.2.149)$$

The summation factor in the right hand side of equation 2.2.149 is a Taylor's expansion of $e^{\lambda e^t}$ and

$$\sum_{k=0}^{\infty} e^{tk} \frac{\lambda^k}{k!} \; e^{-\lambda} \;=\; e^{-\lambda} \, e^{\lambda e^t}$$

$$(2.2.150)$$

Taking the derivative with respect to t of equation 2.2.150, we write

$$\sum_{k=0}^{\infty} k e^{tk} \frac{\lambda^k}{k!} \; e^{-\lambda} \;=\; \lambda e^t e^{-\lambda} \, e^{\lambda e^t}$$

$$(2.2.151)$$

Let t=0 in 2.2.151 and we write

$$\sum_{k=0}^{\infty} k \, \frac{\lambda^k}{k!} \; e^{-\lambda} \;=\; \lambda$$

$$(2.2.152)$$

The left hand side of equation 2.2.152 is equal to the average number of successes in an unlimited number of trials; thus the average for the Poisson distribution is λ.

The Poisson distribution has been applied to many chemical and physical problems. In the application of the Poisson distribution, λ is first calculated by finding the average number of successful events in n trials of the experiment even when n does not represent an infinite number of trials. The probability of having k successes in n trials is then readily calculated from the Poisson probability density function.

$$P(k) = \frac{\lambda^k}{k!} e^{-\lambda}$$

(2.2.153)

Example of the use of the Poisson Distribution
Let λ be the average number of quanta that a silver halide grain absorbs for a given exposure. λ is proportional to the exposure and we write

$$\lambda = B_i E$$

(2.2.154)

Where B_i is the proportionality constant of absorption for grains of class size i, the value of k represents the minimum number of quanta absorbed such that a grain of class size i is rendered developable.

Therefore the probability that a grain of class size i will absorb k quanta at an exposure E is written as

$$P(k, B_i, E) = \frac{(B_i E)^k}{k!} e^{-B_i E}$$

(2.2.155)

On the other hand, later sections will show why the Poisson distribution cannot be used for all types of emulsions. In cases where the Poisson distribution is not suitable we must use the Binomial distribution.

For the Binomial probability density function we define the following terms:

P = probability that a grain will absorb a photon which impinges upon it

A_i = projected area of a grain of class size i

$$E \quad = \text{ exposure in photons/cm}^2$$

$$n \quad = A_i E \quad = \text{ the number of photons that impinge upon a grain of class size i}$$

$$\lambda \quad = np \quad = A_i EP \quad = \text{ the average number of photons that are absorbed by a grain of class size i for a given exposure E.}$$

$$k \quad = \text{ the minimum number of absorbed photons which renders a grain of class size i developable.}$$

Substituting these defined quantities into the Binomial probability density function, we write

$$P(A_i, E, k, \lambda) \quad = \quad \frac{(A_i E)!}{k!(A_i E - k)!} \left(\frac{\lambda}{A_i E}\right)^k \left(1 - \frac{\lambda}{A_i E}\right)^{A_i E - k}$$

$$(2.2.156)$$

The probability that a grain of class size i, at a given exposure, will absorb k photons and be rendered developable is given by equation 2.2.156.

ESTIMATING THE NUMBER OF QUANTA REQUIRED FOR RENDERING A GRAIN DEVELOPABLE

In this determination the assumption is made that only two significant events are important in each process, as shown in Figure 2.2.4.

These two events are characterized by a success event or a failure event.

The success event brings the grain to a new state leading to the formation of a developable center. The failure event leads to a state where the photo electron cannot participate in the formation of a development center.

The preceding section shows that for any experiment having a constant probability of success or failure the ratio of the probability of failure to the probability of success yields the average number of failures before a success.

The significant stages for a grain to form a latent image are (1) the accumulating two electron stage, (2) the nucleation stage, and (3) the growth stage.

STAGE 1

Before a thermally stable nucleus can be formed, we must accumu-

late two free electrons in the grain. The success events in this stage are (a) photon absorption and (b) hole removal. The failure event in this stage is recombination (see Figure 2.2.4).

Earlier the probability per unit time for photon absorption was given as

$$X_{h\nu,AgX} = I k (h\nu, AgX) X_{h_t}$$

(2.2.157)

and the probability per unit time for hole removal was given as

$$X_{h_t} = [h_t] k(h_t)$$

(2.2.158)

while the probability per unit time for recombination was given as

$$X_{\epsilon_f' h_t} = N P(\epsilon_f) [h_t] k(\epsilon_f, h_t)$$

(2.2.159)

The appropriate ratios for determining the average number of failures before a success are written as

$$\frac{\text{Failure due to Recombination}}{\text{Successful photon absorption}} = \frac{NP(\epsilon_f) [h_t] k(\epsilon_f, h_t)}{Ik(h\nu, AgX)}$$

(2.2.160)

$$\frac{\text{Failure due to Recombination}}{\text{Successful Hole Removal}} = \frac{NP(\epsilon_f) [h_t] k(\epsilon_f, h_t)}{[h_t] k(h_t)}$$

(2.2.161)

It is convenient to write equations 2.2.160 and 2.2.161 in the following form.

$$N [h_t] \left(\frac{P(\epsilon_f) k(\epsilon_f, h_t)}{Ik(h\nu, AgX)} \right)$$

(2.2.162)

$$N \left(\frac{P(\epsilon_f) \ [h_t] \ k(\epsilon_f, h_t)}{[h_t] \ k(h_t)} \right)$$

$$(2.2.163)$$

The factors within the parentheses depend upon the values of the operational parameters (see equation 2.2.70 to 2.2.73) and the exposure. The factors outside the parentheses depend upon the state of the grain.

If N and $[h_t]$ are equal to 1, expression 2.2.162 becomes

$$\frac{P(\epsilon_f) \ k(\epsilon_f, h_t)}{Ik(h\nu, AgX)}$$

$$(2.2.164)$$

The expression within the parentheses expresses the average number of electrons that are lost by recombination before two free electrons are accumulated (when the grain contains one free electron and one hole).

When the intensity as given by the denominator in expression 2.2.164 is high when compared to the recombination probability in the numerator, this inefficiency can be neglected. However, as the intensity decreases, the inefficiency increases without limit. At extremely low intensities this inefficiency is the major contribution to the change of slope in the reciprocity curve (see Figure 2.2.8).

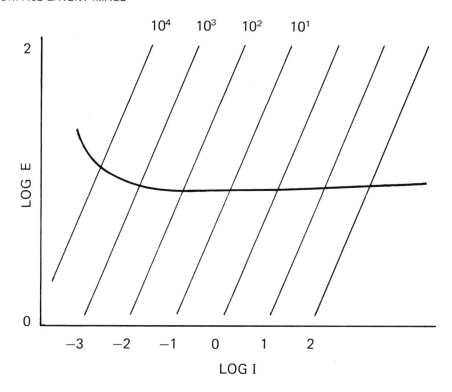

Fig. 2.2.8 *Shows low intensity reciprocity failure*
resulting from the inefficiency in
Accumulating Two Electrons.

Other similar analyses of reciprocity failure have been accomplished by a
number of other authors [Ref: E. Katz, *J. Chem. Phys.* **17**, 1132 (1949);
J. H. Webb, *J. Opt. Soc. Am.* **40**, 3, 197 (1950); P. V. Meiklyar, *Zh.
Nauchn. i Prikl. Fotogr. i Kinematogr* 4, 62 (1959)].

On the other hand, when the intensity is sufficiently low then
expression 2.2.163 gives the inefficiency in achieving the two electron
state. Expression 2.2.163 is the ratio of the probability of recombination
to the probability of hole removal and is independent of intensity. The
expressions 2.2.162 and 2.2.163 represent the two alternate routes for
accumulating two electrons in stage 1. Expressions 2.2.162 and 2.2.163
both have $P(\epsilon_f)k(\epsilon_f,h_t)$ in the numerator; thus this quantity determines
the horizontal placement of the reciprocity failure curve at low intensities.
This point of the horizontal placement on the reciprocity failure curve
actually occurs at the optimum intensity (see Figure 2.2.9).

NUCLEATION AND GROWTH

In a similar manner we may write the expressions for nucleation and growth

$$\frac{\text{Failure due to Recombination}}{\text{Successful Nucleation}} = \frac{\text{Equation 2.2.159}}{\text{Equation 2.2.89}}$$

$$= \frac{NP(\epsilon_f)\,[h_t]\,k(\epsilon_f,h_t)}{NP(\epsilon_f)P(Ag)\,(N-1)k(\epsilon_f,Ag)}$$

$$= \frac{[h_t]}{(N-1)} \left(\frac{k(\epsilon_f,h_t)}{P(Ag)k(\epsilon_f,Ag)}\right)$$

$$(2.2.165)$$

Equation 2.2.165 represents the inefficiency of nucleation. The expression inside the parentheses depends on the values of the operational parameters, while the expression outside the parentheses depends on the state of the grain.

Growth can be hindered by recombination and competing nucleation. The expression for the inefficiency of growth due to recombination is written as

$$\frac{\text{Failure due to recombination}}{\text{Successful Growth}} = \frac{\text{Equation 2.2.159}}{\text{Equation 2.2.66}}$$

$$= \frac{NP(\epsilon_f)\,[h_t]\,k(\epsilon_f,h_t)}{P(\epsilon_f)\,N\,[Ag_n]\,k(\epsilon_f,Ag)}$$

$$= \frac{[h_t]}{[Ag_n]} \left\{\frac{k(\epsilon_f,h_t)}{k(\epsilon_f,Ag)}\,\frac{P(\epsilon_f)}{P(\epsilon_f)}\right\}$$

$$(2.2.166)$$

Let $[Ag_n]$ = number of nuclei which have formed = JAg. Substituting for $[Ag_n]$ we write.

$$\frac{[h_t]}{JAg} \begin{pmatrix} k(\epsilon_f, h_t) & P(\epsilon_f) \\ k(\epsilon_f, Ag) & P(\epsilon_f) \end{pmatrix}$$

(2.2.167)

The expression for inefficiency in growth due to nucleation is written as

$$\frac{\text{Failure due to competing nucleation}}{\text{Successful growth}}$$

$$= \frac{P(\epsilon_f)\, N\, P(Ag)\, (N-1)\, k(Ag,\epsilon_f)}{JAg \quad k(\epsilon_f, Ag)P(\epsilon_f)} \qquad = \frac{N-1}{JAg} N\left(P(Ag)\right)$$

(2.2.168)

Expression 2.2.166 can be neglected for the range of parameter values ascribed by Bayer and Hamilton in their model. In the growth stage, inefficiency is due to competitive nucleation events so that equation 2.2.168 gives an estimate of this type of inefficiency. The average number of additional nuclei formed for each atom added to a nucleus is also given by 2.2.168.

Since all nuclei may grow to critical size of developability, a more precise calculation can be used to account for this phenomenon. This calculation would determine the average number of atoms formed before one nucleus reaches critical size of developability. However, equation 2.2.168 can be used as a fair estimate to determine whether high intensity reciprocity failure is present.

Consider for example a grain having absorbed 40 photons and having formed one stable nucleus. In this example the state of the grain is given by

$$N = 38$$

(2.2.169)

and

$$JAg = 1$$

$$(2.2.170)$$

Therefore, substituting these values into equation 2.2.168, the efficiency of growth is written as

$$\frac{38 \times 37 \, P(Ag)}{1}$$

$$(2.2.171)$$

This means that there are 1406 P(Ag) failure nucleation events for every successful growth event. It should be noted that the value of the operational parameter P(Ag) determines the magnitude of high intensity reciprocity failure.

Given an experimentally determined high intensity reciprocity failure curve, the limiting point on the high intensity end can be used to set the theoretical starting point for P(Ag). From a theoretical standpoint the value of P(Ag) determines the magnitude of high intensity reciprocity failure.

When

$$X_{h\nu, AgX} > P(\epsilon_f) \, k(\epsilon_f, Ag)$$

$$(2.2.172)$$

then the formation of multiple nucleation sites becomes significant and the rate of electron trapping due to growth is less than the rate of photon absorption.

The value of $P(\epsilon_f)k(\epsilon_f, Ag)$ is fixed by the condition that the positioning of the reciprocity curve in the horizontal position for the model matches the actual emulsion with respect to high intensity reciprocity failure.

For a sensitized emulsion, Bayer and Hamilton found that a value of 5.4×10^2 for $P(\epsilon_f) \, k \, (\epsilon_f, Ag)$ gave the best fit.

THE EFFECTS OF SULFUR SENSITIZATION IN THIS MODEL

During the nucleation stage, the major consequence of sulfur sensitization is the reduction of recombination events if moderate intensities are used. Bayer and Hamilton stated that the sensitized emulsion relative to

the unsensitized required approximately ¼ the number of quanta per grain for a given probability of development.

Sensitization can be defined quantitatively by the value of the ratio of the failure due to recombination to that of successful nucleation (also see Section 2.3).

This ratio is given by equation 2.2.165.

An approximation for equation 2.2.165 can be written as

$$\frac{1}{P(Ag)} \left(\frac{P(\epsilon_f) \, k(\epsilon_f, h_t)}{P(\epsilon_f) \, k(\epsilon_f, Ag)} \right)$$

$$(2.2.173)$$

This approximation results from the fact that at moderate intensities recombination is less likely than photon absorption until two or more free electrons accumulate.

Thus $[h_t] \approx N-1$ at moderate intensities and expression 2.2.173 results.

The optimum intensity can be characterized as the least intensity on the horizontal portion of the reciprocity failure curve (see Figure 2.2.9).

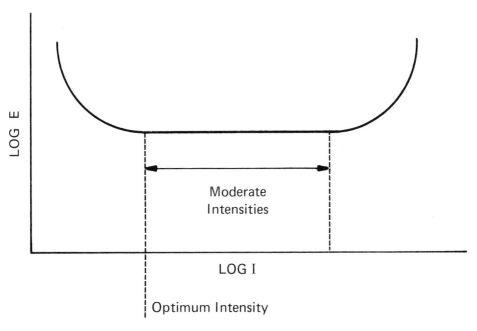

Fig. 2.2.9 *Shows the range of moderate intensities and locates the optimum intensity on the reciprocity failure curve.*

At optimum intensity the ratio 2.173 gives the overall sensitivity.

SUMMARY: ON THE SIMPLIFICATIONS IN THE BAYER AND HAMILTON MODEL

That a grain is rendered developable if it contains one development center cannot be easily determined experimentally.

If a physical developer is used for arresting development to determine the number of developable centers, there is an associated speed loss and not as many development centers will be revealed as with a chemical developer.

If a chemical developer or combination of physical development followed by short chemical development period is utilized, there is a degree of uncertainty with respect to the number of development centers revealed due to the autocatalytic nature of the chemical development.

Therefore it is very difficult to experimentally arrest development and find the number of development centers which correspond to a latent image.

The manner in which Hamilton and Bayer used the techniques of arrested development to justify their theory was within the limitations of the technique. For example, sulfur sensitized emulsions show many development centers per grain whereas unsensitized emulsions show 1 or very few in number per grain. Similarly, low intensity reciprocity failure shows 1 development center per grain for 90% grains developed whereas high intensity reciprocity failure showed 7 or 8 development centers for 90% of grains developed. (Ref: Private Communication - J.F. Hamilton (1969).)

Arrested development techniques are valid for estimating the order of magnitude difference between two extreme states. Low and high intensity reciprocity failure states are determinable by the methods of arrested development. However, the worker should realize that arrested development techniques are limited and should not be used beyond their scope.

The work of Bayer and Hamilton represents a definite advance in conceptualizing latent image formation, reciprocity law failure, and the D log E curve, and should be considered fundamental to any future advances and study in this field.

PROBLEM SET 2.2

1. According to the Hamilton and Bayer model for latent image formation explain:
 a) low intensity reciprocity failure.
 b) high intensity reciprocity failure.
2. Distinguish between and discuss nucleation and growth.
3. Outline the events that may occur when a grain absorbs a photon.
4. Discuss equations 2.2.9 through 2.2.13.
5. Utilizing Figure 2.2.3 verify equations 2.2.36, 2.2.37 and 2.2.38.
6. Derive the probability of forming a silver atom in terms of the parameters of the model.
7. What procedure yields the fraction of grains which have various number of development centers per grain?
8. Construct a plot describing the inefficiency in accumulating two electrons.
9. Reconstruct Figure 2.2.4 using the Trautweiler model. (Chapter 1 Section 3.)
 a) What is the primary difference between the two approaches to latent image formation?
10. Why is it more likely that the early growth stage proceeds according to the Trautweiler model?
 a) At what point in aggregate growth does the negative ion species become stable enough to enter into significant latent image formation?
11. Explain how chemical sensitization (sulfur, gold, etc.) decreases the inefficiency of nucleation.
12. Although there is a degree of uncertainty associated with the number of development centers revealed by arrested development techniques, explain why this technique can be used as an effective experimental technique for distinguishing between high and low reciprocity failure.
13. If a complex emulsion were to be treated by the method of Hamilton and Bayer, what other assumptions would you add?

2.3 Internal Latent Image

In a manner similar to the latent image model developed in the previous section we can include the *internal latent image* [Ref: J.H. Hamilton and B. E. Bayer, *J. Opt. Soc. Am.*, **56**, 1088 (1966)] by the following method.

The inclusion of internal latent image requires that we extend the three-way cycle shown in Figure 2.2.3 (Section 2), to a five-way cycle. The five-way cycle includes two extra states for describing the internal trapping of an electron and the internal formation of silver as shown in Figure 2.3.1.

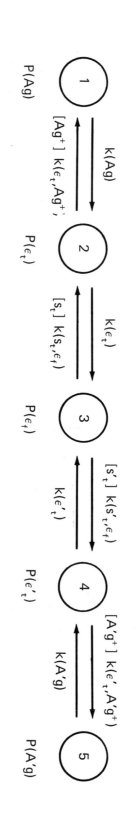

Fig. 2.3.1 Shows the five way electron cycle where the primed terms refer to internal states.

Before considering the mathematical derivation of the various probabilities analogous to equation 2.2.47, 2.2.48 and 2.2.52 (Section 2), we must discuss the meaning of the terms *surface* and *internal latent image*.

OPERATIONAL DEFINITIONS

According to James [Ref: T.H. James, *Phot. Sci. Eng.*, 7, 304 (1963)]

"Although the terms "surface and "internal" latent image carry the connotation of physical location, namely, of latent-image centers on and within the silver halide grain, the practical application of the concepts depends on a definition of experimental conditions. "Surface latent image," as usually determined in practice, is actually that latent image which is developable by a "surface" developer, i.e., a developer having no solvent for silver halide other than water and having no "cracking" or recrystallization—promoting action on the grain. "Internal latent image" is that latent image which is not developable by, and is presumably inaccessible to, a surface developer, but which can be developed if a suitable solvent for silver halide is present in the developer or if an agent such as iodide which tends to crack the grain or promote recrystallization is present.

"Development of the internal image is carried out usually in an active developer, such as a Metol-hydroquinone or Metol-ascorbic acid developer, to which thiosulfate has been added as silver halide solvent, [Ref: G.W.W. Stevens, *Phot. J.*, 82: 42 (1942); T.H. James, W. Vanselow, and R.F. Quirk, *Phot. Sci. Tech.*, 19B, 170 (1953); R.V. Dyba and T.D. Smith, *Phot. Eng.*, 7, 98 (1956).]

"Although some workers [Ref: Cf. A. Hautot, Inventaire des Travaux Menes Dans le Champ de la Photographie Scientifique, Etablissements Ceuterick Louvain, Belgium, (1958)] have used a p-phenylenediamine-sulfite solution that acts primarily as a solution physical developer. [Ref: T.H. James, *J. Phot. Sci.*, 6, 49 (1958)]"

The above quotation by James suggests that the terms surface and internal latent image can be given *operational definitions*.

These concepts will be used in a theoretical manner in the development of this section.

MATHEMATICAL DERIVATION OF THE FIVE-WAY CYCLE PROBABILITIES

Figure 2.3.1 shows that the rate of change of the probability that an electron is free contains four terms; i.e., the positive term represented by the upper arrow $k(\epsilon_t)$ in going from state 2 to state 3, the positive term represented by the lower arrow $k(\epsilon'_t)$ going from state 4 to state 3, the negative term represented by the lower arrow $[s_t] k(s_t, \epsilon_f)$ going from state 3 to state 2 and the negative term represented by the upper arrows $[s'_t] k(s'_t \epsilon_f)$ going from state 3 to state 4. Each of these four processes must be weighted by the respective reverse probabilities so that the differential equation is written as

$$\frac{dP(\epsilon_f)}{dt} = P(\epsilon_t)k(\epsilon_t) - P(\epsilon_f) [s_t] k(s_t, \epsilon_f)$$
$$+ P(\epsilon'_t)k(\epsilon'_t) - P(\epsilon_f) [s'_t] k(s'_t, \epsilon_f)$$

$$(2.3.1)$$

In differential equation 2.3.1 the reverse probabilities are proportional to the number of particles in the states represented by the probabilities and we can write

$$P(\epsilon_t) = N^{-1} \times [\epsilon_t]$$

$$(2.3.2)$$

$$P(\epsilon'_t) = N^{-1} \times [\epsilon'_t]$$

$$(2.3.3)$$

Similarly we can write

$$P(Ag) = N^{-1} \times [Ag]$$

$$(2.3.4)$$

$$P(Ag') = N^{-1} \times [A'g]$$

$$(2.3.5)$$

$$P(\epsilon_f) = N^{-1} \times [\epsilon_f]$$

$$(2.3.6)$$

where N is equal to

$$N = [Ag] + [\epsilon_t] + [\epsilon_f] + [\epsilon'_t] + [A'g]$$

(2.3.7)

Substituting equations 2.3.2, 2.3.3 and 2.3.6 into 2.3.1, we may write

$$\frac{dP(\epsilon_f)}{dt} = N^{-1} \Big\{ [\epsilon_t] \, k(\epsilon_t) \;-\; [\epsilon_f] \, [s_t] \, k(s_t, \epsilon_f)$$
$$+ \; [\epsilon'_t] \, k(\epsilon'_t) \;-\; [\epsilon_f] \, [s'_t] \, k(s'_t, \epsilon_f) \Big\}$$

(2.3.8)

Equation 2.3.8 is a kinetic equation similar to equations derived in Section 2.1.

Thus we see that *basic chemical kinetics are the fundamental tools which are used to develop the analysis in Sections 2.2 and 2.3.*

In a similar manner the equations representing states 2 and 4 contain four terms and are written as

STATE 2

$$\frac{dP(\epsilon_t)}{dt} = P(\epsilon_f) \, [s_t] \, k(s_t, \epsilon_f) \;-\; P(\epsilon_t) \, k(\epsilon_t)$$
$$- \; P(\epsilon_t) \, [Ag^+] \, k(\epsilon_t, Ag^+) \;+\; P(Ag)k(Ag)$$

(2.3.9)

STATE 4

$$\frac{dP(\epsilon'_t)}{dt} = P(\epsilon_f) \, [s'_t] \, k(s'_t, \epsilon_f) \;-\; P(\epsilon'_t) \, k(\epsilon'_t)$$
$$- \; P(\epsilon'_t) \, [A'g^+] \, k(\epsilon'_t, A'g^+) \;+\; P(A'g) \, k(A'g)$$

(2.3.10)

The equations representing states 1 and 5 contain only 2 terms (see Figure 2.3.1) and we write

$$\frac{dP(Ag)}{dt} = P(\epsilon_t) [Ag^+] k(\epsilon_t, Ag^+) - P(Ag) k(Ag)$$

(2.3.11)

$$\frac{dP(A'g)}{dt} = P(\epsilon'_t) [A'g^+] k(\epsilon'_t, A'g^+) - P(A'g) k(A'g)$$

(2.3.12)

Since the sum of all the probabilities

$$P(Ag) + P(\epsilon_t) + P(\epsilon_f) + P(\epsilon'_t) + P(A'g) = 1$$

(2.3.13)

we may now write

$$\frac{dP(Ag)}{dt} + \frac{dP(\epsilon_t)}{dt} + \frac{dP(\epsilon_f)}{dt} + \frac{dP(\epsilon'_t)}{dt} + \frac{dP(A'g)}{dt} = 0$$

(2.3.14)

Equation 2.3.14 serves as a check on the differential equations 2.3.1, 2.3.8, 2.3.9, 2.3.10, 2.3.11 and 2.3.12, since they must sum to zero.

THE STEADY STATE APPROXIMATION FOR THE FIVE-WAY CYCLE

At equilibrium the rate of change of each of the probabilities is equal to zero and we may write

AT EQUILIBRIUM

$$\underbrace{P(\epsilon_t)\ k(\epsilon_t)}_{A} \quad - \quad \underbrace{P(\epsilon_f)\ [s_t]\ k(s_t,\epsilon_f)}_{B}$$

$$+ \quad \underbrace{P(\epsilon'_t)\ k(\epsilon'_t)}_{A'} \quad - \quad \underbrace{P(\epsilon_f)\ [s'_t]\ k(s'_t,\epsilon_f)}_{B'} \quad = \quad 0$$

$$(2.3.15)$$

$$\underbrace{P(\epsilon_f)\ [s_t]\ k(s_t,\epsilon_f)}_{B} \quad - \quad \underbrace{P(\epsilon_t)\ k(\epsilon_t)}_{A}$$

$$- \quad \underbrace{P(\epsilon_t)\ [Ag^+]\ k(\epsilon_t,Ag^+)}_{C} \quad + \quad \underbrace{P(Ag)k(Ag)}_{D} \quad = \quad 0$$

$$(2.3.16)$$

$$\underbrace{P(\epsilon_f)\ [s'_t]\ k(s'_t,\epsilon_f)}_{B'} \quad - \quad \underbrace{P(\epsilon'_t)\ k(\epsilon'_t)}_{A'}$$

$$- \quad \underbrace{P(\epsilon'_t)\ [A'g^+]\ k(\epsilon'_t,A'g^+)}_{C'} \quad + \quad \underbrace{P(A'g)\ k(A'g)}_{D'} \quad = \quad 0$$

$$(2.3.17)$$

$$\underbrace{P(\epsilon_t)\ [Ag^+]\ k(\epsilon_t,Ag^+)}_{C} \quad - \quad \underbrace{P(Ag)\ k(Ag)}_{D} \quad = \quad 0$$

$$(2.3.18)$$

$$\underbrace{P(\epsilon'_t)\ [A'g^+]\ k(\epsilon'_t,A'g^+)}_{C'} \quad - \quad \underbrace{P(A'g)\ k(A'g)}_{D'} \quad = \quad 0$$

$$(2.3.19)$$

For convenience each of the factors of the probabilities has been defined by the symbols A, B, C, D and their primes.

Using these definitions, we may write

$$P(\epsilon_t)A \quad - \quad P(\epsilon_f)B \quad + \quad P(\epsilon'_t)A' \quad - \quad P(\epsilon_f)B' \quad = \quad 0$$

$$(2.3.20)$$

$$P(\epsilon_f)B \quad - \quad P(\epsilon_t)A \quad - \quad P(\epsilon_t)C \quad + \quad P(Ag)D \quad = \quad 0$$

$$(2.3.21)$$

$$P(\epsilon_f)B' \quad - \quad P(\epsilon'_t)A' \quad - \quad P(\epsilon'_t)C' \quad + \quad P(A'g)D' \quad = \quad 0$$

$$(2.3.22)$$

$$P(\epsilon_t)C \quad - \quad P(Ag)D \quad = \quad 0$$

$$(2.3.23)$$

$$P(\epsilon'_t)C' \quad - \quad P(A'g)D' \quad = \quad 0$$

$$(2.3.24)$$

Factoring equations 2.3.21 and 2.3.22, we write

$$P(\epsilon_f)B \quad - \quad P(\epsilon_t) (A \quad + \quad C) \quad + \quad P(Ag)D \quad = \quad 0$$

$$(2.3.25)$$

$$P(\epsilon_t)B' \quad - \quad P(\epsilon'_t) (A' \quad + \quad C') \quad + \quad P(A'g)D' \quad = \quad 0$$

$$(2.3.26)$$

SOLUTIONS OF THE STEADY STATE EQUATIONS

The form of equations 2.3.20, 2.3.23, 2.3.24, 2.3.25 and 2.3.26 suggests that a solution may be obtained by:
(1) Solving equation 2.3.23 in terms of $P(\epsilon_t)$ we write

$$P(\epsilon_t) \quad = \quad \frac{P(Ag)D}{C}$$

$$(2.3.27)$$

If equation 2.3.27 is substituted into equation 2.3.25, the probability term $P(\epsilon_t)$ can be eliminated and the result is written as

$$P(\epsilon_f)B \;-\; \frac{P(Ag)D\,(A \;+\; C)}{C} \;+\; P(Ag)D \;=\; 0 \tag{2.3.28}$$

(2) Repeating the same process with equations 2.3.24 and 2.3.26, we get the result

$$P(\epsilon_f)B' \;-\; \frac{P(A'g)\,D'\,(A' \;+\; C')}{C'} \;+\; P(A'g)D' \;=\; 0 \tag{2.3.29}$$

Equation 2.3.29 is the primed equivalent of equation 2.3.28. Factoring equation 2.3.20, we find

$$P(\epsilon_t)A \;-\; P(\epsilon_f)\,(B \;+\; B') \;+\; P(\epsilon'_t)A \;=\; 0 \tag{2.3.30}$$

The form of equation 2.3.30 suggests the substitution for $P(\epsilon_t)$ and $P(\epsilon'_t)$ in terms of $P(Ag)$ and $P(A'g)$ respectively.
Making this substitution, we write

$$P(Ag)\,\frac{DA}{C} \;-\; P(\epsilon_f)\,(B \;+\; B') \;+\; P(A'g)\,\frac{D'A'}{C'} \;=\; 0 \tag{2.3.31}$$

Equations 2.3.28, 2.3.29 and 2.3.31 represent the reduced system of 3 equations and 3 unknowns accomplished by eliminating $P(\epsilon_t)$ and $P(\epsilon'_t)$. Factoring equation 2.3.28, we write

$$P(\epsilon_f)B \;-\; P(Ag)\left(\frac{DA}{C} \;+\; D \;-\; D\right) \;=\; 0 \tag{2.3.32}$$

Simplifying, we write

$$P(\epsilon_f)B \;-\; P(Ag)\,\frac{DA}{C} \;=\; 0 \tag{2.3.33}$$

and

$$P(\epsilon_f) \;=\; P(Ag)\,\frac{DA}{BC}$$

$$(2.3.34)$$

Similarly for equation 2.3.29, we write

$$P(\epsilon_f) \;=\; P(A'g)\,\frac{D'A'}{B'C'}$$

$$(2.3.35)$$

Recalling that $P(\epsilon_t) = P(Ag)D/C$ and its primed equivalent is equal to $P(\epsilon'_t) = P(A'g)D'/C'$ we proceed to use these relationships with equations 2.3.34, 2.3.35, 2.3.13 and we write

$$P(\epsilon_f) \;+\; P(\epsilon_t) \;+\; P(\epsilon'_t) \;+\; P(Ag) \;+\; P(A'g) \;=\; 1$$

$$(2.3.36)$$

$$\underbrace{P(Ag)\,\frac{DA}{BC}}_{\substack{\text{from eq.}\\(2.3.34)}} \;+\; \underbrace{P(Ag)\,\frac{D}{C}}_{\substack{\text{from eq.}\\(2.3.27)}} \;+\; \underbrace{P(A'g)\,\frac{D'}{C'}}_{\substack{\text{Primed}\\\text{equivalent}\\\text{of eq.}\\(2.3.27)}} \;+\; \underbrace{P(Ag)}_{\substack{\text{no change}\\\text{from eq.}\\(2.3.36)}} \;+\; \underbrace{P(A'g)}_{\substack{\text{no change}\\\text{from eq.}\\(2.3.36)}} \;=\; 1$$

$$(2.3.37)$$

After factoring we rewrite equation 2.3.37 as

$$P(Ag)\,\frac{DA}{BC} \;+\; P(Ag)\left\{\frac{D}{C}+1\right\} \;+\; P(A'g)\left\{\frac{D'}{C'}+1\right\} \;=\; 1$$

$$(2.3.38)$$

Since

$$P(\epsilon_f) \;=\; P(A'g)\,\frac{D'A'}{B'C'}$$

$$(2.3.39)$$

and

$$P(\epsilon_f) = P(Ag) \cdot \frac{DA}{BC}$$

(2.3.40)

then we can write

$$P(A'g) = P(Ag) \frac{DA}{BC} \frac{B'C'}{D'A'}$$

(2.3.41)

Substituting the value of $P(Ag)$ as expressed in 2.3.41 into equation 2.3.38, and after factoring, we write

$$P(Ag) \left\{ \frac{DA}{BC} + \frac{D}{C} + 1 + \frac{DAB'C'}{BCD'A'} + \frac{DAB'}{BCA'} \right\} = 1$$

(2.3.42)

Expressing $P(Ag)$ in terms of $P(\epsilon_f)$ we write

$$P(\epsilon_f) \left\{ 1 + \frac{B}{A} + \frac{BC}{DA} + \frac{B'C'}{D'A'} + \frac{B'}{A'} \right\} = 1$$

(2.3.43)

Therefore the probabilities are

$$P(Ag) = \left\{ \frac{DA}{BC} + \frac{D}{C} + 1 \frac{DAB'C'}{BCD'A'} + \frac{DA}{BC} \frac{B'}{A'} \right\}^{-1}$$

(2.3.44)

$$P(\epsilon_f) = \left\{ 1 + \frac{B}{A} + \frac{BC}{DA} + \frac{B'C'}{D'A'} + \frac{B'}{A'} \right\}^{-1}$$

(2.3.45)

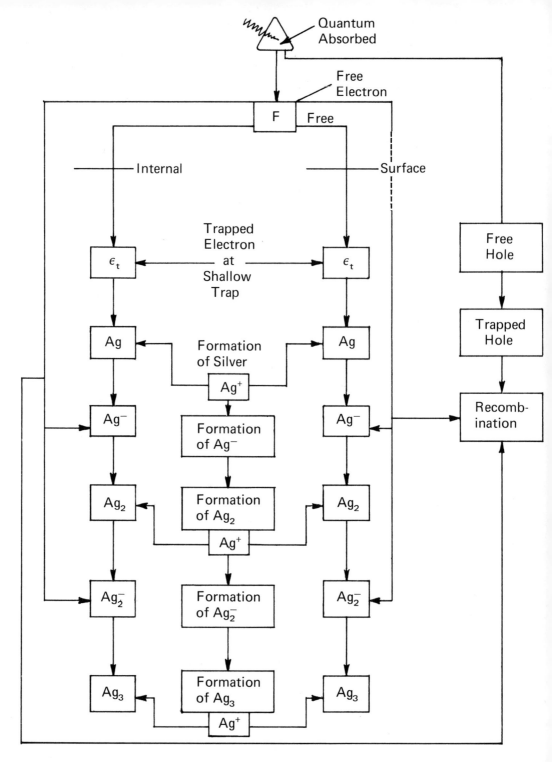

Fig. 2.3.2 *Shows the processes that occur after the* *in terms of the surface and internal image*
 silver halide crystal absorbs a photon *model.*

MATHEMATICAL RATE EXPRESSIONS FOR SURFACE AND INTERNAL PROCESSES

Figure 2.3.2 shows the significant events that take place in the combined surface and latent image model. The probabilities per unit time or rates that characterize the events in this model are as follows:

a) *The rate of absorption of a photon* by a silver halide grain is written as

$$k(h\nu, AgX)I$$

$$(2.3.46)$$

where $k(h\nu, AgX)$ is the rate constant for absorption and I is the intensity in units of the number of photons per grain per second.

b) *The rate of surface nucleation* by means of the formation of Ag^- at the *grain surface* is written as

$$[\epsilon_f] \; [Ag] \; k(\epsilon_f, Ag)$$

$$(2.3.47)$$

According to the relationships 2.2.53, 2.2.55 and the fact that N is now defined as

$$N \; = \; [Ag] \; + \; [A'g] \; + \; [\epsilon_f] \; + \; [\epsilon_t] \; + \; [\epsilon'_t]$$

$$(2.3.48)$$

we can now write equation 2.3.47 as

$$P(\epsilon_f) \; N \; P(Ag) \; (N-1) \; k(\epsilon_f, Ag)$$

$$(2.3.49)$$

Expression 2.3.49 is exactly the same as expression 2.2.61 because the nucleation is taking place at the surface of the silver halide grain.

c) *Internal nucleation* differs from surface nucleation only due to the presence of the primed terms. Thus the probability per unit time for *internal nucleation* is given by

$$P(\epsilon_f) \; NP(A'g) \; (N-1) \; k(\epsilon_f, A'g)$$

$$(2.3.50)$$

The probabilities per unit time for the *growth* of an *n atom* aggregate to an n + 1 atom aggregate on the surface or in the interior of the grain are written respectively as

$$P(\epsilon_f) \ N \ [Ag_n] \ k(\epsilon_f, Ag)$$

$$(2.3.51)$$

and

$$P(\epsilon_f) \ N \ [A'g_n] \ k(\epsilon_f, A'g)$$

$$(2.3.52)$$

For the derivation of equations 2.3.51 and 2.3.52 see equations 2.2.63 and 2.2.66.

d) The most general calculation for the rate of *recombination* involves four terms:

RECOMBINATION AT THE SURFACE

(1) The rate of trapping for a free electron and a trapped hole at the surface is written as

$$[\epsilon_f] \ [h_t] \ k \ (\epsilon_f, h_t)$$

$$(2.3.53)$$

(2) The rate of trapping for a free hole and a trapped electron at the surface is written as

$$[\epsilon_t] \ [h_f] \ k \ (\epsilon_t, h_f)$$

$$(2.3.54)$$

RECOMBINATION AT THE INTERIOR

(3) The rate of trapping for a free electron and a trapped hole at the interior of the grain is written as

$$[\epsilon_f] \ [h'_t] \ k \ (\epsilon_f, h'_t)$$

$$(2.3.55)$$

(4) The rate of trapping for a trapped electron and a free hole at the interior of the grain is written as

$$[\epsilon'_t] \ [h_f] \ k \ (\epsilon'_t,h_f)$$

(2.3.56)

The expression for the total rate of recombination can be obtained by summing equations (2.3.53), (2.3.54), (2.3.55) and (2.3.56), and we write

$$[\epsilon_f] \ [h_t] \ k(\epsilon_f,h_t) \quad + \quad [\epsilon_f] \ [h'_t] \ k(\epsilon_f,h'_t)$$

$$+ \ [\epsilon_t] \ [h_f] \ k(\epsilon_t,h_f) \quad + \quad [\epsilon'_t] \ [h_f] \ k(\epsilon'_t,h_f)$$

(2.3.57)

Expression 2.3.57 is equal to the total rate of recombination on the surface and in the interior of the grain for free electrons and trapped holes, and for trapped electrons and free holes.

Hamilton and Bayer [Ref: J.F. Hamilton and B.E. Bayer, *Investigation of a Latent Image Model: Internal Image, J. Opt. Soc. Am.*, **56**, 8 (1966)] *in their computer model* made the assumption that all the rate constants **k** were equal.

Using the Hamilton and Bayer assumption, we can write

$$k_1 \quad = \quad k(\epsilon_f,h_t) \quad = \quad k(\epsilon_f,h'_t) \quad = \quad k(\epsilon_t,h_f) \quad = \quad k(\epsilon'_t,h_f)$$

(2.3.58)

Using relation (2.3.58), the total rate of recombination becomes

$$\left\{ [\epsilon_f] \ [h_t] \quad + \quad [\epsilon_f] \ [h'_t] \quad + \quad [\epsilon_t] \ [h_f] \quad + \quad [\epsilon'_t] \ [h_f] \right\} k_1$$

(2.3.59)

Expressing the total number of holes [h] as

$$[h] \quad = \quad [h_t] \quad + \quad [h'_t] \quad + \quad [h_f]$$

(2.3.60)

the probability relation for the trapping of a hole is written as

$$P(h_t) = \frac{[h_t]}{[h_t] + [h'_t] + [h_f]} = \frac{[h_t]}{[h]}$$

(2.3.61)

and it follows from (2.3.61) that

$$[h]\, P\,(h_t) = [h_t]$$

(2.3.62)

In a similar manner, we may write

$$[h]\, P\,(h'_t) = [h'_t]$$

(2.3.63)

$$[h]\, P\,(h_f) = [h_f]$$

(2.3.64)

Since the sum of the probabilities must add to 1, we may write

$$P\,(h_t) + P\,(h'_t) + P\,(h_f) = 1$$

(2.3.65)

The analogous expressions for the other concentrations are

$$[\epsilon_f] = N\,P\,(\epsilon_f)$$

(2.3.66)

$$[\epsilon_t] = N\,P\,(\epsilon_t)$$

(2.3.67)

$$[\epsilon'_t] = N\,P\,(\epsilon'_t)$$

(2.3.68)

$$[Ag] = N\,P\,(Ag)$$

(2.3.69)

$$[A'g] = N\,P\,(A'g)$$

(2.3.70)

Substituting the probability expressions of the electrons and holes [equations (2.3.62), (2.3.63), (2.3.64), (2.3.66), (2.3.67) and (2.3.68)] into equation 2.3.59, we obtain

$$N \, [h] \left\{ P \, (\epsilon_f) \, [P \, (h_t) \; + \; P \, (h'_t)] \; + \; [P \, (\epsilon_t) \; + \; P \, (\epsilon'_t)] \, P \, (h_f) \right\} k_1$$

(2.3.71)

PROBABILITY OF TRAPPING A HOLE AT THE SURFACE AND INTERIOR

One might consider that the probability of a hole being trapped at the surface may differ from the probability for internal trapping. This difference may be attributed to the array of forces at the surface as opposed to the interior of the grain. For example, the vector representation of the forces at the surface of the grain acting on a trapped region is quite different than in the interior of the grain (see Madelung constant calculations in Section 1.2).

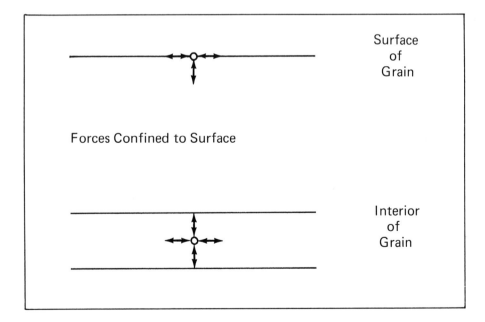

Fig. 2.3.3 *Shows forces acting on a hole at the sur-*
face and at the interior of a grain.

Since the effect of the forces as shown in Figure 2.3.3 cannot be easily measured and the corresponding probabilities $P(h_t)$ and $P(h'_t)$ determined, then at this time there is no *a priori* reason to distinguish between these two probabilities.

Combining the two probabilities into one term, we may write

$$P(\gamma) \;=\; P(h_t) \;+\; P(h'_t)$$

(2.3.72)

Using expressions 2.3.71 and 2.3.72, we may write the *total rate of recombination* as

$$N[h]\left\{ P(\epsilon_f)\,P(\gamma) \;+\; [P(\epsilon_t) \;+\; P(\epsilon'_t)]\,P(h_f) \right\}k_1$$

(2.3.73)

e) The final event which completely characterizes this model is *growth*.

MATHEMATICAL RATE EXPRESSIONS FOR SILVER ATOM GROWTH AT THE SURFACE AND THE INTERIOR

The relation for the growth of silver atom aggregates at the surface of a grain was derived in Section 2.2 as

$$P(\epsilon_f)\,N[Ag_n]\,k(\epsilon_f,Ag)$$

(2.3.74)

The expression for the growth of silver atom aggregates in the interior of the grain is the primed equivalent of equation 2.3.74 and we write

$$P(\epsilon_f)\,N[A'g_n]\,k(\epsilon_f,A'g)$$

(2.3.75)

The four events which completely characterize this model are surface nucleation, internal nucleation, growth, and recombination.

The reader should note that in Section 2.2 the cycling electrons and growth of silver atom aggregates were restricted to the simpler surface case. In Section 2.3 the cycling electron and the growth of silver atom aggregates are probabilistically divided between the surface and the interior of the grain.

$$\frac{P\,(Ag)}{P\,(A'g)} = \text{Relative Probability for Nucleation}$$

(2.3.76)

The ratio expressed in equation 2.3.76 yields the relative probabilities for nucleation at the surface and at the interior of the grain.

DERIVATION OF THE MAXWELL BOLTZMANN DISTRIBUTION

In order to understand the physical significance associated with ratio 2.3.76 that represents the relative probabilities for surface and internal nucleation it is essential that the Maxwell Boltzmann distribution be derived and applied to the model.

Let us consider that we have N_i distinguishable particles at the i^{th} energy state, and g_i equivalent boxes that can contain the N_i distinguishable particles at the i^{th} energy state.

We assume that the N_i particles can be distributed among the g_i boxes or *degenerate* states in any random fashion; i.e., we may distribute the number of particles in such a manner that all are in one box or any number of such particles arranged in other combinations, 2 in one box, 3 in another box, and so forth.

If $g_i = 3$ and $N_i = 2$, some of the i^{th} energy level possible arrangements are shown in Figure 2.3.4.

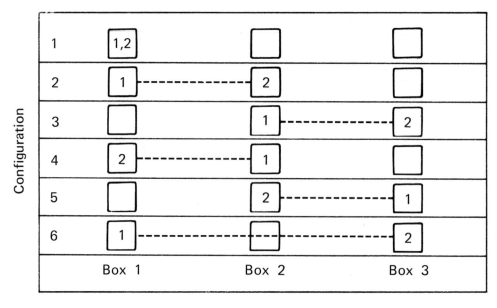

Fig. 2.3.4 *Shows six of the nine possible ways that 2 themselves in three boxes. Each arrange-*
 particles at the i^{th} energy state can arrange ment is called a configuration.

The total number of particles N is written as

$$N = \sum_{i}^{k} N_i$$

(2.3.77)

where the sum is taken over all the possible energy states i.

We wish to calculate the total number of ways that N distinguishable particles can be distributed among i energy levels that have g_i degeneracies for the i^{th} level. Neglecting degeneracies, N distinguishable particles can be distributed among i energy levels in

$$\frac{N!}{\Pi_i \, N_i!}$$

(2.3.78)

different ways with N_i particles in the i^{th} energy level.

The proof for equation 2.3.78 is as follows:

PROOF

Consider the system where three particles are to be placed in two energy levels as shown in Figure 2.3.5

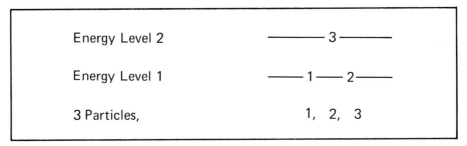

Fig. 2.3.5 *Shows two particles in energy level 1 and one particle in energy level 2.*

We can place the three particles among the two energy levels in only 3 different ways, where there are two particles in one energy level and one particle in the other energy level as shown in Figure 2.3.6.

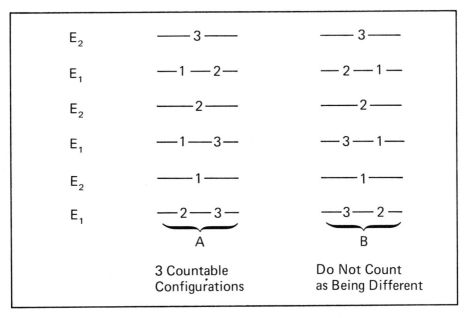

Fig. 2.3.6 *Shows the countable configurations A when a placement is made of 2 particles in the lower energy level and 1 particle in the upper level. Configurations B are not countable because they differ only in the permutations at each energy level.*

We now consider the placement of 4 particles: three particles in the lower energy state and one particle in the higher energy state as shown in Figure 2.3.7.

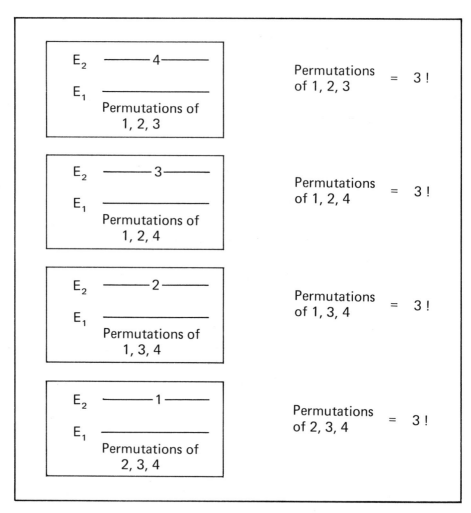

Fig. 2.3.7 *Depicts the four countable permutations that result from a total of 4 x 3! possible between-level and within-level permutations.*

Figure 2.3.7 can be characterized as a linear array

(1,2,3)	(4)	1st between level permutation
(1,2,4)	(3)	2nd between level permutation
(1,3,4)	(2)	3rd between level permutation
(2,3,4)	(1)	4th between level permutation

Level 1 Level 2

Permutations
Within Level

Let us consider a more general case where nine particles are distributed among 3 energy levels.

(1,2,3)	(4,5)	(6,7,8,9)
Energy	Energy	Energy
Level 1	Level 2	Level 3

If we examine this linear array, we note that the number of intra-level non-countable permutations for the first level is 3!, 2! for the second level and 4! for the third level.

Thus the total number of non-countable intra-level permutations for this case is calculated by taking the product of

$$3! \times 2! \times 4!$$

Now if we let C be equal to the number of countable inter-level permutations, then the total number of countable and non-countable permutations combined will be given by the product of the non-countable and countable permutations. BUT the total number of permutations for the nine objects is 9!

Thus we may write

$$9! = C \times 3! \times 2! \times 4!$$

Solving for C, we find

$$C = \frac{9!}{3! \times 2! \, 4!} = \frac{1 \times 2 \times 3 \times 4 \times 5 \times 6 \times 7 \times 8 \times 9}{1 \times 2 \times 3 \times 1 \times 2 \times 1 \times 2 \times 3 \times 4}$$

$$C = 1260$$

In a general manner we may represent any system containing N_1 particles in the first level, N_2 particles in the second level up to N_k particles in the last level as

$$(N_1)\,(N_2)\,(N_3)\cdots(N_k)$$

(2.3.79)

where

$$N = N_1 + N_2 + N_3 + \cdots + N_k = \sum_{i=1}^{k} N_i$$

(2.3.80)

The total number of intra-level (non-countable permutations) permutations is

$$N_1!\ \times\ N_2!\ \times\ N_3!\ \times\ \cdots\ \times\ N_k! = \prod_{i=1}^{k} N_i!$$

(2.3.81)

If we let the total number of inter-level (countable) permutations be C, then the total number of permutations of N particles is

$$C\ \prod_{i=1}^{k} N_i! = N!$$

(2.3.82)

and

$$C = \frac{N!}{\displaystyle\prod_{i=1}^{k} N_i!}$$

Q.E.D.

(2.3.83)

200

If the levels are degenerate (see Figure 2.3.4) then we have additional accountable configurations due to the fact that we have different ways of placing the N_i particles into the g_i boxes or degenerate states. For example, when we consider a case of six particles with a degeneracy at the i^{th} level equal to 3, we can proceed to place the first particle in any one of the three degenerate states (or boxes); then the remaining five particles can be placed one at a time into any of the three degenerate states.

In order to determine the total number of ways that nine particles can arrange themselves among three states, we write

$$
\underbrace{3}_{\substack{\text{Number of ways} \\ \text{of placing the} \\ \text{first particle} \\ \text{in the three} \\ \text{states}}} \quad \times \quad \underbrace{3}_{\substack{\text{Number of ways} \\ \text{of placing the} \\ \text{2nd particle}}} \quad \circ \circ \circ \circ \quad \times \quad \underbrace{3}_{\substack{\text{Number of} \\ \text{ways of} \\ \text{placing} \\ \text{the 9th} \\ \text{particle}}} \quad = \quad 3^9
$$

(2.3.84)

This example shows that there are 729 additional ways of placing nine particles in a particular energy level that has a degeneracy of 3.

In the general case where we have N_i particles at the i^{th} energy level with a degeneracy of g_i, we write

$$
g_i^{N_i} \quad = \quad \begin{array}{l}\text{The number of ways } N_i \text{ particles can} \\ \text{arrange themselves on the } i^{th} \text{ energy} \\ \text{level with a degeneracy of } g_i\end{array}
$$

(2.3.85)

However, since the i^{th} energy level is only one of many possible energy levels, we must take the product of terms similar to equation 2.3.84 for every level. Thus we may write

$$
g_i^{N_1} \quad \times \quad g_2^{N_2} \quad \times \quad \ldots \quad \times \quad g_k^{N_k} \quad = \quad \prod_{i=1}^{k} g_i^{N_i}
$$

(2.3.86)

Equation 2.3.86 expresses the total number of ways of placing N particles into degenerate states after we have placed N_i particles on the i^{th} energy level with a degeneracy of g_i and where

$$N = \sum_{i=1}^{k} N_i$$

Equation 2.3.86 must be multiplied by the number of countable permutations of the population N restricted to N_i particles on the i^{th} energy level, and we write

$$W = C \prod_{i=1}^{k} g_i^{N_i} = \frac{N!}{\prod_{i=1}^{k} N_i!} \prod_{i=1}^{k} g_i^{N_i}$$

(2.3.87)

W in expression 2.3.87 is called the thermodynamic probability and it expresses the total number of ways that a population of N distinguishable particles can be distributed among k energy levels where the population is restricted to N_i particles on the i^{th} level that has a degeneracy of g_i. Max Planck [Ref: M. Planck, *Thermodynamik*, Veit and Co., Leipzig, 3rd ed., 1911] proposed that the entropy S is related to the thermodynamic probability W by the relation

$$S = k\ln W$$

(2.3.88)

where k is equal to the Boltzmann constant.

This relationship bridges the macrocosmic realm of thermodynamics with the statistical microcosmic fluctuations of particles. It is of interest to note that this relation was postulated from intuition and faith rather than from empirical data.

This relationship has withstood the test of time. Planck was probably the first man of stature to recognize the importance of Einstein's Special Theory of Relativity.

When a specific number of particles are placed at the i^{th} energy level so that we have N_i particles at the i^{th} energy level and a prescribed number of particles in all the other energy levels, we cannot expect these particles to remain as prescribed. In other words, the number of particles at a fixed energy level varies with time. The problem now is to calculate the *state of maximum thermodynamic probability* W_{max}.

We shall find that the state W_{max} is given by the prescription

$$N_i = e^{-\alpha} g_i e^{-E_i/kT}$$

(2.3.89)

where α is a constant equal to

$$\alpha = - \frac{\text{Chemical potential}}{RT}$$

(2.3.90)

and where E_i is equal to the energy at the i^{th} energy level.

Expression 2.3.89 is generally referred to as the *Maxwell Boltzmann distribution law*. This law is fundamental to all natural and applied science.

The first step in determining the maximum thermodynamic probability is to apply the natural logarithm to both sides of equation 2.3.87 so that we may apply Stirling's Approximation as expressed in 2.3.92.

$$\ln W = \ln N! - \sum_{i=1}^{k} \ln N_i! + \sum_{i=1}^{k} N_i \ln g_i$$

(2.3.91)

$$\text{Stirling's Approximation} \left\{ \ln N! = N \ln N - N \right\}$$

(2.3.92)

Applying *Stirling's Approximation* to equation 2.3.91, we may write

$$\ln W = N \ln N - N - \sum_{i=1}^{k} (N_i \ln N_i - N_i) + \sum_{i=1}^{k} N_i \ln g_i$$

(2.3.93)

Combining terms, we write

$$\ln W \;=\; N\ln N - N \;+\; \sum_{i=1}^{k} (N_i \ln g_i - N_i \ln N_i + N_i)$$

(2.3.94)

Relationship 2.3.94 is constrained by the fact that the total number of particles is to be considered constant

$$N \;=\; \sum_{i=1}^{k} N_i \;=\; \text{Constant}$$

(2.3.95)

and the total energy of the system is to be considered as constant

$$E \;=\; \sum_{i=1}^{k} N_i \, E_i \;=\; \text{Constant}$$

(2.3.96)

We now apply the calculus of variations (see Chapter 1) which is formally equivalent to differential calculus except that the variation is completely arbitrary in contrast to the differential. The variation of a variable such as N_i is written as

$$\delta N_i$$

(2.3.97)

Taking the variations of equations 2.3.94, 2.3.95 and 2.3.96 and remembering that variations of the constants N, g_i, E and E_i is zero we find

$$\delta N \;=\; \sum_{i=1}^{k} \delta N_i \;=\; 0$$

(2.3.98)

$$\delta E = \sum_{i=1}^{k} E_i \, \delta N_i + \overbrace{N_i \, \delta E_i}^{0} = 0$$

(2.3.99)

$$\delta \ln W = \delta(N\ln N - N) + \sum_{i=1}^{k} \delta(N_i \ln g_i - N_i \ln N_i + N_i)$$

$$= \delta N \ln N + \frac{\cancel{\delta N}}{\cancel{N}} \cancel{N} - \cancel{\delta N} \sum_{i=1}^{k} (\delta N_i \ln g_i$$

$$+ N_i \frac{\delta g_i}{g_i} - \delta N_i \, \ln N_i$$

$$- \frac{\cancel{\delta N_i}}{\cancel{N_i}} \cancel{N_i} + \cancel{\delta N_i}$$

(2.3.100)

Equation (2.3.100) reduces to

$$\delta \ln W = \sum_{i=1}^{k} (\ln g_i - \ln N_i) \, \delta N_i$$

(2.3.101)

Using Lagrange's method of undetermined multipliers, we multiply the first condition of restraint (equation 2.3.95) by α and we multiply the second condition of restraint (equation 2.3.96) by β where α and β are undetermined multipliers. The resulting multiplication is written as:

$$\alpha \delta N = \sum_{i=1}^{k} \alpha \delta N_i = 0$$

(2.3.102)

$$\beta \, \delta E \;=\; \sum_{i=1}^{k} \beta \, E_i \, \delta N_i \;=\; 0$$

$$(2.3.103)$$

By subtracting equations 2.3.102 and 2.3.103 from equation 2.3.101, we find

$$\delta \ln W \;-\; \alpha \delta N \;-\; \beta \, \delta E \;=\; \sum_{i=1}^{k} (\ln g_i \;-\; \ln N_i$$

$$-\; \alpha \;-\; \beta \, E_i) \, \delta N_i$$

$$(2.3.104)$$

The effect of this subtraction is to remove the conditions of restraint 2.3.98 and 2.3.99 and yield an expression in which the variations δN_i are mutually independent. If we had not done this, the variations δN_i could not be considered as independent variable quantities since they would be conditioned by the functional relationships 2.3.98 and 2.3.99.

The undetermined multipliers which are constants are determined so that the variations δN_i remain mutually independent without contradiction.

The condition for an extremum (maximum or minimum) is that the variation of the function be zero. Therefore we may write

$$\sum_{i=1}^{k} (\ln g_i - \ln N_i - \alpha - \beta E_i) \, \delta N_i \;=\; 0$$

$$(2.3.105)$$

Since the variations δN_i are mutually independent, the only way that equation 2.3.105 can equal zero for all arbitrary values of the variation is that the parenthisized coefficients be equal to zero and we write

$$\ln g_i - \ln N_i \; \alpha - \beta E_i \;=\; 0, \quad i \;=\; 1, 2, \cdots, k$$

$$(2.3.106)$$

or

$$\ln \frac{N_i}{g_i} = - \alpha - \beta E_i$$

(2.3.107)

and

$$N_i = g_i e^{-\alpha} e^{-\beta E_i}$$

(2.3.108)

In order to evaluate β we must use the relation

$$S = k \ln W$$

(2.3.109)

Rewriting expression 2.3.94 as

$$\ln W = N \ln N - N + \sum_{i=1}^{k} (\ln g_i + 1 - \ln N_i) N_i$$

(2.3.110)

and rewriting expression 2.3.106 as

$$\ln N_i = \ln g_i - \alpha - \beta E_i$$

(2.3.111)

we find by substituting the latter expression into the former that

$$\ln W = N \ln N - N + \sum_{i=1}^{k} (\ln g_i + 1 - \ln g_i + \alpha + \beta E_i) N_i$$

(2.3.112)

Recalling the relations

$$\sum_{i=1}^{k} N_i = N$$

and

$$\sum_{i=1}^{k} E_i N_i = E$$

we can now write

$$\ln W = N\ln N - \cancel{N} + \alpha N + \beta E + \cancel{N}$$

(2.3.113)

Substituting equation 2.3.113 into 2.3.109, we write

$$S = kN\ln N + k\alpha N + k\beta E$$

(2.3.114)

Taking the partial derivative of S with respect to E, when the volume and the number of particles are held constant (since N is held constant we do not have expressions from terms in 2.3.114 that contain an N).

$$\left(\frac{\partial S}{\partial E}\right)_{N,V} = k\beta$$

(2.3.115)

In Chapter 3 we have shown that

$$\left(\frac{\partial S}{\partial E}\right)_{V,N} = \frac{1}{T}$$

(2.3.116)

Therefore we can write

$$k\beta = \frac{1}{T} \qquad \text{or} \qquad \beta = \frac{1}{kT}$$

(2.3.117)

Substituting relation 2.3.117 into 2.3.108, we write

$$N_i = g_i e^{-\alpha} e^{-E_i/kT}$$

(2.3.118)

If we let

$$C_i = g_i e^{-\alpha}$$

(2.3.119)

then we can write

$$\boxed{N_i = C_i e^{-E_i/kT}}$$

(2.3.120)

Expression 2.3.120 is the celebrated Maxwell Boltzmann distribution.

THE PHYSICAL SIGNIFICANCE OF THE PROBABILITIES OF NUCLEATION AT THE SURFACE AND INTERIOR OF THE GRAIN

The Maxwell Boltzmann distribution can now be used to functionalize the parameters which relate to the relative probabilities for nucleation at the surface and at the interior of the grain.

The physical significance of equation 2.3.41 can be expressed by considering the following factors (the primed quantities refer to internal processes.):

(a) $[s_t]$ the number of shallow traps

(b) ν_{Ag} and ν_{et} vibrational terms related respectively to both the decay of a silver atom and to the electron as it escapes from a shallow trap.

(c) E_{et}, E'_{et} the activation energies associated with an electron escaping from a shallow trap at the surface and at the interior of the grain.

(d) E_{Ag}, E'_{Ag} the activation energies associated with the thermal decay of an atom of silver at the surface and at the interior of the grain.

(e) σ the cross section of a shallow electron trap

(f) I the rate for the ionic step per trapped electron which is probably dependent upon the region (surface or interior) and is presumed to be directly related to the ionic conductivity.

These factors are utilized and expressed as follows.

The vibrational terms are interpreted in a manner similar to transition state theory (see equation 2.1.111).

$$k\,(\epsilon_t) \;=\; \nu_{\epsilon_t}\,e^{-E_{\epsilon_t}/kT}$$

(2.3.121)

$$k\,(\epsilon'_t) \;=\; \nu_{\epsilon_t}\,e^{-E'_{\epsilon_t}/kT}$$

(2.3.122)

$$k\,(Ag) \;=\; \nu_{Ag}\,e^{-E_{Ag}/kT}$$

(2.3.123)

$$k\,(A'g) \;=\; \nu'_{Ag}\,e^{-E'_{Ag}/kT}$$

(2.3.124)

Expressions 2.3.121 thru 2.3.124 are Arrhenius type expressions describing *single particle reactions* (see equation 2.1.105).

From transition theory we expect the value of ν to be equal to kT/h. At 298° K we can calculate the value of ν as follows

$$k = 1.358 \times 10^{-16} \ \text{erg/deg}$$

$$h = 6.63 \times 10^{-27} \ \text{erg-sec}$$

$$\frac{kT}{h} = 6.10 \times 10^{12} \ \text{cycles/sec}$$

(2.3.125)

The value expressed in equation 2.3.125 should be thought of as representing a universal lattice vibrational frequency.

The value of ν_{ϵ_t} is known to vary widely with different materials. This is due to the fact that the strength of the bonds between electrons and traps varies considerably for different materials. As an illustrative example, Hamilton and Bayer [Ref: J.F. Hamilton and B.E. Bayer, *J. Opt. Soc. Am.*, **55**, 1088 (1966)] chose for ν_{ϵ_t} a value (safe value) between 10^8 and 10^{12} cycles/sec, whereas a value of 2.5×10^{11} cycles/sec was suggested for ν_{Ag}.

We now perform an elementary calculation to determine E_{ϵ_t} and E_{Ag}. If we let $k(\epsilon_t)$ be equal to 2×10^8 cycles/sec, ν_{ϵ_t} equal 10^{10} cycles/sec (for emulsions that have not been chemically sensitized) and the Boltzmann constant k is equal to 8.477×10^{-5} electron volts/°K, then using equation 2.3.121, we may write

$$\frac{k(\epsilon_t)}{\nu_{\epsilon_t}} = \frac{2 \times 10^8}{10^{10}} = e^{-E_{\epsilon_t}/kT}$$

(2.3.126)

and when

$$T = 298°K$$

$$E_{\epsilon_t} = 0.098 \ \text{electron volts}$$

(2.3.127)

EXERCISE

Similarly we can choose for $k(Ag)$ a value of 0.5×10^{10} cycles/sec, and ν_{Ag} a value of 2.5×10^{11} cycles/sec, where the temperature T is taken at 298°K. Using these values, go on to calculate the value of E_{Ag}.

To determine how the *cross section* of a shallow trap enters into the rate expression we consider the following analysis.

For the trapping of an electron at a shallow trap in a silver halide grain we consider the following model.

1) Consider that throughout the grain there are shallow traps that consist of kink sites occupied by silver ions [Ref: F. Seitz, *Rev. Mod. Phys.*, 23, 328 (1951)].

2) The electron has a thermal velocity v_e about 10^7 cm/sec.

3) The mean grain volume V is about 4×10^{-15} cm^3.

4) The cross section of a shallow trap is assumed to be determined principally by the electric field associated with a silver ion Ag^+ in such a trap.

5) The presence of a silver aggregate (Ag, Ag_2, etc.) adjacent to the trap does not alter the cross section of the trap because the extent of the electric field is assumed greater than the geometrical size of the silver aggregate.

6) Actual cross sections as large as 10^{-12} cm^2 for traps in silver chloride of unknown nature have been found [Ref: R.S. Van Heyningen and F.C. Brown, *Phys. Rev.*, 111, 462 (1958)].

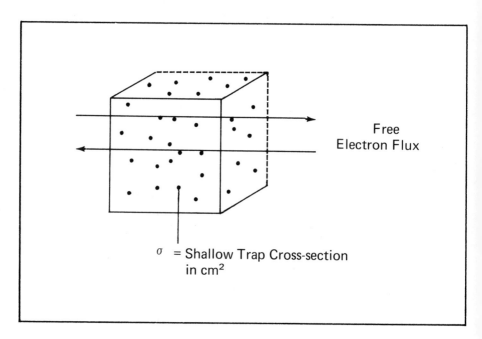

σ = Shallow Trap Cross-section in cm^2

Fig. 2.3.8 *Shows electron flux traversing a section of silver halide grain of volume V. The cross section of the shallow electron traps for capture of free electrons in cm^2 is given the symbol σ.*

Since atomic dimensions are in the order of 10^{-16} cm^2, these statements allow us to make an assumption that the minimum value for σ is between 10^{-16} and 10^{-12} cm^2. Therefore a reasonable value for the minimum value of σ is about 10^{-14} cm^2. Based upon Figure 2.3.8 we can rewrite the *rate constant for the trapping* of an electron as

$$k\,(\epsilon_f, s_t) = \frac{\sigma\ v_\epsilon}{V}$$

(2.3.128)

and the *rate of trapping* is now written as

$$\text{Rate of Trapping of a Free Electron} = \frac{[\epsilon_f]\,[s_t]\,\sigma\,v_\epsilon}{V}$$

(2.3.129)

EXERCISE

Explain why the rate of trapping is constant for a wide range of values of V.

Utilizing the information that

$$\sigma \geqslant 10^{-14} \quad ; \quad v_\epsilon = 10^7 \quad ; \quad V = 4 \times 10^{-15}$$

we find that the rate constant for trapping of a free electron is

$$k\,(\epsilon_f, s_t) \geqslant 2.5 \times 10^7$$

(2.3.130)

Similarly we can define the internal rate constant as

$$k\,(\epsilon_f, s'_t) = \frac{\sigma\ v_\epsilon}{V}$$

(2.3.131)

and the rate of *internal trapping* of a free electron is written as

$$\frac{\text{Rate of Internal}}{\text{Trapping}} = \frac{[\epsilon_f]\,[s'_t]\,\sigma\,v_\epsilon}{V}$$

(2.3.132)

The previous considerations allow us to determine the physical significance of the ratio $P(Ag)/P(A\acute{g})$, (see equation 2.3.76).

Rewriting equation 2.3.41, we have

$$\frac{P(Ag)}{P(A'g)} = \frac{\overbrace{\nu_{Ag}\,e^{-E'_{Ag}/kT}}^{k(A'g)}\;\overbrace{\nu_{\epsilon_t}\,e^{-E_{\epsilon_t}/kT}}^{k(\epsilon'_t)}\quad\overbrace{[s_t]\;\;k\;\;(s_t,\epsilon_f)}^{\sigma\frac{v_\epsilon}{V}}\;\overbrace{[Ag^+]\;k\;(\epsilon_t,\,Ag^+)}^{I}}{\underbrace{\nu_{Ag}\,e^{-E_{Ag}/kT}}_{k(Ag)}\;\underbrace{\nu_{\epsilon_t}\,e^{-E_{\epsilon_t}/kT}}_{k(\epsilon_t)}\quad\underbrace{[s'_t]\;\;k\;\;(s'_t,\epsilon_f)}_{\sigma'\frac{v_\epsilon}{v}}\;\underbrace{[A'g^+]\;\;k\;\;(\epsilon'_t,\,A'g^+)}_{I'}}$$

(2.3.133)

$$\frac{P(Ag)}{P(A'g)} = \frac{[s_t]\;\;\sigma\;\;I\;\;\nu_{\epsilon'_t}\;\;\nu_{A'g}}{[s'_t]\;\;\sigma'\;\;I'\nu_{\epsilon_t}\;\;\nu_{Ag}}\,e^{(E_{\epsilon_t}\;-\;E'_{\epsilon_t}\;+\;E_{Ag}\;-\;E'_{Ag})/kT}$$

(2.3.134)

Equation 2.3.134 represents the physical significance of the ratio of the relative probabilities for nucleation at the surface and at the interior of the grain.

If a silver halide emulsion is chemically sensitized (sulfur sensitized), the physical effect occurs largely at the surface of the grain. Thus E_{ϵ_t} and E_{Ag} are increased whereas their primed equivalents E'_{ϵ_t} and E'_{Ag} do not change. The result is that the ratio $P(Ag)/P(A\acute{g})$ becomes larger when an emulsion has been chemically sensitized and the surface sensitivity is enhanced at the expense of internal sensitivity.

There are two other effects that are brought about by chemical sensitization.

1) The sum $P(Ag) + P(A\acute{g})$ is increased. Since chemical sensitization causes surface traps to be more efficient in trapping electrons while lowering the probability for silver atom decay at the surface the competitive effect of neighboring silver atom aggregate growth results in a greater degree of high intensity reciprocity law failure. At medium intensity

chemical sensitization has the effect of increasing the efficiency of silver formation.

2) The probability for an electron being free $P(\epsilon_f)$ is decreased by chemical sensitization. Therefore the region of low intensity reciprocity law failure is shifted to a lower intensity.

SULFUR SENSITIZATION

Sulfur sensitization has the effect of increasing the activation energy barrier for trapped electrons in the system. Then we can write the following expressions:

Unsensitized		Sensitized	
$E_{\epsilon_t} (U)$	$<$	$E_{\epsilon_t} (S)$	(2.3.135)
$E_{Ag} (U)$	$<$	$E_{Ag} (S)$	(2.3.136)

Expressions 2.3.135 and 2.3.136 show that the probabilities for decomposition of silver atoms and release of electrons from trapped regions are lessened when the emulsion has been chemically sensitized (sulfur sensitized).

Thus we may write

$$E_{Ag} (S) \quad = \quad E_{Ag} (U) \quad + \quad E (S)$$

Activation Energy Barrier for Sulfur Sensitized Emulsion	Activation Energy Barrier for Unsensitized Emulsion	Activation Energy Increment Due to Sulfur Sensitization

$$(2.3.137)$$

If we assume that the increment of activation energy $E(S)$ is the same for the thermal decay of a trapped electron, we may write

$$E_{\epsilon_t}(S) = E_{\epsilon_t}(U) + E(S)$$

$$(2.3.138)$$

Utilizing expressions 2.3.137 and 2.3.138, we may write the following rate constants

$$k(\epsilon_t)_s = \nu_{\epsilon_t} \, e^{-\dfrac{E_{\epsilon_t}(U) + E(S)}{kT}}$$

$$(2.3.139)$$

and

$$k(Ag)_s = \nu_{Ag} \, e^{-\dfrac{E_{Ag}(U) + E(S)}{kT}}$$

$$(2.3.140)$$

Sulfur sensitization is specific to the surface of the grain. Thus the increment of increase in the activation energy for the thermal decay of a trapped electron and a single silver atom is zero for these processes in the interior of the grain.

TECHNIQUES FOR INTERNAL IMAGE DEVELOPMENT

Before we make any assumptions concerning the size of an internal development center silver aggregate, we must consider the techniques for internal image development.

a) The technique of bleaching the surface latent image by means of a bleaching solution produces varying results depending upon the emulsion, the exposure level and the development procedure.

If a strong bleach (oxidizing agent) is used, holes may be injected into the crystal (holes injected into the silver halide valence band) that bleach the internal as well as the surface latent image. These oxidizing agents may capture electrons from the valence band of the bromide ions, thus producing a bromine atom hole. These holes may travel to the internal image aggregates, reforming silver halide and bleaching internal image by recombination.

On the other hand, if a weak bleach is used, *latensification* of the internal latent image may occur. This result is produced when a two-atom silver aggregate at the surface of the silver halide is reduced to a one-atom aggregate by the bleaching action. The remaining one-atom aggregate is

unstable and may quickly decay thermally yielding an electron into the conduction band of the silver halide crystal.

If this free electron is trapped at an interior development center, it will cause the aggregate to grow. Thus any attempt to remove the surface latent image by the use of bleaching agents (weak or strong) can influence the internal image, depending upon the amount and character of the oxidizing agent and the amount and type of surface silver available.

b) The technique of using a silver halide solvent type developer to develop both the internal and surface image depends upon the rate at which an internal silver atom aggregate is uncovered and the rate at which the remainder of the silver halide is developed. In other words, development of the surface image proceeds at points on the grain where surface silver atom aggregates are located. Simultaneous to the development of surface image the silver halide solvent is dissolving the remainder of this crystal. As the receding grain interface passes an internal silver atom aggregate, the rate of development of this internal aggregate must proceed at a faster rate than the rate of solution of the silver halide grain. If the rate of solution is faster than the rate of internal development, then no internal development will result. Prolonged development in the presence of silver halide solvents is not helpful since the solution of the silver halide grain is excessive.

Therefore one may conclude that the size of the internal silver atom aggregate must be larger than the surface aggregates because development of the internal image must begin after the center has been uncovered but before the receding grain interface passes the aggregate.

DERIVATION OF THE OPERATIONAL PARAMETERS

From earlier measurement of the electron drift mobility [Ref: J.F. Hamilton and L.E. Brady, *J. Appl. Phys.*, **30**, 1893, 1902 (1959)], a value for the ratio 2.3.141

$$\frac{P\left(\epsilon_f\right)}{P\left(\epsilon_f\right) \;+\; P\left(\epsilon_t\right) \;+\; P\left(\epsilon'_t\right)}$$

$$(2.3.141)$$

was estimated as approximately 1/100.

Thus we may write

$$\frac{P(\epsilon_t) + P(\epsilon'_t)}{P(\epsilon_f)} \approx 100$$

(2.3.142)

according to expression 2.3.27

$$P(\epsilon_t) = P(Ag)\frac{D}{C}$$

(2.3.143)

Substituting equation 2.3.44 into 2.3.143, we write

$$P(\epsilon_t) = \left(\frac{C}{D}\right)^{-1} \left\{ \frac{DA}{BC} + \frac{D}{C} + 1 + \frac{DAB'C'}{BCD'A'} + \frac{DA}{BC}\frac{B'}{A'} \right\}^{-1}$$

(2.3.144)

Simplifying 2.3.144, we write

$$P(\epsilon_t) = \left\{ \frac{A}{B} + 1 + \frac{C}{D} + \frac{AB'C'}{BD'A} + \frac{AB'}{BA'} \right\}^{-1}$$

(2.3.145)

Since the primed quantities are symmetrical to the unprimed quantities, we can write

$$P(\epsilon'_t) = \left\{ \frac{A'}{B'} + 1 + \frac{C'}{D'} + \frac{A'BC}{B'DA} + \frac{A'B}{B'A} \right\}^{-1}$$

(2.3.146)

Recalling equation 2.3.45 and factoring $(A/B)^{-r}$ from expression 2.3.145, we find

$$P(\epsilon_t) = \left(\frac{A}{B}\right)^{-1} \left\{1 + \frac{B}{A} + \frac{BC}{AD} + \frac{B'C'}{D'A'} + \frac{B'}{A'}\right\}^{-1}$$

(2.3.147)

or

$$P(\epsilon_t) = \left(\frac{A}{B}\right)^{-1} P(\epsilon_f)$$

(2.3.148)

Similarly for $P(\epsilon'_t)$ we find that

$$P(\epsilon'_t) = \left(\frac{A'}{B'}\right)^{-1} P(\epsilon_f)$$

(2.3.149)

Substituting expressions 2.3.148 and 2.3.149 into 2.3.142, we may write

$$\left(\frac{A}{B}\right)^{-1} + \left(\frac{A'}{B'}\right)^{-1} \approx 100$$

(2.3.150)

or

$$\frac{B}{A} + \frac{B'}{A'} \approx 100$$

(2.3.151)

Decoding A, B, A' and B' according to expression 2.3.15, we have

$$\frac{[s'_t] \, k \, (s'_t, \epsilon_f)}{k(\epsilon'_t)} + \frac{[s_t] \, k \, (s_t, \epsilon_f)}{k(\epsilon_t)} \approx 100$$

(2.3.152)

Hamilton and Bayer, for the unsensitized model [Ref: J.F. Hamilton and B.E. Bayer, *J. Opt. Soc. Am.*, **56**, 1088 (1966)], arbitrarily chose

$$\frac{B}{A} = \frac{[s_t]\ k\ (s_t,\epsilon_f)}{k\ (\epsilon'_t)} = 200$$

(2.3.153)

and

$$\frac{B'}{A'} = \frac{[s'_t]\ k\ (s'_t,\epsilon_f)}{k\ (\epsilon'_t)} = 20$$

(2.3.154)

since they reasoned that there are probably a far greater number of traps at the surface than at the interior of a silver halide grain.

Hamilton and Bayer performed a trial simulation for the unsensitized state where the appropriate parameter values resulted when

$$\frac{C}{D} = \frac{[Ag^+]\ k\ (Ag^+,\epsilon_t)}{k(Ag)} = 0.05$$

(2.3.155)

and

$$\frac{C'}{D'} = \frac{[A'g^+]\ k\ (A'g^+,\epsilon'_t)}{k(A'g)} = 2.5$$

(2.3.156)

Equations 2.3.155 and 2.3.156 imply that silver atom aggregates formed at the interior of an unsensitized silver halide crystal are more stable than surface silver atom aggregates; since the ionic step is no more rapid at the surface than at the interior of the grain, the numerator for expressions 2.3.155 and 2.3.156 are the same in value.

The greater stability of the interior latent image aggregates over surface aggregates is attributed to the difference in the values of $k(Ag)$ and $k(A\overset{\circ}{g})$ and we write

$$k(Ag) > k(A'g)$$

Thus the different values for the ratios C/D and C'/D' are due only to the different denominator values in expressions 2.3.155 and 2.3.156.

Substituting equations 2.3.153, and 2.3.154, 2.3.155 and 2.3.156 into equations 2.3.45, we find

$$P\left(\epsilon_f\right) = \left\{1 + 200 + 20 + 200 \times .05 + 20 \times 2.5\right\}^{-1}$$

$$(2.3.157)$$

Thus the probability of finding a free electron in the silver halide grain for the choices expressed in expressions 2.3.155 and 2.3.156 is

$$P\left(\epsilon_f\right) = .00356 = .0036$$

$$(2.3.158)$$

Using the value of $P(\epsilon_f)$ in expression 2.3.158, it is now possible to calculate the remaining operational parameters.

$$P\left(\epsilon_t\right) = \frac{B}{A} P\left(\epsilon_f\right)$$

$$(2.3.159)$$

Substituting the values of A, B and $P(\epsilon_f)$ we have

$$P\left(\epsilon_t\right) = 200 \times .00356 = 0.712$$

$$(2.3.160)$$

Solving for $P(\epsilon_t')$ we may write

$$P\left(\epsilon_t'\right) = \frac{B'}{A'} P\left(\epsilon_f\right) = 20 \times .00356 = 0.071$$

$$(2.3.161)$$

Solving for P(Ag) and P(Aǵ) we have

$$P\left(Ag\right) = \frac{C}{D} P\left(\epsilon_t\right) = .05 \times 0.712 = 0.036$$

$$(2.3.162)$$

$$P\left(A'g\right) = \frac{C'}{D'} P\left(\epsilon_t'\right) = 2.5 \times .071 = 0.178$$

$$(2.3.163)$$

Due to rounding off error, the probabilities sum to 1.0006.

We can go on to calculate the operational parameters, rate of *surface nucleation* given as

$$P(\epsilon_f) \ N \ P(Ag) \ (N-1) \ k(\epsilon_f, Ag) \tag{2.3.164}$$

Substituting calculated values, we have

$$0.00013 \ N \ k(\epsilon_f, Ag) \ (N-1) \tag{2.3.165}$$

Rate of *internal nucleation* given as

$$P(\epsilon_f) \ NP(A'g) \ (N-1) \ k(\epsilon_f, Ag) \tag{2.3.166}$$

Substituting, we may write

$$0.00064 \ Nk(\epsilon_f A'g) \ (N-1) \tag{2.3.167}$$

Earlier we wrote for the rate of growth of a silver atom aggregate at the surface

$$P(\epsilon_f) \ N \ [Ag_n] \ k(\epsilon_f, Ag) \tag{2.3.168}$$

and using the calculated values, we have

$$0.0036 \ N \ [Ag_n] \ k(\epsilon_f, Ag) \tag{2.3.169}$$

Previously we wrote for the rate of growth silver aggregates at the interior

$$P(\epsilon_f) \ N \ [A'g_n] \ k(\epsilon_f, A'g) \tag{2.3.170}$$

after substitution of the calculated values, we may write

$$0.0036 \ N \ [A'g_n] \ k(\epsilon_f, A'g)$$

(2.3.171)

and the total rate of recombination can be calculated from the previously derived expression

$$N \ [h] \ \left\{ P(\epsilon_f) \ [P(h_t) + P(h'_t)] \right.$$
$$\left. + [P(\epsilon_t) + P(\epsilon'_t)] \ P(h_f) \right\} k_1$$

(2.3.172)

Using the calculated values, we have

$$N \ [h] \ \left\{ .0036 \times .999 + (0.712 + .071) .001 \right\} k_1$$

(2.3.173)

Simplifying, we write

$$0.0044 \ N \ [h] \ k_1$$

(2.3.174)

Expressions 2.3.165, 2.3.167, 2.3.169, 2.3.171 and 2.3.173 are the operational parameters for the *unsensitized states* that are used in a *Monte Carlo* calculation similar to the computer simulation as described in Section 2.2.

The difference between this model and the earlier model (Section 2.2) is that a high internal sensitivity implies four possibilities:

Possibility A. Internal traps may have a larger cross section or be in greater number than surface traps.

Possibility B. The activation energy associated with the thermal decay of a trapped electron is greater for an internally trapped electron than for an electron at the surface of a silver halide grain.

Possibility C. The diffusion rate of silver ions at the interior of the grain is more rapid than at the surface.

Possibility D. The activation energy associated with the thermal decay of a single atom of silver is greater in the interior than at the surface of the grain.

Any one of these possibilities is sufficient to explain high internal sensitivity.

This simulation emphasizes Possibility D. (See values for P(Ag) and P(A$\overset{\prime}{g}$).)

SULFUR SENSITIZATION MODEL

Since sulfur sensitization is attributed to change that occurs only at the surface of the grain, only the factors that bring about an increase in the value of P(Ag) are to be considered important.

Hamilton and Bayer chose to increase the factor C/D by a factor of 100 for their sensitized case. [Ref: J. F. Hamilton and B. E. Bayer, *J. Opt. Soc. Am.*, **56**, 1088 (1966).]

For the value

$$\frac{C}{D} = 1$$

and utilizing the previously derived expressions for the probabilities of the events of the unsensitized state, we write

$$P(\epsilon_f) = 0.0036$$

$$P(\epsilon_t) = 200 \times 0.00356 = 0.712$$

$$P(Ag) = 0.036$$

$$P(A'g) = 0.178$$

Sections 2.2 and 2.3 have sufficiently prepared the reader to read and understand the original papers of Hamilton and Bayer referred to in this text. It is suggested that the reader consult these original papers before attempting to answer the questions at the end of this section.

The authors do not summarize the results of the Hamilton and Bayer simulation because we believe it is of greater consequence that the reader

understand the concepts than particular results.

In this way the reader may be inspired to perform his own computer simulation in latent image or other photographic areas.

J.F. Hamilton [Ref: J.F. Hamilton, *Phot. Sci. Eng.*, **13**, 331 (1969)] has recently done a digital simulation of the effects of high vacuum exposure on the photographic sensitivity of undyed photographic materials.

The authors believe that this series of digital simulations heralds an explosion in the application of digital computers to photographic investigations.

PROBLEM SET 2.3

1. What is the primary difference between the three-way cycle and the model of this section?

2. Why do the equations representing states 1 and 5 contain only 2 terms?

3. Discuss internal and surface nucleation in an unsensitized (not chemically sensitized) emulsion.

4. Derive equations 2.3.51 and 2.3.52.

5. Derive the Maxwell Boltzmann distribution and discuss its application to latent image formation.

6. Explain the effects of chemical sensitization with respect to:
a) lowering the probability for silver atom decay only at the surface of the grain,
b) greater degree of high intensity reciprocity low failure,
c) $P(\epsilon_f)$.

7. Derive equation 2.3.140.

8. Using the values $C/D = 0.01$, $C'/D' = 0.5$ calculate: $P(\epsilon_f)$, $P(\epsilon_t)$, $P(\epsilon_t')$, $P(Ag)$ and $P(Ag')$, where $B/A = 200$, $B'/A' = 20$.

9. Using the results of 8, find the rate of surface and internal nucleation.

10. Justify the statement that, on the average, internal silver atom aggregates that develop are larger than surface aggregates.

11. According to this model what does high internal sensitivity imply?

12. For an unsensitized emulsion why is the activation energy associated with the decay of an atom of silver greater in the interior than at the surface of the grain?

13. Discuss the relation between the Trautweiler model and the three and five-way cycle presented in this chapter.

14. Consider the digital simulation of the five-way cycle integrated with energy levels depending on the energy states of the latent image as a function of aggregate size and charge. Complete the simulation using different Fermi levels corresponding to temperature changes in development.

2.4 Characteristic Curve

The contribution to total density is a function of photographic layer thickness due to the fact that the individual elementary layer absorption is a function of layer depth.

When we consider a thick emulsion composed of many elementary layers it is apparent (see Fig. 2.4.1) that the outermost elementary layer and all other layers of a thick emulsion system are exposed by incident and reflected quanta.

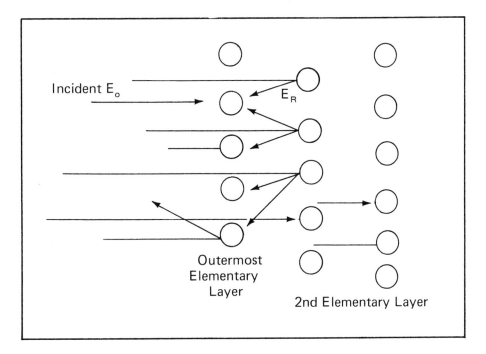

Fig. 2.4.1 *Shows a grain in an elementary layer of an emulsion during an exposure receiving incident and reflected quanta.*

A theoretical analysis was made of the absorption of quanta in thick emulsion [Ref: H. Frieser and E. Klein, *Z. Elektrochem.* **62**, 874 (1958)].

Consider that E_o is the number of quanta impinging on one square centimeter of a thick photographic emulsion of thickness W (see Figure 2.4.2). Furthermore, W is divided into an equal number of increments dX.

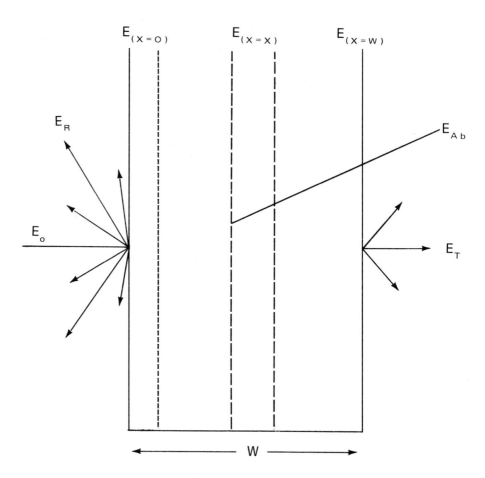

Fig. 2.4.2 *Shows incident quantum radiation being reflected E_R transmitted E_T and absorbed E_{Ab}.*

In terms of these three quantities, we can now write

$$E_o = E_R + E_T + E_{Ab}$$

$$(2.4.1)$$

The *transmission coefficient* is defined as

$$E_T = C_T E_o$$

<div align="right">(2.4.2)</div>

The *reflection coefficient* is defined as

$$E_R = C_R E_o$$

<div align="right">(2.4.3)</div>

Referring to Figure 2.4.3, we see that when intensity is measured at $E_{(X=0)}$ we may write

$$E_{(X=0)} = E_o + E_R$$

<div align="right">(2.4.4)</div>

In the neighborhood of the plane $E_{(X=W)}$ an observer, if placed in the region, can measure only the transmitted quantum intensity (see Figure 2.4.3).

Thus we may write

$$E_{(X=W)} = E_T = C_T E_o$$

<div align="right">(2.4.5)</div>

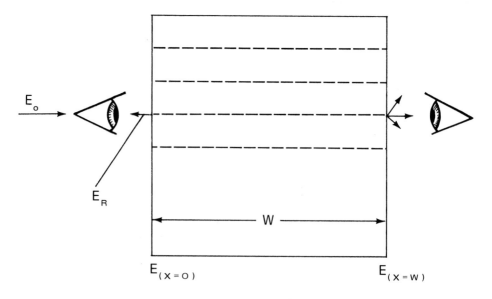

Fig. 2.4.3 *In this region the observer sees the* *The observer sees only the transmitted*
incident and reflected quantum intensity. *quantum intensity.*

Substituting equation 2.4.3 into 2.4.4, we may write

$$E_{(x=0)} \;=\; E_o \, (1 + C_R)$$

(2.4.6)

If we assume, as did Frieser and Klein, [Ref: H. Frieser and E. Klein, *Z. Elektrochem.*, **62**, 874 (1958)] that the Beer Lambert law holds throughout the thickness of an emulsion, then we have

$$E_{(x=x)} \;=\; E_{(x=0)} \; e^{-Bx}$$

(2.4.7)

Utilizing equation 2.4.7, we write

$$E_{(x=w)} \;=\; E_{(x=0)} \; e^{-Bw}$$

(2.4.8)

where B is called the *absorption coefficient.*

Substituting equation 2.4.4 and equation 2.4.5 into equation 2.4.8, we write

$$C_T E_o = E_o (1 + C_R) e^{-BW}$$

$$(2.4.9a)$$

$$\frac{1 + C_R}{C_T} = e^{BW}$$

$$(2.4.9b)$$

Solving for B, we write

$$B = \frac{1}{W} \ln \frac{1 + C_R}{C_T}$$

$$(2.4.10)$$

The *optical transmission density* D can be defined as W B' where B' = $1/W \log [(1 + C_R)/C_T]$. Thus $D = \log [(1 + C_R)/C_T]$.

Since we are interested in calculation the intensity of photons in the inner layer of the thick emulsion; i.e., at $E_{(X=X)}$ in terms of C_R and C_T, then we write

$$E_{(X=X)} = (1 + C_R) E_o e^{-BX}$$

$$(2.4.11)$$

Equation 2.4.11 is obtained by substituting 2.4.6 into 2.4.7.

The right hand side of equation 2.4.11 can be written entirely in terms of C_R and C_T by substituting equation 2.4.10 into 2.4.11. The resultant equation is

$$E_{(X=X)} = E_o (1 + C_R) \left(\frac{1 + C_R}{C_T} \right)^{-\frac{X}{W}}$$

$$(2.4.12)$$

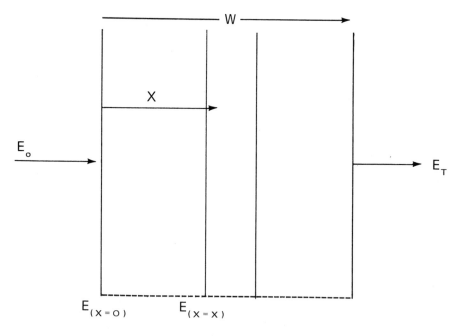

Fig. 2.4.4 *Shows schematically the outer and inner layers $E_{(x = 0)}$ and $E_{(x = x)}$ of a thick emulsion of thickness W.*

We can conclude from the prior analysis that there are two funda-mental equations that represent the thick emulsion as shown in Fig. 2.4.4

$$D = \log \frac{1 + C_R}{C_T}$$

(2.4.13)

and from equation 2.4.12, we write

$$E_{(x = x)} = E_o (1 + C_R) \left(\frac{1 + C_R}{C_T} \right)^{-\frac{x}{W}}$$

(2.4.14)

Expression 2.4.13 relates the optical transmission density of the thick emulsion with the transmission and reflection coefficients.

Expression 2.4.14 yields the total number of quanta available at layer depth X from the surface.

Taking the logarithms of expression 2.4.14, we may write

$$\log E_{(X=x)} = \log E_o + \log (1 + C_R) - \frac{X}{W} \log \frac{1 + C_R}{C_T}$$

$$(2.4.15)$$

$$\log E_{(x=x)} = \log E_o + \log (1 + C_R) - \frac{X}{W} D$$

$$(2.4.16)$$

If the coefficient of reflection is negligible when compared to the value 1, then we write

$$\log (1 + C_R) = \log 1 = 0$$

$$(2.4.17)$$

and

$$\log E_{(x=x)} = \log E_o - \frac{X}{W} D$$

$$(2.4.18)$$

For the two regions of the emulsion at X=0 and X=W we may write

$$\log E_{X=0} = \log E_o$$

$$(2.4.19)$$

$$\log E_{(x=w)} = \log E_o - D$$

$$(2.4.20)$$

The characteristic curve (H & D) for a thick emulsion can be expressed as

$$D = f (\log E)$$

$$(2.4.21)$$

It is possible to analyze a thick emulsion in terms of thin elementary layers. A thin elementary layer has a corresponding characteristic curve. A characteristic curve representing a thin layer expresses the rate of change of density with respect to the differential increment of log E.

Thus if g (log E) represents the characteristic curve of a thin layer within the thick emulsion, then the rate of change of density with respect to log E for the thin layer is proportional to g (log E) and inversely proportional to D, where D is the density of the thick layer, and we write

$$\frac{d\ D/D_{max}}{d\ (\log E)} = -\frac{1}{D}\ g\ (\log E)$$

(2.4.22)

The rate of change of the thin layer within a thick emulsion must be inversely proportional to the density of the thick emulsion in order to satisfy the boundary condition that

$$\lim_{D \to D_\infty} \frac{d\ D/D_{max}}{d\ (\log E)} = O$$

(2.4.23)

For example, if we consider a developed thick emulsion of high optical transmission density as $D \to D_\infty$, the slope of all elementary layers approaches zero.

EXERCISE

Explain why equation 2.4.20 holds in the neighborhood of D = 0.

In order to obtain the characteristic curve for the thick emulsion D = f (log E), from all the elementary layers it is necessary to integrate equation 2.4.22 as follows

$$\int_0^D \frac{d\,D}{D_{max}} = -\frac{1}{D} \int_{\log E_o}^{\log E_o - D} g\,(\log E)\,d\,(\log E)$$

(2.4.24)

and we change the sign by switching the limits and write

$$\frac{D}{D_{max}} = \frac{1}{D} \int_{\log E_o - D}^{\log E_o} g\,(\log E)\,d\,(\log E)$$

(2.4.25)

The *thin layer integral equation 2.4.25* has been derived by other writers [Ref: H. Biusson and C. Fabry, *Rev. Optique*, 3, 1 (1924); L. Silberstein, *J. Opt. Soc. Am.* 32, 326 (1942); P. C. Burton, *Fundamental Mechanisms of Photographic Sensitivity*, edited by J. W. Mitchell, Butterworth, London (1951), p. 188]. The reader may consult these publications for a different approach to the derivation of equation 2.4.25.

Webb [Ref: J.H. Webb, *J. Opt. Soc. Am.*, 38, 27 (1948)] has given a graphical analysis of the problem that results in equation 2.4.25. The accuracy of this theoretical analysis was tested by experimentation.

Since the D log E curve for a thick emulsion can be obtained from equation 2.4.25, the remaining problem is to determine g (log E).

PRELIMINARIES TO THE DERIVATION OF THE ELEMENTARY LAYER D LOG E CURVE

The derivation of the elementary layer D log E curve requires a knowledge of the following factors:

The size of a silver halide grain in terms of the diameter **d** is not constant. Thus we must consider the grain size frequency distribution of the emulsion under analysis. The grain size frequency distribution can be symbolically represented as

$$\Phi_i$$

(2.4.26)

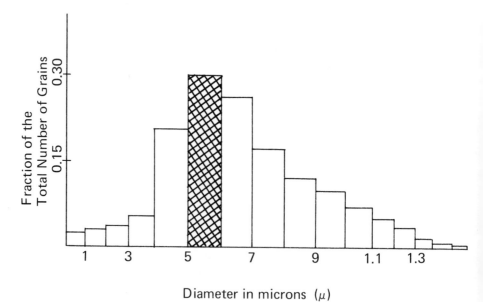

Diameter in microns (μ)

Fig. 2.4.5 *Shows a histogram representing Φ_i. The cross hatched region represents one of the class sizes i, specifically the fraction of the total number of grains that have a diameter in the interval 0.5 to 0.6 but not including 0.6 microns.*

The grain size frequency distribution (Fig. 2.4.5) can be approximated by a continous function called the log normal function.

When it is approximated by this continuous function, it is written $\phi(d)$ where d represents the diameter of a grain. The empirical expression for the continous grain size frequency density function is given as

$$\phi(d) \cong \frac{0.434}{d.\sigma \sqrt{2\pi}} \, e^{-[\log(d/d_o)]^2/2\sigma^2}$$

(2.4.27)

where σ is equal to the standard deviation for the distribution and d_o is the average diameter of the grain distribution.

The relationship between d_o and the most frequent diameter, d_{max} that corresponds to the $\phi(d)$, $\phi(d_{max})$ is

$$d_{max} = d_o \, e^{-5.3\sigma^2}$$

(2.4.27a)

Equation 2.4.27 is derived in the sub-section *Sensitivity Distribution* for another random variable. However, the analysis is exactly the same when applied to the g.s.f.d. (grain size frequency distribution).

The *log normal gaussian function* was first derived in a mathematical study of botanical distributions [Ref: J.C. Kapteyn and M.J. van Uven, *Skew Frequency Curves in Biology and Statistics,* 2nd paper, Hoitsema Brothers, Gröningen, Netherlands (1916)].

Previous workers have found that they may obtain the same type of distribution regardless of what size characteristic such as diameter, areas, volume, weight of the grain is measured [Ref: R.P. Loveland and A.P.H. Trivelli, *J. Phys. Coll. Chem.,* **51**, 1004 (1947)].

The only thing that changes is the values of the parameters. (σ and d_o in equation 2.4.27). A log normal distribution has the same property and this characteristic justifies its use for grain size frequency distribution applications.

The *grain size frequency distribution* (g.s.f.d.) function controls the shape of the characteristic curve partly because the absorption of light by a grain is proportional to the volume of the grain, and because grains of different class size i contribute differently to optical transmission density.

Since the grain size frequency distribution function ϕ_i indicates the total number of grains of class size i, we may write

$$N\phi_i \;\; = \;\; N_i \text{ grains}$$

$$(2.4.28)$$

where N is the total number of grains.

The **g.s.f.d.** function can also be considered as the probability of finding a grain in class size **i.**

Thus we may write

$$\sum_{i=0}^{\infty} \phi_i \;\; = \;\; 1$$

$$(2.4.29)$$

and since the total number of grains N is the sum of the grains in all class sizes, we have

$$\sum_{i=0}^{\infty} N_i \;=\; N$$

(2.4.30)

We postulate that a grain must absorb at least E^* quanta before it can be rendered developable. Furthermore, in class size i, each grain absorbs E_i average number of quanta. If the absorption of photons by a grain is considered to be a random process, we may use the Poisson distribution (see Section 2.3 for derivation) and we write

$$\psi(E_i, E^*) \;=\; \text{The probability that a grain will absorb } E^* \text{ quanta} \;=\; e^{-E_i}(E_i^{E^*}/E^*!)$$

(2.4.31)

Since many grains absorb E^* quanta and more, we must calculate the probability $P(E_i, E^*)$ that a grain of class size i will absorb a minimum of E^* quanta.

The probability $P(E_i, E^*)$ is merely the sum of the probabilities of a grain of class size i absorbing E^* quanta, $E^* + 1$ quanta, $E^* + 2$ quanta, $E^* + n$ quanta to an infinite number of quanta. We must exclude the sum of the probabilities for $a = 0$ to $a = E^* - 1$ because these probabilities do not represent a developable grain.

Thus we may write

$$P(E_i, E^*) \;=\; \sum_{a=E^*}^{\infty} e^{-E_i} \left(\frac{E_i^{\,a}}{a!} \right)$$

(2.4.32)

We have shown in Section 2.3 that the total sum of the Poisson probabilities is 1. Thus we may write

$$\sum_{a=0}^{\infty} e^{-E_i} \left(\frac{E_i^{\,a}}{a!} \right) \;=\; 1$$

(2.4.33)

or breaking the summation into the sum of probabilities that *do not* represent a developable grain, plus the summation that *does* represent a developable grain, we have

$$\sum_{a=0}^{E^*-1} e^{-E_i} \left(\frac{E_i^{\,a}}{a\,!} \right) \quad + \quad \sum_{a=E^*}^{\infty} e^{-E_i} \left(\frac{E_i^{\,a}}{a\,!} \right) = 1$$

Non Developable Probabilities Developable Probabilities

(2.4.34)

By substituting equation 2.4.32 into equation 2.4.34, we have

$$P\,(E_i, E^*) \;=\; 1 \;-\; \sum_{a=0}^{E^*-1} e^{-E_i} \left(\frac{E_i^{\,a}}{a\,!} \right)$$

(2.4.35)

Equation 2.4.35 expresses the probability that a grain will absorb at least E^* quanta and be rendered developable.

This probability can also be interpreted as the fraction of grains of class size i that are rendered developable.

For a simple case where all the silver halide grains of an emulsion are of the same class size and have the same sensitivity, we may equate

$$\frac{D}{D_{max}} \;=\; P\,(E, E^*)$$

(2.4.36)

A FIRST APPROXIMATION TO THE D LOG E CURVE OF AN ELEMENTARY LAYER

Following Webb [Ref: J.H. Webb, *J. Opt. Soc. Am.*, **38**, 27 (1948)] we compute the values of $P\,(E, E^*)$ for the following values of E^*.

a) $\quad E^* = 1 \; ; \dfrac{D}{D_{max}} \quad = 1 - e^{-E}$

(2.4.37)

b) $\quad E^* = 2 \; ; \dfrac{D}{D_{max}} \quad = 1 - e^{E} \quad (1 + E)$

(2.4.38)

c) $\quad E^* = 3 \; ; \dfrac{D}{D_{max}} \quad = 1 - e^{E} \quad (1 + E + \dfrac{E^2}{2!})$

(2.4.39)

d) $\quad E^* = 4 \; ; \dfrac{D}{D_{max}} \quad = 1 - e^{E} \quad (1 + E + \dfrac{E^2}{2!} + \dfrac{E^3}{3!})$

(2.4.40)

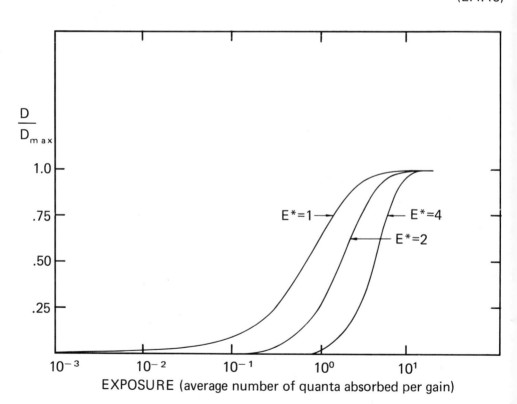

Fig. 2.4.6 *Shows a plot of equations 2.4.37, 2.4.38 and 2.4.40.*

TABLE 2.4.1

E	e^{-E}	$1 + E$	$\dfrac{D}{D_{max}} = 1 - e^{-E}(1 + E)$
.001	.999	1.001	.001
.01	.990	1.01	.001
.03	.970	1.03	.001
.1	.905	1.1	.005
1	.368	2	.264
2	.135	3	.595
3	.0498	4	.958
10	4×10^{-5}	11	.999

Table 2.4.1 shows how calculations for D_{max} for given values of E^* are made. The example given represents a calculation when $E^* = 2$. This data is plotted in Figure 2.4.6.

The theory of the characteristic curve cannot be based entirely on equation 2.4.35 since it does not include the effects of:

1) The class size i as represented by a grain size frequency distribution.

2) The variation in sensitivity of the grains as a function of class size i and E^*.

3) The probability that a grain will absorb a photon as a function of the volume of the grain.

4) The contribution of grains of different class size i to the optical transmission density.

All of these factors will be included in the more comprehensive treatment of the characteristic curve that follows.

THE DETERMINATION OF E_i

The material that follows is based largely on the work of Frieser and Klein [Ref: H. Freiser and E. Klein, *Phot. Sci. Eng.*, 4, 264 (1960)].

We are interested in determining E_i; i.e., the average number of quanta absorbed for a given class size i in terms of the initial exposure E_o. In order to perform this determination, we must define the intrinsic probability ψ_i, that a grain of class size i will absorb a photon.

The reader should not confuse the probability ψ_i with the probability $P(E_i, E^*)$ which is based solely on the assumption (1) that there is an average number of photons that a grain of class size i will absorb; (2) that there is a threshhold number of photons which a grain must absorb before it can be rendered developable; (3) that this process is random such that it follows a Poisson distribution.

The intrinsic probability ψ_i of a grain of class size i absorbing a photon is directly proportional to the grain volume for exposure to light in the region of silver halide absorption.

Thus we may write

$$\psi_i = k_a d_i^3$$

(2.4.41)

where k_a is the constant of proportionality and d_i is the diameter of the grain of class size i.

Using expression 2.4.41, we may write

$$\begin{array}{ll} \text{The number of photons} & \\ \text{absorbed by a grain} & = \quad \psi_i E_o \\ \text{of class size } i & \end{array}$$

(2.4.42)

If there are N_i grains of class size i per cm^2, then the total number of photons absorbed by all the grains in a given class size i per cm^2 is written as

$$E_{i\,(TOTAL)} = N_i \psi_i E_o$$

(2.4.43)

Since E_o is the number of photons arriving at 1 cm^2 of an elementary layer and E is equal to the number of photons that are actually absorbed in this 1 centimeter2 region, we may write that

$$E = \sum_{i=0}^{\infty} E_{i(TOTAL)} = E_o \sum_{i=0}^{\infty} \psi_i N_i$$

(2.4.44)

and equation 2.4.44 reduces to

$$E_o = \frac{E}{\sum_{i=0}^{\infty} \psi_i N_i}$$

(2.4.45)

Substituting expression 2.4.45 into equation 2.4.43, we may write

$$E_{i(TOTAL)} = \frac{N_i \psi_i E}{\sum_{i=0}^{\infty} \psi_i N_i}$$

(2.4.46)

We specifically include the grain size frequency distribution by substituting equation 2.4.28 into equation 2.4.46. The result is written as

$$E_{i(TOTAL)} = \frac{N \phi_i \psi_i E}{N \sum_{i=0}^{\infty} \psi_i \phi_i} = \frac{\phi_i \psi_i E}{\sum_{i=0}^{\infty} \psi_i \phi_i}$$

(2.4.47)

Since E_i is equal to the average number of photons absorbed by grains of class size i per cm^2, we may write

$$E_i = \frac{E_{i(TOTAL)}}{N_i}$$

(2.4.48)

Thus by substituting expression 2.4.47 into 2.4.48, we have

$$E_i = \frac{\phi_i \psi_i E}{N_i \sum\limits_{i=0}^{\infty} \psi_i \phi_i}$$

(2.4.49)

Finally, the quantity N_i can be rewritten by use of equation 2.4.28 and expression 2.4.49 becomes

$$E_i = \frac{\psi_i E}{N \sum\limits_{i=0}^{\infty} \psi_i \phi_i}$$

(2.4.50)

Expression 2.4.50 relates the average number of photons absorbed for a particular class size i per cm^2 with the intrinsic probability, the exposure (photons absorbed per cm^2) and the grain size frequency distribution.

By substituting equation 2.4.41 into equation 2.4.50, we may write

$$E_i = \frac{d_i^3 E}{N \sum d_i^3 \phi_i}$$

(2.4.51)

Equation 2.4.51 can be used to estimate E_i from experimentally determined parameters. The quantity E_i estimated in this manner will then give a value of $P(E_i, E^*)$ which can be directly related to a real emulsion.

The next step in the derivation of the characteristic curve discusses the manner in which the criterion for developability depends upon the inherent sensitivity of grains as a function of class size i and E^*.

SENSITIVITY DISTRIBUTION

Since the criterion for developability of exposed silver halide grains is a function of class size i and the minimum number of quanta E*, we may use these quantities as independent variables and write

$$\text{SENSITIVITY DISTRIBUTION} = S(i, E^*)$$

(2.4.52)

Due to the sensitivity distribution, the value of E* varies from grain to grain. This variation in sensitivity can be ascribed to the variation during chemical sensitization and treatment of the silver halide grains; i.e., grains of the same size may absorb differently due to the physical nature of the individual grains. However, it is safe to postulate that the sensitivity distribution peaks for values of E* between 10 and 100.
Thus Figure 2.4.7 shows such a hypothetical distribution.

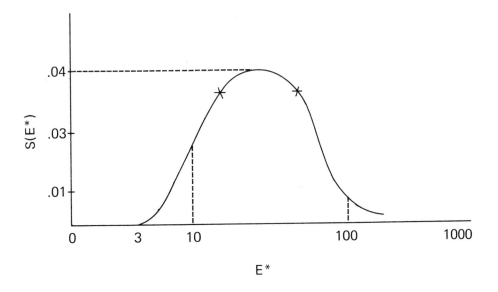

Fig. 2.4.7 Shows a continous function representing the
 sensitivity distribution for values of E*.

The curve shown in figure 2.4.7 corresponds to the equation

$$S(E^*) \;=\; (0.434/E^*\sigma(2\pi)^{\frac{1}{2}})\, \exp\left(-[\log E^*/E_o^*]^2/2\sigma^2\right)$$

$$(2.4.53)$$

where $E_o^* = 16$ and $\sigma = 0.25$.

It is of fundamental importance to determine the maximum value of this function so as to find how the maximum varies as a function of the standard deviation σ and E_o^*.

Converting to the natural log, we rewrite expression 2.4.53 as

$$S(E^*) \;=\; (0.434/E^*\sigma(2\pi)^{\frac{1}{2}})\, \exp\left(-[0.434 \ln E/E_o^*]^2/2\sigma^2\right)$$

$$(2.4.54)$$

Differentiating equation 2.4.54 with respect to E_o, we obtain

$$\frac{dS(E^*)}{dE^*} \;=\; -(0.434/E^{*2}\sigma(2\pi)^{\frac{1}{2}})\, \exp\left(-[0.434 \ln E^*/E_o^*]^2/2\sigma^2\right)$$

$$+\; (0.434/E^*\sigma(2\pi)^{\frac{1}{2}})\, \exp\left(-[0.434 \ln E^*/E_o^*]^2/2\sigma^2\right)$$

$$\left\{-(2/2\sigma^2)(0.434 \ln E^*/E_o^*)(0.434/E^*)\right\}$$

$$(2.4.55)$$

$$\frac{dS(E^*)}{dE^*} \;=\; -(0.434/E^{*2}\sigma(2\pi)^{\frac{1}{2}})\, \exp\left(-[0.434 \ln E^*/E_o^*]^2/2\sigma^2\right)$$

$$-(0.434/E^{*2}\sigma(2\pi)^{\frac{1}{2}})\, \exp\left(-[0.434 \ln E^*/E_o^*]^2/2\sigma^2\right)$$

$$\left\{(0.434/\sigma)^2 \ln E^*/E_o^*\right\}$$

$$(2.4.56)$$

We obtain the maximum value S for the values of E* which satisfy equation 2.4.57

$$\frac{dS(E^*)}{dE^*} = -\frac{S(E^*_{max})}{E^*_{max}} - \frac{S(E^*_{max})}{E^*_{max}} \left\{ \left(\frac{0.43}{\sigma}\right)^2 \ln\frac{E^*_{max}}{E^*_o} \right\} = 0$$

$$(2.4.57)$$

Rewriting the right hand side of expression 2.4.57, we have

$$-\frac{S\,(E^*_{max})}{E^*_{max}} \left(1 + \left(\frac{0.43}{\sigma}\right)^2 \ln\frac{E^*_{max}}{E^*_o} \right) = 0$$

$$(2.4.58)$$

Expression 2.4.58 can be zero for all values of E* if and only if the bracketed expression is zero, because $S(E^*_{max})$ can take on the value of zero only when E^*_{max} is equal to zero and E^*_{max} is equal to infinity.
Thus we may write

$$1 + \left(\frac{0.43}{\sigma}\right)^2 \ln\frac{E^*_{max}}{E^*_o} = 0$$

$$(2.4.59)$$

and since

$$-\left(\frac{\sigma}{0.43}\right)^2 = \ln\frac{E^*_{max}}{E^*_o}$$

$$(2.4.60)$$

we may write

$$E^*_{max} = E^*_o\, e^{-(\sigma/0.43)^2}$$

$$(2.4.61)$$

and

$$E^*_{max} = E^*_o e^{-5.3\sigma^2}$$

<div align="right">(2.4.61a)</div>

It should be noted that all distributions; i.e., g.s.f.d., sensitivity, etc., which are of the log normal type result from taking the derivative of the cumulative frequency function Q (log X).

For the case of the g.s.f.d. function, the cumulative frequency function gives the total number of grains which have the diameter d or less. This can be symbolized as

$$Q \ (\log \ d)$$

<div align="right">(2.4.62)</div>

The derivative of expression 2.4.62 with respect to log d results in a normal grain size frequency distribution that can be expressed in the manner

$$\frac{\partial Q \ (\log \ d)}{\partial \ (\log \ d)} = \frac{1}{\sigma\sqrt{2\pi}} e^{-[\log \ d/d_o]^2/2\sigma^2}$$

<div align="right">(2.4.63)</div>

Since

$$\frac{\partial Q \ (\log \ d)}{\partial \ (\log \ d)} \frac{\partial \ (\log \ d)}{\partial \ (d)} = \frac{\partial Q \ (\log \ d)}{\partial \ (d)}$$

<div align="right">(2.4.64)</div>

then the following relationship is true and we write

$$\frac{\partial \ (\log \ d)}{\partial \ (d)} = \frac{\partial \ (0.434 \ \text{ln} d)}{\partial \ (d)} = \frac{0.434}{d}$$

<div align="right">(2.4.65)</div>

Substituting equations 2.4.64 and 2.4.65 into expression 2.4.63, we arrive at $\phi \ (d)$.

$$\phi\,(d) \;=\; \frac{\partial Q\,(\log d)}{\partial\,(d)} \;=\; \frac{0.434}{d.\sigma\sqrt{2\pi}}\; e^{-\,[\log\,d/d_o]^2/2\sigma^2}$$

(2.4.66)

The inclusion of d in the denominator of expression 2.4.66 makes it a log normal distribution.

The symbol for partial derivative is used to indicate the total derivative in order to avoid confusion with the symbols representing the diameter of the grains.

In this analysis the diameter of the grain d corresponds to the diameter of a sphere which has the same volume as the grain.

The sensitivity distribution is a function of E* for a given class size i.

This fact indicates that the sensitivity varies from grain to grain in a given class size i. Therefore we must combine the sensitivity distributions S (i,E*) as a factor with P(E_i,E*)

$$P\,(E_i,\ E^*) \qquad\qquad S\,(i,\ E^*) \qquad = \qquad \begin{array}{l}\text{Fraction of}\\ \text{grains which will}\\ \text{develop for a}\\ \text{value of E*}\end{array}$$

Fraction of de-
velopable grains
in class size i
for a development
criterion of E* or
more quanta.

Fraction of grains
in class size i
which will develop
for the development
criterion (single
value) of E* quanta.

(2.4.67)

Let us consider the value for the sensitivity distribution when E* is equal to 1.

Figure 2.4.7 shows that S (E*) is equal to zero when E* is equal to 1. Therefore we do not have to consider this value of E*. On the other hand, E* values above 3 have corresponding S (E*) values greater than zero.

These facts define the lower limit of summation for expression 2.4.67.

Thus we may write

$$\sum_{E^*=1}^{\infty} P\,(E_i,\ E^*)\ S\,(i,\ E^*)$$

(2.4.68)

Equation 2.4.68 expresses the fraction of grains of class size i that are rendered developable.

EXERCISE

What value symbolically does the sum attain if the sensitivity distribution is 0.02 for $E* = 10$ and 0.04 for $E*$ equal to 16 and zero elsewhere?

In order to arrive at the total number of grains of class size i which are rendered developable symbolized as N_i' it is necessary to multiply expression 2.4.68 by N_i

$$N_i' = N_i \sum_{E*=0}^{\infty} P(E_i, E*) S(i, E*)$$

(2.4.69)

Using equation 2.4.28, we may write

$$N_i' = N \phi_i \sum_{E*=0}^{\infty} P(E_i, E*) S(i, E*)$$

(2.4.70)

Expression 2.4.70 is a fundamental expression that gives the total number of developable grains of class size i in terms of g.s.f.d., Poisson distribution and the sensitivity distribution.

The total number of developable grains of all class sizes, N' can be found by summing expression 2.4.70 over i.

Summing over i, we have

$$N' = N \sum_{i=0}^{\infty} \phi_i \sum_{E*=0}^{\infty} P(E_i, E*) S(i, E*)$$

(2.4.71)

Equation 2.4.71 does not include the effect of unequal sizes which contribute differently to the total optical transmission density (due to the differences in mean projected area).

THE PROJECTIVE AREA DISTRIBUTION

The grains N' do not contribute equally to the total optical transmission density because they have different mean projective areas.

The probability $P_D(i)$ of grains of class size i contributing to the optical transmission density is proportional to the mean projective area, a_i of the grain.

Thus we may write

$$P_D(i) = k_D a_i$$

(2.4.72)

However, the projective area for grains of class size i is proportional to the square of the diameter d_i in the following manner

$$a_i = \alpha d_i^2$$

(2.4.73)

where α is the proportionality constant. When

$$k_D' = k_D \alpha$$

(2.4.74)

we may write

$$P_D(i) = k_D' d_i^2$$

(2.4.75)

Therefore the total contribution of grains of class size **i** to the optical transmission density is

$$N_i' P_D(i)$$

(2.4.76)

and *for an elementary layer* the total contribution to density for grains of all class sizes is written by summing over i and we have

$$\sum_{i=0}^{\infty} N'_i P_D(i)$$

(2.4.77)

On the other hand, if all the grains in the elementary layer are rendered developable, we may drop the prime in 2.4.77 and this maximum contribution to density is

$$\sum_{i=0}^{\infty} N_i P_D(i)$$

(2.4.78)

Therefore the fundamental equation of the elementary layer in terms of D/D_{max} may now be written as

$$g(\log E) = \frac{\sum_{i=0}^{\infty} N'_i P_D(i)}{\sum_{i=0}^{\infty} N_i P_D(i)}$$

(2.4.79)

By substituting equations 2.4.70 and 2.4.75, we can now write

$$g(\log E) = \frac{\sum_{i=0}^{\infty} \phi_i d_i^2 \sum_{E^*=0}^{\infty} P(E_i, E^*) S(i, E^*)}{\sum_{i=0}^{\infty} \phi_i d_i^2}$$

(2.4.80)

This equation was derived by Freiser and Klein [Ref: H. Freiser and E. Klein, *Phot. Sci. Eng.*, 4, 264 (1960)].

SUMMARY

Expression 2.4.80 can be used to digitally simulate the characteristic curve for an elementary layer.

The value of E_i can be computed from equation 2.4.51.

In order to obtain the characteristic curve for a thick emulsion, equation 2.4.80, which represents the characteristic curve for the elementary layer, must be substituted into equation 2.4.25. The integration of expression 2.4.25 then yields the characteristic curve for the thick emulsion.

Freiser and Klein have applied this theory to a real emulsion.

They found an excellent match between their experimental and theoretical curves.

For this case, the g.s.f.d. was written as

$$\phi\,(d) \;=\; \frac{0.43}{d\cdot.0098\,\sqrt{2\pi}}\; e^{-(\log d/1.34 \times 10^{-4}\,\mathrm{cm})^2/2\,(.0098)^2}$$

The sensitivity distribution $S\,(E^*)$ was in the form of

$$S\,(E^*) \;=\; \frac{0.43}{E^*\cdot 0.60\,\sqrt{2\pi}}\; e^{-(\log E^*/14)^2/2(.06)^2}$$

These data indicated that the average number of quanta absorbed to render a grain developable was 14. The minimum amount of quanta absorbed in the toe region of the characteristic curve before a grain could be rendered developable was approximately 4.

When the D_{max} for an elementary layer was 0.07, the fraction of the grains that absorbed 4 quanta was approximately 60%.

A relationship between these results and the Computer Model of the Latent Image in Sections 2.2 and 2.3 does exist.

If 14 photons are absorbed on the average by grains in order to render the grains developable, how many photons are wasted due to the inefficiences associated with latent image formation? (See Sections 2.2 and 2.3).

If parameters chosen for the model yield experimental and theoretical characteristic curves of good fit similar to those of Freiser and

Klein [Ref: H. Freiser and E. Klein, *Phot. Sci. Eng.*, 4, 264 (1960)] then by digital simulation using the Monte Carlo methods the probabilities for nucleation, growth, recombination, etc., can be found. These digital simulated techniques could use as a starting point the fact that 14 photons are absorbed by grains on the average; then by using the three or five cycle the actual number of photons which are absorbed and contribute to forming, a developable grain 4, 5, or 6 atom aggregate might be established. This analysis could also relate the criterion for developability in terms of the size of silver atom aggregates as a function of a discrete (14) number of absorbed photons on the average.

The application of the digital simulation of Hamilton and Bayer to the theory of the characteristic curve may be most valuable for establishing the sensitivity distribution for various emulsions.

PROBLEM SET 2.4

1. Explain the $- 1/D$ term in equation 2.4.22.

2. Establish the limits in equation 2.4.24.

3. Derive equation 2.4.27a.

4. Why would you expect the absorption of photons by a grain to be a random process?

5. Does the absorption of photons change in any way during the growth of the latent image and the interval of exposure time?

6. Derive the expression for the probability that a silver halide grain will absorb at least E^* quanta and be rendered developable.

7. Calculate the values of D_{max} for the cases $E^* = 3$ and $E^* = 4$ (see Table 2.4.1).

(a) Plot $E^* = 3$.

8. Discuss the facts that set the lower limit summation for expression 2.4.67.

9. Construct a model for a digital simulation in order to find the criterion for developability in terms of the size and charge of the aggregate of the latent image as a function of a discrete number of absorbed photons on the average (review Sections 1.3, 2.2, 2.3).

As development temperature changes, how would the Fermi level of the developer affect the criterion for developability as a function of E^*?

3 Thermodynamics for Photography

The processes of latent image formation, development, theory of the characteristic curve, dye sensitization and desensitization in photography are all concerned with changes in energy.

The fundamental physical science that is concerned with systematizing energy changes involved in the appearance or disappearance of work coupled with the transfer of heat for photographic processes is *thermodynamics*.

Since thermodynamics is very general in applicability and depends solely upon its basic postulates, it is independent of any theory or model.

Thus refinements in present photographic theories will not affect the results and the conclusions of thermodynamics. However the exceeding generality of thermodynamics results in a loss of information. For example, thermodynamics can indicate that a particular photographic process is energetically possible, but it will not give information as to the rate for this process.

The purpose of this chapter is to discuss the three laws of thermodynamics, the application of the entropy concept, and to derive and use both free energy and the half wave potential in photographic application.

This section also supports the elements of thermodynamics that are applied in the rest of this text.

Since this section is written for the photographic worker, topics that are discussed in depth are those relating directly to photography.

Although only selected topics in thermodynamics are discussed, it will provide adaquate preparation for reading the photographic literature.

3.1 First Law

When considering a photographic emulsion in room air and under the conditions of evacuation, we specify the emulsion in the former case at a temperature of $\sim 300°$ K, and at a pressure of 1 atmosphere.

In the latter case, the emulsion is brought to the environmental conditions where the pressure may vary from 760 mm of mercury to 10^{-10} torr (1 mm Hg = 1 torr).

If we assume that the pressure in the evacuated state is 10^{-8} torr and that the corresponding temperature is 225° K, then we can characterize the state of this system as

$$P = 10^{-8} \text{ torr}$$

$$T = 225°\text{K} \tag{3.1.1}$$

The state of the former system is characterized by

$$P = 760 \text{ torr}$$

$$T = 300°\text{K} \tag{3.1.1a}$$

This example is an illustration of the state of a thermodynamic system.

When considering an ideal gas, we assume that an equation exists which connects the variables pressure, volume and temperature.

On the other hand, for photographic emulsions or other complex systems, it is often necessary to also specify the different phases present and the composition in order to completely specify the state of a system.

The equation that relates the state variables for an ideal gas (an ideal gas can be considered a system of point particles that do not interact with each other) may be derived as follows:

The investigator Boyle found that the product

$$PV = \text{Constant}$$

(3.1.1b)

at a given temperature.

Charles and Gay-Lussac found that the volume of a gas is proportional to the temperature at a constant pressure

$$V = kT$$

(3.1.2)

where k is the proportionality constant.

Equation 3.1.1b is called *Boyle's law* and equation 3.1.2 is referred to as *Charles' law*.

If we consider a gas at constant temperature going from state 1 to state 2, then Boyle's law is written

$$P_1 V_1 = P_2 V_2$$

(3.1.3)

For this same change of state at constant pressure, Charles' law indicates

$$\frac{V_1}{T_1} = \frac{V_2}{T_2}$$

(3.1.4)

This change of state can be written as

$$(P_1, V_1, T_1) \longrightarrow (P_2, V_2, T_2)$$

(3.1.5)

We can arrive at the new state by first holding temperature constant and then holding pressure constant (Figure 3.1.1). The equation for the former change is

$$(P_1, V_1, T_1,) \xrightarrow{\text{Temp. Constant}} (P_2, V_x, T_1)$$

<div align="right">(3.1.6)</div>

and for the latter we write

$$(P_2, V_x, T_1) \xrightarrow{\text{Pressure Constant}} (P_2, V_2, T_2)$$

<div align="right">(3.1.7)</div>

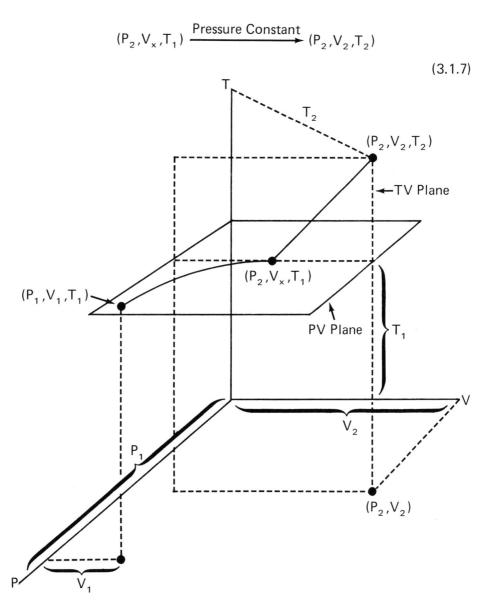

Fig. 3.1.1 *Shows the constant temperature and pressure planes for the paths from* (P_1, V_1, T_1) *to* (P_2, V_x, T_1) *and to the final position* (P_2, V_2, T_2).

Since equation 3.1.6 represents a process taking place at constant temperature, it can be described by Boyle's law

$$V_x = \frac{P_1 V_1}{P_2}$$

(3.1.8)

Equation 3.1.7 proceeds at constant pressure and applying Charles' and Gay-Lussac's law, we write

$$V_x = \frac{V_2 T_1}{T_2}$$

(3.1.9)

Equating equations 3.1.8 and 3.1.9, we obtain

$$\frac{P_1 V_1}{T_1} = \frac{V_2 P_2}{T_2}$$

(3.1.10)

Equation 3.1.10 shows that

$$\frac{PV}{T} = k$$

(3.1.11)

where k is a constant.

According to Avogadros law, the volume of a gas at a constant temperature and pressure is proportional to the number of moles of the gas.

Rewriting equation 3.1.11, we have

$$V = \frac{kT}{P}$$

(3.1.12)

Applying Avogadros law, we may identify k as

$$k = nR$$

where n = the number of moles of the gas
and R = a constant and is the same for all gases
 (1.987 cal/deg mole)

We can now write the familiar *ideal gas equation*

$$PV = nRT$$

(3.1.13)

Since real gases cannot be accurately characterized by the PVT relations used for the ideal gas laws, further refinements of 3.1.13 are necessary. Van der Waals' work led to the inclusion of two terms that corrected for the volume occupied by the molecules and a correction term for the weak forces of attraction between molecules. These intermolecular attractive forces (now called van der Waals' forces) although relatively weak, are responsible for the condensation of all gases at low temperature. Since the attractive force is proportional to the density of molecules, where n is the number of moles of a gas in volume V, we have

$$\frac{n}{V}$$

(3.1.14)

and since neighboring molecules also exert an attractive force on all other molecules, then the total attractive power of a gas with respect to these interactions is proportional to

$$\left(\frac{n}{V}\right)^2$$

<div align="right">(3.1.15)</div>

Thus the van der Waals' equation is

$$\left(P + \frac{an^2}{V^2}\right)(V - nb) = nRT$$

<div align="right">(3.1.16)</div>

where b = the excluded volume of a gas that is considered
a constant and representative of each gas
a = proportionality constant

The van der Waals' constants a and b can be used to predict the critical temperature for the liquification of gases. These constants can also be used to predict the vapor pressure of liquids.

The most general equation of state that can be used for exacting determinations for gases is the *virial equation.* For one mole of gas the equation has the form

$$PV = RT + AP + BP^2 + CP^3 + \ldots$$

<div align="right">(3.1.17)</div>

where A = The second virial coefficient
B = The third virial coefficient
C = The fourth virial coefficient

An alternate form of the virial equation is

$$\frac{PV}{RT} = 1 + \frac{A'}{V} + \frac{B'}{V^2} + \frac{C'}{V^3} + \ldots$$

<div align="right">(3.1.18)</div>

where A, B, C, A', B', C' are all functions of temperature that can be determined by the measurement of gases at various pressures for each temperature being measured.

When dealing with liquids and solids, one may approximate the equation of state by defining constants such that the volume is related to temperature and pressure in a linear manner.

The following equation utilizes two empirical constants α and β that can be used for a good approximation.

$$V = V_o (1 + \alpha T - \beta P)$$

$$(3.1.19)$$

Equation 3.1.19 can be extended in a manner analagous to the virial equations 3.1.17 or 3.1.18. Thus higher power terms in T and P can be added to the equation and we have

$$V = V_o (1 + \alpha_1 T + \alpha_2 T^2 + \alpha_3 T^3 + \ldots$$
$$- \beta_1 P - \beta_2 P^2 - \beta_3 P^3 \ldots)$$

$$(3.1.19a)$$

The extra work involved in determining the constants α and β in equation 3.1.19a is justified only for data of high accuracy.

These equations of state are usually related to the system rather than the surroundings, where the system is a portion of the universe separated from the surroundings by real or imaginary boundaries.

WORK

If we consider a gas or liquid at some pressure P in a cylinder exerting a force against a piston that is exactly balanced by a confining force f that also acts on the piston, then the force produced by the pressure P, in force per unit area, against a piston of cross sectional area A is

$$f = PA$$

$$(3.1.20)$$

If the piston is moved a distance dl due to an infinitesimal expansion, the *work* may be expressed as

$$\text{d}\!\!\!/w = fdl$$

$$(3.1.21)$$

where the slash indicates that dw is not the differential of any function.

Since the change in volume for the cylinder is

$$Adl = dV \qquad (3.1.22)$$

we can write

$$\overline{d}w = \frac{f}{A}(Adl) \qquad (3.1.23)$$

Since the pressure is defined as

$$P = \frac{f}{A} \qquad (3.1.23a)$$

the work of expansion may be written as

$$\overline{d}w = PdV \qquad (3.1.24)$$

and

$$w = \int_{V_1}^{V_2} PdV \qquad (3.1.25)$$

The integral of equation 3.1.25 cannot be evaluated unless a definite path is chosen. Therefore the summation is accomplished by line integration where the value of the integral represents the work done and depends entirely on the path chosen.

When the forces are exactly balanced during a compression or expansion, the process is said to take place *reversibly*. The maximum work is obtained from a reversible process. On the other hand, if the pressure in the system is much greater than the pressure in the surroundings, the piston will be driven out with a strong force. This process is *irreversible* and the work done is less than the maximum work attainable in a reversible process.

Although there are no reversible processes in nature, the concept of reversibility enables the worker to calculate the energy changes for many irreversible processes.

A chosen path implies that we must find the functional relationship for P in terms of V. An example for a reversible path is an ideal gas in an isothermal process.

When work is done on the surroundings for an ideal gas assuming an isothermal process (Table 3.1.1) we have

$$PV = nRT$$

(3.1.26)

$$P = \frac{nRT}{V}$$

(3.1.27)

Since temperature is constant in an isothermal process,

$$WORK = \int \frac{nRT}{V} dV = nRT \int_{V_1}^{V_2} \frac{dV}{V}$$

(3.1.28)

$$w = nRT \ln \left(\frac{V_2}{V_1}\right)$$

(3.1.29)

TABLE 3.1.1

THERMODYNAMIC PROCESSES		
Isothermal process	=	Constant temperature
Isopiestic process	=	Constant pressure
Adiabatic process	=	No heat flow across the boundaries that separate the system and the surroundings
Cyclical process	=	Initial and final states of the system are the same

For an isopiestic reversible process involving an ideal gas, the pressure is constant and we write

$$w = \int PdV = P \int_{V_1}^{V_2} dV = P(V_2 - V_1) = P\Delta V$$

$$= nR(T_2 - T_1)$$

(3.1.30)

Since $\Delta V = V_2 - V_1$, and $\Delta T = T_2 - T_1$

(3.1.31)

equation 3.1.30 becomes

$$P\Delta V = nR\Delta T$$

(3.1.32)

FIRST LAW OF THERMODYNAMICS

In photographic chemical systems, the law of conservation-of-energy is conveniently expressed in terms of the quantities: work, heat and energy.

By convention, q is the heat *added* to the system. When heat is removed from the system, it is negative. Similarly, when *work* is *done* on the system, the sign is negative and when it appears in the surroundings, it is positive.

Let us consider a chemical reaction representing a photographic process where the system goes from an initial to a final state with a change in temperature. Since the internal energy change for this system is dependent only on the initial state **a** and final state **b**, and not on the path chosen, we may write

$$\Delta E = E_b - E_a$$

(3.1.33)

Arbitrarily we define

q = heat absorbed by the system from the
 surrounding
w = work done by the system on the surroundings
ΔE = change in the internal energy of a system.

The quantities q and w depend upon path while the quantity q − w is independent of path.

Since every state of a system is represented by an energy E, then any change in the state of a system has associated with it a change in energy, ΔE, and we may write

$$dE \quad = \quad dq \quad - \quad dw$$

Exact Differential Inexact Differential Inexact Differential

(3.1.34)

where the addition of two inexact differentials produces an exact differential.

Since energy is a function of the state of the system whose change can be measured independent of path, then this function does not change when a cyclic process occurs and the system returns to its initial state. Thus for such a cyclic process we write

$$\oint dE = 0$$

(3.1.35)

When functions have a cyclic integral equal to zero, they are called *state functions*.

Thus we may state the first law of thermodynamics as: When at system undergoes a change in state, *the quantity q - w depends only upon the initial and the final states of the system and is independent of path*.

Mathematically this definition is expressed by

$$\boxed{\Delta E = q - w}$$

(3.1.36)

When we assume that the only work being done is in contraction or expansion and if we neglect the effects of friction, where

$$w = \int PdV \text{ reversible}$$

(3.1.37)

then at constant pressure

$$\Delta E = q_p - P\Delta V$$

(3.1.38)

If the process occurs at constant volume, i.e., $\Delta V = 0$, and if the only work is that of expansion or contraction, then the heat absorbed at constant volume is equal to the change in energy, and we write

$$\Delta E_V = q_V$$

(3.1.39)

The heat absorbed by the system at constant pressure is written as

$$q_p = \Delta E_p + P\Delta V$$

(3.1.40)

We now define a new quantity called the *enthalpy* function symbolized as H.

Enthalpy is defined as

$$H = E + PV$$

(3.1.41)

and

$$\Delta H = \Delta E + \Delta(PV)$$

(3.1.42)

Thus the enthalpy change at constant pressure equals the heat absorbed by the system and we write

$$\Delta H_p = \Delta E + P\Delta V = q_p$$

(3.1.43)

or

$$\boxed{\Delta H_p = q_p}$$

(3.1.44)

Since the cyclic integrals for E, P and V are equal to zero, these variables are state functions. Since H is a function of these variables, it is a state function.

Ordinarily when we think of the 1st law we think of the system absorbing heat from the surroundings and doing useful work on the surroundings. A certain amount of the heat is not available to do useful work so that it simply increases the internal energy of the system.

When the first law is applied to the primary process of latent image formation we think of the action of absorbed photons in an emulsion system giving rise to hole electron pairs. Photons possessing less than the energy needed to produce a hole electron pair may still be absorbed by the emulsion system to produce heat in the form of vibrational molecular motion.

Now as we consider that the function of the photon is to do work in terms of producing hole electron pairs, then those absorbed photons that do not produce hole electron pairs increase the internal energy of the system and do no useful work.

The process of photon absorption that can give rise to hole-electron pair formation is analogous to the first law of thermodynamics.

A calculation of the difference in the number of photons absorbed and the number of hole electron pairs produced provides quantitative data with respect to the increase in internal energy of the undissociated molecules.

However, in order to produce a calculation for the change in internal energy of an emulsion system, the energy needed to produce a hole electron pair is multiplied by the number of hole electron pairs and must be subtracted from the energy of the absorbed photons.

For photons of constant frequency we may write

$$\Delta E = h\nu N_{ab} - E_{h,e} N_{h,e}$$

(3.1.45)

where ΔE = change in internal energy of the system.
 $h\nu$ = energy of a photon of frequency ν.
 h = 6.623×10^{-27} erg-sec.
 N_{ab} = The number of absorbed photons of frequency ν.

$E_{h,e}$ = The amount of energy required to produce a hole electron pair. (The binding energy of a hole electron pair.)

$N_{h,e}$ = The number of hole electron pairs produced.

For broad spectrum radiation (photons of many frequencies) we construct an integral according to Figure 3.1.2.

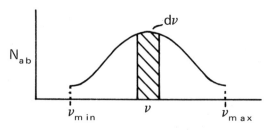

Fig. 3.1.2 *Shows a continuous absorption spectrum over a wide range of frequencies. The total* *energy absorbed is equal to the area under the curve multiplied by Planck's constant.*

$$h \int_{\nu_{min}}^{\nu_{max}} N_{ab}(\nu)\nu d\nu \quad = \quad \text{Total energy of absorbed photons in the interval } \nu_{min} \to \nu_{max}.$$

(3.1.46)

Using the above integral, the change in internal energy of the system becomes

$$\Delta E \quad = \quad h \int_{\nu_{min}}^{\nu_{max}} N_{ab}(\nu)\nu d\nu \quad - \quad N_{h,e} E_{h,e}$$

(3.1.47)

The integral term in equation 3.1.47 represents an easily measurable quantity. It can be determined by measuring the total number of photons absorbed. The term ΔE in this equation representing the change in internal energy of the system can be determined by measuring the heat capacity $\partial E/\partial T_v$ and the temperature rise of the emulsion (see Section 3.2).

Thus at least in principle the number of hole electron pairs can be computed from the difference in these measured quantities.

A possible source of error in this calculation may occur when a photon is completely absorbed but does not produce a hole electron pair or a measurable heat change.

It is also possible for photons to be absorbed by the gelatin and produce a polymerization reaction. Fortunately the gelatin absorption in the visible region of the spectrum is less than 1%, with almost total absorption occurring at approximately 3000 Å.

3.2 Derivatives of E and H

The heat capacity for a substance at constant volume is defined as

$$C_V = \frac{q_V}{\Delta T}$$

$$(3.2.1)$$

Substituting 3.1.39 into 3.2.1, we obtain

$$C_V = \frac{\Delta E_V}{\Delta T}$$

$$(3.2.2)$$

The limiting definition of C_V is written as

$$\lim_{\Delta T \to 0} \frac{\Delta E_V}{\Delta T} = \left(\frac{\partial E}{\partial T}\right)_V$$

$$(3.2.3)$$

Thus we may define

$$C_V = \left(\frac{\partial E}{\partial T}\right)_V$$

$$(3.2.4)$$

Similarly the heat capacity at constant pressure is defined as

$$C_P = \frac{Q_P}{\Delta T} = \frac{\Delta H_P}{\Delta T}$$

$$(3.2.5)$$

The limiting definition of C_P is

$$\lim_{\Delta T \to 0} \Delta H_P / \Delta T = \left(\frac{\partial H}{\partial T}\right)_P$$

(3.2.6)

thus we may write

$$C_P = \left(\frac{\partial H}{\partial T}\right)_P$$

(3.2.7)

The limiting definition of C_V suggests that we consider energy as a function of temperature and pressure $E(T,V)$.

Since state functions have exact differentials, we may write

$$dE = \left(\frac{\partial E}{\partial T}\right)_V dT + \left(\frac{\partial E}{\partial V}\right)_T dV = C_V dT + \left(\frac{\partial E}{\partial V}\right)_T dV$$

(3.2.8)

Similarly, since

$$H(T, P)$$

(3.2.9)

we obtain

$$dH = \left(\frac{\partial H}{\partial T}\right)_P dT + \left(\frac{\partial H}{\partial P}\right)_T dP = C_P dT + \left(\frac{\partial H}{\partial P}\right)_T dP$$

(3.2.10)

DERIVATION OF $C_P - C_V$

Since

$$E(T, V)$$

(3.2.11)

and

$$dE = \left(\frac{\partial E}{\partial T}\right)_V dT + \left(\frac{\partial E}{\partial V}\right)_T dV$$

(3.2.12)

If we assume a functional relationship between T, P and V, we may write

$$E \ (P, T) \quad \text{or} \quad E \ (P, V)$$

(3.2.13)

In order to derive the relationship

$$\left(\frac{\partial E}{\partial T}\right)_P = \left(\frac{\partial E}{\partial V}\right)_T \left(\frac{\partial V}{\partial T}\right)_P + \left(\frac{\partial E}{\partial T}\right)_V$$

(3.2.14)

we allow

$$E \ (P, T)$$

(3.2.15)

and we write

$$dE = \left(\frac{\partial E}{\partial P}\right)_T dP + \left(\frac{\partial E}{\partial T}\right)_P dT$$

(3.2.16)

Assuming that

$$V \ (T, P)$$

(3.2.17)

we write

$$dV = \left(\frac{\partial V}{\partial T}\right)_P dT + \left(\frac{\partial V}{\partial P}\right)_T dP$$

(3.2.18)

Substitution of equation 3.2.18 into 3.2.12 results in

$$dE = \left\{ \left(\frac{\partial E}{\partial V}\right)_T \left(\frac{\partial V}{\partial T}\right)_P + \left(\frac{\partial E}{\partial T}\right)_V \right\} dT + \left(\frac{\partial E}{\partial V}\right)_T \left(\frac{\partial V}{\partial P}\right)_T dP$$

(3.2.19)

Comparison of the coefficients of dT in equation 3.2.19 and equation 3.2.16 shows that

$$\left(\frac{\partial E}{\partial T}\right)_P = \left(\frac{\partial E}{\partial V}\right)_T \left(\frac{\partial V}{\partial T}\right)_P + \left(\frac{\partial E}{\partial T}\right)_V$$

(3.2.20)

Similarly, the comparison of the coefficients of dP in these two equations results in

$$\left(\frac{\partial E}{\partial P}\right)_T = \left(\frac{\partial E}{\partial V}\right)_T \left(\frac{\partial V}{\partial P}\right)_T$$

(3.2.21)

Using the definitions of C_P and C_V, we may write

$$C_P - C_V = \left(\frac{\partial H}{\partial T}\right)_P - \left(\frac{\partial E}{\partial T}\right)_V$$

(3.2.22)

Since H = E + PV, we can substitute and write

$$C_P - C_V = \left(\frac{\partial E}{\partial T}\right)_P + P\left(\frac{\partial V}{\partial T}\right)_P - \left(\frac{\partial E}{\partial T}\right)_V$$

(3.2.23)

Substituting equation 3.2.20 into 3.2.23, we have

$$C_P - C_V = \left(\frac{\partial E}{\partial V}\right)_T \left(\frac{\partial V}{\partial T}\right)_P + \left(\frac{\partial E}{\partial T}\right)_V + P\left(\frac{\partial V}{\partial T}\right)_P - \left(\frac{\partial E}{\partial T}\right)_V$$

(3.2.24)

Simplifying, we find

$$C_P - C_V = \left\{P + \left(\frac{\partial E}{\partial V}\right)_T\right\} \left(\frac{\partial V}{\partial T}\right)_P$$

(3.2.25)

The term $(\partial E/\partial V)_T$ in equation 3.2.25 represents the internal energy dependence on the volume at constant pressure. Since ideal gases do not account for intermolecular interactions, this term vanishes because the internal energy is not a function of volume. Thus an ideal gas is defined by the equations

$$PV = nRT$$

(3.2.26)

and

$$(\partial E/\partial V)_T = 0$$

(3.2.27)

For one mole of an ideal gas

$$\left(\frac{\partial V}{\partial T}\right)_P = \frac{R}{P}$$

(3.2.28)

Substituting equations 3.2.28 and 3.2.27 into equation 3.2.25, we find for an ideal gas that

$$C_P - C_V = R$$

(3.2.29)

where R is equal to the gas constant.

EXERCISE

1. Given a pure AgBr crystal, how would we find the minimum photon energy needed to produce a measurable electronic pulse?
2. What parameter do the results measure?

For solids and liquids, the volume changes accompanying their heating are small so that

$$C_P \approx C_V$$

(3.2.30)

Thus in the case of an emulsion we may use C_P in place of C_v as long as the emulsion is not heated to its melting point.

Heat capacities ordinarily vary with temperature and we may express such variations as

$$C_P = a + bT + cT^2 + dT^3 \tag{3.2.31}$$

The constants a, b, c and d are determined empirically for each substance.

When these empirical constants have been determined in a calorimeter, the equation can be integrated over some temperature range to determine the change in enthalpy for a gas or the change in energy for a solid or a liquid. Thus for an emulsion, the value of E for some temperature change can be determined by finding the empirical constants and integrating over some temperature range.

Since E is a state function of the system, we can produce the same temperature rise and the same change in E by irradiation and subsequent absorption of photons. The energy of the absorbed photons can easily be calculated by use of the integral term of equation 3.2.32.

$$\Delta E = h \int_{\nu_{min}}^{\nu_{max}} N_{ab}(\nu)\nu d\nu - N_{h,e} E_{n,e} \tag{3.2.32}$$

Utilizing equations 3.2.4, 3.2.30 and 3.2.32 we obtain

$$\int_{T_1}^{T_2} C_p dT = h \int_{\nu_{min}}^{\nu_{max}} N_{ab}(\nu)\nu d\nu - N_{h,e} E_{h,e} \tag{3.2.33}$$

Solving for the number of hole electron pairs produced we write

$$N_{h,e} = \left\{ h \int_{\nu_{min}}^{\nu_{max}} N_{ab}(\nu)\nu d\nu - \int_{T_1}^{T_2} C_p dT \right\} / E_{h,e} \tag{3.2.34}$$

The value of $E_{h,e}$ can be estimated by finding the threshold photon energy required to achieve ionization of the bromide ions of the silver bromide emulsion.

3.3 Applications of the First Law

The application of the first law of thermodynamics to photographic chemical reactions is called thermochemistry. The measurement of calculation of the heat absorbed or given off in chemical reactions is the nature of thermochemistry. Thermochemistry is used to determine the lattice energy of silver halides and the heat given off or absorbed during the chemical reactions of the photographic process. Further applications of thermochemistry are the determination of *bond enthalpies* and *bond energies* of molecules.

THE ENERGY AND ENTHALPY OF REACTIONS

The *energy of a reaction* is written as

$$\Delta E = E \text{ (products)} - E \text{ (reactants)} \tag{3.3.1}$$

and the *enthalpy of a reaction* is written as

$$\Delta H = H \text{ (products)} - H \text{ (reactants)} \tag{3.3.2}$$

The energy change for the reaction

$$Ag_{(m)} + \tfrac{1}{2}Br_{2\,(l)} \longrightarrow AgBr_{(c)}$$

where m = metal, l = liquid and c = crystal

$$\tag{3.3.3}$$

is written as

$$\Delta E = E(AgBr) - E(Ag) - \tfrac{1}{2}E(Br_2)$$

$$(3.3.4)$$

The enthalpy change for reaction 3.3.3. is

$$\Delta H = H(AgBr) - H(Ag) - \tfrac{1}{2}H(Br_2)$$

$$(3.3.5)$$

The units of ΔE, E, ΔH and H are kilocalories per mole.

When ΔE and ΔH are positive quantities, heat is absorbed by the reacting system and the reaction is called an *endothermic* reaction.

When ΔE and ΔH are negative, heat is given off to the surroundings and the reaction is called *exothermic*.

Many reactions that proceed spontaneously and irreversibly after simple mixing may be either endothermic or exothermic.

When the addition of heat is required in order to initiate a reaction which can then proceed spontaneously (striking of a match), this reaction can still be considered as spontaneous and irreversible.

Since spontaneous reactions can be both endothermic and exothermic, the methods of thermochemistry cannot be used to determine whether a reaction can take place. The state function called *entropy* that is treated later in this chapter determines whether a reaction can occur.

Since enthalpy is related to energy by the equation

$$H = E + PV$$

$$(3.3.6)$$

then

$$\Delta H = \Delta E + \Delta(PV)$$

$$(3.3.7)$$

If both the reactants and products remain in either liquid or solid form, the $\Delta(PV)$ term can be neglected. On the other hand, if either the reactants or products proceed from solid to gaseous states or liquid to gaseous states or vice versa, this term cannot be neglected.

In order to obtain an estimate of this term, we consider that a

reaction takes place in room air at constant pressure and temperature. Assuming that the ideal gas law holds and that Δn moles of gas are produced in the course of the reaction, we may write

$$\Delta H = \Delta E + \Delta(nRT)$$

(3.3.8)

and

$$\Delta H = \Delta E + \Delta nRT$$

(3.3.9)

where

$$\Delta n = n(\text{gas products}) - n(\text{gas reactants})$$

(3.3.9a)

ENTHALPY, ENERGY AND HEAT OF A PROCESS

The enthalpy H has been defined and shown to be a state function, which means that the enthalpy change for any process is independent of the path chosen.

Similarly, ΔH_p has been shown to be the heat absorbed at constant pressure for the process.

Thus, whenever this text refers to the heat of a process, it is to be interpreted as the change in enthalpy at constant pressure where the only work involved is PV work.

We define the following enthalpies and heats of processes.

a) The heat involved during the formation of a compound from its elements is called the *heat of formation* and is symbolized as

$$\Delta H_f$$

(3.3.10)

b) The heat absorbed during the process taking a liquid to a gaseous state is called the *heat of vaporization* and is symbolized as

$$\Delta H_{vap}$$

(3.3.10a)

c) The heat involved in a process taking a solid to the gaseous state is called the *heat of sublimation* and is symbolized as

$$\Delta H_{sub}$$

(3.3.10b)

d) The heat involved in a process taking a liquid to the solid state is called the *heat of fusion* and given the symbol

$$\Delta H_{fus}$$

(3.3.10c)

The change in energy related to these heats is given by the equation

$$\Delta H = \Delta E + \Delta(PV)$$

(3.3.11)

Since the heat of formation can be written

$$\Delta H_f = \Delta E_f + \Delta(PV)$$

(3.3.12)

the energy of formation becomes

$$\Delta E_f = \Delta H_f - \Delta(PV)$$

(3.3.13)

In all cases it is assumed that the ideal gas law holds, so that we may write

$$\Delta E_f = \Delta H_f - \Delta nRT$$

(3.3.14)

Since the heat of fusion involves a process going from the liquid to the solid state, the corresponding volume change is very small, the PV work can be neglected and we arrive at the equation

$$\Delta H_{fus} = \Delta E_{fus}$$

$$(3.3.15)$$

However, the PV work cannot be neglected in the processes of vaporization and sublimation.

Consequently, we may write

$$\Delta H_f = \Delta E_f + \Delta nRT$$

$$(3.3.16)$$

$$\Delta H_{vap} = \Delta E_{vap} + \Delta nRT$$

$$(3.3.17)$$

$$\Delta H_{fus} = \Delta E_{fus}$$

$$(3.3.18)$$

$$\Delta H_{sub} = \Delta E_{sub} + \Delta nRT$$

$$(3.3.19)$$

STANDARD HEAT OF FORMATION

The standard state of any substance is the physical and chemical state of that substance at 1 atmosphere of pressure and at a temperature of $25°C$.

By the arbitrary assignment of zero to the enthalpies of elements in the standard state we can satisfy all enthalpy equations in the following manner.

a) Find the heat of formation of the compounds in the reaction being studied.

b) Place the values of the heat of formation multiplied by the stoichiometric coefficients under each term in the algebraic term.

c) Add the terms representing the products; then add the terms representing the reactants.

d) Subtract the sum representing the reactants from the sum representing the products. The result will be the enthalpy of the equation.

By the above method, the heat of any reaction can be easily computed by reference to tables.

Example

Consider the reaction

$$2AgNO_3 \ + \ H_2S_{(g)} \longrightarrow Ag_2S_{(c)} \ + \ 2HNO_{3(1)}$$

(3.3.20)

Calculate the heat of formation for this reaction.
We look for a table of standard heats of formation,

$$\Delta H_f^\circ$$

(3.3.21)

where the standard heat of formation is the heat of formation of compounds relative to their elements in the standard state.

According to *Lang's Handbook of Chemistry* [Ref: 10th edition, McGraw-Hill Book Company (1961), pp. 1576-1647] the standard heats of formation of the compounds in this reaction are given in Table 3.3.1.

TABLE 3.3.1

COMPOUND OR ATOM	ΔH_f° (kcal/mole)
$HNO_{3(l)}$	$-$ 41.40
$AgNO_{3(c)}$	$-$ 29.43
$Ag_2S_{(c)}$	$-$ 7.60
$H_2S_{(g)}$	$-$ 4.82
$AgBr_{(c)}$	$-$ 23.78
$AgCl_{(c)}$	$-$ 30.36
$AgI_{(c)}$	$-$ 14.91
$C_{(g)}$	$+$ 171.70
$H_{(g)}$	$+$ 52.09
$Br_{(g)}$	$+$ 26.71
$Cl_{(g)}$	$+$ 29.01
$S_{(g)}$	$+$ 53.25
$Ag_{(g)}$	$+$ 69.12
$I_{(g)}$	$+$ 25.48
$CH_{4(g)}$	$-$ 17.89

Using the values in Table 3.3.1, we calculate

$$\Delta H = 2(-41.40) + (-7.60) - (-4.82) - 2(-29.43)$$

$$(3.3.22)$$

$$\Delta H = -26.72 \frac{kcal}{mole} \text{ of } Ag_2S \text{ formed}$$

(3.3.23)

$$\Delta H = -13.36 \frac{kcal}{mole} \text{ of } HNO_3 \text{ formed}$$

(3.3.24)

This calculation shows that reaction 3.3.20 is exothermic.

The standard energy of formation ΔE_f° is defined as the change in energy for the reaction of elements in the standard state going to products.

In order to calculate the standard energy of formation ΔE_f° we utilize the equation

$$H = E + PV$$

(3.3.25)

and

$$\Delta H_f^\circ = \Delta E_f^\circ + \Delta(PV)$$

(3.3.26)

Assuming that the ideal gas law holds and since the temperature is constant, we may write

$$\Delta H_f^\circ = \Delta E_f^\circ + \Delta nRT$$

(3.3.27)

At standard conditions, $298^\circ K$

$$RT = 0.593 \text{ kcal/mole}$$

(3.3.28)

Substituting the result of 3.3.28 into equation 3.3.27, we write

$$\Delta H_f^\circ = \Delta E_f^\circ + 0.593 \Delta n$$

(3.3.29)

Applying equation 3.3.29 to the reaction

$$Ag_{(m)} \ + \ \tfrac{1}{2}Br_{2\,(l)} \ \longrightarrow \ AgBr_{(c)}$$

(3.3.29a)

we may write

$$\Delta n \ = \ n(\text{gas products}) \ - \ n(\text{gas reactants})$$

(3.3.30)

where both the number of moles of gas products and the number of moles of gas reactants for reaction 3.3.29a are zero and we have

$$\Delta n \ = \ 0$$

(3.3.31)

Thus we may write

$$\Delta H_f^\circ \ \approx \ \Delta E_f^\circ$$

(3.3.32)

and the standard heat of formation of silver bromide crystals is approximately equal to the standard energy of formation of silver bromide crystals.

The standard heat of formation of silver chloride in the crystal state is -30.36 kilocalories/mole. (Table 3.3.1).

This heat of formation corresponds to the reaction

$$Ag_{(m)} \ + \ \tfrac{1}{2}Cl_{2\,(g)} \ \longrightarrow \ AgCl_{(c)}$$

(3.3.33)

Reaction 3.3.33 shows one half of a mole of chlorine gas as a reactant and zero moles of gaseous products. Consequently, we may write

$$\Delta H_f^\circ \ = \ \Delta E_f^\circ \ - \ \tfrac{1}{2}RT$$

(3.3.34)

Substituting the value for the standard heat of formation, we write

$$\Delta E_f^\circ = -30.36 + 0.296$$

(3.3.35)

$$\Delta E_f^\circ = -30.06 \, \frac{kcal}{mole}$$

(3.3.36)

This reaction for the formation of silver chloride from its elements in the standard state shows that the PV term cannot be neglected.

HEAT OF SOLUTION

When a solute is added to a solvent to form a solution, an enthalpy change is involved. This enthalpy change is called the *heat of solution*.

The change in enthalpy that attends the mixing of two liquids is called the *heat of mixing*.

The diluting of a solution by addition of more solvent has an enthalpy change for this process that is called the *heat of dilution*.

A solution is said to be *infinitely dilute* with respect to enthalpy when additional dilution does not produce any further heat effect.

An example of an equation for the heat of solution of 1 mole of potassium bromide dissolved in 10 moles of water is

$$KBr + 10\,Aq \longrightarrow KBr \circ 10\,Aq - 3.96 \, kcal$$

(3.3.37)

The heat of solution for other dilutions of KBr dissolved in aqueous solution may be obtained from the Heat of Formation Table 3.3.2. The data obtained for Table 3.3.2 are from *Lang's Handbook of Chemistry*, 10th ed., McGraw-Hill Book Company, 1961.

TABLE 3.3.2

SOLUTE	MOLES H_2O/MOLES SOLUTE	ΔH_f°
KBr	0	− 93.73
KBr	10	− 89.77
KBr	50	− 89.07
KBr	1000	− 88.88
KBr	∞	− 88.94
$AgNO_3$	0	− 29.43
$AgNO_3$	∞	− 0.93
Na_2SO_3	0	− 260.60
Na_2SO_3	1	− 263.80
Na_2CO_3	0	− 270.30
Na_2CO_3	15	− 278.13
	40	− 277.30
Na_2CO_3	200	− 276.17
NaOH	0	− 101.99
NaOH	3	− 109.89
NaOH	6	− 111.52
NaOH	25	− 112.22
NaOH	∞	− 112.24
CH_3COOH	gas, 0 water	− 104.72
CH_3COOH	5	− 116.31
CH_3COOH	∞	− 116.74
$Na_3PO_4 \cdot 12H_2O$	0	−1309.00

In equation 3.3.37, the symbol Aq represents H_2O liquid. This notation is used since chemists arbitrarily assign 0 kcal/mole for the heat of formation of Aq whenever water acts as an inert solvent that is not involved in a chemical reaction.

In order to obtain equation 3.3.37, we must add the equation of formation for potassium bromide in 10 moles of water (equation 3.3.38) to the reverse of the equation of formation of dry potassium bromide.

$$\text{K} \ + \ \tfrac{1}{2}\text{Br}_2 \ + \ 10 \text{ Aq} \longrightarrow \text{KBr} \cdot 10 \text{ Aq} \ + \ 89.77$$

(3.3.38)

According to Table 3.3.2, equation 3.3.38 is an exothermic reaction. The reverse of the equation of formation for dry potassium bromide is

$$KBr \longrightarrow K + \tfrac{1}{2}Br_2 \quad - \quad 93.73$$

(3.3.39)

By addition of equations 3.3.38 and 3.3.39, we obtain

$$KBr + 10\,Aq \longrightarrow KBr\,10\,Aq \quad - \quad 3.96\,\frac{kcal}{mole}$$

(3.3.40)

A precipitation reaction for the formation of silver bromide at an infinite dilution of silver nitrate and potassium bromide at standard conditions is

$$AgNO_3 \cdot \infty Aq + KBr \cdot \infty Aq \longrightarrow AgBr_{(s)} + KNO_3 \cdot \infty Aq$$

(3.3.41)

This reaction gives off a considerable amount of heat. It is also found that the reaction of sodium bromide and silver nitrate yields the same amount of heat.

Furthermore, an infinitely dilute solution of potassium bromide and potassium nitrate when mixed do not give a heat of mixing. These facts can be explained by the ionic theory.

Implications of the theory are:

1) Electrolytes such as NaCl, KBr, $AgNO_3$, KCl, Na_2SO_3, Na_2CO_3 are completely ionized in infinitely dilute solutions.
2) The mixing together of electrolytes in infinitely dilute solutions the ions of which do not react produces no heat effect.
3) The mixing together of electrolytes that react will produce a heat effect.

We can conclude from this ionic theory that the heat effect produced in reaction 3.3.41 is due to the reaction of the silver and bromide ions.

Thus, according to the ionic theory, we can rewrite reaction 3.3.41 as

$$Ag^+ \cdot \infty \, Aq \quad + \quad Br^- \cdot \infty Aq \longrightarrow AgBr_{(c)} \quad + \quad \infty \, Aq$$

$$(3.3.42)$$

In order to calculate the heats of reaction in solution, the chemist conventionally takes the heat of formation of the hydrogen ion at infinite dilution

$$H^+ \cdot \infty \, Aq$$

$$(3.3.43)$$

to be zero.

By using this convention, a table of the heats of formation of ions at infinite dilution with respect to the elements in standard states at $25°C$ and be constructed (Table 3.3.3).

The data for Table 3.3.3 were obtained from *Chemical Thermodynamics* [Ref: F. T. Wall, W. H. Freeman Co., 1965, 2nd ed., p. 59].

TABLE 3.3.3

ION AT ∞ DILUTION	ΔH_f
H^+	0.00
Ag^+	25.31
Na^+	$-$ 57.28
K^+	$-$ 60.04
Zn^{++}	$-$ 36.43
Br^-	$-$ 28.90
Cl^-	$-$ 40.00
I^-	$-$ 13.37
OH^-	$-$ 54.96
$S^=$	10.00
$CO_3^=$	-161.63
$SO_3^=$	-149.20
$SO_4^=$	-216.90

Calculation of the heat of reaction for equation 3.3.42 proceeds first by finding the heat of formation for both the silver and bromide

ions at infinite dilution from Table 3.3.3. Next the heat of formation for silver bromide is obtained from Table 3.3.1. Finally we may find the heat of reaction for equation 3.3.42 by algebraically adding heats of formation for the ions at infinite dilution and subtracting this result from the heat of formation of the silver bromide crystal.

The result is

$$\Delta H_{reaction} = -23.78 - (-28.90 + 25.31)$$

$$= -20.19 \text{ kcal/mole of AgBr formed}$$

$$(3.3.44)$$

It is surprising that the precipitation of silver bromide produces more heat than the neutralization of an acid by a base (13.36 kcal/mole for acid base neutralization at infinite dilution).

EXERCISE

Calculate the enthalpy of the reaction

$$Ag^+ \cdot \infty \text{ Aq} + Cl^- \cdot \infty \text{ Aq} \longrightarrow AgCl_{(c)} + \infty \text{ Aq}$$

BOND ENERGIES AND ENTHALPIES

If a molecule absorbs sufficient heat to break all the bonds, thereby separating the molecule into its gaseous atomic components, then this total change in heat is called the *bond enthalpy* of the molecule. This process can be regarded as resulting in the sum of the heats of dissociation for the bonds in the molecule. Before considering calculations of the bond energies, it is necessary to discuss the implications of the *kinetic theory of gases*.

KINETIC THEORY OF GASES

The pressure exerted by the molecules of a gas enclosed in a container arises from the collision of the molecules with the walls of the container.

If we assume a cubic container (Figure 3.3.1) of side L, filled with n molecules, we start by examining the velocity of one molecule. The

velocity of one molecule may be resolved into its component velocities (Figure 3.3.1).

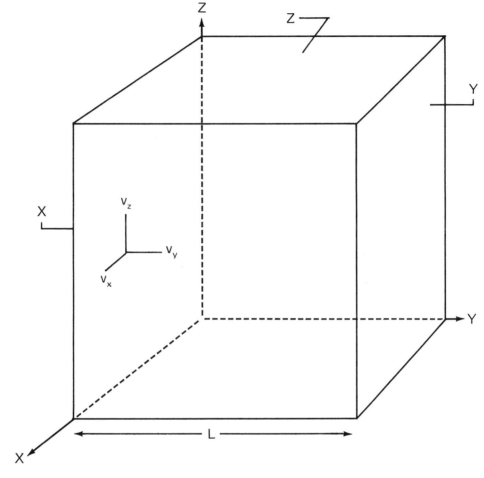

Fig. 3.3.1 *Shows how the velocity of a molecule may*
be resolved into its component velocities.

Because of the component of velocity v_x the molecule will collide with the side labeled X in Figure 3.3.1, rebound, and collide with the oppisite side.

It is the total sum of all collisions of this type that produces gas pressure according to the kinetic molecular theory. Considering the side X in Figure 3.3.1, the momentum associated with the molecule prior to collision is

$$mv_x$$

$$(3.3.45)$$

After collision, we write

$$- mv_x$$

(3.3.46)

Therefore, the total change in momentum for this process is

$$mv_x \quad - \quad (-mv_x) \quad = \quad 2\,mv_x$$

(3.3.47)

The time between collisions is obtained by dividing the distance the molecule must travel between collisions by the velocity of the molecule and we write

$$\frac{2L}{v_x}$$

(3.3.48)

Dividing the change in momentum by the time between changes results in the rate of change of momentum

$$\frac{2\,mv_x}{2L/v_x} \quad = \quad \frac{mv_x^2}{L}$$

(3.3.49)

where m is equal to the mass of molecule.

According to Newton's law, the rate of change of momentum is equal to the force, so that we write

$$\text{Force on side X} \quad = \quad \frac{mv_x^2}{L}$$

(3.3.50)

Since the pressure is force per unit area, we obtain

$$\text{Pressure on side X} \quad = \quad \frac{\text{Force on side X}}{L^2} \quad = \quad \frac{mv_x^2}{L^3} \quad = \quad \frac{mv_x^3}{V}$$

(3.3.51)

where V is equal to the volume of the container.

Since many of the molecules will not have the same velocity in the X direction, we must obtain the average velocity with respect to component.

The average value of v_x^2 is written

$$\overline{v_x^2}$$

(3.3.52)

and the pressure of N molecules in the container is written as

$$P = \frac{Nm\overline{v_x^2}}{V}$$

(3.3.53)

The magnitude of the square of the velocity can be written in terms of its components

$$\overline{v}^2 = \overline{v_x^2} + \overline{v_y^2} + \overline{v_z^2}$$

(3.3.54)

Similarly, the magnitude of the average velocity is written as

$$\overline{v^2} = \overline{v_x^2} + \overline{v_y^2} + \overline{v_z^2}$$

(3.3.55)

For a large number of molecules the components of velocity are randomly distributed such that

$$\overline{v_x^2} = \overline{v_y^2} = \overline{v_z^2}$$

(3.3.56)

Hence

$$1/3\,\overline{v^2} = \overline{v_x^2}$$

(3.3.57)

Substituting equation 3.3.57 into equation 3.3.53, we have

$$PV = \frac{1}{3} N m \overline{v^2}$$

(3.3.58)

The average kinetic energy of a molecule can be written

$$\overline{K.E.} = 1/2 \, mv^2$$

(3.3.59)

Substituting equation 3.3.59 into 3.3.58, we may write

$$PV = \frac{2}{3} N \overline{K.E.}$$

(3.3.60)

We may express the number of molecules N as the number of moles of molecules by use of Avogadros number

$$N_A = 6.023 \times 10^{23} \, \frac{molecule}{mole}$$

(3.3.61)

and

$$nN_A = N$$

(3.3.62)

where n is the number of moles.
By substitution, we write

$$PV = \frac{2}{3} n \, (N_A \overline{K.E.})$$

(3.3.63)

Since the term in parentheses represents the kinetic energy of 1 mole of molecules, we may define

$$E_{kin} = N_A \overline{K.E.}$$

(3.3.64)

Substituting 3.3.64 into 3.3.63, we obtain

$$PV = \frac{2}{3} n E_{kin}$$

(3.3.65)

We may now relate this expression to the expression

$$PV = nRT$$

(3.3.66)

and

$$E_{kin} = \frac{3}{2} RT$$

(3.3.67)

This expression shows that the energy of an ideal gas is a function of temperature alone.

We can multiply equation 3.3.55 by

$$\tfrac{1}{2} Nm$$

(3.3.68)

we find

$$\frac{1}{2} Nm\overline{v^2} = \frac{1}{2} Nm\overline{v_x^2} + \frac{1}{2} Nm\overline{v_y^2} + \frac{1}{2} Nm\overline{v_z^2}$$

(3.3.68a)

Rewriting equation 3.3.68a in terms of kinetic energy, we have

$$E_{kin} = \tfrac{1}{2} RT + \tfrac{1}{2} RT + \tfrac{1}{2} RT$$

(3.3.69)

EXERCISE

Derive equation 3.3.69.

Equation 3.3.69 shows that each degree of freedom of *translational energy* contributes $\frac{1}{2}RT$ to the total energy of the molecule. This result is called the *equi-partition of energy principle*.

Although this was originally a classical result, quantum mechanics also predicts that the average translational energy of a mole of molecules is equal to

$$\frac{1}{2}RT \text{ per degree of freedom}$$

$$(3.3.69a)$$

This result is due to the fact that the translational energy levels are very closely spaced so that a significant number of levels are populated at room temperature.

This principle can be generalized for molecules which are not point masses and therefore can be applied to real gases.

Diatomic molecules such as Cl_2, N_2, O_2 or HC1 also have *rotational degrees of freedom* (Figure 3.3.2).

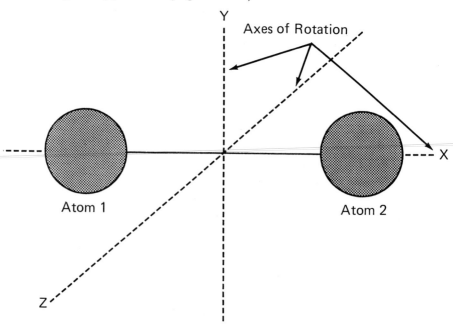

Fig. 3.3.2 *Shows the three axes of rotation for a diatomic molecule.*

As a molecule rotates in a random manner, its rotation can be resolved into components that lie on the x, y and z axes. The component lying on the x axis as illustrated in Figure 3.3.2 does not contribute significantly to the thermal rotational energy of the molecule. Thus for purposes of applying the *equi-partition of energy principle,* a linear molecule is considered to have only two rotational degrees of freedom.

These two rotational degrees of freedom contribute an additional

$$2 \quad \times \quad \tfrac{1}{2}RT$$

$$(3.3.70)$$

to the thermal energy of the molecule.

On the other hand, a non-linear molecule such as methane contributes an additional

$$3 \quad \times \quad \tfrac{1}{2}RT$$

$$(3.3.71)$$

to the thermal energy of the molecule because the contribution from each of the three axes is equal to $\tfrac{1}{2}RT$.

Other possible sources of contribution to the total energy of the molecule are vibrational, electronic and the *zero point* energies.

The zero point energy is the energy of the molecule at $0°K$ and is a constant independent of temperature symbolized as E_o.

Since E_o is not zero, it indicates that even at $0°K$ there is some kinetic energy due to harmonic motion. As the mass of the particle increases, the corresponding harmonic oscillatory motion and the magnitude of variation of these particles in a rectilinear path from their original position become insignificant. For purposes of calculation, we shall neglect the zero point energy.

The thermal energy of the molecule is defined as

$$E_{thermal} \quad = \quad E_{tot} \quad - \quad E_o$$

$$(3.3.72)$$

In this chapter, the symbol **E** will be used to represent the total energy of the molecule.

Including all contributions to the total energy of the molecule, we may write

$$E = E_o + E_{kin} + E_{rot} + E_{vib} + E_{electronic}$$

$$(3.3.73)$$

Some thermodynamic texts write the kinetic term E_{kin} as

$$E_{translational}$$

$$(3.3.74)$$

At room temperature the total energy of an atom may be written as

$$E = E_o + \frac{3}{2}RT + 0 + 0 + 0$$

$$(3.3.75)$$

neglecting the zero point energy, we have

$$E = \frac{3}{2}RT$$

$$(3.3.76)$$

Since

$$H = E + PV$$

$$(3.3.77)$$

we may write

$$H = \frac{3}{2}RT + RT$$

$$(3.3.78)$$

and

$$H = \frac{5}{2}RT \text{ for an atom}$$

$$(3.3.79)$$

For a linear molecule at 298° K, we write

$$E = \frac{3}{2}RT + RT + E_{vib}$$

(3.3.80)

$$E = 890 + 593 + E_{vib}$$

(3.3.81)

$$E = 1483 + E_{vib}$$

(3.3.82)

Table 3.3.4 lists the E_{vib} for three molecules.

TABLE 3.3.4*

MOLECULE	TEMP	$E_{vib} \dfrac{cal}{mole}$
N_2	298° K	0
O_2	298° K	2
NO_2	298° K	68

*Data obtained from G.M. Barrow, *Physical Chemistry*, McGraw-Hill Book Co., 1966, 2nd ed., p-173.

For a non-linear molecule at 298°K, we write

$$E = \frac{3}{2}RT + \frac{3}{2}RT + E_{vib}$$

(3.3.83)

$$E = 1780 + E_{vib}$$

(3.3.84)

For first approximations E_{vib} can be neglected at 298° K.

CALCULATION OF BOND ENTHALPY

The dissociation of the methane molecule is written as

$$\Delta H_{bonds} + CH_{4(g)} \longrightarrow C_{(g)} + 4H_{(g)}$$

(3.3.85)

where ΔH_{bonds} is called the bond enthalpy of methane.
Using the definition of enthalpy, the bond enthalpy becomes

$$\Delta H_{bonds} = \Delta E_{bonds} + \Delta(PV)$$

(3.3.86)

where ΔE_{bonds} is called the bond energy and represents the average energy required to break 4 carbon hydrogen bonds.

Since five moles of gaseous products are produced in reaction 3.3.85 starting with one mole of reacting gas, we may write

$$\Delta(PV) = 4RT$$

(3.3.87)

In order to determine the bond energy of the carbon hydrogen bond in the methane molecule, it is necessary to use the standard heats of formation of the gaseous atoms and the heat of formation of the molecule by methods shown earlier.

Using Table 3.3.1, we may write

$$\Delta H_{bonds} = 4 \times 52.09 + 171.70 + 17.89$$

(3.3.88)

$$\Delta H_{bonds} = 397.95 \frac{kcal}{mole}$$

(3.3.89)

Substituting equations 3.3.87 and 3.3.89 into equation 3.3.86, we have

$$\Delta E_{bonds} = 397.75 - 2.37$$

(3.3.90)

$$\Delta E_{bonds} = 395.58 \frac{kcal}{mole}$$

(3.3.91)

Dividing by four, we find the bond energy for each carbon hydrogen bond

$$\Delta E_{C-H} = 98.89 \frac{kcal}{mole}$$

(3.3.92)

Bond energies have been shown to be very nearly the same regardless of the type of molecule. Thus the carbon hydrogen bond energy in methane is very nearly the same as in benzene, butane, or ethane. Tables listing the bond energies at $0°K$ are available. [Ref: K.S. Pitzer, *J. Am. Chem Soc.*, **70**, 2140 (1948).]

BORN-HABER CYCLE

A further application of the bond energy concept is the determination of the lattice energy of a crystal. In this case the amount of heat necessary to take a crystal in the solid state to its gaseous ions at infinite separation is called the lattice energy of the crystal.

The calculation of the lattice energy of silver bromide was shown in Section 1.2 by use of Madelung constant methods.

The Born-Haber cycle is another method used to determine lattice energies of a crystal. The Born-Haber cycle calculation of crystal energies is considered to be an *experimental determination* of the lattice energy of the crystal.

In the case of silver bromide, we can utilize the Born-Haber cycle (Figure 3.3.3).

Fig. 3.3.3 *Shows the Born-Haber cycle for silver bro-*
 mide.

Path 1 of the Born-Haber cycle shown in Figure 3.3.3 has the same starting and ending points as paths 2, 3 and 4.

Consequently, when calculating the change in enthalpy for process 1, an indirect determination for this process is obtained by finding the sum of the enthalpy changes for the remaining processes in the cycle, i.e., processes 2, 3 and 4.

Going on to calculate the lattice enthalpy of the silver bromide crystal for process 1, we write

$$\Delta H_{(c)} \ = \ \Delta H(2) \ + \ \Delta H(3) \ + \ \Delta H(4)$$

(3.3.93)

Since process 2 is describing the heat of return of the molecule to its elements in the standard state, it is the reverse of the heat of formation and we write

$$\Delta H(2) \ = \ - \Delta H_f^o \ (AgBr)$$

(3.3.94)

Process (3) describes silver metal going to the gaseous state and bromine going from the liquid to the gaseous state.

$$\Delta H(3) \ = \ \Delta H_{sub}(Ag) \ + \ \Delta H_f^o \ (Br)$$

(3.3.95)

Process (4) describes the ionization of silver in the gaseous state and symbolized as E_I, while the capture of an electron by a bromine atom in the gaseous state is the negative of the electron affinity. Thus we write

$$\Delta H(4) = E_I - E_A + \Delta(PV)$$

(3.3.96)

Since the change in the number of moles of gas for this process is zero, then

$$\Delta(PV) = 0$$

(3.3.96a)

Substituting into equation 3.3.93, we obtain

$$\Delta H_{(c)} = -\Delta H_f^o(AgBr) + \Delta H_{sub}(Ag) + \Delta H_f^o(Br) + E_I - E_A$$

(3.3.97)

The values of the parameters in the Born-Haber cycle for silver bromide are listed in Table 3.3.5.

TABLE 3.3.5

	$-\Delta H_f^o$	$\Delta H_{sub}(Ag)$	$\Delta H_f^o(Br$ or $Cl)$	E_I	$-E_A$
AgBr	+ 23.78	+ 67.9	+ 26.71	173.6	− 82
AgCl	+ 30.36	+ 67.9	+ 29.01	173.6	− 87

Utilizing Table 3.3.5, we may write

$$H_c = 209.99 \frac{kcal}{mole}$$

(3.3.98)

EXERCISE

Using the Born-Haber cycle, determine the experimental lattice enthalpy for silver chloride.

3.4 Entropy and the Second Law

Since enthalpy and energy changes do not give information as to whether reactions will take place, a new state function that will give this information must be defined.

This new state function is called *entropy* and symbolized as S.

The quantitative definition of entropy is derived as a consequence of the second law of thermodynamics.

Statements of the second law of thermodynamics are based upon cyclic processes. A refrigerator can be considered a machine that can perform a cyclic thermodynamic process where heat is removed from within the refrigerator and transferred to the surroundings. This cooling is achieved by the action of a pump that circulates an easily vaporizable liquid through a system of pipes.

The statement of the second law with respect to refrigeration was first given by Clausius, "It is impossible to transfer heat from a cold to a hot reservoir without at the same time converting a certain amount of work into heat."

This statement sums up all of our extensive experience with refrigeration without exception.

The vaporizable liquid being pumped throughout the pipes, as well as everything within the inner shell of the refrigerator, represents the system. Everything outside the inner shell boundaries of the refrigerator is considered the surrounding.

The cold reservoir or system transfers heat to the hot reservoir that is a portion of the surroundings (the radiator at the back of the refrigerator). This process can occur only if a certain amount of work is simultaneously converted into heat, where the refrigerator motor supplies the necessary work.

Another statement of the second law of thermodynamics is based on systems such as the steam engine, gas turbine, or the familiar reciprocating gas engine: *It is impossible to obtain work from cyclic processes by taking heat from a reservoir without at the same time trans-*

ferring heat from a hot to a cold reservoir. This statement is based originally on Lord Kelvin's interpretation of his observations and experience with machines operating in cyclic processes.

The Clausius' statement of the second law shows that in order to make heat flow from a cold to a hot reservoir the machine must do work. All of our experience shows that heat flows spontaneously from a hot to a cold reservoir when they are in contact with each other. This last statement is called the zeroith law of thermodynamics.

A more general statement of the second law is: It is impossible to construct a machine that operates in cycles designed to convert heat into work without producing other changes in the surrounding.

All of the statements of the second law are statements of impotence. These assertions of impossibility allow for predictions of possibility. Practical results from these statements can be obtained by considering a *Carnot cycle*.

When a substance undergoes an isothermal expansion, adiabatic compression in this order, the process is called a *Carnot cycle* if the substance is returned to its initial state (Figure 3.4.1).

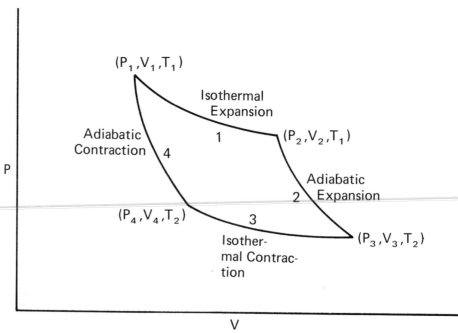

Fig. 3.4.1 *Shows a PV diagram of a reversible Carnot cycle for an ideal gas. Step 1 is an isothermal expansion at a temperature T_1. Step 2 is an adiabatic expansion where the temperature changes from the high temperature T_1 to the lower temperature T_2. Step 3 is an isothermal contraction at the lower temperature T_2. Step 4 is an adiabatic compression where the temperature increases from T_2 to T_1.*

For process 1 of Figure 3.4.1, the ideal gas does not change the temperature during the isothermal expansion. Since the energy of an ideal gas depends solely upon temperature, then we may write

$$\Delta E_1 = 0$$

$$(3.4.1)$$

Since

$$\Delta E_1 = q_1 - w_1$$

$$(3.4.2)$$

then

$$q_1 = w_1$$

$$(3.4.3)$$

Furthermore

$$w_1 = \int_{V_1}^{V_2} P dV = nRT_1 \int_{V_1}^{V_2} \frac{dV}{V}$$

$$(3.4.4)$$

$$= nRT_1 \ln\left(\frac{V_2}{V_1}\right)$$

$$(3.4.5)$$

Thus we conclude for the first step of the Carnot cycle that the heat absorbed is equal to the work done in the expansion at constant temperature.

Step 2 represents the adiabatic expansion of an ideal gas from a volume V_2 to the volume V_3. During this expansion, the temperature drops from T_1 to a new value T_2 and the gas does work. Since heat is not transferred in an adiabatic process, we write

$$q_2 = 0$$

$$(3.4.6)$$

and from the first law, we obtain

$$\Delta E_2 = -w_2$$

$$(3.4.7)$$

Expression 3.4.7 may also be written as

$$dE = -dw_{reversible}$$

$$(3.4.8)$$

For an ideal gas, we obtain

$$dE = \left(\frac{\partial E}{\partial T}\right)_V dT + \underbrace{\left(\frac{\partial E}{\partial V}\right)_T}_{\substack{\shortparallel \\ 0 \\ \text{for an ideal} \\ \text{gas}}} dV$$

$$(3.4.9)$$

and

$$-dw = \left(\frac{\partial E}{\partial T}\right)_V dT$$

$$(3.4.10)$$

For the work of expansion or contraction, we have

$$dw = PdV$$

$$(3.4.11)$$

for an ideal gas

$$P = \frac{nRT}{V}$$

$$(3.4.12)$$

Substituting, we have

$$dw = \frac{nRT}{V} dV$$

(3.4.13)

$$\left(\frac{\partial E}{\partial T}\right)_V dT = -\frac{nRT}{V} dV$$

(3.4.14)

after dividing through by T

$$\left(\frac{\partial E}{\partial T}\right)_V \frac{dT}{T} = -nR \frac{dV}{V}$$

(3.4.15)

Utilizing the definition of heat capacity, we obtain

$$C_V \frac{dT}{T} = -nR \frac{dV}{V}$$

(3.4.16)

where equation 3.4.16 represents the reversible adiabatic expansion or contraction of an ideal gas.

Integration with the appropriate limits for step 2 in the Carnot cycle, yields

$$\int_{T_1}^{T_2} C_V \frac{dT}{T} = -nR \int_{V_2}^{V_3} \frac{dV}{V}$$

(3.4.17)

Evaluating the right hand side of equation 3.4.17, we write

$$\int_{T_1}^{T_2} C_V \frac{dT}{T} = -nR \ln \frac{V_3}{V_2}$$

<div align="right">(3.4.18)</div>

The left hand side of equation 3.4.15 cannot be integrated because we do not know the functional representation of C_V.

However, this equation is important since it relates V_3 and V_2 with V_4 and V_1 of the second adiabatic process in the Carnot cycle.

At this point many text books go on to write the expression

$$\Delta E_2 = -w_2 = C_V (T_2 - T_1)$$

<div align="right">(3.4.18a)</div>

It is not necessary or accurate to make this assumption since C_V is not strictly constant for the adiabatic expansion of an ideal gas.

For the second isothermal process, recalling that the energy of an ideal gas is a function of temperature only, we may write

$$\Delta E_3 = 0$$

<div align="right">(3.4.19)</div>

and from the first law we have

$$\Delta E_3 = q_3 - w_3$$

<div align="right">(3.4.20)</div>

$$q_3 = w_3$$

<div align="right">(3.4.21)</div>

Thus the net work done in the isothermal contraction is

$$w_3 = \int_{V_3}^{V_4} PdV = nRT_2 \ln\left(\frac{V_4}{V_3}\right)$$

<div align="right">(3.4.22)</div>

Step 4 is the second adiabatic process of an ideal gas as it contracts from V_4 to V_1.

Since heat does not flow in an adiabatic process, we write

$$q_4 = 0$$

(3.4.23)

and from the first law, we obtain

$$\Delta E_4 = -w_4$$

(3.4.24)

Equation 3.4.16 can be integrated with the appropriate limits for the second adiabatic process and we write

$$\int_{T_2}^{T_1} C_V \frac{dT}{T} = -nR \int_{V_4}^{V_1} \frac{dV}{V}$$

(3.4.25)

After integration of the right side of equation 3.4.25, we have

$$\int_{T_2}^{T_1} C_V \frac{dT}{T} = -nR \ln\frac{V_1}{V_4}$$

(3.4.26)

Reversing the limits of integration, we write

$$-\int_{T_1}^{T_2} C_V \frac{dT}{T} = -nR \ln\frac{V_1}{V_4}$$

(3.4.27)

Comparing equations 3.4.18 and 3.4.27, we have

$$\ln\frac{V_1}{V_4} = \ln\frac{V_2}{V_3}$$

(3.4.28)

or

$$\frac{V_1}{V_2} = \frac{V_4}{V_3}$$

(3.4.29)

The total change in energy for this cyclic process is zero, and we write

$$\Delta E_1 + \Delta E_2 + \Delta E_3 + \Delta E_4 = 0$$

(3.4.30)

However, the work done during the entire cycle is equal to

$$w = w_1 + w_2 + w_3 + w_4$$

(3.4.31)

where

$$w_2 + w_4 = 0$$

(3.4.32)

and

$$w_1 + w_3 = RT_1 \ln\frac{V_2}{V_1} + RT_2 \ln\frac{V_4}{V_3}$$

(3.4.33)

Substituting equation 3.4.29 into 3.4.33, we write

$$w = nRT_1 \ln\frac{V_2}{V_1} + nRT_2 \ln\frac{V_1}{V_2}$$

(3.4.34)

$$= nRT_1 \ln\frac{V_2}{V_1} - nRT_2 \ln\frac{V_2}{V_1}$$

<div align="right">(3.4.35)</div>

and

$$w = nR(T_1 - T_2) \ln\frac{V_2}{V_1}$$

<div align="right">(3.4.36)</div>

A summary of the reversible Carnot cycle expressions for an ideal gas is listed in Table 3.4.1.

TABLE 3.4.1

STEP NUMBER	ΔE	HEAT	WORK
1	$\Delta E_1 = 0$	$q_1 = w_1$	$w_1 = nRT_1 \ln\left(\frac{V_2}{V_1}\right)$
2	$\int_{T_1}^{T_2} C_V\, dT$	$q_2 = 0$	$w_2 = -\int_{T_1}^{T_2} C_V\, dT$
3	$\Delta E_3 = 0$	$q_3 = w_3$	$w_3 = nRT_2 \ln\left(\frac{V_1}{V_2}\right)$
4	$\int_{T_2}^{T_1} C_V\, dT$	$q_4 = 0$	$w_4 = -\int_{T_2}^{T_1} C_V\, dT$
where $T_1 > T_2$, $V_2 > V_1$			

The energy and work expressions for steps 2 and 4 of Figure 3.4.1 are the integrated forms of equation 3.4.9.

The Carnot cycle represents a quantitative procedure conforming to the requirements established by the second law.

Figure 3.4.1 depicts the hot reservoir at T_1 and the cold reservoir at T_2.

The heat absorbed from the hot reservoir at T_1 is

$$q_1 = nRT_1 \ln (V_2/V_1)$$

(3.4.37)

In order to calculate the efficiency of a machine operating in a reversible Carnot cycle with an ideal gas, the fraction of q_1 that is converted into useful work must be calculated. Since the net work for the Carnot cycle was found to be

$$w_1 + w_3 = nR(T_1 - T_2) \ln (V_2/V_1)$$

(3.4.38)

then the fraction may be written as

$$\frac{w_1 + w_3}{q_1} = \frac{nR(T_1 - T_2) \ln (V_2/V_1)}{nR(T_1) \ln (V_2/V_1)}$$

(3.4.39)

and

$$\frac{w_1 + w_3}{q_1} = \frac{T_1 - T_2}{T_1}$$

(3.4.40)

Equation 3.4.40 is the expression for the maximum efficiency for any machine utilizing any gas that operates in a Carnot cycle.

If a machine operating in a Carnot cycle could be built such that the maximum efficiency for the machine would defy equation 3.4.40 and yield a higher maximum efficiency, then a perpetual motion machine would be made possible. A perpetual motion machine of this type is referred to as perpetual motion machine of the second type since it violates the second law of thermodynamics.

A typical example of a perpetual motion machine of the second type is to run a refrigerator and to use the heat transferred to the radiator to operate the pump that is doing the necessary work required for refrigeration.

ENTROPY

Examination of Table 3.4.1 shows that

$$\frac{q_1}{T_1} = nR \ln\left(\frac{V_2}{V_1}\right)$$

(3.4.41)

and

$$\frac{q_3}{T_2} = -nR \ln\left(\frac{V_2}{V_1}\right)$$

(3.4.42)

If q_1/T_1 is defined as the entropy change

$$\Delta S_1$$

(3.4.43)

for step one of the Carnot cycle, and q_3/T_2 is defined as the entropy change

$$\Delta S_3$$

(3.4.44)

for step three in the Carnot cycle, then we may write

$$\Delta S_1 + \Delta S_3 = 0$$

(3.4.45)

or the total change in entropy for the Carnot cycle is zero. Furthermore, since q_1 represents the heat absorbed by the system and q_3 the heat absorbed by the surroundings, then we obtain

$$\Delta S_{system} \quad + \quad \Delta S_{sur.} \quad = \quad 0$$

(3.4.46)

Since equation 3.4.46 is valid for any reversible cyclic process, then the change in entropy for the universe for any reversible cyclic process is zero.

For an infinitesimal change in entropy we may write

$$dS \quad = \quad \frac{dq_{rev}}{T}$$

(3.4.47)

Any reversible cycle involving an ideal gas can be thought of as a large number of Carnot cycles (Figure 3.4.2).

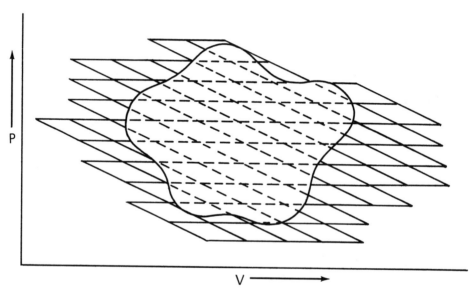

P

V

Fig. 3.4.2 *Shows schematically a cyclic process approximated by a large number of infinitesimal Carnot cycles where the interior steps* *cancel out. The grid is made up of isotherms and adiabatic processes.*

The cancelling out of the interior steps of the Carnot cycles is due to the fact that each interior isothermal or adiabatic process is traversed in opposite directions as shown in Figure 3.4.3.

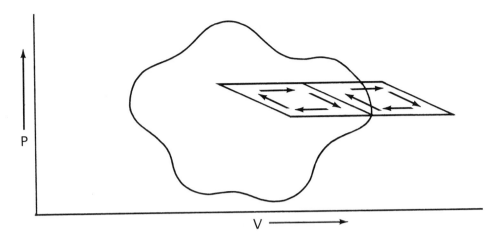

Fig. 3.4.3 *Shows a magnified portion of Figure 3.4.2. The isotherms and adiabatics in the interior are traversed in opposing directions. This results in the cancellation of all quantities such as work, heat and entropy for the* *interior Carnot cycles. The portion of these Carnot cycles that remains uncancelled and results in an approximation of the cyclic process is the outer parts along the boundary.*

The prior results obtained for the entropy of an ideal gas operating in a reversible Carnot cycle enable us to write

$$\sum \frac{q_{rev}}{T} = 0$$

All Carnot
cycles in
Grid

(3.4.48)

for the grid in Figure 3.4.2.
 Separating this sum into two parts, we have

$$\sum \frac{q_{rev}}{T} + \sum \frac{q_{rev}}{T} = 0$$

cycles in cycles
interior at bou-
 ndary

(3.4.49)

Since the interior Carnot cycles sum to zero, we may write the sum for the portion of the Carnot cycles that approximate the boundary

$$\sum_{\text{boundary}} \frac{q_{rev}}{T} = 0$$

(3.4.50)

Applying the limit as q reversible goes to zero, we may write

$$\lim_{q_{rev} \to 0} \sum_{\text{boundary}} \frac{q_{rev}}{T} = \oint \frac{dq_{rev}}{T} = 0$$

(3.4.51)

Since the differential change in entropy may be written as

$$\frac{dq_{rev}}{T}$$

(3.4.52)

then for the general cyclic process, we may write

$$\oint dS = 0$$

(3.4.53)

Equation 3.4.53 shows that entropy is a state function and that its value is independent of path.

Thus for any arbitrary path A to B (as illustrated in Figure 3.4.4)

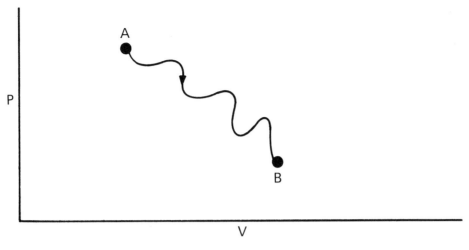

Fig. 3.4.4 *Shows schematically an arbitrary path from*
 A to B.

we may write

$$\int_A^B dS = S_B - S_A$$

(3.4.54)

where S_B is the entropy at position B and S_A is the entropy at position A in the PV diagram shown in Figure 3.4.4. Equation 3.4.54 represents the entropy change for the system under consideration.

Since the entropy is a state function, equation 3.4.54 can also be used for irreversible processes that have an initial position A and final position B.

Equation 3.4.54 illustrates the general theorem: *the total entropy change of a system and of the surroundings* is always zero for a reversible process.

This theorem will be proven with the aid of Figure 3.4.5.

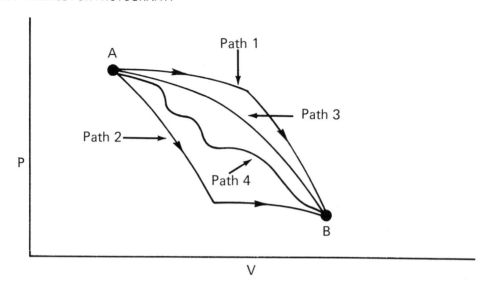

Fig. 3.4.5

Shows a reversible process between the points A and B. Path 1 represents the isothermal and adiabatic expansions of a Carnot cycle. Path 2 represents the last 2 steps of a Carnot cycle in the reverse direction. Paths 3 and 4 are arbitrarily chosen reversible paths from position A to B.

Since path 1 of Figure 3.4.5 represents a reversible isothermal expansion followed by an adiabatic expansion, we may write for the entropy change of the system

$$\Delta S_{system} = \frac{q_1}{T_1}$$

(3.4.55)

where q_1 represents the heat absorbed by the system from the surroundings.

Since entropy is independent of path, equation 3.4.55 represents the entropy change for any path from A to B.

Conversely, the entropy change for the surroundings for any path going from A to B is

$$\Delta S_{surrounding} = \frac{-q_1}{T_1}$$

(3.4.56)

Adding the entropy change for the reversible process as given by equation 3.4.55 and 3.4.56, we may write

$$\Delta S_{system} \quad + \quad \Delta S_{surrounding} \quad = \quad 0$$

(3.4.57)

IRREVERSIBLE PROCESSES AND ENTROPY

An irreversible or spontaneous process was defined as a process taking place in an uncontrolled manner. All natural occurring processes are irreversible without exception.

The total entropy change for irreversible processes is not zero. If we consider two bodies with very large heat capacities such that small amounts of heat flow into these systems do not affect the temperature, we may allow a quantity of heat q to flow from the hot body at a temperature T_1 to a cold body at temperature T_2 (Figure 3.4.6).

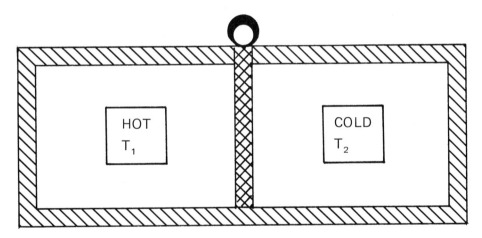

Fig. 3.4.6 *Shows two insulated systems of high heat capacity.*

In order to prevent the flow of heat to the surroundings, the bodies are insulated from each other and from the surroundings.

When the insulation between the bodies is removed, the bodies can be made to come into contact and an amount of heat q is transferred. After heat has been transferred, the insulation is replaced.

The entropy change for this irreversible process cannot be calculated directly for the system.

Since the bodies are insulated such that heat cannot flow to the surroundings, then the entropy change for the surroundings is zero.

In order to calculate the entropy change for the system we must consider a reversible path. The reversible path chosen will be a Carnot cycle between T_1 and T_2 where the heat absorbed by the system at T_1 is q and the heat released at compression is q at T_2.

Thus we may write the entropy change for the system as

$$\Delta S_{system} = \frac{-q}{T_1} + \frac{q}{T_2}$$

(3.4.58)

Since $T_2 < T_1$, the entropy change for this system is a positive quantity and the total entropy change for the system and surrounding is a positive quantity.

These examples point out that for a process going from A to B if the total change in entropy is greater than zero, then the process will go spontaneously from A to B. If the total change in entropy is zero, then the process is at equilibrium and no change will occur. If the entropy change is less than zero, then the process will go spontaneously from B to A.

3.5 Free Energy

Earlier sections showed that irreversible processes are spontaneous. In order to establish criteria for spontaneity, we will examine irreversible and reversible heat and work.

In order to derive a relation, we consider two possible methods of going from state 1 to state 2 for an isothermal process (Figure 3.5.1).

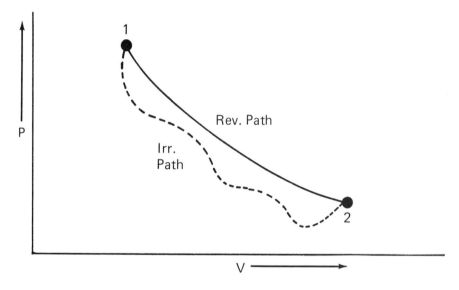

Fig. 3.5.1 *Shows schematically two possible paths from state 1 to state 2. The reversible path is well defined but the irreversible path* *cannot be well defined and is thus represented by a dotted line.*

The reversible path must conform to the first law and we write

$$\Delta E_{rev} = q_{rev} - w_{rev}$$

(3.5.1)

Since the irreversible path must conform to the first law, we have

$$\Delta E_{irr} = q_{irr} - w_{irr}$$

(3.5.2)

Energy is a state function independent of path; therefore we obtain

$$\Delta E_{rev} = \Delta E_{irr}$$

(3.5.3)

Substitution of equations 3.5.1 and 3.5.2 into 3.5.3 results in

$$q_{irr} - q_{rev} = w_{irr} - w_{rev}$$

(3.5.4)

If we assume that work attending an irreversible process is greater than the work of a reversible process, we may write

$$w_{irr} > w_{rev}$$

(3.5.5)

This assumption makes the right hand side of equation 3.5.4 greater than zero.

Thus the irreversible heat must be greater than the reversible heat and we have

$$q_{irr} > q_{rev}$$

(3.5.6)

The isothermal process depicted in Figure 3.5.1 takes place at a temperature T_1. If the irreversible path is chosen in proceeding from state 1 to state 2 of Figure 3.5.1, then the amount of heat absorbed by the system at T_1 is q_{irr} while the work done on the surroundings during the expansion is w_{irr}. The system is then returned to state 1 by a reversible path at T_1. Having accomplished a cyclic process at a constant temperature, we can calculate the net amount of heat and work attending these two processes.

The net amount of work done on the surroundings during the entire cycle is

$$w_{irr} - w_{rev} > 0$$

(3.5.7)

On the other hand, the net amount of heat absorbed by the system during the entire cycle is

$$q_{irr} - q_{rev} > 0$$

(3.5.8)

These equations imply that we can obtain a positive amount of work and heat for an isothermal cyclic process. *This is a violation of the second law of thermodynamics.* The second law states that net work can be obtained only when heat flows from a hot to a cold reservoir. No work can be obtained from any machine operated isothermally.

Since the assumption in equation 3.5.5 and equation 3.5.6 violates the second law, we can only conclude that

$$w_{rev} > w_{irr}$$

(3.5.9)

and

$$q_{rev} > q_{irr}$$

(3.5.10)

Conversely, if we assume that this result implies that the reversible work is equal to the irreversible work, then, using equation 3.5.4, the reversible heat would be equal to the irreversible heat and the entropy change would be zero. Such a process would be at equilibrium and would be a contradiction to the statement that the system proceeds from state 1 to state 2 at constant temperature by a spontaneous irreversible process.

For infinitesimal changes in work and heat we may write the differentials

$$dw_{rev} > dw_{irr}$$

(3.5.11)

and

$$dq_{rev} > dq_{irr}$$

(3.5.12)

Since the entropy criterion for spontaneity depends on both the system and surroundings, we must find a thermodynamic quantity that gives a criterion for the spontaneity of the system independent of the surroundings.

As a consequence of the second law we may write for a reversible isothermal process

$$\Delta S = \frac{q_{rev}}{T}$$

(3.5.13)

while for an irreversible isothermal process we have

$$\Delta S > \frac{q_{irr}}{T}$$

(3.5.14)

or

$$T\Delta S \geqslant q$$

(3.5.15)

where the equality holds for reversible processes and the inequality for all others.

From the first law we recognize that

$$\Delta E = q - w$$

(3.5.16)

Since

$$\Delta E + w = q$$

(3.5.17)

utilizing equation 3.5.15, we write

$$\Delta E \ + \ w \ = \ q \leqslant T\Delta S$$

$$(3.5.18)$$

Going on to solve for work, we obtain

$$\Delta E \ + \ w \leqslant T\Delta S$$

$$(3.5.19)$$

and

$$w \leqslant \ - \ \Delta E \ + \ T\Delta S$$

$$(3.5.20)$$

Earlier ΔE and ΔS were defined as state functions that were independent of path.

We now define a state function that is capable of measuring the maximum (reversible) work attainable for an isothermal process.

The thermodynamic label attached to this state function is *work content*.

The work content, or Helmholtz free energy state function A, is defined as

$$A \ = \ E \ - \ TS$$

$$(3.5.21)$$

For an isothermal process, we write

$$\Delta A \ = \ \Delta E \ - \ T\Delta S$$

$$(3.5.22)$$

and

$$- \Delta A \ = \ -\Delta E \ + \ T\Delta S$$

$$(3.5.23)$$

Thus for an isothermal process, the maximum work obtained can be found by substitution of equation 3.5.20 into equation 3.5.23 and we write

$$w \leqslant - \Delta A$$

(3.5.24)

or

$$-w \geqslant \Delta A$$

(3.5.25)

If we consider an isothermal process involving only PV work where the volume is maintained constant, then we have

$$w = 0$$

(3.5.26)

and

$$0 \leqslant - \Delta A$$

(3.5.27)

or

$$0 \geqslant \Delta A$$

(3.5.28)

Thus the criterion for an isothermal process at constant volume involving only PV work to proceed spontaneously is

$$\Delta A < 0$$

(3.5.29)

We can conclude that when an isothermal process occurs at constant volume, the work content will spontaneously decrease to a minimum and the process will then be at equilibrium.

Since many isothermal processes under consideration in photographic science occur at constant pressure, we define the *Gibbs free*

energy state function as

$$G = A + PV \qquad (3.5.30)$$

Utilizing equation 3.5.21, we may write

$$G = E - TS + PV \qquad (3.5.31)$$

$$G = \underbrace{E + PV}_{H} - TS \qquad (3.5.32)$$

Thus the Gibbs free energy function may also be defined as

$$G = H - TS \qquad (3.5.33)$$

The change in free energy at constant pressure may be written as

$$\Delta G = \Delta A + P \Delta V \qquad (3.5.34)$$

After substitution of equation 3.5.25 into 3.5.34, we may write

$$\Delta G \leqslant -w + P \Delta V \qquad (3.5.35)$$

and

$$-\Delta G \geqslant w - P \Delta V \qquad (3.5.36)$$

In equation 3.5.36 the expression

$$w \quad - \quad P\Delta V$$

$$(3.5.37)$$

represents all the work other than pressure volume work. If we define

$$w' \quad = \quad w \quad - \quad P\Delta V$$

$$(3.5.38)$$

then equation 3.5.36 becomes

$$-\Delta G \geqslant w'$$

$$(3.5.39)$$

If the process is carried out reversibly, we have

$$-\Delta G \quad = \quad w'$$

$$(3.5.40)$$

Since w' represents the *useful work* other than pressure volume work, then equation 3.5.40 indicates that the decrease in Gibbs free energy for a reversible isothermal process at constant pressure is equal to the useful work.

When the process is carried out irreversibly, we obtain

$$-\Delta G > w'$$

$$(3.5.41)$$

Since useful work (w') is a positive number, then equation 3.5.41 shows that

$$\Delta G \leqslant 0$$

$$(3.5.42)$$

Thus the criterion for spontaneous change for an isothermal process carried out at constant pressure is that the change in the Gibbs free energy must be less than zero.

The Gibbs free energy was given as

$$G = H - TS$$

(3.5.43)

therefore

$$dG = dH - TdS - SdT$$

(3.5.44)

Enthalpy was defined as

$$H = E + PV$$

(3.5.45)

and

$$dH = dE + PdV + VdP$$

(3.5.46)

Substituting equation 3.5.46 into 3.5.44, we write

$$dG = dE + PdV + VdP - TdS - SdT$$

(3.5.47)

Since

$$dE = dq - PdV$$

(3.5.48)

$$dG = dq + VdP - TdS - SdT$$

(3.5.49)

From the second law we obtain

$$dS = \frac{dq}{T}$$

(3.5.50)

or

$$dq = TdS$$

(3.5.51)

After substitution of equation 3.5.51 into equation 3.5.49, we write

$$dG = VdP - SdT$$

(3.5.52)

Since dT = 0 for an isothermal process, then

$$dG = VdP$$

(3.5.53)

for an ideal gas

$$V = \frac{nRT}{P}$$

(3.5.54)

After substitution, we have

$$dG = \frac{nRT}{P} dP$$

(3.5.55)

Integration of equation 3.5.55 results in

$$\int_{G_1}^{G_2} dG = \int_{P_1}^{P_2} \frac{nRT}{P} dP$$

(3.5.56)

After integration we find that the change in free energy may be written as

$$\Delta G = nRT \ln\frac{P_2}{P_1}$$

(3.5.57)

The earlier work has established the criteria for spontaneity and equilibrium as related to the free energy functions. Furthermore the sign of the change in free energy predicts whether the reaction will take place spontaneously, independent of any consideration of the surroundings.

It is possible to calculate the equilibrium constant for a reaction proceeding at standard conditions when the change in free energy for the reaction is known.

The change in free energy associated with the formation of a substance in its standard state at a designated temperature is symbolized as ΔG_f°, or simply referred to as *the standard free energy of formation*.

CHEMICAL POTENTIAL

Another important quantity in chemical thermodynamics is the partial molar free energy, more often referred to as the chemical potential.

The definition of the chemical potential μ for systems containing n moles of various components at constant pressure and temperature is written as

$$\mu_i = \left(\frac{\partial G}{\partial n}\right)_{T,P,n_1,n_2,...}$$

(3.5.58)

When the system contains only one component, the chemical potential can be written

$$\mu = \left(\frac{\partial G}{\partial n}\right)_{T,P,}$$

(3.5.59)

Since the change in free energy of a pure substance is linearly related to the number of moles of the substance, then equation 3.5.59 becomes

$$\mu = \frac{G}{n}$$

(3.5.60)

Equation 3.5.60 shows that the Gibbs free energy is an extensive property of the system, that is it is directly proportional to the amount of material under consideration. Other extensive state function variables are Helmholtz free energy, energy, entropy, enthalpy and volume.

EXERCISE

Discuss the problems encountered if G were not an extensive property of the system.

The magnitude of an extensive variable is characteristic of the whole system while the magnitude of an *intensive variable* is characteristic of both the whole system and any portion thereof.

Thus the chemical potential is an intensive variable. Other intensive variables are pressure, temperature, and the partial molar derivatives of E, A, H, V and S.

$$\frac{\partial E}{\partial n}, \quad \frac{\partial A}{\partial n}, \quad \frac{\partial H}{\partial n}, \quad \frac{\partial V}{\partial n}, \quad \frac{\partial S}{\partial n}$$

$$(3.5.61)$$

The chemical potential can be related to the partial molar values of a number of different state functions. This section will discuss the relation of *partial molar entropy* to the chemical potential.

Arbitrarily we consider a two-component system where n_1 and n_2 are the number of moles for the species 1 and 2, respectively.

Thus the independent variables for the free energy function are

$$T, P, n_1, n_2$$

The total differential of G for this two component system may be written as

$$dG = \left(\frac{\partial G}{\partial P}\right)_{T,n_1,n_2} dP + \left(\frac{\partial G}{\partial T}\right)_{P,n_1,n_2} dT$$

$$+ \left(\frac{\partial G}{\partial n_1}\right)_{T,P,n_2} dn_1 + \left(\frac{\partial G}{\partial n_2}\right)_{T,P,n_1} dn_2$$

$$(3.5.62)$$

Utilizing equation 3.5.52, we may write

$$dG = VdP - SdT + \mu_1 dn_1 + \mu_2 dn_2$$

$$(3.5.63)$$

From the definition of G, we write

$$A = G - PV$$

$$(3.5.64)$$

where the differential form is

$$dA \;=\; dG \;-\; PdV \;-\; VdP$$

<div align="right">(3.5.65)</div>

After substituting equation 3.5.63 into equation 3.5.65, we obtain

$$dA \;=\; -PdV \;-\; SdT \;+\; \mu_1 \, dn_1 \;+\; \mu_2 \, dn_2$$

<div align="right">(3.5.66)</div>

Equation 3.5.66 indicates that the chemical potentials

$$\mu_1 \;=\; \left(\frac{\partial A}{\partial n_1} \right)_{T,V,n_2} \;,\quad \mu_2 \;=\; \left(\frac{\partial A}{\partial n_2} \right)_{T,V,n_1}$$

<div align="right">(3.5.67)</div>

and the relations for entropy and pressure are written as

$$\left(\frac{\partial A}{\partial V} \right)_{T,n_1,n_2} \;=\; -P \;,\quad \left(\frac{\partial A}{\partial T} \right)_{V,n_1,n_2} \;=\; -S$$

<div align="right">(3.5.68)</div>

EXERCISE

Verify the equations 3.5.67 and 3.5.68 by substitution into equation 3.5.66.

Equation 3.5.67 shows that chemical potential is also the partial molar work content at constant volume and temperature.

The relations of equation 3.5.68 represent only 2 of many that can be derived. These particular relations are used in calculations involving the change in work content as a function of volume and temperature.

Earlier we defined enthalpy as

$$H \;=\; G \;+\; TS$$

<div align="right">(3.5.69)</div>

where the differential expression is

$$dH = dG + TdS + SdT$$

(3.5.70)

After substitution of equation 3.5.63 into equation 3.5.70, we may write

$$dH = VdP + TdS + \mu_1 dn_1 + \mu_2 dn_2$$

(3.5.71)

The relations for volume and temperature may be written as

$$\left(\frac{\partial H}{\partial P}\right)_{T,n_1,n_2} = V \quad , \quad \left(\frac{\partial H}{\partial S}\right)_{P,n_1,n_2} = T$$

(3.5.72)

and for the chemical potentials we have

$$\mu_1 = \left(\frac{\partial H}{\partial n_1}\right)_{P,S,n_2} \quad , \quad \mu_2 = \left(\frac{\partial H}{\partial n_2}\right)_{P,S,n_1}$$

(3.5.73)

Using the definition of enthalpy, we write

$$dH = dE + PdV + VdP$$

(3.5.74)

Substitution of equation 3.5.74 into equation 3.5.71 results in the expression

$$dE = -PdV + TdS + \mu_1 dn_1 + \mu_2 dn_2$$

(3.5.75)

EXERCISE

Write the chemical potentials and relations analogous to equations 3.5.72 using equation 3.5.75.

Solving equation 3.5.75 for dS, we find

$$dS = \frac{1}{T}dE + \frac{P}{T}dV - \frac{\mu_1}{T}dn_1 - \frac{\mu_2}{T}dn_2$$

(3.5.76)

Equation 3.5.76 shows that the chemical potentials

$$\mu_1 = -T\left(\frac{\partial S}{\partial n_1}\right)_{E,V,n_2} , \quad \mu_2 = -T\left(\frac{\partial S}{\partial n_2}\right)_{E,V,n_1}$$

(3.5.77)

and

$$\frac{1}{T} = \left(\frac{\partial S}{\partial E}\right)_{V,n_1,n_2}$$

(3.5.78)

Expressions 3.5.77 and 3.5.78 are used in Chapter 1 to define the undetermined multipliers α and β respectively.

FUGACITY

Utilizing equation 3.5.57 for a system having free energies G_1 and G_2 at a pressure P_1 and P_2 respectively, we may write

$$G_2 - G_1 = nRT \ln (P_2/P_1)$$

(3.5.79)

Dividing through by n, we obtain

$$\frac{G_2}{n} - \frac{G_1}{n} = RT \ln (P_2/P_1)$$

(3.5.80)

After using relation 3.5.60, we have

$$\mu_{1,P_2} = \mu_{1,P_1} + RT \ln (P_2/P_1)$$

(3.5.81)

Relating this equation to the standard state such that $P_1 = 1$ and $P_2 = P_i$ for the ideal gas, we write

$$\mu_i = \mu_i^\circ + RT \ln P_i$$

(3.5.82)

In order to treat non-ideal gases, we require a new function called *fugacity*, symbolized as f.

Fugacity must be defined in such a manner that equation 3.5.82 will be exact for non-ideal gas systems. As the gases of the system approach ideality, the fugacity must approach the pressure of the gases in the system.

As the pressure of a non ideal gas approaches zero, the gas approaches ideality and we write

$$\lim_{P_i \to 0} \frac{f_i}{P_i} = 1$$

(3.5.83)

where i = the i^{th} component.

Since fugacity is a correction pressure function it has the same units as pressure.

We may also define the fugacity coefficient as

$$\gamma_i = \frac{f_i}{P_i}$$

(3.5.84)

We may now write the exact form of the chemical potential equation as

$$\mu_i = \mu_i^{\circ} + RT \ln f_i$$

(3.5.85)

or

$$\mu_i = \mu_i^{\circ} + RT \ln \gamma_i P_i$$

(3.5.86)

Since equations 3.5.85 and 3.5.86 are restricted to gases, they may be of less importance to the photographic worker than equations that can be used for reactions taking place in solution.

Thus we must relate the chemical potential of component i to a new function called *activity* by means of the equation

$$\mu_i = \mu_i^{\circ} + RT \ln a_i$$

(3.5.87)

where a_i is the activity of the i^{th} component in solution having the units of moles per liter in this text.

Activity is defined such that equation 3.5.87 is exact for solutions. The activity of a solute in solution is zero at infinite dilution; thus for the reference state at infinite dilution we write

$$\lim_{C_i \to 0} \frac{a_i}{C_i} = 1$$

(3.5.88)

where C_i is the concentration of the i^{th} component in moles per liter.

When activity is defined in this manner, it approaches C_i as the solution becomes infinitely dilute.

The *activity coefficient* is defined as

$$\gamma_i = \frac{a_i}{C_i}$$

(3.5.89)

One of the more important photographic applications of the changes in chemical potential is the electrochemical cell.

THE THIRD LAW OF THERMODYNAMICS

According to Planck, *the entropy of a perfect crystal at absolute zero is equal to zero.* Experimental verification of this law is not possible, but the determination of absolute entropies for pure substances above $0°K$ can be made by use of this law.

Using the heat capacity information determined by calorimetry for the substance at some temperature T, the entropy for a solid may be determined from

$$\int_0^T \frac{dq_{rev}}{T} = S = \int_0^T \frac{C_p}{T} dT = \int_0^T C_p d (\ln T)$$

(3.5.90)

while the entropy for liquids may be found by using the expression

$$S = \int_0^{T_{mp}} \frac{C_p (S)}{T} dT + \frac{\Delta H_{fus}}{T_{mp}} + \int_{T_{mp}}^T \frac{C_p (l)}{T} dT$$

(3.5.91)

where T_{mp} = melting point of the solid
ΔH_{fus} = heat of fusion at the melting point
$C_p(S)$ = heat capacity of the solid
$C_p(l)$ = heat capacity of the liquid

The entropy that is reported for a substance at 298°K and 1 atmosphere of pressure is obtained by summing all contributions from the extrapolation made from absolute zero to the desired temperature.

A partial listing of entropies at standard conditions for substances in their standard state is given in Table 3.5.1.

TABLE 3.5.1

SUBSTANCE: 298.15° K	$S° \dfrac{Cal}{deg\ mole}$
$Ag_{(s)}$	10.20
$I_{2(s)}$	27.76
$NaCl_{(s)}$	17.3
$Br_{2(l)}$	36.4
$Cl_{2(g)}$	53.3

3.6 Nernst Equation and Half Wave Potential

This section will apply the chemical potential in order to determine the electromotive force (emf) of electrochemical cells. The electrochemical cell in some applications is known as a battery and can under these circumstances do useful work. In other applications, the electrochemical cell is used in the reduction of metals. In both cases the process involves the transfer of electrons. Latent image formation, photographic development and spectral sensitization also involve the transfer of electrons.

A method of studying these reduction oxidation (redox) reactions is the determination of the voltage of the electrochemical cells made up by the molecules under consideration.

A reaction of photographic interest that can be studied by the electrochemical cell method is a solution of hydroquinone in acid solution and silver metal in the presence of silver ions.

This reaction can be written as

$$QH_2 \ + \ 2Ag^+ \ \longrightarrow \ 2Ag_{(s)} \ + \ Q \ + \ 2H^+$$

$$(3.6.1)$$

Reaction 3.6.1 shows hydroquinone in acid solution reacting with silver ions producing quinone, silver metal and hydrogen ions.

An electrochemical cell can be constructed to measure the electromotive force of reaction 3.6.1. (Figure 3.6.1).

Fig. 3.6.1 *Shows an electrochemical cell for reaction 3.6.1.*

A platinum electrode is immersed in a solution of hydroquinone that has been acidified with HC1. Platinum is used since it is an inert metal that does not interfere with the chemical reaction. The silver metal electrode dips into an aqueous solution of silver nitrate which acts as a source for silver ions. A salt bridge (KC1 and gelatin) is used to prevent the mixing of both solutions in each *half cell* while allowing the passage of current in the form of ions.

The reaction taking place at the platinum electrode is

$$QH_2 \longrightarrow Q + 2H^+ + 2e$$

(3.6.2)

while the second half cell reaction at the silver electrode is written as

$$2Ag^+ + 2e \longrightarrow 2Ag$$

(3.6.3)

Addition of the half cell reactions 3.6.2 and 3.6.3 produces the overall reaction which is the only reaction that is actually observed.

The cell is constructed such that it can measure the voltage produced in a state of balance. The balance is maintained by a backing voltage that is supplied by a battery in a potentiometric circuit (Figure 3.6.2).

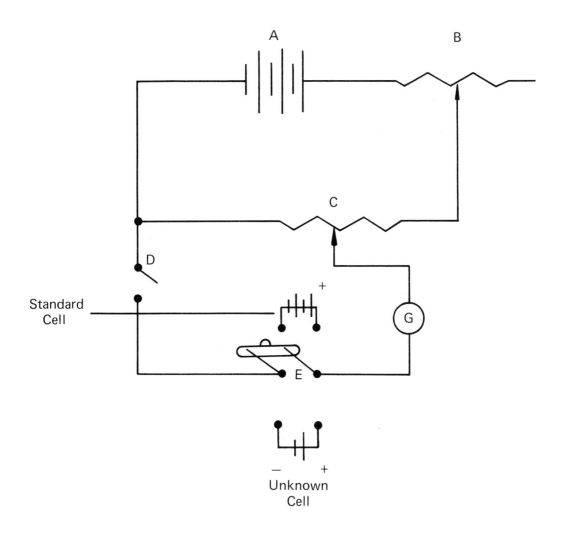

Fig. 3.6.2 Depicts a potentiometric circuit that voltage without drawing any current from
 is utilized to measure an unknown cell the unknown cell.

This circuit must first be calibrated by throwing the switch E to the standard cell of known voltage; then potentiometer C is positioned at the known voltage of the cell.

At this point the switch D is closed momentarily to determine if current is flowing by looking for a deflection of the pointer on the galvanometer. If current is flowing, then potentiometer B is adjusted until no current flows. After the potentiometer C is calibrated, the switch E is thrown to the cell of unknown voltage and potentiometer C is adjusted until no current flows.

The new reading of potentiometer C gives the voltage for the unknown cell.

Under these balance conditions the measurement of the electromotive force of the cell is due to a reversible process.

We now ask the question: how much work is performed by the cell under these reversible conditions?

To answer this question, we imagine that the reaction produces one mole of quinone while two moles of electrons traverse the circuit from the negatively charged platinum electrode to the positively charged silver electrode when the system is in a state of reversible balance. This amount of work is written as

$$2F\epsilon$$

(3.6.4)

where one Faraday (F) is equal to 96493 coulombs/mole of electrons, and ϵ is the electromotive force of the cell in volts.

Since the system has done this amount of useful reversible work, the free energy must have decreased by this same amount.

This decrease in free energy can be written in terms of chemical potential as

$$\Delta\mu \ = \ -2F\epsilon$$

(3.6.5)

where

$$\Delta\mu \ = \ \sum_{i=\text{products}} C_i\mu_i \ - \ \sum_{j=\text{reactants}} C_j\mu_j$$

(3.6.6)

and where C_i and C_j are the stoichiometric coefficients.

In explicit form, equation 3.6.6 becomes

$$\Delta\mu = 2\mu(Ag) + \mu(Q) + 2\mu(H^+) - \mu(QH_2) - 2\mu(Ag^+)$$

(3.6.7)

Although many texts define the useful work attending an electrochemical cell in terms of free energy ΔG per mole, this text defines this useful work in terms of the chemical potential and we write

$$\Delta\mu = -nF\epsilon$$

(3.6.8)

and in the standard state we have

$$\Delta\mu^\circ = -nF\epsilon^\circ$$

(3.6.8a)

Since

$$\mu_i = \mu_i^\circ + RT \ln a_i$$

(3.6.9)

we may write for reaction 3.6.1

$$\Delta\mu = \Delta\mu^\circ + RT \ln \frac{a^2 (Ag)\, a(Q)\, a^2 (H^+)}{a(QH_2)\, a^2 (Ag^+)}$$

(3.6.10)

where the metallic silver activity is constant in the solid form and is combined into the standard chemical potential change.

After substituting equations 3.6.8 and 3.6.8a into equation 3.6.10, we write

$$\epsilon \; = \; \epsilon^{\circ} \; - \frac{RT}{2F} \; \ln \; \frac{a(Q) \, a^2(H^+)}{a(QH_2) \, a^2(Ag^+)}$$

(3.6.11)

Equation 3.6.11 is the Nernst equation for reaction 3.6.1. For any general reaction of the type

$$n_1 C_1 \;\; + \;\; n_2 C_2 \longrightarrow n_3 C_3 \;\; + \;\; n_4 C_4$$

(3.6.12)

the corresponding Nernst equation is written as

$$\epsilon \; = \; \epsilon^{\circ} \; - \frac{RT}{nF} \ln \frac{a^{n_3}(C_3) \, a^{n_4}(C_4)}{a^{n_1}(C_1) \, a^{n_2}(C_2)}$$

(3.6.13)

where ϵ° is the electromotive force of the cell measured in volts, when all substances are in the reaction in their standard states.

Tables of ϵ° values are available obtained from the emf measurements of the electrode in question relative to the hydrogen electrode for the reaction

$$H_2 \longrightarrow 2H^+ \;\; + \;\; 2e$$

(3.6.14)

at one atmosphere of pressure and at unit activity for the hydrogen ion. This standard half cell reaction was arbitrarily chosen to have zero emf with respect to all other half cells.

When the reaction is at equilibrium, the emf of the cell is zero and the chemical potential is zero.

Thus when

$$\Delta\mu \; = \; 0$$

(3.6.15)

and

$$\epsilon = 0$$

(3.6.16)

we may write equation 3.6.13 as

$$\epsilon^o = \frac{RT}{nF} \ln K_{eq}$$

(3.6.17)

Furthermore

$$\Delta \mu^o = - RT \ln K_{eq}$$

(3.6.18)

Equation 3.6.17 shows that the knowledge of ϵ^o for a reaction at a specified temperature will yield the equilibrium constant for the reaction. When the equilibrium constant has been determined, it can be substituted into equation 3.6.18 and the change in standard chemical potential can be found.

SIGN CONVENTIONS FOR ELECTROCHEMICAL CELLS

Each of the electrodes and its solution of the electrochemical cell is generally considered to be a half cell with a corresponding half cell reaction. A typical half cell reaction for hydroquinone was given in equation 3.6.2. The shorthand representation of hydroquinone half cell illustrated in Figure 3.6.1 is

$$Pt \left| QH_2, Q, H^+ \quad (X \text{ moles/liter}) \right.$$

(3.6.19)

where the vertical line separates different phases.

The silver half cell shorthand may be written as

$$Ag \,|\, Ag^+ \ (X \ moles/liter)$$

$$(3.6.20)$$

After the electrodes are chosen as shown by equations 3.6.19 and 3.6.20, we must decide on the orientation of the electrodes relative to the overall cell; that is, the silver or the platinum electrode on the left or right.

Placing the electrodes according to Figure 3.6.1, the entire cell notation is

$$Ag \,|\, Ag^+ \ (X \ moles/liter) \ \left|\begin{array}{c} K \ Cl \\ Bridge \end{array}\right| \ QH_2, \, Q, \, H^+ \ (X \ moles/liter) \,|\, Pt$$

$$(3.6.21)$$

The sign convention for the cell of equation 3.6.21 is such that the emf of the cell is considered positive when electrons are spontaneously driven from left to right.

The electrode reactions are conventionally written such that the left electrode donates electrons to the external circuit while the right hand electrode accepts electrons from the external circuit. Thus we may write

$$2Ag \longrightarrow 2Ag^+ \ + \ 2e \quad Left \ Electrode$$

$$(3.6.22)$$

$$2e \ + \ Q \ + \ 2H^+ \longrightarrow QH_2 \quad Right \ Electrode$$

$$(3.6.23)$$

$$2Ag \ + \ Q \ + \ 2H^+ \longrightarrow QH_2 \ + \ 2Ag^+ \quad \begin{array}{l} Overall \\ Reaction \end{array}$$

$$(3.6.24)$$

352

Since

$$\Delta\mu = -nF\epsilon \tag{3.6.25}$$

using these conventions, a positive cell voltage implies that the chemical potential decreases and that electrons spontaneously flow from left to right with a corresponding amount of work being done on the surroundings.

When ϵ is zero, the system is in equilibrium, and electrons do not flow in the system.

On the other hand, when ϵ is negative, the spontaneous electron flow will be from right to left and the reaction will proceed in the opposite direction with respect to the written direction.

In order to determine the standard electrode potential for half cells, the hydrogen electrode (equation 3.6.14) is chosen as the left electrode. The electrode to be determined is then chosen as the right electrode. The emf of this cell is equal to ϵ° for the electrode being measured. A partial listing of ϵ° values is given in Table 3.6.1.

TABLE 3.6.1

ELECTRODE REACTION ACIDIFIED SOLUTION	CELL VOLTAGE ϵ°
$Na \rightleftharpoons Na^+ + e^-$	$-$ 2.7142
$Cr \rightleftharpoons Cr^{3+} + 3e^-$	$-$ 0.744
$Fe = Fe^{++} + 2e^-$	$-$ 0.4402
$Ag + I^- = AgI + e^-$	$-$ 0.1518
$H_2 = 2H^+ + 2e^-$	0
$Ag + Br^- = AgBr + e^-$	$+$ 0.0713
$Ag + Cl^- = AgCl + e^-$	$+$ 0.2225
$QH_2 = Q + 2H^+ + 2e^-$	$+$ 0.6994
$Ag = Ag^+ + e^-$	$+$ 0.7991
$2Cl^- = Cl_2 + 2e^-$	$+$ 1.3595

Using Table 3.6.1, we may write

$$\epsilon^\circ (QH_2) \ = \ 0.6994 \text{ volts}$$

(3.6.26)

$$\epsilon^\circ (Ag) \ = \ 0.7991 \text{ volts}$$

(3.6.27)

Since the silver is the reactant and hydroquinone the product of the cell, we write

$$\epsilon^\circ (Cell) \ = \ \epsilon^\circ (QH_2) \ - \ \epsilon^\circ (Ag)$$

(3.6.28)

$$\epsilon^\circ (Cell) \ = \ -0.0997 \text{ volts}$$

(3.6.29)

According to the earlier established conventions, equation 3.6.29 indicates that electrons will spontaneously flow from right to left and the silver ions will be reduced when all substances are in their standard states (Figure 3.6.1).

The emf of the cell at different concentrations can be obtained by applying the Nernst equation to each half cell reaction and subtracting the ϵ (reactants) from the ϵ (products).

The Nernst equation for each half cell of Figure 3.6.1 is written as

$$\epsilon(Ag) \ = \ \epsilon^\circ (Ag) \ - \ \frac{RT}{2F} \ln \frac{a^2(Ag^+)}{a^2(Ag)}$$

(3.6.30)

and

$$\epsilon(QH_2) = \epsilon^\circ(QH_2) - \frac{RT}{2F} \ln \frac{a(QH_2)}{a(Q)\, a^2(H^+)}$$

(3.6.31)

and the total cell reaction is

$$\epsilon\,(Cell) = \epsilon^\circ(QH_2) - \epsilon^\circ(Ag) - \frac{RT}{2F} \ln \frac{a(QH_2)}{a(Q)\, a^2(H^+)}$$

$$+ \frac{RT}{2F} \ln \frac{a^2(Ag)}{a^2(Ag^+)}$$

(3.6.32)

$$= \epsilon^\circ\,(Cell) - \frac{RT}{2F} \ln \frac{a(QH_2)\, a^2(Ag^+)}{a(Q)\, a^2(H^+)\, a^2(Ag)}$$

(3.6.33)

After substitution of the values of the constants, we write equation 3.6.33 in the \log_{10} form as

$$.0997 - \frac{.0591}{2} \log \frac{a(QH_2)\, a^2(Ag^+)}{a(Q)\, a^2(H^+)}$$

(3.6.34)

Under most conditions the rate of photographic development is a function of concentration and pH of the developer solution.

EXAMPLE

The analysis of the composition of a photographic developer solution yielded the following data:

$$\begin{aligned}
a(QH_2) &= 10^{-1} \text{ mole/liter} \\
a(Q) &= 10^{-5} \text{ mole/liter} \\
a(Ag^+) &= 10^{-5} \text{ mole/liter} \\
a(H^+) &= 10^{-10} \text{ mole/liter}
\end{aligned}$$

After substitution of these values into equation 3.6.34, we write

$$\epsilon \text{ (Cell)} \quad = \quad -.0997 \quad - \quad (.02914)\ 14$$

$$\epsilon \text{ (Cell)} \quad = \quad -.513 \text{ volts}$$

This highly negative value for the cell shows that the change in chemical potential is a relatively large positive quantity producing a driving force for the reduction of silver ion to metallic silver.

Analysis of equation 3.6.34 shows that as the concentration of silver ions is reduced, for example by the addition of bromide or iodide that precipitates the silver ion, then the driving force for the reduction of silver also decreases.

Conversely, the example shows that as the hydrogen ion concentration decreases, the tendency for the reduction of silver ions to metallic silver increases.

Clearly the Nernst equation is a fundamental tool of photographic chemistry.

POLAROGRAPHY AND THE HALF WAVE POTENTIAL

The application of the polarographic method of measuring electrode potentials has become one of the more important experimental techniques in photographic science (see Section 4.4).

In 1922 Jaroslav Heyrovsky, while at the University of Prague, suggested a new way of measuring the potentials of reducible substances in solution. In 1924 Heyrovsky and Shikata built a polarograph in order to demonstrate and utilize the earlier concept of 1922.

The polarograph has an elegant operational method of utilizing a dropping mercury electrode which provides an electrode of very small area.

The utility of employing cathodes of small area is that they minimize perturbations with reference to reversibility and prevent the current from becoming high.

In 1938 Ilcovic derived an equation which showed the relationship between the standard electrode potential and the half wave polarographic potential. This theoretical derivation essentially completed the modern view of polarography and gave impetus to world wide applications. The preliminaries to polarography involve the electrolysis of solutions containing two or more cations.

A solution containing different cations such as

$$Ag^+ \ , \ Cu^{++} \ ,$$

is to be electrolyzed by placing into the solution an anode and cathode as shown in Fig. 3.6.3.

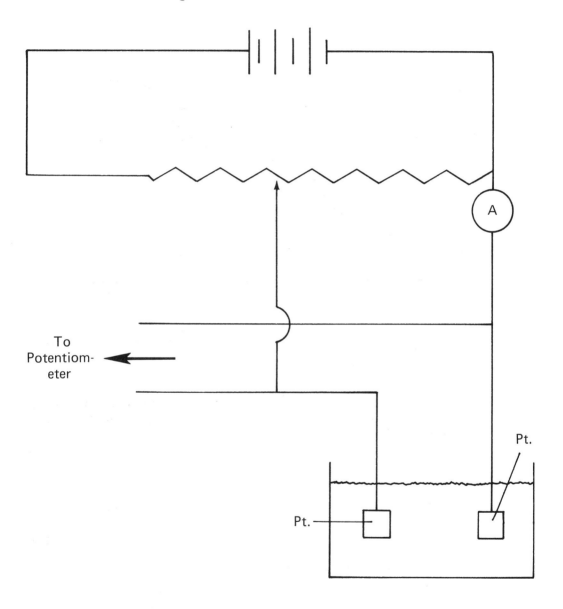

Fig. 3.6.3 Shows a simple arrangement for the electrol- to the potentiometer is made in order
ysis of a solution containing different to measure the reversible reduction
cations, i.e., Ag^+, Cu^{++}. The connection potential of the ion.

As the potential is gradually increased when we plot current versus potential, we find a curve similar to the one shown in Figure 3.6.4

Fig. 3.6.4

Is a schematic representation of the current voltage curve recorded by the apparatus of Figure 3.6.3. The dotted lines show the *potentials at which the cation begins to be reduced (discharge potential). This part of the curve is called the cathodic wave.*

As the applied voltage is increased, the cations do not become reduced until the reversible potential corresponding to the Nernst equation is fulfilled.

For the cation of silver we write

$$\epsilon \;=\; \epsilon^{o} \;+\; \frac{.0592}{1}\log a(Ag^{+}) \qquad\qquad e^{-} \;+\; Ag^{+} \rightarrow Ag^{o}$$

$$(3.6.35)$$

For the cation of copper we write

$$\epsilon \;=\; \epsilon^{o} \;+\; \frac{.0592}{2}\log a(Cu^{++}) \qquad\qquad 2e \;+\; Cu^{++} \longrightarrow Cu^{o}$$

$$(3.6.36)$$

As the voltage of the cell is gradually increased, the cation with the largest ϵ value deposits first. As the applied voltage continues to increase, the current density also increases. The concentration of the ion being discharged becomes depleted in the neighborhood of the cathode as the current density increases, especially if the solution is not stirred.

This phenomenon is called *concentration polarization.*

Eventually a limiting value for the current is reached. This value is directly proportional to the diffusibility of the ions in solution, concentration and charge, and inversely proportional to the thickness of the layer of depletion.

The curve becomes flat at this point and the potential rises to the discharge potential of the Cu^{++} ion even though there may still be large amounts of Ag^+ ion in the bulk of the solution. Also the anode becomes polarized by the collection of negative ions at its surface. All of these effects work to prevent identification of ions by their discharge potentials and to prevent measurement of their concentrations.

The dotted lines in Figure 3.6.4 show the approximate position of the discharge potentials. The discharge potentials are not reproducible.

The polarograph overcame these defects. Figure 3.6.5 shows the main features of a polarograph.

Fig. 3.6.5 *Depicts schematically a dropping mercury polarograph.*

Figure 3.6.5. shows the dropping mercury cathode which presents a clean, reproducible, constantly renewed cathode surface to ions.

The mercury pool anode is also constantly renewed by the dropping mercury and has such a large area that it is negligibly polarized.

The mercury droplets are about 0.5 mm in diameter. An excess of salt such as KNO_3 is added to the solution to carry most of the current so that the current is not limited by the ability of the anion to move through the solution.

Oxygen is removed by bubbling N_2 through the apparatus because oxygen is reduced at a relatively low potential. Other reference electrodes such as the saturated calomel electrode can be used instead of the mercury pool.

However, they must be of large area.

The current voltage curve oscillates between a maximum and a minimum as each mercury drop grows and falls as shown in Figure 3.6.6.

Fig. 3.6.6

Shows schematically a plot of current versus applied voltage obtained from a dropping mercury electrode. This type of plot which is obtained from a polarograph is called a polarogram. The portion of the curve below the abscissa is called the anodic wave while the portion above this region is termed the cathodic wave. The anodic wave represents the oxidation of the ion while the cathodic wave characterizes the reduction of the ion. The polarogram is extremely valuable in determining reaction mechanisms, equilibrium and formation constants and single electrode potentials. I_d is the limiting or diffusion current. The half wave potential $\epsilon_{\frac{1}{2}}$ is that voltage corresponding to one half of the diffusion current. In this polarogram the voltage is measured with respect to the standard hydrogen electrode. Often the voltage is measured with respect to the standard calomel electrode (SCE).

The polarographic wave is the rise from one flat portion of the curve to the next. The steep slope between the rises is used to mark the half wave potential and serves to identify the reducible ion. The diffusion limited current for each ion is the vertical difference between two flat portions of the curve and it is proportional to the concentration of the ion.

The Ilcovic equation can be derived from the Nernst equation for the reaction at the electrode surface and the law of diffusion.

We may write the half reaction for the reduction of a metal ion M^{n+} at the surface of the mercury drop which forms a soluble amalgam $M(Hg)$ as

$$M^{n+} + ne^- + Hg \rightleftharpoons M(Hg)$$

(3.6.37)

If this reaction is reversible, its potential is given by the Nernst equation

$$\epsilon_{d.Hg.l} = \epsilon_M^o - \frac{RT}{nF} \ln \frac{a^s \text{ (amalgam)}}{a^s (M^{n+}) \, a(Hg)}$$

(3.6.38)

where $\epsilon_{d.Hg.l}$ is the potential of the dropping mercury electrode, ϵ_M^o is the standard electrode potential of the metal M, a^s(amalgam) is the activity of the metal in the amalgam at the electrode surface, $a^s(M^{n+})$ is the activity of the metal ion at the surface of the electrode, and $a(Hg)$ is the activity of the mercury.

Replacing the activities by their equivalents in terms of activity coefficients and molar concentrations, we have

$$\epsilon_{d.Hg.l} = \epsilon_M^o - \frac{RT}{nF} \ln \frac{[M]^s \gamma^s (M)}{a(Hg) \, [M^{n+}]^s \gamma^s (M^{n+})}$$

(3.6.39)

where $\gamma^s (M)$ is equal to the activity coefficient of the metal in the amalgam at the surface of the drop, and the other terms have similar

definitions. The activity of the mercury a(Hg) is taken to be 1 since the amalgam formed is very dilute.

Thus

$$a(Hg) = 1$$

$$(3.6.40)$$

At any point of the wave it is assumed that the rate of diffusion of M^{n+} to the electrode surface is such that the current i is proportional to the difference between the concentrations of the metal ion at the surface $[M^{n+}]^S$ and in the bulk of the solution $[M^{n+}]^B$

Thus

$$i = k_1 \left([M^{n+}]^B - [M^{n+}]^S \right)$$

$$(3.6.41)$$

At the flat surface of the wave, the ions are reduced as rapidly as they reach the surface of the drop such that

$$[M^{n+}]^S \approx 0$$

$$(3.6.42)$$

At this flat portion of the wave, the current observed is the diffusion current i_d where

$$i_d = k_1 [M^{n+}]^B$$

$$(3.6.43)$$

The concentration of the metal in the amalgam is proportional to the current

$$i = k_2 [M]^S$$

$$(3.6.44)$$

We note that

$$i_d - i = k_1 [M^{n+}]^B - \left\{ k_1 \left([M^{n+}]^B - [M^{n+}]^s \right) \right\}$$

(3.6.45)

$$i_d - i = k_1 [M^{n+}]^s$$

(3.6.46)

Substituting the proper form of equations 3.6.40, 3.6.44 and 3.6.46 into equation 3.6.39, we find

$$\epsilon_{d.Hg.l.} = \epsilon_M^o - \frac{RT}{nF} \ln \frac{(i/k_2) \gamma^s (M)}{\left\{ i_d - i/k_1 \right\} \gamma^s (M^{n+})}$$

(3.6.47)

or

$$\epsilon_{d.Hg.l.} = \epsilon_M^o - \frac{RT}{nF} \ln \frac{k_1 \gamma^s (M)}{k_2 \gamma^s (M^{n+})} - \frac{RT}{nF} \ln \frac{i}{i_d - i}$$

(3.6.48)

At the half wave potential where

$$i = i_d/2$$

(3.6.49)

the last term of equation 3.6.48 vanishes and we have

$$\epsilon_{\frac{1}{2}} = \epsilon_M^o - \frac{RT}{nF} \ln \frac{k_1 \gamma^s (M)}{k_2 \gamma^s (M^{n+})}$$

(3.6.50)

After substitution of equation 3.6.50 back into equation 3.6.48 we obtain

$$\epsilon_{d.Hg.l.} = \epsilon_{\frac{1}{2}} - \frac{RT}{nF} \ln \frac{i}{i_d - i}$$

(3.6.51)

Equation 3.6.50 is the equation which relates the half wave potential $\epsilon_{\frac{1}{2}}$ to the standard electrode potential ϵ_M^o.

The ratio k_1/k_2 is the ratio of the diffusion currents of equal concentrations of M and M^{n+} in the same supporting electrolyte under identical conditions.

Accordingly, this ratio is very close to 1. For the same reasons the ratio $\gamma_M^s/\gamma_{Mn+}^s$ is very close to 1. Thus the ln term drops out and we may write

$$\boxed{\epsilon_{\frac{1}{2}} \approx \epsilon_M^o}$$

(3.6.52)

The half wave potential therefore is approximately equal to the standard electrode potential of the half reaction occurring at the dropping electrode. The order of magnitude of the error may be as large as 1%.

The scope of this section does not permit a complete discussion of polarography and its manifold applications to the photographic field.

For a complete exposition on Polarography see J. Heyrowsky and J. Kuta, *Principles of Polarography*, Academic Press, New York, 1966.

Brezina, Jaenicke *et al.*, [Ref: M. Brezina, W. Jaenicke, and H. Taithel, *Photogr. Sci. Eng.*, 13, 320 (1969)] reported the half wave potentials of some photographic developing agents versus the hydrogen electrode as shown in Table 3.6.2

TABLE 3.6.2

DEVELOPING AGENT	pH	$\epsilon_{\frac{1}{2}}$
Phenidone	9.3 – 13	0.145 ± .003V
4,4'–dimethyl–Phenidone	>10	0.159 ± .003V

These workers found by analysis of the anodic wave that the first step of the oxidation of Phenidone and its derivative 4,4'-dimethyl-Phenidone is a reversible one electron step.

The analysis of the anodic wave of hydroquinone corresponded to a reaction mechanism in which the semiquinone dismutates reversibly to hydroquinone and to quinone. This reaction may be written as

$$2QH_2 \longrightarrow 2SQ + 2e + 4H^+$$

(3.6.53)

$$2H^+ + 2SQ \rightleftharpoons QH_2 + Q$$

(3.6.54)

Addition of equations 3.6.53 and 3.6.54 results in

$$QH_2 \longrightarrow Q + 2e + 2H^+$$

(3.6.55)

where QH_2 = hydroquinone
 Q = quinone
 SQ = semiquinone

The dismutation reaction 3.6.54 is treated in Chapter 5.

The work of Brezina et al., showed that the oxidation product hydrogen peroxide could be evaluated easily and quantitatively by polarography and that oxidation kinetics could be examined.

The increasing application of polarographic techniques to photographic science justifies a need for the knowledge of this technique by the photographic scientist or worker.

PROBLEM SET 3.1

1. What information can thermodynamics give? What are its limitations?

2. A gas at an initial pressure of 50 torr and initial volume of 30 liters is taken at constant temperature to a pressure of 100 torr. Calculate the volume of the final state.

3. A gas of 50 torr, 30 liters, and 273° K is taken to 100 torr and 10 liters. Calculate the temperature of the final state.

4. The van der Waals' constants for SO_2 are

$a = 6.71$ atm-liter2/mole2

$b = 0.0564$ liter/mole.

In these units the gas constant is

$R = 0.082054$ liter-atm/mole-degree Kelvin.

Calculate the pressure at which 2 moles of sulfur dioxide will occupy a volume of 3 liters at 300°K. Compare your result with the corresponding pressure calculated from the ideal gas law.

5. What assumptions were made by van der Waals to correct the ideal gas equation?

6. At what conditions of temperature and pressure would a real gas diverge strongly from an ideal gas?

7. Is the reaction of photographic development reversible or irreversible?

8. What is the meaning of the statement, "the heat of fusion of ice is 79.7 calories/gram?"

9. What is the physical state of Bromine, Br_2, in its standard state?

10. What is the importance of the knowledge of the heat of formation of AgBr in solution to the photographic emulsion maker?

11. Define an ideal gas from the standpoint of kinetic theory.

12. What causes the pressure of a gas?

13. What is the pressure of 1 mole of an ideal gas that has a kinetic energy of 1000 calories in a 10 liter container?

14. What is the kinetic energy of 1 mole of an ideal gas at 300°K?

15. What is the enthalpy of the gas in problem 9?

16. Calculate the energy of a non-linear molecule at 100°K? (Neglect the vibrational energy and the zero point energy.)

17. Calculate the bond enthalpy of the silver-bromide bond using Table 3.3.1. Explain why this result does *not* give the lattice enthalpy.

18. A perpetual motion machine of the first type is defined as a machine which violates the first law of thermodynamics. Give an example of such a machine.

19. Calculate the work done on the surroundings by an ideal gas at 300°K in a reversible isothermal expansion from 30 liters to 100 liters.

20. Calculate the work done on the surroundings by an ideal gas at 760 torr in a reversible isopiestic expansion from 27°C to 100°C.

21. If a system absorbs 10 calories of heat and does 0.082 liter-atmospheres of work, at constant pressure, then according to the first law of thermodynamics what is the change in internal energy of the system in units of calories?

22. If the system of problem 21 is constrained to constant volume so that no work of expansion is done, then what is the change in internal energy of the system, assuming that no other work is done?

23. What is the enthalpy change for the system of problem 21?

24. Prove that H is a state function. Hint: Take the differential of $H = E + PV$ and, show that $\oint dH = 0$.

25. Consider energy E as a function of pressure and volume and write the corresponding differential expression.

26. Cite examples of exothermic and endothermic photographic reactions.

27. Can either the enthalpy or energy change of a reaction determine whether the reaction will take place spontaneously?

28. Derive the enthalpy change for a van der Waals' gas at constant pressure.

29. Using Table 3.3.1 calculate the heat of the reactions
$$Ag_{(g)} + Cl_{(g)} \rightarrow Ag\ Cl_{(c)}$$
$$Ag_{(g)} + \tfrac{1}{2}Br_{2(1)} \rightarrow Ag\ Br_{(c)}$$

30. Calculate energy change $\Delta E°$ for the reactions of problem 29.

31. Calculate the heat of solution of 1 mole of KBr in 50 and 1000 moles of H_2O.

32. Give the rational for the calculation of the heat of precipitation of AgBr described in the text. (Hint: Consider the reactions that must be added.)

33. Calculate the heat of precipitation of AgI at infinite dilution. Why is a knowledge of this heat important to the photographic emulsion maker?

34. Prove equation 3.3.88.

35. Show that the results of section 3.4 hold true for real gases. (Hint: Consider a machine operating in ½ of a Carnot cycle with a real gas and in the other half Carnot cycle with an ideal gas. Show that the assumption that the real gas machine is more efficient than the ideal gas machine violates the second law.)

36. Discuss how the Gibbs free energy is of use in determining the efficiency of a developing agent.

37. Verify that the heat of formation of gaseous benzene from carbon and hydrogen atoms in the gaseous state is − 1318 kcal/mole (see Figure 4.3.11).

38. Determine the resonance energy of benzene using the methods of Section 4.3.

39. Discuss how the free energy of development varies as a function of the concentration of oxygen that is present in a photographic emulsion.

40. Discuss the effects on the digital simulations of sections 2.2 and 2.3 when oxygen is removed from the system.

41. Relate the free energy change for chemical development of an exposed silver halide grain with an unexposed grain.

42. How does Tani (Section 4.4) relate the half wave potential of dyes to their sensitizing and desensitizing characteristics?

43. Write a quantitative expression for the chemical potential of the silver aggregate Ag_{n+1}, $\mu(Ag_{n+1})$, in terms of the chemical potential of the aggregate Ag_n, $\mu(Ag_n)$, and the concentrations of these aggregate species, $[Ag_n]$, $[Ag_{n+1}]$.

44. The thermodynamic criterion for photographic development is established by the difference in redox potential of the Ag/Ag^+ and the developer/oxidized developer systems in the neighborhood of the developing grain. Under conditions where these systems are thermodynamically reversible, then the free energy ΔG associated with development is related to the redox potentials ΔE by (a) what equation? (b) In order for this reaction to take place, the quantity $E_{Ag} - E_{dev}$ must have what values? (c) Given the system

$$Ag^+ + e \rightleftharpoons Ag^\circ$$
$$Dev \rightleftharpoons Dev^+ + e$$

write the equation for $E_{Ag} - E_{Dev}$ in terms of the concentrations of the active species.

4 Photographic Physical— Organic Topics

This chapter is divided into four sections. Section 1 introduces the reader to the benzene ring, the organic classification of some photographic developing agents and their naming. Section 2 is an introduction to the naming and structure of photographic sensitizing dyes restricted largely to the cyanine type dyes. Section 3 is an introduction to the concepts involved in understanding the absorption of radiation. This section also contains a discussion on the aggregation of photographic sensitizing dyes in solution and adsorbed to the surface of silver halide crystals.

Section 4 is a discussion of the mechanism of dye sensitization and desensitization in photography.

Appendices 4A, 4B and 4C support Chapter 4 by giving more insight into radiation processes.

4.1 Photographic Organic Chemistry

THE BENZENE RING

Auguste Kekulé, one of the founders of organic chemistry, was the first man to determine that the valence of carbon was 4.

In the 1850's, some chemists who were contemporaries of Kekulé insisted that methane gas (see Appendix 4B, The Electronic Structure of the Carbon Atom) had the formula

$$H - C - H$$

$$(4.1.1)$$

or in condensed notation, written as

$$CH_2$$

$$(4.1.2)$$

Other chemists believed that methane had the formula

$$\begin{array}{c} H \\ | \\ H-C-H \\ | \\ H \end{array}$$

$$(4.1.3)$$

or in condensed notation, written as

$$CH_4$$

$$(4.1.3a)$$

Kekulé reasoned that the exact formula could be obtained by successive substitution of chlorine for the hydrogens in methane gas.

Consequently, he progressively substituted a chlorine atom to methane one step at a time until the substitution of chlorine for hydrogen was complete. At each step of the process he isolated the unknown compounds, some of which could be easily precipitated as liquids. By measuring the physical and chemical properties of the products at each step of the process, he found that only four different substitution products of chlorine with methane could be made.

Kekulé concluded that each chlorine atom substituted into methane was replacing one of four hydrogen atoms connected to the carbon atom. Thus he wrote the following formula

1st Substitution Product $\underbrace{CH_3C1}$
methyl
chloride

(4.1.4)

2nd Substitution Product $\underbrace{CH_2C1_2}$
methylene
chloride

(4.1.5)

3rd Substitution Product $\underbrace{CHC1_3}$
chloroform

(4.1.6)

4th Substitution Product $\underbrace{CC1_4}$
carbon
tetrachloride

(4.1.7)

Chemists of the 19th century referred to the attraction of one atom for another as the affinity of atoms. Therefore it was natural for Kekulé to say that carbon had an affinity of 4.

Shortly after Kekulé published his discoveries, the German chemist Wichelhaus used the term "Wertigkeit" for affinity.

Subsequently "Wertigkeit" was translated into English as *valence* and from then on the valence of carbon was 4.

Kekulé was the student of Justus von Liebig, who had collaborated with Friedrich Wöhler in a series of studies of what we now call the *benzoyl radical.*

We now know that the benzoyl radical has the formula

$$C_6H_5CO$$

$$(4.1.8)$$

The studies of Liebig and Wöhler indicated that the benzoyl radical was composed of carbon and hydrogen and a part containing carbon and oxygen. The part containing carbon and hydrogen was known at that time to be related in some way to liquid benzene.

The analysis of benzene indicated that it contained an equal number of carbon and hydrogen atoms. Thus it was natural for the scientists of the 19th century to write

$$CH$$

$$(4.1.9)$$

It could also have been written as

$$C_2H_2$$

$$C_3H_3$$

$$C_4H_4$$

$$C_5H_5$$

$$C_6H_6$$

$$\vdots$$

$$C_nH_n$$

$$(4.1.10)$$

Kekulé was very interested in the benzene problem; i.e., what was the exact formula of benzene.

While studying the results of Liebig and Wöhler, he found from their analysis of the carbon to oxygen ratio that the part containing the carbon and hydrogen had much more carbon in it than one could ascribe to the formula CH. Kekulé concluded from this literature study that the formula for benzene was C_6H_6. This prediction was not compatible with the beliefs held by his contemporaries. Most of them did not accept that the formula for benzene was C_6H_6.

Kekulé, sure of his result, immediately used C_6H_6 as the basis for determining the geometrical structure of benzene. He was far ahead of his contemporaries who were still arguing over the benzene formula.

Kekulé was faced with the problem of placing the 6 carbon atoms and the 6 hydrogen atoms into a geometric structure such as to satisfy the tetravalence for carbon and the monovalence for hydrogen.

It was evident that the structure

$$\begin{array}{ccccccccccc}
 & & H & & & & & & H & & \\
 & & | & & & & & & | & & \\
H & - & C & - & C & - & C & - & C & - & C & - & C & - & H \\
 & & | & & & & & & | & & \\
 & & H & & & & & & H & &
\end{array}$$

(4.1.11)

did not satisfy both valency conditions.

Many structures similar to 4.1.11 can be drawn that do not satisfy both valency conditions.

It is interesting that the structural representation came to Kekulé in a day dream. [Ref: *Berichte der Deutschen Chemischen Gesellschaft* 23, 1306 (1890)].

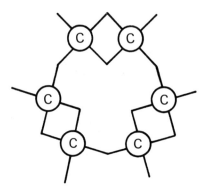

Fig. 4.1.1 *Shows the benzene model proposed by Kekulé [Ref: A. Kekulé, Lehrbuch der Organischem Chemie, Stuttgart: F. Enke (1866)].*

The alternate single and double bonds depicted in Figure 4.1.1 preserve both valency conditions.

A modern view of the benzene ring is a regular hexagon.

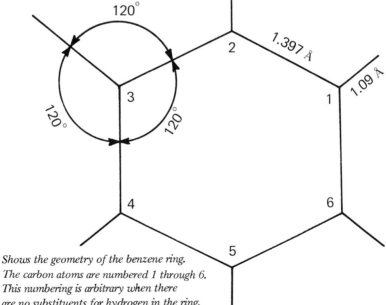

Fig. 4.1.2

The modern interpretation of the benzene ring is that the π electrons of the double bonds are delocalized so that every carbon carbon bond in the ring has a partial double bond character. Thus one cannot experimentally distinguish between the single and double bonds in the benzene ring (Figure 4.1.2).

X-ray diffraction and spectroscopic studies of benzene (C_6H_6) show that it is a flat molecule with six carbon atoms that are 1.397 Å $(1.397 \times 10^{-8}$ cm) apart in a regular hexagonal ring.

The angles between all $H - C - C$ and $C - C - C$ bonds are $120°$.

The hydrogen atoms are 1.09 Å from the carbon to which they are attached and they radiate out from the ring. Figure 4.1.3 shows these geometrical relationships.

Fig. 4.1.3 *Shows the geometry of the benzene ring.*
The carbon atoms are numbered 1 through 6.
This numbering is arbitrary when there
are no substituents for hydrogen in the ring.

EXERCISE

Calculate the straight line distance between carbon atoms 1 and 3, 1 and 4 and 2 and 5 in the benzene ring as shown in Figure 4.1.3.

A more condensed structure for the benzene ring which will be used in this text is

(4.1.12)

The symbol

(4.1.13)

is sometimes used to represent the benzene ring. The circle indicates that the ring contains only six hydrogens and that the double bonds are not localized. The authors take the view that this representation is uninformative and sometimes misleading when reactions between benzene and other molecules are considered.

NAMING AND CLASSIFICATION OF ORGANIC PHOTOGRAPHIC COMPOUNDS

According to the organic classification methods of Anderson and Lumiére which were extended and modified by Kendall and Pelz [Ref: M. Anderson, *Phot. Mit.*, **28**, 124, 286, 296, 340 (1891, 1892); A. and L. Lumiére, *Bull Soc. Franc. Phot.*, **7**, 310 (1891); J.D. Kendall, *Proc. IX Congr. Intern. Phot. Paris*, (1935) p-227; W. Pelz, *Angew. Chem.*, **66**, 231 (1954).] organic developing agents can be classified by using simple empirical rules.

According to these rules, with a few exceptions, developing agents satisfy the basic formula

$$A \quad - \quad (X = Y)_n \quad - \quad B$$

$$(4.1.14)$$

where A and B are used to represent the active groups OH and NH_2.

The symbol X represents a carbon atom and Y is either a carbon or a nitrogen atom.

The developing agents hydroquinone and 'Phenidone' can be classified as shown in Figure 4.1.4.

STRUCTURE AND NAME CLASSIFICATION

$$HO \quad - \quad (C = C)_2 \quad - \quad OH$$

Hydroquinone

1,4 dihydroxybenzene

$$HO(C = N)_1 \, NH_2$$

Phenidone

1-phenyl-3-pyrazolidone

Fig. 4.1.4 *Shows how the developing agents hydro-* *the active OH groups. In the case*
quinone and Phenidone can be classified. *of Phenidone, there is only one carbon*
The subscript 2 indicates a maximum *nitrogen double bond between the active*
number of carbon double bonds between *groups.*

The Phenidone structure has a doubly substituted amine group (NH_2), but these substitutions do not violate the classification.

A partial listing of important developing agents according to their classification follows in Table 4.1.1.

TABLE 4.1.1

CLASSIFICATION	STRUCTURE	NAME	MOLECULAR WEIGHT
$HO - (C = C)_2 - OH$	HO—⟨⟩—OH	Hydroquinone 1,4–dihydroxy-benzene	110
$HO - (C = C)_2 - OH$	Cl HO—⟨⟩—OH	Chlorohydro-quinone 2–chloro–1,4–dihydroxy-benzene	145
$HO - (C = C)_2 - OH$	OH / OH (naphthalene)	1,4–dihydroxy-naphthalene	160
$HO - (C = C)_2 - OH$	OH OH	Pyrocatechin Catechol 1,2–dihydroxy-benzene	110
$HO - (C = C)_2 - OH$	OH OH OH	Pyro, Pyrogallol 1,2,3–dihydroxy-benzene	127

TABLE 4.1.1

CLASSIFICATION	STRUCTURE	NAME	MOLECULAR WEIGHT
$HO - (C = C)_1 - HO$		Ascorbic Acid Vitamin C	144
$HO - (C = C)_2 - NH_2$		Ortho-aminophenol	109
$HO - (C = C)_2 - NH_2$		1,3−dialkyl−4−amino−5−hydroxy-pyrazolidone	99
$HO - (C = C)_2 - NH_2$		N−(β−hydroxy-ethyl)−ortho-aminophenol (Atomal)	153
$HO - (C = C)_2 - NH_2$		N−methyl ortho-aminophenol	123

TABLE 4.1.1

CLASSIFICATION	STRUCTURE	NAME	MOLECULAR WEIGHT
$HO - (C = C)_1 - NH_2$	NHCH$_3$ · ½ H$_2$SO$_4$ OH	Metol, Elon N–methylpara- aminophenol sulfate	172
$HO - (C = C)_1 - NH_2$	NH$_2$ OH	Para- aminophenol	109
$HO - (C = C)_1 - NH_2$	NHCH$_2$COOH OH	Glycin N–(4–hydroxy- phenyl) glycine	167
$HO - (C = C)_1 - NH_2$	NH$_2$ · HC1 NH$_2$ OH	Amidol 2,4–diaminophenol hydrochloride	160
$HO - (C = C)_1 - NH_2$	C$_2$H$_5$ N C$_2$H$_5$ · HC1 NH$_2$	N,N–diethylpara phenylenediamine hydrochloride	196

TABLE 4.1.1

CLASSIFICATION	STRUCTURE	NAME	MOLECULAR WEIGHT
$NH_2 - (C=C)_2 - NH_2$![structure: para-diaminobenzene] HCl	Paraphenylene diamine hydrochloride	144

Willems and Van Veelan [Ref: J. Willems, G. Van Veelan *Phot. Sci. Eng.*, **6**, 49 (1962)] reported on the *superadditivity* of the following substituted para-aminophenols with hydroquinone:

HX	R$_1$	R$_2$
½H$_2$SO$_4$	CH$_3$	CH$_3$
½H$_2$SO$_4$	C$_2$H$_5$	CH$_3$
½H$_2$SO$_4$	C$_2$H$_5$	C$_2$H$_5$
—	CH$_3$	C$_2$H$_4$OH
—	H	C$_6$H$_5$
—	CH$_3$	CH$_2$CH$_2$−NHSO$_2$CH$_3$

4.2 Photographic Dye Sensitizers

The silver halides of silver that are used as the image forming *crystals* of the photographic plate are in general insensitive to green, yellow and red light. Such films are called "color-blind" and yield black and white photographs which distort the tone renditions of the original scene. For example, a "color-blind" film material renders reds in the original scene as if they were black.

In 1873, H.W. Vogel performed an experiment to prevent halation. Vogel treated a collodion plate with a yellow dye. Subsequent exposure to the solar spectrum showed a sensitivity to green light.

He found that the green sensitivity of the emulsion was due to the presence of the yellow dye. [Ref: H.W. Vogel, *Ber.,* **6**, 1302 (1873).]

Vogel's discovery that the effective wavelength of absorption for a silver halide emulsion system could be extended by the use of dyes was a fundamental contribution to modern photography since panchromatic and color recording materials require dyes to extend their effective spectral range.

CYANINE DYE STRUCTURE

A benzene ring can be fused with another benzene ring to form a molecule called napthalene (Figure 4.2.1).

Napthalene

Fig. 4.2.1

383

Napthalene has sp^2 hybridization and is planar; i.e., the ring is flat.

Quinoline is a molecule of photographic interest based on the double ring system of napthalene and containing nitrogen in place of one of the carbons in the ring (Figure 4.2.2).

Quinoline

Fig. 4.2.2

When an atom other than carbon is introduced into a ring system such as benzene and napthalene, the ring is said to be *heterocyclic*.

Thus the quinoline molecule is heterocyclic, planar, and has sp^2 hybridization.

The positions on the quinoline molecule are numbered as shown in Figure 4.2.3.

Fig. 4.2.3

EXERCISE

Sketch three other representations of quinoline by introducing the nitrogen atom at three other appropiate positions in this heterocyclic ring. Renumber each ring system and explain why they are all identical.

An sp^3 hybridized ethyl iodide molecule (C_2H_5I) can be attached to the nitrogen forming 1 - ethylquinoline.

1-ethylquinoline iodide

Fig. 4.2.4

The 1-ethylquinoline iodide molecule (Figure 4.2.4) is sometimes named N-ethylquinoline iodide where N means that the ethyl group is attached to the nitrogen atom in the ring.

A cyanine dye which contains two 1-ethylquinoline heterocyclic rings, an iodide ion and an sp^2 hybridized linear chain (conjugated chain) is shown in Figure 4.2.5.

Fig. 4.2.5 *Shows the cyanine dye 1,1'–diethyl–*
2,2'–carbocyanine iodide.

This cyanine dye has a positive part consisting of the heterocyclic rings and the conjugated chain, and a negative part consisting of the iodide ion. The name of this cyanine dye is determined by arbitrarily choosing one ring system as an unprimed system and the other ring system as a primed system. The prefix carbo in the word carbocyanine arises from the following conventions:

1) The general formula for a cyanine dye based on the quinoline ring is shown in Figure 4.2.6.

Fig. 4.2.6

where n = 0, 1, 2, 3, . . . , and the group in parentheses is called a *vinyl* group.

2) The number of vinyl groups determines the prefix before the word cyanine as shown in Table 4.2.1.

TABLE 4.2.1

Value of n	Prefix
0	none or iso
1	carbo
2	dicarbo
3	tricarbo
4	tetracarbo
5	pentacarbo

EXERCISE

Draw the structures and name the cyanine dyes when n = 0, 3 and 5.

An example for a cyanine dye when n = 4 is 1, 1–diethyl – 2, 2' – tetraquinocarbocyanine iodide (Figure 4.2.7).

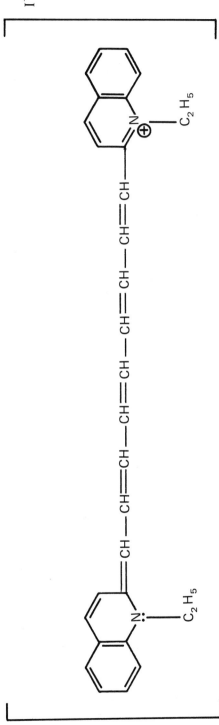

Fig. 4.2.7

When the conjugated chain of vinyl groups is connected at the 4 or 4′ position of one of the quinoline molecules, the number prior to the name of the particular cyanine dye is changed to 4 or 4′. An example of a cyanine dye of this type is ethyl red (Figure 4.2.8). The descriptive name of this dye is 1, 1′–diethyl–2, 4′–cyanine iodide.

Ethyl Red

Fig. 4.2.8

RESONANCE STRUCTURES OF THE CYANINE DYES

It is not possible to distinguish between the structures shown in Figure 4.2.9.

Fig. 4.2.9

The two structures shown in Figure 4.2.9 are said to be the major contributors to the ground state (lowest energy state) of the cyanine dye.

Each of these structures arises from the movement of electrons from the uncharged nitrogen to the charged nitrogen across the conjugated chain as shown in Figure 4.2.10.

Fig. 4.2.10

The movement of electrons that result in the two extreme structures (see Figure 4.2.9) produces a stabilization of the molecule. The actual ground state of the molecule is considered to be a blend or resonance hybrid of the two extreme states.

This phenomenon is termed *resonance stabilization*.

Other structures may be drawn for the molecule shown in Figure 4.2.10 that are at higher energy than the extreme structures. These structures are called excited state structures and are the major contributors to the excited state of the cyanine dye.

Three excited state structures are shown in Figure 4.2.11.

Fig. 4.2.11

EXERCISE

Draw 3 other excited state structures.

The excited state structures are characterized by the positive charge being associated with a carbon atom rather than a nitrogen atom. The excited state is considered to be a resonance hybrid of the structure (or states) having a carbon atom positively charged.

Appendix 4C of this chapter shows how the length of a conjugated chain is related to the frequency of absorption.

NUCLEI OF THE CYANINE DYES

Many other fused and single heterocyclic ring systems can be used to make dyes similar to the cyanine dyes. These ring systems are given the general name nuclei. (Not to be confused with nuclei of atoms.)

The structure, name and prefix for a number of different nuclei of cyanine dyes are given in Table 4.2.2.

TABLE 4.2.2

STRUCTURE	NAME	PREFIX
	benzimidazole	imida
	dimithylindolenine	dimethylindolenino
	benzoselenazole	selena
	B-napthothiazole	B-napthothia

TABLE 4.2.2

STRUCTURE	NAME	PREFIX
	benzothiazole	thia
	thiazoline	thiazolino
	thiazole	thiazolo
	benzoxazole	oxa
	3-pyrolle	3-pyrollo
	3-indole	3-indolo

Utilizing Table 4.2.2, we may name the cyanine dye in structure 4.2.12 as 3, 3′–diethyl–2, 2′–thiacarbocyanine iodide.

Fig. 4.2.12

Similarly, the structure 4.2.13 is named, 1, 1′–dimethyl–2, 2′–dimethylindoleninodicarbocyanine iodide.

Fig. 4.2.13

The heterocyclic ring is numbered by starting with the heterocyclic atom and proceeding around the ring in such a manner as to give the other substituents or other hetero atoms the lowest numbered positions. In the

case where there are 2 or more different hetero atoms in the ring, oxygen takes precedence over sulfur and sulfur over nitrogen for the number 1 position.

EXERCISE

Using Table 4.2.2, construct 3 symmetrical cyanine dyes (same nuclei on both sides of the conjugated chain).

UNSYMMETRICAL CYANINE DYES

If the nuclei at each end of the polyvinyl chain of a cyanine dye are the same, it is said to be symmetrical.

Unsymmetrical cyanine dyes result when the nuclei are different, as shown in Figure 4.2.14.

1, 1 – diethyl – 2 – quino – 2 – thiacarbocyanine iodide

Fig. 4.2.14

The prefix quino in the name of the cyanine dye shown in Figure 4.2.14 refers to the quinoline nuclei.

Either a symmetrical or unsymmetrical cyanine dye contains the amidinium ion system. (Figures 4.2.15, 4.2.16, where the figures are drawn in such a manner as to preserve the $120°$ angular relationship between sp^2 hybridized atoms and where the arrows show the movement of electrons.)

Fig. 4.2.15

Fig. 4.2.16

The two resonance forms of the amidinium ion system shown in Figures 4.2.15 and 4.2.16 that contain n double bonds and n−1 vinyl groups are the major contributors to the lowest energy state of the system and are indistinguishable.

Linear chains such as the amidinium ion system are conveniently drawn where the angular relationship is not preserved (Figure 4.2.17).

Fig. 4.2.17

In the resonance structure of Figure 4.2.15, the left hand nitrogen atom has an unshared set of electrons and is electron donating or basic nitrogen. The acidic nitrogen (or electron attracting) is positively charged and located at the right end of the chain.

The relative force by which the nuclei at each end of the polyvinyl chain repel an electron is a measure of the basicity of the nuclei.

Absorption characteristics of all cyanine dyes are a function of the basicity of the nuclei and the length of the polyvinyl chain. The function-

al relationship between these independent variables and the wavelength of maximum absorption may be considered from several theoretical standpoints.

Since molecules of photographic interest, i.e., dye sensitizers and developing agents, are very large, the approximate methods of quantum mechanics must be used to describe these molecules.

These approximate methods may be accuratized by semiempirical methods, i.e., by combining Hückel linear combination of atomic orbitals into molecular orbitals, then calculating the quantized energy levels of the molecules in terms of the undetermined parameters α and β and finally fixing the values of these undetermined parameters by means of experimentally determined quantities such as half wave potential, ionization potential and electron affinity.

4.3 Absorbtion of Radiation

INTRODUCTION

Photographic panchromatic sensitized materials absorb radiation in the region of wavelength 400—700 nanometers ($1nm = 10^{-7}$ cm).

Radiation in this wavelength range evokes a visual sensation and is called visible light.

The relationship between the energy and frequency or wavelength of radiation is given by Planck's equation

$$E = h\nu = \frac{hc}{\lambda}$$

(4.3.1)

where E is the energy of the quanta, h is Planck's constant, c the velocity of light, λ is the wavelength of the quanta, ν is the frequency of the quanta.

When a molecule absorbs a photon having sufficient energy, an electron in the ground state (lowest energy state) may be excited to a high energy state (excited state).

This process is shown in Figure 4.3.1 and Figure 4.3.2.

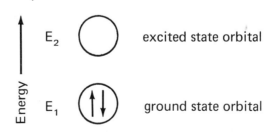

Fig. 4.3.1 *Shows schematically a molecule containing two paired electrons in the lowest energy orbital. The excited state orbital is empty.*

Fig. 4.3.2 *Shows the result of the molecule of Figure and causing a transition of an electron from*
4.3.1 absorbing a photon of energy E_2-E_1 the ground state to the excited state.

Depending upon the energy of the photon, a number of different transitions may take place.

The absorption of a photon having greater energy than $E_2 - E_1$ may result in a transition of the electron to a higher excited state orbital, or the electron may be set free from the molecule.

When the photon energy is less than the energy required for an electronic transition, then the only other transitions that are possible are vibrational, rotational or translational (Table 4.3.1 and Figure 4.3.3).

TABLE 4.3.1

The order of magnitude of energy level spacing

	$cal/mole$	$erg/molecule$
Electronic	10^5	10^{-11}
Vibrational	10^3	10^{-13}
Rotational	10^0	10^{-16}
Translational	10^{-18}	10^{-34}

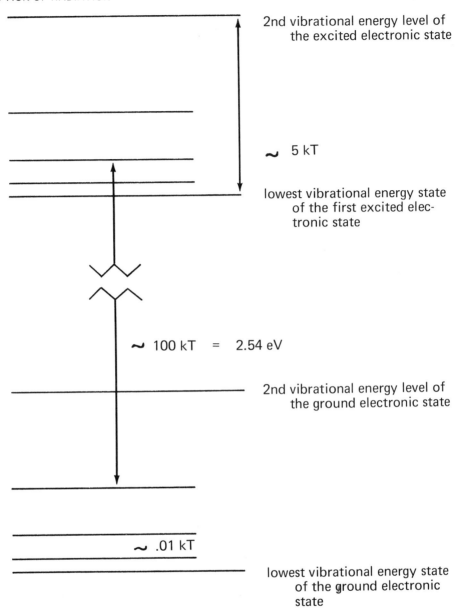

2nd vibrational energy level of the excited electronic state

~ 5 kT

lowest vibrational energy state of the first excited electronic state

~ 100 kT = 2.54 eV

2nd vibrational energy level of the ground electronic state

~ .01 kT

lowest vibrational energy state of the ground electronic state

Fig. 4.3.3 *Shows schematically the energy level spacing for the gound state and first excited electronic energy state.*

Only two of the many vibrational levels are shown in each electronic state. The energy spacing between these electronic energy states is approximately 100 kT whereas the corresponding spacing between the

vibrational and rotational energy is \sim 5 kT and \sim .01 kT respectively. Since the translational energy level spacing is \sim 10^{-10} kT, these lines are not shown. The unit of energy for this diagram is kT where T is taken as $300°$ K and where k = 8.48 x 10^{-5} eV/$°$K and kT = 0.0254 eV at $300°$K.

EXERCISE

Calculate the energy in electron volts required for a transition between two translational states at $300°$ K.

When a photon is absorbed, the energy associated with the photon is equal to the difference in energy between two states E_1 and E_2. This process can be quantitatively expressed by the equation

$$E_{photon} \ = \ E_2 \ - \ E_1 \ = \ \frac{hc}{\lambda}$$

(4.3.2)

Equation 4.3.2 can be expressed in units of electron volts where λ is in nanometers as follows

$$E \ = \ \frac{hc}{\lambda} \ = \ \frac{1240 \text{ electron volts}}{\lambda_{nm}}$$

(4.3.3)

Table 4.3.2 gives the photon energies for each wavelength calculated from equation 4.3.3.

EXERCISE

Calculate the photon energies for the following wavelengths: 1nm, 50nm, 350nm, 437nm, 750nm, 2.5μ.

TABLE 4.3.2

Photon Energy (eV)	λ (nm)
6.20	200
3.10	400
2.76	450
2.48	500
2.25	550
2.07	600
1.91	650
1.77	700
1.55	800
1.24	1000

Table 4.3.2 shows that the energy of a photon is linearly related to $1/\lambda$. Photon energies range from 3.1 to 1.77 electron volts in the visible region of the electromagnetic spectrum.

When a gas, liquid or solid at low temperature absorbs a photon, the effect is visually indicated by a black absorption line or a band of lines at the wavelengths of absorption. Conversely, when a photon is reradiated from such an excited system, the observed effect is a series of colored transmission lines, usually at the same position as the absorption lines. The former case is called absorption spectra while the latter is designated as transmission spectra.

Absorption spectra result in the case of electronic transitions to a higher energy (see Figure 4.3.3).

When an electron makes a transition from a higher to a lower energy state, this electronic transition results in transmission spectra.

As the temperature is increased from $1°K$ to room temperature, the sharply defined line spectra of molecules become broadened into bands.

At room temperature the band spectra of molecules are a function of the aggregation or clumping of molecules, the liquid that the molecule is dissolved in, the surface that the molecule is adsorbed onto, and the presence of other molecules in the solution.

When the band spectra of a molecular system are shifted to shorter wavelengths by any of these factors, it is called a hyposchromic shift—to longer wavelengths, a bathochromic shift.

Certain substances exhibit color in a natural state at room temperature when they are illuminated. This color (operational definition of color see Section 5.1) that is perceived is a combination of absorption and transmission band spectra.

Before the advent of quantum mechanics in 1925, a substance or group of atoms which produced color upon illumination was called a *chromophore*. However, if upon illumination such a system did not produce color but enhanced it upon reacting with a *chromophore*, it was called an *auxochrome*.

Thus prior to 1925 it was known that one or more unsaturated groups, such as the vinyl group $- CH = CH -$, the diazo group $-N = N-$, the carbonyl group $-C = 0$, produced color and were designated *chromophores*.

It was noted that conjugated configurations were significant to color formation.

The polyvinyl chain represents such a configuration (Figure 4.3.4).

$$- \ CH \ = \ CH \ - \ CH \ = \ CH \ - \ CH \ = \ CH \ -$$

Fig. 4.3.4

Typical auxochromes are the amine and hydroxyl groups.

Present literature still uses the theory of chromophores and auxochromes despite the fact that the theory of color is more easily explained in terms of quantum mechanical concepts, i.e., transitions between orbitals (Figure 4.3.3).

ATOMIC AND MOLECULAR ORBITALS

The 1s electron of the hydrogen atom exists at an energy state E_{1s} and is characterized by a wave function ψ_{1s} that is a solution to the *Schrödinger equation*

$$H\psi_{1s} \ = \ E_{1s}\psi_{1s}$$

$$(4.3.4)$$

where H is called the *Hamiltonian* energy operator that contains both kinetic and potential energy terms.

The molecular orbital approach for constructing the wave function for the hydrogen molecule H_2 requires the construction of a *linear combination of the atomic wave functions* ψ_{1s} (1,A) and ψ_{1s} (2,B) for electrons 1 and 2 on nuclei A and B.

ψ_{1s} (1)

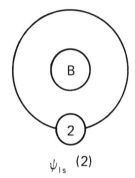

ψ_{1s} (2)

Wave function for the 1s electron on hydrogen atom 1

Wave function for the 1s electron on hydrogen atom 2

Fig. 4.3.5 *Shows the wave functions for two 1s electrons localized at two hydrogen atoms A and B.*

When two hydrogen atoms combine to form the hydrogen molecule, a new wave function that characterizes the molecule must be constructed. This new wave function must be constrained by the requirement that the electrons are delocalized and indistinguishable; i.e., they are free to move throughout the molecule.

An approximate wave function for electron 1 can thus be written as

$$\psi(1) = \frac{1}{\sqrt{2}}[\psi_{1s}(1,A) + \psi_{1s}(1,B)]$$

(4.3.5)

and for electron 2 we have

$$\psi(2) = \frac{1}{\sqrt{2}}[\psi_{1s}(2,A) + \psi_{1s}(2,B)]$$

(4.3.6)

Equations 4.3.5 and 4.3.6 show that electron 1 and 2 can appear in the domain of both nuclei.

The constant $1/\sqrt{2}$ is called the *normalization constant (see Appendix 4B)*.

The total approximate wave function for the hydrogen molecule can now be written as

$$\psi(1)\,\psi(2) \;=\; \tfrac{1}{2}[\psi_{1s}(1,A) + \psi_{1s}(1,B)][\psi_{1s}(2,A) + \psi_{1s}(2,B)]$$

(4.3.7)

Equation 4.3.7 represents the *σ bonding molecular orbital.*

The molecular orbital represented by equation 4.3.7 is a solution to equation 4.3.4. We may construct other solutions to equation 4.3.4 by writing

$$\psi(1) \;=\; \frac{1}{\sqrt{2}}[\psi_{1s}(1,A) - \psi_{1s}(,B)]$$

(4.3.8)

$$\psi(2) \;=\; \frac{1}{\sqrt{2}}[\psi_{1s}(2,A) - \psi_{1s}(2,B)]$$

(4.3.9)

The product of equations 4.3.8 and 4.3.9 is the *σ* antibonding molecular orbital.*

σ* Antibonding
molecular orbital

Is

1s

σ Bonding molecular
orbital

Fig. 4.3.6 *Shows two 1s electrons combining to form either the stable σ bonding molecular* *orbital or the unstable σ* molecular orbital, depending upon the energy in the system.*

Equations 4.3.8 and 4.3.9 representing the σ^* antibonding molecular orbital give rise to the positive and negative lobes, and a node results (no charge density) wherever the wave function changes sign between the nuclei. The σ bonding molecular orbital does not have a node and consequently is a "totally" bonding molecular orbital.

In more complicated molecules than the hydrogen molecule only the outer valence electrons participate in chemical bonding, forming σ, σ^*, π and π^* bonding and antibonding molecular orbitals.

The π bond orginates when p electrons combine to form a molecular orbital that is perpendicular to the plane of symmetry (Figure 4.3.7).

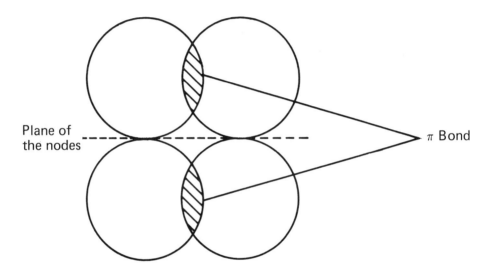

Fig. 4.3.7 *Shows the overlap of two p electrons forming a π bond above and below the plane of the nodes of the p orbitals.*

A more complicated molecule to be considered from a molecular orbital standpoint is benzene.

The molecular orbital treatment for the benzene ring considers that the electrons in the sigma bonds that contribute to the hexagonal configuration of the ring are localized. These localized sigma electrons are assumed not to influence the electronic character of the π bonds in the molecule. Since each carbon atom in the benzene ring has a π electron that forms a π bond, we may write the molecular orbital for the i^{th} electron as

$$\Psi_i = C_{1i} \Psi_{2p}(1,i) + C_{2i} \Psi_{2p}(2,i)$$

$$+ C_{3i} \Psi_{2p}(3,i) + C_{4i} \Psi_{2p}(4,i)$$

$$+ C_{5i} \Psi_{2p}(5,i) + C_{6i} \Psi_{2p}(6,i)$$

$$\text{where } i = 1, 2, \dots 6; \text{ and } C_{ni} = \text{constants}$$

$$n = 1, 2, \dots 6.$$

(4.3.10)

Equation 4.3.10 is a *linear combination of the 2p atomic orbitals* from each carbon atom of the benzene ring (the unhybridized orbital) forming a molecular orbital. This method of forming molecular orbitals is abbreviated as MO–LCAO.

When a molecular orbital expressed in 4.3.10 is determined by substitution into the Schrödinger equation 4.3.4, the solutions result in six energy levels, of which three are bonding and three represent the antibonding orbitals (Figure 4.3.8).

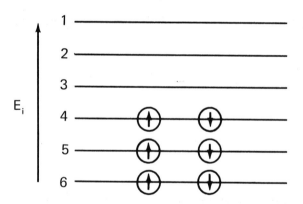

Fig. 4.3.8 *Shows the filling of each of the π molecular orbital energy levels by two paired electrons, according to the Pauli principle. The* *antibonding π* orbitals are unoccupied and lie at higher energies.*

RESONANCE ENERGY

The *Hückel approximation* results in the energy states shown in Figure 4.3.8. [Ref: J.D. Roberts, Notes on Molecular Orbital Calculation, Benjamin, N.Y. 1961].

When the calculation outlined above is made with the assumption that π electrons are delocalized, i.e., corresponding to the structure

Fig. 4.3.9

and not to the structure

Fig. 4.3.10

the lowest energy states are found.

The difference in energy between the states represented by Figures 4.3.9 and 4.3.10 is called the resonance energy of benzene.

Thus the benzene ring is said to be resonance stabilized.

The resonance energy for benzene can be estimated in the following manner: The enthalpy changes for the following reactions are given as

$$6 \text{ carbons (graphite)} + 3H_2 \text{ gas} \longrightarrow C_6H_6 \text{ (gas)}; \Delta H = 19.8 \text{ k cal.}$$

$$(4.3.11)$$

$$6 \text{ carbons (graphite)} \longrightarrow 6 \text{ carbons (gas)}; \Delta H = (6)(171) = 1026 \text{ k cal.}$$

$$(4.3.12)$$

$$3H_2 \text{ (gas)} \longrightarrow 6H \text{ (gas)}; \quad \Delta H = (3)(104) = 312 \text{ k cal.}$$

$$(4.3.13)$$

Using equations 4.3.11, 4.3.12 and 4.3.13, we may calculate the enthalpy of formation for benzene in the gaseous state.

Rewriting equations 4.3.12 and 4.3.13, we have

$$6 \text{ carbons (gas)} \longrightarrow 6 \text{ carbons (graphite)}; \quad \Delta H = - 1026 \text{ k cal.}$$

$$(4.3.14)$$

$$6 \text{ H (gas)} \longrightarrow 3 H_2 \text{ (gas)}; \quad \Delta H = - 312 \text{ k cal.}$$

$$(4.3.15)$$

$$6 \text{ carbons (graphite)} + 3H_2 \text{ (gas)} \longrightarrow C_6H_6 \text{ (gas)}; \Delta H = 19.8 \text{ k cal}$$

$$(4.3.15a)$$

$$6 \text{ carbons (gas)} + 6 H \text{ (gas)} \longrightarrow C_6H_6 \text{ (gas)}; \Delta H = -1318 \text{ k cal}$$

$$(4.3.16)$$

Therefore the heat of formation of gaseous benzene from carbon and hydrogen atoms in the gaseous state is -1318 kcal/mole.

Since the heat of formation is negative, the benzene system is 1318 k cal. below the level of its free atoms.

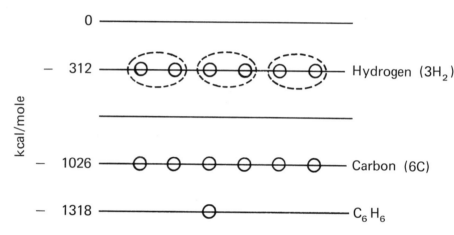

Fig. 4.3.11 *Shows a plot of the enthalpies of three hydrogen molecules, six carbon atoms (graphite), and benzene relative to six carbon atoms and six hydrogen atoms, which are arbitrarily taken as zero.*

The enthalpy state for benzene (Figure 4.3.9) of -1318 kcal/mole can be compared with the enthalpy of the Kekulé structure shown in Figure 4.3.10. This structure has 6 carbon-hydrogen bonds, three carbon-carbon bonds, and 3 carbon=carbon bonds.

TABLE 4.3.2a

BOND	BOND ENERGY
C — H	99 k cal/mole
C — C	83 k cal/mole
C = C	147 k cal/ mole

Table 4.3.2a shows the amount of energy required to dissociate the bonds and produce the component atoms in the gaseous form.

The enthalpy state for Kekulé benzene may be written as

$$\Delta H = -3(C-H) - 3(C-C) - 3(C=C) \longrightarrow$$

$$\underbrace{-594 \frac{kcal}{mole}} \quad \underbrace{-249 \frac{kcal}{mole}} \quad \underbrace{-441 \frac{kcal}{mole}} \quad \underbrace{-1284 \frac{kcal}{mole}}$$

(4.3.17)

The difference in energy between the ΔH values for benzene as given in Figure 4.3.11 and equation 4.3.17 is called the resonance energy. An alternate method for determining the resonance energy of benzene may be found by comparing the values for the hydrogenation of ethylene and benzene.

$$\underbrace{C_2 H_4}_{\text{ethylene}} + 2H^+ \longrightarrow C_2 H_6 ; \Delta H = -28.8 \frac{k\,cal}{mole}$$

(4.3.18)

$$\underbrace{C_6 H_6}_{\text{benzene}} + 6H^+ \longrightarrow C_6 H_{12} ; \Delta H = -49.8 \frac{k\,cal}{mole}$$

(4.3.19)

Since ethylene has one C=C bond and benzene has three C=C bonds, we must multiply ΔH of equation 4.3.18 by the factor 3 prior to making a comparison with benzene (Figure 4.3.12).

Fig. 4.3.12

Fig. 4.3.12 *Shows a plot of the heat of formation* *since the hydrogenation of benzene yields*
 of benzene and cyclohexane. The resonance *49.8 k cal/mole.*
 energy for benzene is − 36.6 k cal/mole,

Aromatic compounds can be defined as ring compounds that consist of alternating double bonds between carbon atoms where benzene is the parent compound of the aromatic series. Aromatics have a high resonance energy relative to straight chain unsaturated compounds containing a similar number of double bonds.

When constructing resonant structures, only the π electrons shift while the nuclear position with reference to the atoms must remain constant. π electrons can shift to receiving molecular orbitals only where the valency condition is maintained.

The possible resonance forms of butadiene are shown in Figure 4.3.13.

Fig. 4.3.13 *Depicts that the only resonance forms that* *required to separate the charge is very large*
 can be drawn for butadiene require *and these resonance states must*
 separation of charge over relatively long *be considered as the major contributors*
 distances. Although the charge structures *to the excited state rather than to the*
 will make some contribution to a complete *ground state of the neutral molecule. Thus*
 description of the molecule, the force *butadiene is not an aromatic compound.*

Another more complicated case of nonaromaticity is *quinone.* The resonance forms of quinone are similar to that of butadiene since the resonance forms show a separation of charge (Figure 4.3.14).

Fig. 4.3.14 *Shows three resonance forms of quinone, which, similar to the butadiene charged* *resonance forms, result in being the major contributors to the excited state.*

Since the uncharged form is the major contributor to the ground state of the neutral molecule, quinone is neither resonance stabilized nor aromatic.

The resonance forms of hydroquinone are the same as those of benzene with respect to the movement of double bonds, and therefore hydroquinone is an aromatic compound.

Since hydroquinone is resonance stabilized, we should expect that its ground state should lie farther away from its excited state than the ground state of quinone lies from its excited state (Figure 4.3.15).

Fig. 4.3.15 *Shows that $E_{HQ} > E_Q$. Hydroquinone is resonance stabilized and thus requires* *more energy to reach its excited state than does quinone.*

EXERCISE

With the aid of Figure 4.3.15 explain why hydroquinone is colorless in aqueous solution while quinone is highly colored in aqueous solution.

MOLECULAR ORBITAL TRANSITIONS

An electron making a transition may originate from either a non bonding atomic orbital of one of the atoms in the molecule (n electron) or a bonding σ or π molecular orbital.

The higher energy states that are available for electronic transitions are the antibonding σ^* and π^* molecular orbitals. A transition is symbolized as

$$X \longrightarrow Y$$

(4.3.20)

where $X = n, \sigma, \pi$; and $Y = \sigma^*, \pi^*$.

By using partial Lewis structures, a schematic series of some of the transitions for quinone may be drawn (Table 4.3.3).

When an electron makes a transition from an n shell (the n shell electrons are those electrons that are not involved in bonding, nonbonding electrons of an atom such as carbon, oxygen, nitrogen or chlorine) of an atom to either the π^* or σ^* molecular orbital, the molecule becomes partially polarized. This partial polarization is due to the separation of charge that results when the n electron leaves its original orbital and transits to either the π^* or σ^* orbital.

Polarized molecules often facilitate reactions with electrophilic or nucleophilic reagents.

If the n electron (non bonding electron) transits from a carbon atom of an aromatic ring, then probabilistically nucleophilic reagents (OH^-, Cl^-, NH_2^-) will favor this carbon for reaction during the time of electron deficiency.

Ordinarily an aromatic ring such as benzene attracts electrophilic reagents due to the presence of delocalized π electron charge above and below the benzene ring. Thus irradiation of a molecule at the appropriate frequency in the presence of reagents can give rise to reactions that could not occur from the ground state of these molecules.

TABLE 4.3.3

TYPE OF TRANSITION	PATH OF ELECTRON	SCHEMATIC REPRESENTATION
$n \longrightarrow \pi^*$	From the n shell of the oxygen atom to the π^* molecular orbital of the quinone molecule	
$\pi \longrightarrow \pi^*$	From the π molecular orbital to the π^* molecular orbital of the quinone molecule	
$\pi \longrightarrow \sigma^*$	From the π molecular orbital to the σ^* molecular orbital	

When an electron transits to π^* or σ^* antibonding states as shown in Table 4.3.3, an interpretation of the schematic representations is that the probability of finding these electrons in the ground state goes to zero while the probability of finding them at new spatial coordinates becomes a maximum value.

The electronic molecular orbital energies can be arranged in order of increasing energy

$$\sigma < \pi < n < \pi^* < \sigma^* \tag{4.3.21}$$

The hydroxyl groups of hydroquinone are *nucleophilic* (electron donating). These groups tend to inject electrons into the ring, thereby changing both the ground and excited state levels of the molecule. However since the injection of electrons into the ring is mutually opposed by these two groups, this effect is minimized.

On the other hand, in the case of paranitrophenol which contains a nitro group opposed to a hydroxyl group, the electron withdrawing tendency of the nitro group augments the electron donating tendency of the hydroxyl group and a push-pull effect results. Hence we should expect that p-nitrophenol has a λ_{max} greater than either hydroquinone or benzene.

The benzene molecule has two interesting absorption bands with λ_{max} values located at 2000 Å and 2550 Å.

Both bands are due to $\pi \rightarrow \pi^*$ transitions. They differ in that the excited state of the first band has significant contributions from polar structures and is called the benzene chromophore. The second band has significant contribution from non-polar structures (benzenoid structures) and is referred to as the benzenoid band. The λ_{max} of paranitrophenol compared to the benzene chromophore is 3175 Å, whereas the λ_{max} of hydroquinone compared to the benzenoid band is 2900 Å.

Therefore we conclude that the excited state in paranitrophenol is closer to its ground state than the excited state of the benzene chromophor is to its ground state.

EXERCISE

Calculate the energies of both $\pi \rightarrow \pi^*$ transitions and compare their differences.

Using relation 4.3.21, the molecular orbital construction of the nitrogen molecule can be derived as shown in Figure 4.3.16.

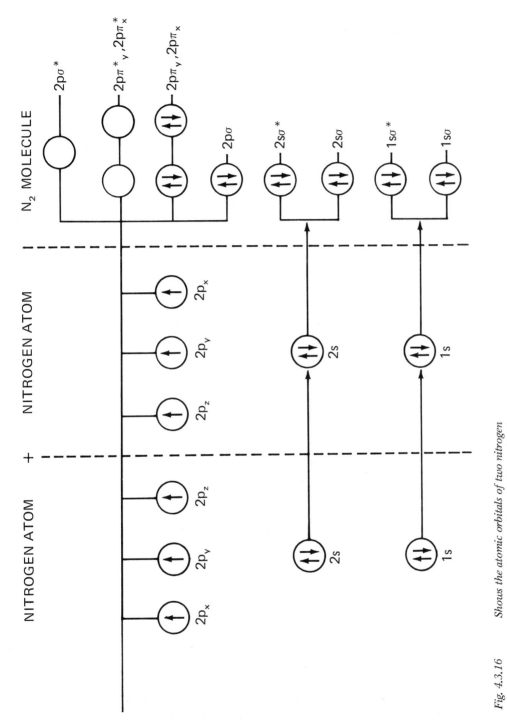

Fig. 4.3.16 Shows the atomic orbitals of two nitrogen atoms combining to form the N_2 molecular orbitals as described in equation 4.3.21.

The net effect of bonding for the 1s and 2s molecular orbitals is zero since the bonding and antibonding σ orbitals are filled. The bonding molecular orbitals for the nitrogen molecule are given by the $2p\sigma$, $2p\pi_y$ orbitals (Figure 4.3.17).

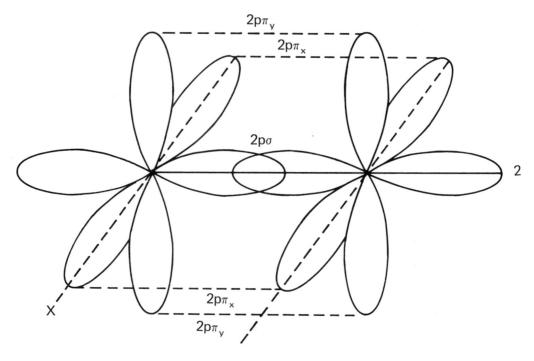

Fig. 4.3.17

By analysis of the electronic band spectra of many compounds, a representation of the approximate order of electron transitions as a function of energy is

$$n \rightarrow \pi^* < \pi \rightarrow \pi^* < n \rightarrow \sigma^* < \pi \rightarrow \sigma^*$$

$$< \sigma \rightarrow \pi^* < \sigma \rightarrow \sigma^*$$

$$(4.3.22)$$

ABSORPTION BAND SPECTRA OF PHOTOGRAPHIC SENSITIZING DYES

The absorption band spectra of cyanine dyes in solution changes as a function of the concentration of the dye (Figures 4.3.18a and 4.3.18b).

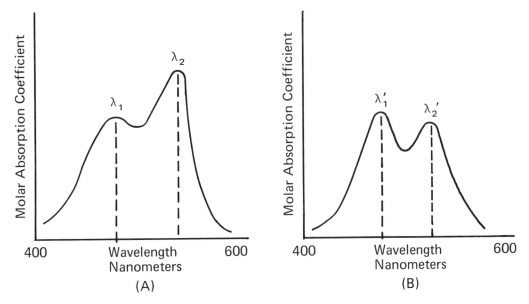

Fig. 4.3.18a *Shows the absorption spectra of a cyanine dye at two different concentrations.*

The concentration (A) is so low that the dye is mainly in the molecular form ($\approx 10^{-5}$ molar).

The concentration (B) is large enough for *dimerization* of the molecule ($\approx 10^{-3}$ molar).

The absorption spectrum of the cyanine dye at concentration (A) follows Beer's law so that the spectrum is due to the isolated dye molecule in interaction with the solvent and not with other dye molecules.

On the other hand, when the concentration is increased to (B), intermolecular interactions take place so that a new absorption maximum appears.

The absorption maximum for the dye at concentration (A) is at λ_2 and a secondary maximum at λ_1, which is probably due to a population of vibrational levels coexisting simultaneously with the electronic levels, (Figure 4.3.3) also appears.

The absorption at λ_2 is due to the primary electronic transition $\pi \rightarrow \pi^*$ (M band).

The dimerization occurring at concentration (B) is responsible for the slight hypsochromic shift in wavelength form λ_1 to λ_1'.

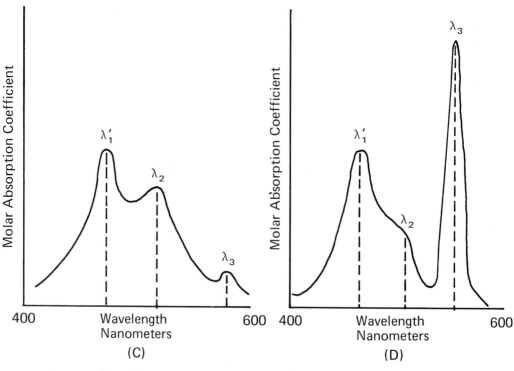

Fig. 4.3.18b *Shows the absorption spectra of the cyanine* *concentrations where (C)≈5 x 10⁻³ molar,*
dye of Figure 4.3.18a at two higher *(D)≈10⁻² molar.*

As the concentration is increased to (C) ≈ 5 x 10^{-3} molar, the absorption increases in magnitude at λ_1' (Figure 4.3.18b) with a corresponding decrease at λ_2, and the appearance of a new band at λ_3. Finally as the concentration is increased to (D) ≈ 10^{-2} molar, the magnitude of absorption at λ_1' increases slightly. The band at λ_2 drops sharply and the band at λ_3 increases sharply. This band at λ_3 is called the J band. It signifies a new state of J molecular aggregation.

The band at λ_1' is designated the H band and is due to H aggregates. The H and J states of aggregation are reversible since an increase of temperature causes the reverse changes to take place in the absorption curve until the curve appears as at concentration (A) in Figure 4.3.18a.

This type of concentration and temperature dependent absorption spectra is observed in many dyes. However, not all dyes show a J band.

Fig. 4.3.19 Shows the dimer aggregate 1,1'—diethyl—
quinocyanine corresponding to the H band.

Dimerization of a cyanine dye (Figure 4.3.19) occurs by the reaction of two molecules of the cyanine dye called monomers forming a two-molecule-aggregate called a dimer.

The coupling of these molecules occurs by an acidic nitrogen coupling with a basic nitrogen. When more than two molecules couple, the resultant aggregates are called trimer, tetramer, pentamer and so on for three, four, five molecular aggregates respectively.

The J aggregation consists of many monomers of dye molecules forming a polymer.

Concurrent with the appearance of a J band, the viscosity of an aqueous solution increases markedly. In order for the J band to appear in any dye solvent system, the dye must have a high solubility in its solvent. [Ref: C.E.K. Mees and T.H. James, *The Theory of the Photographic Process,* 3rd ed., Macmillan Co., New York (1966), Chapters 11 and 12.]

SPECTRA OF DYES ADSORBED ON SILVER HALIDE GRAINS

When a dye is adsorbed to a silver halide surface, J molecular aggregation begins at a much lower concentration relative to the same dye concentration in solution. Often dyes that do not show J aggregation in solution do become J aggregated when adsorbed to a silver halide surface.

Since the *spectral sensitivity* of an emulsion is due to the adsorption spectra of the silver halide-dye system, J molecular aggregation is of prime importance in the manufacturing of three color sensitized products.

Bird *et al.,* [Ref: G. Bird, K. Norland, A. Rosenoff, H. Michaud, *Phot. Sci. Eng.,* **12,** 196 (1968)] have studied the absorption spectrum of a dye sensitized working photographic emulsion (Table 4.3.4).

Table 4.3.4 shows sensitizing dye 1 having a dye loading on the emulsion of 1 mg. of dye per gram of silver in the emulsion. The composition of silver halide was silver bromide with 1 mole % of incorporated iodide. Each cm^2 of emulsion contained 110μ grams of silver.

EXERCISE

Calculate the number of milligrams of dye per cm^2 of emulsion.

TABLE 4.3.4

SILVER HALIDE COMPOSITION	COATING COMPOSITION	SENSITIZING DYE # 1	DYE LOADING PER GRAM OF SILVER
1 mole % Iodide-Silver bromide emulsion	110 μ gr silver/cm^2	3, 3', 9–tri- ethyl–5, 5'– dichloro- thiacarbo- cyanine iodide	1 mg/gram silver

This emulsion was coated onto a clear acetate substrate. By measuring the total reflection and the total transmission at a number of wavelengths, using an integrating sphere for both measurements, the emulsion absorption spectrum was derived (Equation 4.3.23).

$$A = 100 - T - R$$

where A = % light absorbed

T = % light transmitted

R = % light reflected

(4.3.23)

Bird *et al.* chose this emulsion system because it produced a less complex absorption spectrum. The sensitizing dye in this emulsion formed only the J molecular aggregate. The hypsochromically shifted (to shorter λ) bands of the H aggregates and the characteristic molecular band spectra (M band) were absent. Thus this working system served well for theoretical study.

The rationale behind the use of a relatively simple system for study is:

1) Simple systems are more amenable to theoretical treatments.

2) Complicating factors tend to obscure and perturb the basic system so that the fundamental mechanism is not easily recognized.

3) Fundamental progress in science is made by extrapolations from simple systems.

Previous theorists had derived a theory of aggregates. [Ref: G.S. Levison, W.T. Simpson and W. Curtis, *J. Am. Chem. Soc.*, 79, 4314 (1957); E.G. McRae and M. Kasha, *J. Chem. Phys.*, 28, 721 (1958); E.G. McRae and M. Kasha, in Augenstein Rosenberg and Mason, *Physical Processes in Radiation Biology*, Academic Press, New York, 1964, 23-42; R.M. Hochstrasser and M. Kasha, *Photo Chem. and Photo Biol.*, Volume 3, 317, (1964); Kasha, Rawls and El-Bayoumi, *Pure and Appl. Chem.*, 11, 371 (1965)].

This theory of aggregates results in the equation

$$\Delta \bar{\nu} \;=\; (2/hc)\,(N-1/N)\;\frac{(9.185 \times 10^{-39})\,(1-3\cos^2 \alpha)}{\gamma^3}\int_{\lambda_1}^{\lambda_2}(\epsilon/\lambda)\,d\lambda$$

$$(4.3.24)$$

where

$\Delta \bar{\nu}$	=	The spectral shift in wave numbers (cm^{-1}) of an N-mer
c	=	3×10^{10} cm/sec
h	=	Planck's constant
N	=	The number of monomeric units in the polymer.
r	=	The separation between molecular centers.
α	=	The tilt angle between the line of·centers in the molecular long axis
λ_1, λ_2	=	The limits of a well defined absorption band
ϵ	=	molar extinction coefficient in units of $(moles/liter)^{-1}\ cm^{-1}$
λ	=	wavelength

These theories as modified by Bird *et al.*, [Ref: G. Bird, K. Norland, A. Rosenoff, H. Michaud, *Phot. Sci. Eng.*, **12**, 196 (1968)] result in equation 4.3.26.

The distance r and the angle α are related (Figure 4.3.20) and the equation is

$$r = \frac{d}{\sin \alpha}$$

(4.3.25)

When equation 4.3.25 is substituted into equation 4.3.24, the result is

$$\Delta \bar{\nu} = (2/hc)\,(N-1/N)\,\frac{\sin^3 \alpha - \sin^3 \alpha \cos^2 \alpha}{(3.37 \times 10^{-8}\ \text{cm})^3}$$

$$(9.185 \times 10^{-39}) \int_{\lambda_1}^{\lambda_2} (\epsilon/\lambda)\, d\lambda$$

(4.3.26)

where $d = 3.37$ Å (Figure 4.3.20).

Equation 4.3.24 relates to the molecular spectrum of the molecule in question. When the integration is carried out over a region of the electronic spectrum that contains a peak corresponding to a transition then it is possible to correlate experimental and theoretically obtained dipole strengths.

Experimentally, a plot of the molecular extinction coefficient, ϵ, versus $1/\lambda$ is performed. This plot is obtained from the Beer-Lambert Bouquer law

$$\text{Log}\ I_o/I = \epsilon Cl$$

4.3.26a

where C = concentration in moles/liter
l = thickness of the cell in cms
I_o = intensity of the incident radiation
I = intensity of the transmitted radiation.

Thus equation 4.3.24 represents an experimentally derived quantity.

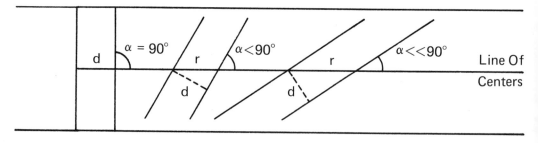

$$d = \text{distance between planes} = 3.37 \text{ Å}$$

$$r = \text{distance between molecular centers}$$

Fig. 4.3.20 Shows that if the distance between molecular planes is held constant at 3.37 Å, the relationship between r and α is

$$r = d/\sin \alpha = \frac{3.37 \times 10^{-8} \text{ cm}}{\sin \alpha}$$

Although equations 4.3.24 and 4.3.26 do not yield quantitatively accurate results, *they are valuable* since they give insight into the classification of the aggregates and the structural nature of the J molecular aggregation on the surface of a silver halide crystal. Furthermore, equation 4.3.26 establishes the limits on the allowable structures for the J aggregates on the surface of a silver halide crystal.

The usefulness of equation 4.3.24 can be derived by considering r, α, λ_1 and λ_2 as constants. Thus we may write

$$\Delta \bar{\nu} = \bar{\nu}_{max}(N) - \bar{\nu}_{max}(1) = k\left(\frac{N-1}{N}\right)$$

(4.3.27)

rearranging, we have

$$\bar{\nu}_{max}(N) = k(N-1/N) + \bar{\nu}_{max}(0)$$

(4.3.28)

Hence, although equation 4.3.24 does not yield quantitatively accurate results, it does predict a straight line relationship between $(N-1)/N$ and $\bar{\nu}_{max}(N)$, where $\bar{\nu} = 1/\lambda$.

Bird proposed that equation 4.3.28 be considered as an approximate empirical law that can be used to classify the sizes of aggregates.

There is reliable evidence [Ref: P.J. Wheatley, *J. Chem. Soc.*, 3245, 4096 (1959)] that cyanine dye molecules can pack with center to center distances on the order of 3.37 Å. Wheatley determined by X-ray analysis of 3,3′—diethylthiacarbocyanine bromide that the packing was similar to a 90° deck of cards (Figure 4.3.21).

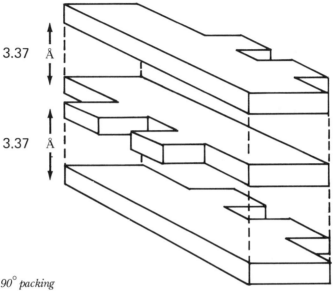

3.37 Å

3.37 Å

Fig. 4.3.21 *Shows a 90° packing of 3,3′—diethylthiacarbocyanine bromide with center to center distances of 3.37 Å. The protruding ethyl groups alternate in direction during stacking.*

Thus it is not unreasonable to choose a value of d equal to 3.37 Å as the distance of planar separation for cyanine dyes of the diethylthiacarbocyanine class (includes dyes 1, 2 and 3 in Table 4.3.6).

The bromide counter ion layer is found above and below the planes of stacked molecules and is well outside the envelope function of the molecular planes.

The graphite packing distance of 3.4 Å is very close to the 3.37 Å of many individual cyanine dyes.

Example

A cyanine dye which formed H aggregates in solution had the following λ_{max} values (Table 4.3.5).

TABLE 4.3.5

ν_{max}	λ_{max}	SOLVENT	TEMPERATURE
18,218 cm^{-1}	547 nm	H_2O	85° C
17,271 cm^{-1}	579 nm	2 methyl benzo-thiazole	85° C
19,723 cm^{-1}	507 nm	H_2O	5° C
20,523 cm^{-1}	487 nm	H_2O	5° C
20,964 cm^{-1}	477 nm	H_2O	5° C
22,222 cm^{-1}	450 nm	H_2O	5° C

These data indicated that cyanine dye molecular aggregation was inversely proportional to temperature.

The problem is to determine which of the peaks correspond to the monomer, dimer, trimer, tetra-mer, and the infinite-mer.

The higher temperature entries in Table 4.3.5 ensure that the cyanine dye is in the monomer state.

At the high temperature it was found necessary to use the 2 methyl benzothiazole solvent in order to achieve the correct dielectric constant conditions so that a comparison could be made with the larger aggregates. A molecule in the dimer, trimer and higher aggregated state experiences a different dielectric constant than does a monomer. Thus a strict comparison can be made only when the solvent has a dielectric constant approaching that of the aggregate. Each peak at the lower temperature level was obtained by slowly increasing the concentration of the dye until successive peak shifts were observed (Figure 4.3.22).

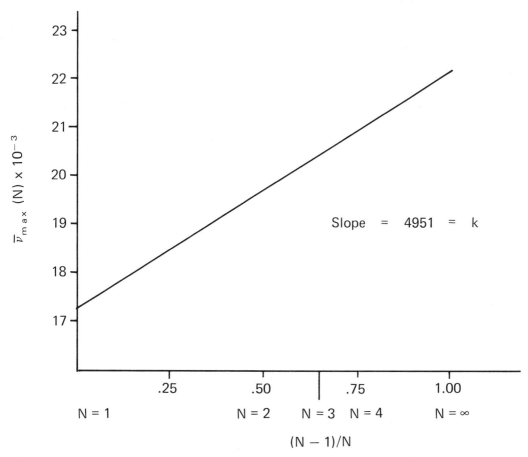

Dye 2 = 3, 3′ — bis (2 — Carboxyethyl)
5, 5′ — dichloro — 9 — methylthiacarbocyanine betaine

Fig. 4.3.22 *The plot of $\bar{\nu}_{max}$ (N) versus (N–1)/N shown in Figure 4.3.22 indicates that the dimer absorbs at 507 nm, the trimer at 487 nm, the tetramer at 477 nm and the infinite-mer at 450 nm.*

The only point representing the monomer that fell on the straight line was where the solvent was 2-methylbenzothiazole. The reason for this anomalie is that the dielectric constant experienced by a molecule in a dimer or larger aggregation is quite different than for the monomer in aqueous solution. Thus a solvent with a higher dielectric constant than water was utilized in order to obtain a peak which was bathochromically shifted to the straight line.

In order to explain the absorption spectrum of dye 1 (Figure 4.3.23), Bird chose dyes 2 and 3 having the characteristics shown in Table 4.3.6. Experimental studies of dyes 2 and 3 led to the explanation of the absorp-

tion spectrum of dye 1 and gave information on the nature of H and J aggregation.

TABLE 4.3.6

DYE 1	DYE 2	DYE 3
J–aggregates on silver bromide surface of a working emulsion No H aggregation observed on silver bromide surface of working emulsion Complexed with iodide ion which confers less solubility in aqueous solution	H–aggregates easily in solution, forms J aggregates on silver bromide surface with difficulty. Forms no J aggregates in solution Has carboxyl groups to ethyl groups at the 3 and 3' positions, methyl group at position 9 Dye 2 has been complexed with betaine for greater solubility in aqueous solution	Forms J aggregates easily both in solution and when adsorbed to silver halide surface Has an ethyl group at the 9 position in place of methyl Has carboxyl groups to ethyl groups at 3 and 3' positions

When the 9 ethyl substitution is made for the methyl group in Dye 2, J aggregation is facilitated both in solution and on the surface of the silver halide. This significant fact helps us to explain the absorption spectrum of the working emulsion Dye 1 (Figure 4.3.23).

EXERCISE

Explain how the 9 ethyl substitution facilitates J molecular aggregation as a function of the silver sulfur ligand bond formation and the achievement of the aggregate packing where α is of the order of 30°

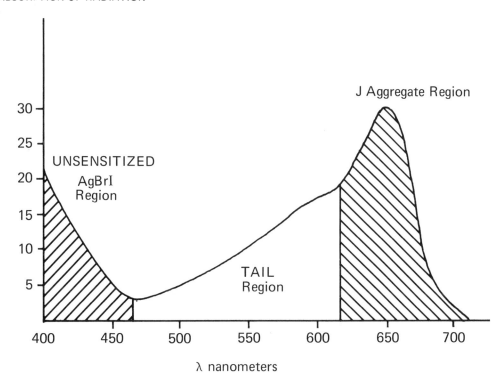

Fig. 4.3.23

This is a simple spectra since it contains three well defined regions of absorption. Below 460 nm is the region of absorption for the unsensitized AgBrI emulsion. Between 460 nm and approximately 612 nm is the tail region.

Beyond 612nm is the absorption region due to J aggregation, with a corresponding λ_{max} approximating 650 nm.

The sensitizing dye in the working emulsion has an ethyl group in the 9 position, making it very similar to dye 3 in this respect. However, dye 2 has the methyl group at this position.

These facts tend to support the Bird *et al.,* hypothesis [Ref: G. Bird, K. Norland, A. Rosenofff, H. Michaud, *Phot. Sci. Eng.,* **12**, 196 (1968)] that the presence of the ethyl groups force the formation of the J aggregation by making each of the dye molecules move in a manner to avoid the protruding ethyl groups, thereby facilitating the 3.37 Å packing. The reasonability of this hypothesis becomes evident when one realizes that the sulfur atoms of the dye molecules would tend to form sulfur ligand bonds with the silver atoms of the emulsion.

These ligand bonds are "toed-in" at a 45° angle (Figure 4.3.24).

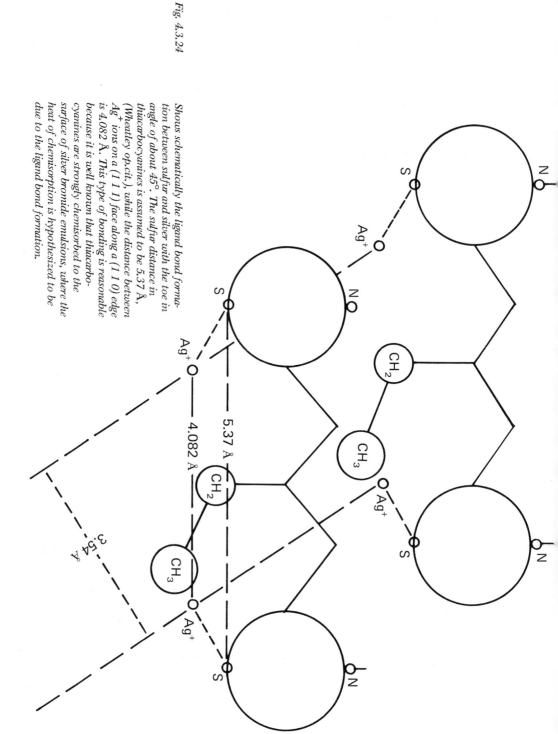

Fig. 4.3.24

Shows schematically the ligand bond forma-
tion between sulfur and silver with the toe in
angle of about 45°. The sulfur distance in
thiacarbocyanines is assumed to be 5.37 Å.
(Wheatley op.cit.), while the distance between
Ag⁺ ions on a (1 1 1) face along a (1 1 0) edge
is 4.082 Å. This type of bonding is reasonable
because it is well known that thiacarbo-
cyanines are strongly chemisorbed to the
surface of silver bromide emulsions, where the
heat of chemisorption is hypothesized to be
due to the ligand bond formation.

Hence the Bird *et al.*, theory of the J aggregate requires that the J aggregate be packed where the angle α is on the order of $30°$ to $45°$. On the other hand, H aggregation occurs when the molecules stack in the $90°$ configuration.

With the parameters given by Bird, equation 4.3.26 can be used to calculate the angular limits for J aggregation.

DETERMINATION OF α FOR J AGGREGATION

The parameters given by Bird for an infinite linear aggregate for dye 2 are

$$d \quad = \quad 3.37 \text{ Å} \quad = \quad 3.37 \times 10^{-8} \text{ cm}$$

$$(4.3.29)$$

$$r \quad = \quad \frac{d}{\sin \alpha}$$

$$(4.3.30)$$

$$\bar{\nu}_{max}(1) \quad = \quad \frac{1}{\lambda_{max.}} \quad = \quad \frac{1}{547 \times 10^{-7} \text{ cm}} \quad = \quad 18,282 \text{ cm}^{-1}$$

$$(4.3.31)$$

$$9.185 \times 10^{-39} \int_{\lambda_1}^{\lambda_2} (\epsilon/\lambda) \, d\lambda \quad = \quad 1.11 \times 10^{-34} \text{ statcoulombs}^2 \text{ cm}^2$$

$$(4.3.32)$$

With these values for the parameters, equation 4.3.26 may be used to calculate the infinite-mer

$$\nu_{max}(\infty, \alpha) \quad = \quad \frac{2.22 \times 10^{-34} (\sin^3 \alpha \quad - \quad 3 \sin^3 \alpha \cos^2 \alpha)}{6.63 \times 10^{-27} \times 3 \times 10^{10} \times (3.37 \times 10^{-8})^3} + 18,282$$

$$(4.3.33)$$

and

$$\bar{\nu}_{max} (\infty, \alpha) = 29{,}157 (\sin^3 \alpha - 3 \sin^3 \alpha \cos^2 \alpha) + 18{,}282$$

$$(4.3.34)$$

The Bird et al., hypothesis states that the tilt angle α for the H aggregate is $90°$, thus for the H_∞ aggregate equation 4.3.34 becomes

$$\bar{\nu}_{max} (\infty) = 29{,}025 + 18{,}282 = 47{,}307 \text{ cm}^{-1}$$

$$(4.3.35)$$

On the other hand, the observed value for the H_∞ aggregate is 450 nm or 22,222 cm^{-1}.

Hence the calculated value is approximately 100% greater than the observed value.

This discrepancy has been removed by summing the dipole interactions over a density map of the dipole transitions where the *latest value of the tilt angle* for the H_∞ aggregate has been *set at 60°* [Ref: Private Communication, K.S. Norland, Polaroid Corp., Cambridge, Mass., March (1970)].

The McRae, Kasha equation does not predict a linear relation with respect to $(N-1/N)$ in spite of the fact that it holds experimentally. McRae and Kasha pointed out that the term $(N-1/N)$ can be considered to hold only for cyclic rather than the linear polymers considered in this section. On the other hand, K.S. Norland has derived the $(N-1/N)$ term for linear polymers, which implies that experiment and theory in this area are rapidly converging.

When equation 4.3.34 is used to obtain the observed J_∞ absorption at 15,385 cm^{-1}, the tilt angle is approximately $25°$. The same solution is obtained at a tilt angle of $50°$.

Although equation 4.3.34 is not quantitatively accurate, it places the tilt angle for J aggregation between $25°$ and $50°$. On the basis of geometrical considerations, the tilt angle could be either $30°$ or $19°6'$. The more rigorous calculations of Norland et al., will certainly establish the tilt angle to fall somewhere in this interval, $19°6'$ to $30°$.

The preceding discussion establishes the reasons for the J aggregate peak of the working emulsion which was sensitized by dye 1.

However, the tail region (Figure 4.3.22) can be explained in terms of the disorder that is associated with the adsorption of the aggregate to the silver halide surface, Bird et al., found that the spectra of two monomeric dyes that gave sharp peaks individually showed a broad spectrum free of peaks when they were mixed together in a 1 : 1 molar ratio.

These dyes were chosen so that they would exhibit a high degree of disorder in the aggregate position.

Thus the tail region was attributed to localized disorder or defects of the aggregate.

Cyanine dyes have molecular lengths of the order of 20 Å and they are separated in the aggregate form by distances as small as 3.4 Å.

Equations 4.3.24 and 4.3.26 were derived with the assumption that ratio of one half the charge distribution distance to the distance at which the measurement is made is a small number; in the case of cyanine dyes this number is approximately

$$\frac{20}{2 \times 3.4} = 2.81$$

(4.3.36)

This value is too large to allow the series to converge, since the expansion is performed in powers of this number.

The method of Norland *et al.,* is to calculate the actual dipole interactions over the envelope of the molecule and determine its effect at other spatial coordinates. [Ref: Private Communication: K.S. Norland, Polaroid Corp., Cambridge, Mass., March 1970).]

We summarize the results of H and J aggregation as

$$\begin{array}{l} \text{limit} \quad M_n = H_\infty \\ n \to \infty \\ \alpha = 60° \end{array}$$

where n = the degree of polymerization and M is the monomer.

$$\begin{array}{l} \text{limit} \quad M_n = J_\infty \\ n \to \infty \\ \alpha = (19°6°-30°) \end{array}$$

SUMMARY

The results of this section show that the spectra of cyanine dye aggregates adsorbed to the surface of silver halide emulsions can be explained in terms of the structure of the system. We have shown that in most cases the adsorbed aggregate has one molecule per unit cell. This structure yields an absorption spectrum having one strong band and a long

absorption tail due to local disorder inherent in the ordered molecular structure of the adsorbed dye. The deck of cards structure exhibits a hypsochromic shifted maximum with a corresponding absorption tail towards the longer wavelengths.

When the deck of cards structure is tilted such that the tilt angle is less than $54°$, the absorption spectrum consists of a bathochromically shifted peak and a tail towards the blue.

At the present time the workers at Polaroid have derived a theory (unpublished) which gives both a quantitatively accurate value of the spectral shift and a prediction that the maximum absorption peak of small aggregate spectra will shift according to the relationship that the frequency shift of an N-mer is N-1/N times the frequency shift of an infinite-mer. Evidence suggests that the chemisorption of the benzothiazole dyes occurs with the sulfurs on the grain forming the silver sulfur ligand bond. The molecular short axis of these molecules is approximately perpendicular to the grain. It appears that the separation of molecular planes for these dyes approximates the interlayer graphite spacing ($3.37Å$).

By utilizing the results of this section it is possible to place very sharp limits on the allowed structures that give rise to J aggregation when the dye is adsorbed to real silver halide emulsions.

The observed absorption tail region is manifested by a packing disorder associated with the aggregation of the dye at the crystal surface. This aggregate disorder is responsible for creating a large number of different intermediate excited states and allows transitions to these states.

Since the energies of these transitions are not all the same, the observed effect is a long sloping absorption tail.

Problem 4.3.1

West *et al.* [Ref: W. West, S.P. Lovell, W. Cooper, *Phot. Sci. Eng.*, 14, 52 (1970) p. 61] found sharp absorption maxima at 428nm, 420nm, 416nm and 410 nm, for 3, 8, 3′, 10-diethylenethiacarbocyanine bromide in a polar solution. Classify these maxima as to monomer, dimer, trimer and infinite-mer and determine whether the plot follows Bird's proposal.

4.4 Dye Sensitization

The photographic effect of spectral sensitization and desensitization is thought to proceed by the transfer of either an electron or resonance energy to the silver halide grains.

Although many workers have investigated cyanine and other sensitizing dyes and desensitizing dyes, the actual mechanism associated with the spectral sensitization and desensitization of photographic emulsions has not been determined.

DEFINITIONS

When a photo-excited dye molecule transfers an electron to the conduction band of a silver halide grain of an emulsion, this mechanism is called *electron transfer*. The electron transfer process for an electron of an excited dye molecule occurs if and only if the electron can tunnel through the potential energy barrier that separates the dye from the silver halide.

According to Bucher, Kuhn, *et al.,* [Ref: H. Bucher, H. Kuhn, B. Mann, D. Mobius, L von Szentapaly and P. Tillman, *Phot. Sci. Eng.,* 11, 233 (1967)] if the dye is in close proximity with the surface of a silver halide grain, the tunneling time is approximately 10^{-11} seconds (Figure 4.4.1).

On the other hand, the excitation energy of a dye can transfer to an impurity in the silver halide grain, and it is assumed that this acceptor impurity region produces a conduction electron, thereby sensitizing the emulsion grain. This mechanism is called *energy transfer.*

Bucher, Kuhn *et al.,* report that for grains containing impurities, energy transfer should occur in 10^{-11} seconds when the sensitizer silver grain separation distance is less than 30Å. The Bucher *et al.,* experiment showed that if electron transfer is not energetically probable and if the sensitizer silver halide grain separation was 55 Å or less, then energy transfer is likely to occur (Figure 4.4.1).

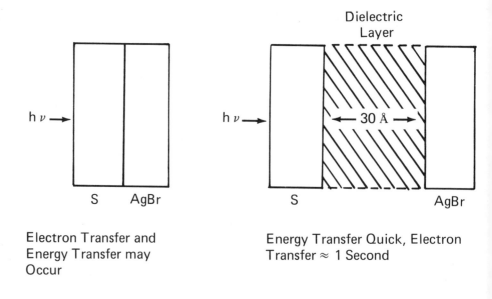

Electron Transfer and
Energy Transfer may
Occur

Energy Transfer Quick, Electron
Transfer ≈ 1 Second

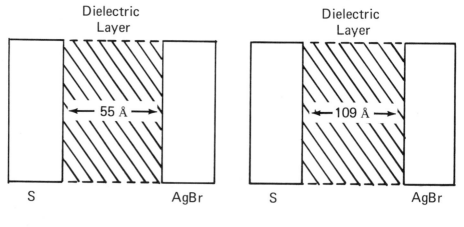

Only Energy Transfer Likely

No Sensitization

Fig. 4.4.1 *Shows that energy transfer takes place when
electron transfer is not probable. At separa-
tions of 109 Å neither process occurred.*

Although this experiment favors the energy transfer mechanism
when electron transfer is not probable, the spectral sensitization of emul-
sion grains in the photographic process does not require the spatial separa-
tion of the dye and the silver halide; in fact, the dye sensitizers are
adsorbed to the silver halides of the emulsion system and during the

process of sensitization must be considered to be in the neighborhood of the surface of these crystals. Thus there exists a possibility that electron and energy transfer mechanisms are competitive processes during spectral sensitization.

The work of Tani and Kikuchi *et al.*, that has appeared since 1967 represents a departure from the classical approach to this problem. These men, using the approximate methods of quantum mechanics coupled with experimental parameters such as half wave polarographic measurements, have opened a new frontier to this long standing dilemma. The authors believe that much of this work is fundamental and should serve as a springboard for the settlement of this problem with all its ramifications.

It is the purpose of this section to discuss the modified electron transfer mechanism of dye sensitization in both a qualitative and quantitative manner. This model requires the application of the Fermi-Dirac statistics presented in Chapter 1 and the elements of Thermodynamics that were treated in Chapter 3.

The treatment in this section is based upon the following five publications:

(1) [Ref: T. Tani and S. Kikuchi, *Phot. Sci. Eng.*, 11, 129 (1967)].
(2) [Ref: T. Tani, S. Kikuchi and K. Honda, *Phot. Sci. Eng.*, 12, 80 (1968)].
(3) [Ref: T. Tani, *Phot. Sci. Eng.*, 13, 231 (1969)].
(4) [Ref: T. Tani, *Phot. Sci. Eng.*, 14, 63 (1970)].
(5) [Ref: T. Tani *Phot. Sci. Eng.*, 14, 72 (1970)].

Further reference to these publications in this section will be Tani (1), Tani (2), Tani (3), Tani (4) and Tani (5), respectively.

Many profound correlations of the calculated and experimentally derived quantities can be made with the sensitizing and desensitizing properties of the dyes studied. This is the first plausible attempt to describe this process using a quantitative quantum mechanical approach.

Tani (2) suggests that the spectral sensitization in photography does not follow either the electron or energy transfer mechanisms but that another explanation is required. This reasoning is based on two principal assumptions.

ASSUMPTION 1

According to the *energy transfer* mechanism, if the E_{max} is above some threshold value, then a sufficient amount of energy can be transferred to the silver halide, producing an electron in the conduction band of the silver halide grain. Thus we may write

$$E_{max} = \frac{hc}{\lambda_{max}} = E_{1v} - E_{ho}$$

$$(4.4.1)$$

where E_{1v} = the lowest vacant energy state
E_{ho} = the highest occupied energy state.

ASSUMPTION 2

The *electron transfer* mechanism depends upon the direct transfer of an electron from the excited dye molecule to the conduction band of the silver halide. Therefore the electron transfer mechanism is directly related to the polarographic half wave potential $\epsilon_{1/2}$ (see Chapter 3).
Thus we may write

$$\epsilon_{1/2} \approx \epsilon^{\circ} = \frac{\Delta H^{\circ} - T \Delta S^{\circ}}{nF}$$

$$(4.4.2)$$

Since the electron transfer mechanism depends upon the threshold value of $-\epsilon_{1/2}$, we can expect that dyes having a redox potential equal to, or more positive than, the threshold value $-\epsilon_{1/2}$ will be efficient sensitizers. On the other hand, those dyes that sensitize by the energy transfer mechanism should have an E_{max} equal to or greater than the threshold E_{max} value.
Considering these facts, we should be able to determine whether the mechanism of spectral sensitization is accomplished by electron or energy transfer by plotting E_{max} versus $\epsilon_{1/2}$ (Figures 4.4.2, 4.4.3, 4.4.4).

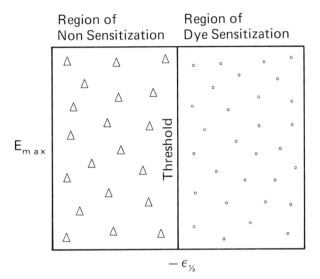

Region of Non Sensitization

Region of Dye Sensitization

E_{max}

Threshold

$-\epsilon_{1/2}$

Fig. 4.4.2 Shows schematically a plot that separates the nonsensitizing dyes from the sensitizing dyes on the basis of the electron transfer mechanism. Since the electron transfer mechanism depends upon a threshold value of $\epsilon_{1/2}$, an arbitrary threshold line separates the two regions. The actual location of this threshold line must be experimentally determined.

Similarly, a plot on the basis of the energy transfer mechanism can be constructed (Figure 4.4.3).

Region of Dye Sensitization

Threshold Line

E_{max}

Region on Non Sensitization

$-\epsilon_{1/2}$

Fig. 4.4.3 Shows schematically a plot separating sensitizing and non sensitizing dyes on the basis of the resonance energy transfer mechanism. Since the energy transfer mechanism is dependent upon a threshold λ_{max} value, an arbitrary E_{max} line separates these two regions.

In the case where both mechanisms are operating, two threshold lines determine the regions of dye sensitization and non sensitization (Figure 4.4.4).

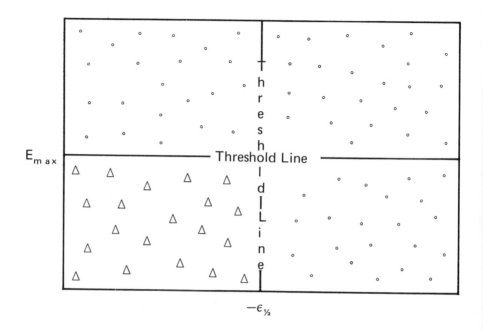

Fig. 4.4.4 *Shows the region of dye sensitization o, and non sensitization △ for a two mechanism hypothesis.*

Tani (2) found that the plot of E_{max} versus $-\epsilon_{1/2}$ for many dyes yields two distinct distributions. The dyes listed in Table 4.4.1 follow two different straight lines (Figure 4.4.5).

TABLE 4.4.1

SENSITIZING DYES		$-qF$
(a)	1,1'—diethyl—2,2'—quinocyanine iodide	4.38
(b)	1,1'—diethyl—2,2'—quinocarbocyanine iodide	4.29
(c)	1,1'—diethyl—2,2'—quinotricarbocyanine iodide	4.23
(d)	3,3'—diethylthiacarbocyanine iodide	4.39
(e)	3,3'—diethylthiatetracarbocyanine iodide	4.36
(f)	3,3'—diethyloxacyanine iodide	4.49
(g)	3,3'—diethylselenacyanine iodide	4.38
(h)	3,3'—diethylselenacarbocyanine iodide	4.34
(i)	1,1'—diethyl—4,4'—quinotricarbocyanine iodide	
(j)	3,3'—diethyloxacarbocyanine iodide	4.43
NON SENSITIZING DYES		$-qF$
(a)	Methylene blue	4.96
(b)	Capri blue	4.95
(c)	Thionine	5.19
(d)	Phenosafranine	5.01

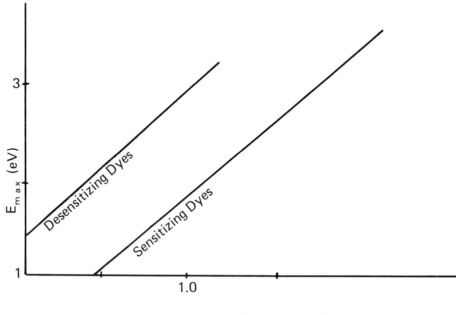

$$- \quad \epsilon_{\frac{1}{2}} \text{ (Volts versus Saturated Calomel Electrode, (SCE))}$$

Fig. 4.4.5 *Shows that sensitizing dyes and non sensi-* *polarographic half wave potentials are*
 tizing follow two straight lines when their *plotted versus excitation energy.*

Because the plot of E_{max} versus $-\epsilon_{\frac{1}{2}}$ is not consistent with Figure 4.4.4, Tani (2) proposed a *modified electron transfer mechanism. This theory states that if a dye is a sensitizer then the quasi-Fermi level of the dye must be greater than the Fermi level of the silver halide system.*
 The mathematical relationship for the sensitizing dye can be expressed by

$$\epsilon_{\frac{1}{2}} \text{ (V vs. SCE)} \quad + \quad \frac{1}{2} E_{max} \text{ (eV)} \quad = \quad - \quad 0.025$$

$$(4.4.3)$$

The expression that characterizes the straight line for the non-sensitizers may be written as

$$\epsilon_{\frac{1}{2}} \text{ (V vs. SCE)} \quad + \quad \frac{1}{2} E_{max} \text{ (eV)} \quad = \quad 0.6$$

$$(4.4.4)$$

Tani (1) calculated the lowest vacant and highest occupied energy levels (E_{lv} and E_{ho}, respectively) for many dyes, using the Hückel molecular orbital methods.

Equations 4.4.3 and 4.4.4 may be related to the E_{lv} and E_{ho} by the following.

The reduction of aromatic compounds (see Section 4.3) may be written as

$$R \ + \ ne \rightleftharpoons R^{n-} \ (n = 1 \text{ or } 2)$$

(4.4.5)

where R = neutral aromatic compound
R^{n-1} = reduced aromatic compound

Utilizing equation 3.3.7 and recalling that $\Delta(PV)$ may be neglected we write

$$\Delta H \ = \ \Delta E$$

(4.4.6)

Allowing $E°(R)$ and $E°(R^{n-1})$ to be the standard energy of the neutral and reduced form of the aromatic compound respectively, then 4.4.6 becomes

$$\Delta H° \approx E°(R^{n-1}) - E°(R)$$

(4.4.7)

Since the reducing electrons must drop into the lowest vacant level, E_{lv}, we obtain

$$E°(R^{n-1}) \ - \ E°(R) \ = \ -nFE_{lv}$$

(4.4.8)

Substituting equation 4.4.8 into equation 4.4.7, we find

$$\Delta H° \approx -nFE_{lv}$$

(4.4.9)

After substitution of equation 4.4.9 into equation 4.4.2 we may write

$$\epsilon_{\frac{1}{2}} \ = \ (nFE_{lv} - T\Delta S°)/nF$$

(4.4.10)

Taking $\Delta S° \approx$ constant, for a reduction since both the structure and the number of molecules does not change

$$\Delta S° \approx \text{Constant}$$

(4.4.11)

Finally we may write at constant temperature

$$\epsilon_{\frac{1}{2}} = -E_{1v} + \text{Constant}$$

(4.4.12)

Since

$$E_{max} = E_{1v} - E_{ho}$$

(4.4.13)

we may write

$$\frac{1}{2}E_{max} = \frac{1}{2}E_{1v} - \frac{1}{2}E_{ho}$$

(4.4.14)

Adding 4.4.14 and 4.4.12 we write

$$\epsilon_{\frac{1}{2}} + \frac{1}{2}E_{max} = -\frac{1}{2}E_{1v} - \frac{1}{2}E_{ho} + \text{Constant}$$

(4.4.15)

The hyper-redox potential and the quasi-Fermi level have been defined by Tani (2) as

$$\underbrace{\epsilon_{\frac{1}{2}} + \frac{1}{2}E_{max}}_{\substack{\text{hyper-redox} \\ \text{potential}}} = -\underbrace{\frac{E_{1v} + E_{ho}}{2}}_{\substack{\text{quasi-Fermi} \\ \text{level}}} + \text{Constant}$$

(4.4.16)

Substituting 4.4.3 and 4.4.4 into 4.4.16, we find for sensitizing dyes

$$- \frac{E_{1v} + E_{ho}}{2} + C = - 0.025$$

(4.4.17)

while for non sensitizing dyes, we have

$$- \frac{E_{1v} + E_{ho}}{2} + C = + 0.60$$

(4.4.18)

Thus the *hyper redox potential* or the quasi-Fermi (qF) level establishes the boundary between sensitizing and non sensitizing dyes.
We may define

$$- qF_{SD} = \text{quasi-Fermi level for sensitizing dyes}$$

and

$$- qF_{ND} = \text{quasi-Fermi level for non sensitizing dyes}$$

Using these definitions, equations 4.4.17 and 4.4.18 may be written as

$$- qF_{SD} + C = - 0.025$$

(4.4.19)

and

$$- qF_{ND} + C = 0.6$$

(4.4.20)

Subtraction results in

$$qF_{SD} \quad - \quad qF_{ND} \quad = \quad 0.625$$

$$(4.4.21)$$

Equation 4.4.21 shows that the quasi-Fermi level of sensitizing dyes is greater than the quasi-Fermi level of non sensitizing dyes.

Tani (1) calculated the quasi-Fermi level of many sensitizing and non sensitizing dyes. Table 4.4.1 shows a marked separation for the quasi-Fermi level of sensitizing and desensitizing dyes which fall above and below the −4.75 eV value representing the Fermi level of the silver bromide crystal.

IONIZATION ENERGY AND ELECTRON AFFINITY

The electronic energy level of the highest occupied state is related to the ionization energy by

$$E_{ho} \quad = \quad - \quad E_I$$

$$(4.4.22)$$

The energy of the lowest vacant state is related to the electron affinity and is written

$$E_{1v} \quad = \quad - \quad E_A$$

$$(4.4.23)$$

In the terms of equations 4.4.22 and 4.4.23, the quasi-Fermi level may be written as

$$qF \quad = \quad \frac{+ \quad (E_I \quad + \quad E_A)}{2}$$

$$(4.4.24)$$

The quasi-Fermi energy or work function is defined as

$$E_{qF} \quad = \quad \frac{- \quad (E_I \quad + \quad E_A)}{2}$$

$$(4.4.25)$$

The right hand term in equation 4.4.25 was defined by Mulliken as the electro-negativity of an atom. [Ref: R.S. Mulliken, *J. Chem. Phys.* Vol. 2, 782 (1934)]. Following Mulliken and Tani (2), we designate the right hand side of equation 4.4.25 as the electronegativity of a molecule.

DETERMINING E_A AND E_I FOR A DYE IN A PHOTOGRAPHIC EMULSION

According to Matsen [Ref: F.A. Matsen, *J. Chem. Phys.*, 24, 602 (1956)) the electron affinity E_A of the molecule in vacuo is related to the polarographic half wave reduction potential of an organic molecule with respect to the saturated calomel electrode (SCE) by

$$E_A \text{ (eV)} = \underbrace{\epsilon_{1/2} \text{ (V versus SCE)}}_{} \underbrace{- \Delta E_{sol}}_{} + 5.07$$

$$\underbrace{}_{\text{vacuo}} \qquad \underbrace{}_{\text{in solution}} \qquad \underbrace{}_{\substack{\text{solvation} \\ \text{energy} \\ \text{difference} \\ \text{due to} \\ \text{coulomb} \\ \text{forces}}}$$

$$(4.4.26)$$

The half-wave potential is measured for the reaction

$$\text{Dye} + \text{e} \rightleftharpoons \text{Dye}^-$$

$$(4.4.27)$$

where ΔE is the solvation energy difference (eq. 4.4.26) between the species Dye and Dye$^-$.

It should be noted that when the uncharged dye is in the emulsion state and adsorbed to the silver bromide, the amount of energy required to bring it to the gaseous state is called the van der Waal's energy or the energy of vaporization. On the other hand, when the dye is charged and in the emulsion state, the energy involved in the change of state is the van der Waal energy plus the difference in coulomb energies of the gaseous and emulsion state. The coulomb energy of two charges of radius r in contact with each other in the gaseous state is

$$+ \quad \frac{e^2}{2r}$$

(4.4.28)

In the emulsion state, the coulomb energy may be written as

$$+ \quad \frac{e^2}{2Dr}$$

(4.4.29)

where **D** is the *dielectric constant* of the emulsion

$$n^2 \quad = \quad \left(\frac{c}{v}\right)^2 \quad = \quad D$$

(4.4.30)

and

$$
\begin{aligned}
c \quad &= \quad \text{velocity of light in vacuo} \\
v \quad &= \quad \text{velocity of light in media} \\
n \quad &= \quad \text{index of refraction}
\end{aligned}
$$

The coulomb energy term ΔE of solvation or adsorption can be derived as follows:

The ionization energy necessary to ionize a dye molecule in the solid state adsorbed on the silver bromide crystal of an emulsion is

$$E_I^{(emulsion)} \quad + \quad Dye_{(emulsion)} \longrightarrow Dye^+_{(emulsion)} \quad + \quad e$$

(4.4.31)

Equation 4.4.31 is the sum of the sequence of reactions

$$E_{(vaporization)} \quad + \quad Dye_{(emulsion)} \longrightarrow Dye_{(gas)}$$

(4.4.32)

$$E_I^{(vacuo)} \quad + \quad Dye_{(gas)} \longrightarrow Dye^+_{(gas)} \quad + \quad e$$

(4.4.33)

$$Dye^+_{(gas)} \longrightarrow Dye^+_{(emulsion)} \quad + \quad E'_{(vaporization)} \quad + \quad \Delta E_{(coulombs)}$$

$$(4.4.34)$$

Addition of equations 4.4.32, 4.4.33 and 4.4.34 results in

$$E_{(vap)} \quad + \quad E_I^{(vap)} \quad + \quad Dye_{(em)} \longrightarrow$$

$$Dye^+_{(em)} \quad + \quad e \quad + \quad E_{(vap)} \quad + \quad \Delta E_{(coul)}$$

$$(4.4.35)$$

$$E_I^{(vac)} \quad + \quad E_{(vap)} \quad - \quad E'_{(vap)} \quad - \quad \Delta E_{(coul)} \quad + \quad Dye_{(em)} \longrightarrow$$

$$Dye^+_{(em)} \quad + \quad e$$

$$(4.4.36)$$

Comparison of equation 4.4.31 with equation 4.4.36 shows that

$$E_I^{(em)} \quad = \quad E_I^{(vac)} \quad + \quad E_{(vap)} \quad - \quad E'_{(vap)} \quad - \quad \Delta E_{(coul)}$$

$$(4.4.37)$$

Tani (1) assumed that the two terms representing the van der Waals' energy of vaporization for both the uncharged dye in the emulsion state $(E_{(vap)})$ and the charged dye in the emulsion state $(E'_{(vap)})$ are approximately equal when the coulomb energy term is accounted for.
Invoking this approximation, we may write

$$E_{(vap)} \quad \cong \quad E'_{(vap)}$$

$$(4.4.38)$$

and equation 4.4.37 becomes

$$E_I^{(em)} \quad = \quad E_I^{(vac)} \quad - \quad \Delta E$$

$$(4.4.39)$$

Figure 4.4.6 shows that

$$\Delta E \quad = \quad (1 - \frac{1}{D}) \frac{e^2}{2r}$$

$$(4.4.40)$$

Substituting 4.4.40 into 4.4.39, we have

$$E_I^{(em)} = E_I^{(vac)} - (1 - \frac{1}{D}) \frac{e^2}{2r}$$

(4.4.41)

Tani (1) proposed equation 4.4.41 as an approximation that can be used for either solvation or adsorption of charged species.

The sequence of reactions that result in the relationship between the electron affinity of the solid and the electron affinity of the vapor is as follows:

$$E_{(vap)} + Dye_{(em)} \longrightarrow Dye_{(gas)}$$

(4.4.42)

$$Dye_{(gas)} + e \longrightarrow Dye^-_{(gas)} + E_A^{(vac)}$$

(4.4.43)

$$Dye^-_{(gas)} \longrightarrow Dye^-_{(em)} + E''_{(vap)} + \Delta E$$

(4.4.44)

By addition we obtain

$$E_{(vap)} + Dye_{(em)} + e \longrightarrow$$

$$Dye^-_{(em)} + E_A^{(vac)} + E''_{(vap)} + \Delta E$$

(4.4.45)

and

$$Dye_{(em)} + e \longrightarrow$$

$$D^-_{(em)} + E_A^{(vac)} + E''_{(vap)} - E_{(vap)} + \Delta E$$

(4.4.46)

Comparison of 4.4.46 and the relation

$$Dye_{(em)} + e \longrightarrow Dye^-_{(em)} + E_A^{(em)}$$

(4.4.47)

yields the expression

$$E_A^{(em)} = E_A^{(vac)} + E''_{(vap)} - E_{(vap)} + \Delta E$$

(4.4.48)

Invoking the approximation established in equation 4.4.38, we have

$$E_A^{(em)} = E_A^{(vac)} + \Delta E$$

(4.4.49)

The coulomb energy term in equation 4.4.49 represents the interaction between two negatively charged molecules and can be approximated by equation 4.4.40 so that we may write

$$\boxed{E_A^{(em)} = E_A^{(vac)} + \left(1 - \frac{1}{D}\right)\frac{e^2}{2r}}$$

(4.4.50)

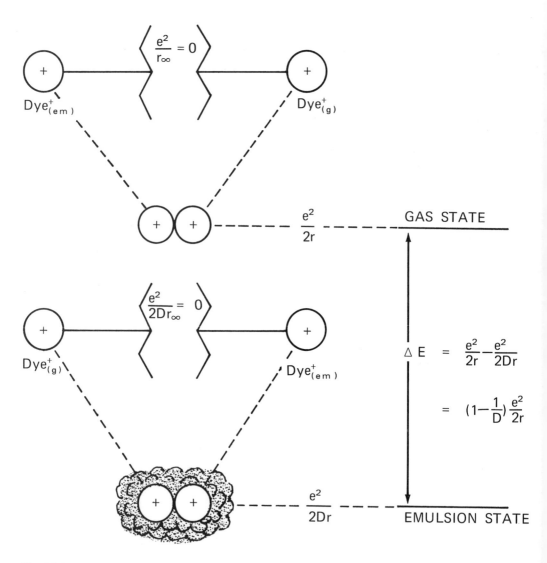

Fig. 4.4.6 *Shows the coulomb energy difference between the charged dye in the gaseous and the emulsion state. The emulsion state is at a lower energy due to the dielectric constant, which has a value greater than one. This means that ΔE is a positive quantity and that energy is given off to the surroundings in the transition from the gaseous to the emulsion state.*

Tani and Kikuchi (1) have shown that the ΔE of solvation or adsorption may be approximated by (see Figure 4.4.6)

$$\Delta E_{sol} = (1 - 1/n^2)\ \frac{e^2}{2r}$$

(4.4.51)

where n = the refractive index of the medium surrounding
 the molecule

n^2 = the optical dielectric constant of the medium
 surrounding the molecule

e = charge on electron

r = 3 Å = the effective radius of the cloud of the electron
 in the molecule

Since the dielectric constant of the mercury at the dropping mercury electrode is infinite, the constant of the surrounding medium is also considered to be infinite (Chapter 3).

Using equation 4.4.51, we write

$$\Delta E_{sol} = (1 - 0)\ \frac{23.04 \times 10^{-20}}{6 \times 10^{-8}} = 3.84 \times 10^{-12}\ ergs$$

(4.4.52)

and

$$\Delta E = 6.242 \times 10^{11}\ \frac{eV}{erg} \times 3.84 \times 10^{-12}\ erg = 2.4\ eV$$

(4.4.53)

Utilizing equations 4.4.26 and 4.4.53, we have

$$E_A\ (vac) = \epsilon_{\frac{1}{2}}\ (V\ versus\ SCE) + 2.67\ eV$$

(4.4.54)

The electron affinity in vacuo is expressed by equation 4.4.54. On the other hand, the electron affinity in a medium is written as

$$E_A\ (Medium) = E_A\ (Vacuo) + (1 - 1/n^2)\ \frac{e^2}{2r}$$

(4.4.55)

Since we are interested in determining E_A for an emulsion, we must determine the dielectric constant for the silver bromide and gelatin system.

The dielectric constant for the emulsion is obtained by taking the arithmetical mean of the optical dielectric constants of silver bromide and gelatin.

Mizuki gave the optical dielectric constant of silver bromide as 4.65. [Ref: E. Mizuki, "Kaimengensho, Koshikekkan," Kyoritsu-Shuppan, Tokyo, Japan (1963) p. 350]. The dielectric constant for gelatin is 2.32. [Ref: C.D. Hodgeman, *Handbook of Chemistry and Physics,* 43rd ed., Chemical Rubber Pub. (1962) p. 3018].

Using these values for the dielectric constant, we write

$$n^2 \;=\; D \;=\; \frac{4.65 \;+\; 2.32}{2} \;=\; 3.48$$

(4.4.56)

Substituting equation 4.4.56 into 4.4.55, we have

$$E_A \text{ (Emulsion)} \;=\; E_A \text{ (Vacuo)} \;+\; (1 - \frac{1}{3.48}) \; 2.40 \text{ eV}$$

(4.4.57)

$$E_A \text{ (Emulsion)} \;=\; E_A \text{ (Vacuo)} \;+\; 1.71 \text{ eV}$$

(4.4.58)

Utilizing equations 4.4.54 and 4.4.58, we have

$$E_A \text{ (Emulsion)} \;=\; \epsilon_{1/2} \text{ (V versus SCE)} \;+\; 4.38 \text{ eV}$$

(4.4.59)

Thus the electron affinity for the emulsion can be determined by measuring the polarographic half-wave potential in solution and using the correction term $(1 - 1/n^2) \, e^2/2r$ for the actual adsorption of the dye to the silver halide.

Similarly, we can derive a general equation for the electron affinity of any organic molecule surrounded by a medium that interacts with the molecule by electrostatic and van der Waals' forces. This equation is

$$E_A{}^m \text{ (eV)} = \epsilon_{1/2} \text{ (V vs. SCE)} + 2.40 \left(1 - \frac{1}{n^2}\right) + 2.67$$

$$\underbrace{\hspace{2.5cm}}$$

Electron
affinity.
in
medium

(4.4.60)

Although this is an approximate expression, Tani found that it gave very good results (Table 4.4.4). Furthermore, it has great utility since if $\epsilon_{1/2}$ is measured in water and mercury, and if the refractive index of the medium is known, then the electron affinity in medium is determined immediately.

Tani (3) points out that the quasi-Fermi level of dyes is independent of the surrounding medium. This implies that the quasi-Fermi level is an intrinsic property of a dye independent of the medium, substrate, or the state of aggregation. This result can be shown by: The coulomb energy term for the ionization energy is

$$-\left(1 - \frac{1}{n^2}\right) \frac{e^2}{2r}$$

(4.4.61)

The ionization energy in a medium is related to the ionization energy in vacuo by the relation

$$E_I{}^{med} = E_I{}^{vac} - \left(1 - \frac{1}{n^2}\right) \frac{e^2}{2r}$$

(4.4.62)

Rewriting equation 4.4.55, we obtain

$$E_A{}^{med} = E_A{}^{vac} + \left(1 + \frac{1}{n^2}\right) \frac{e^2}{2r}$$

(4.4.63)

Adding equations 4.4.62 and 4.4.63, we may write

$$E_I{}^{med} + E_A{}^{med} = E_I{}^{vac} + E_A{}^{vac}$$

$$(4.4.64)$$

Equation 4.4.64 shows that the sum of the ionization energy and electron affinity is *independent of medium.* Since this sum divided by 2, depending upon sign, can be either the quasi-Fermi level or the quasi-Fermi energy (equations 4.4.24 and 4.4.25 respectively), these quantities are independent of surroundings.

ELECTRONIC ENERGY LEVEL REQUIREMENTS FOR SENSITIZATION

Tani *et al.* (Tani (2)) calculated the π electron energy levels by use of a semi-empirical Hückel molecular orbital method for a number of dyes. Table 4.4.2 shows the quasi-Fermi level of 29 sensitizing and desensitizing dyes from this calculation. Analysis of these results shows *in all cases* that when the quasi-Fermi level of the dye is greater than the Fermi level of the silver bromide (≈ -4.75 eV), the dye is a sensitizer and when the quasi-Fermi level of the dye is less than the Fermi level of the silver bromide, the dye is a desensitizer.

Under certain conditions a sensitizing dye can give a desensitization effect occurring in the blue and ultraviolet spectral region where the dye does not absorb radiation.

Such a dye is in the ground state when adsorbed at normal concentration onto a chemically sensitized emulsion at room air (see Table 4.4.3 and Figure 4.4.8).

Conversely a dye giving a desensitizing effect can show a sensitizing effect called the Capri blue effect (see Table 4.4.3 and Figure 4.4.9). The Capri blue effect occurs at low concentrations of the dye ($\sim 10^{-6}$ molar) when adsorbed onto chemically unsensitized emulsions at room air.

Prior to the classical works of Tani and Kikuchi these effects were not well understood with respect to both the mechanism and quantitative analysis of the problem.

TABLE 4.4.2

The calculated quasi-Fermi levels for 29 sensitizing and desensitizing dyes (Tani (2)).

SENSITIZING DYES	$- q\,F$ (eV)
1	4.38
2	4.29
3	4.25
4	4.23
5	4.23
6	4.22
7	4.38
8	4.39
9	4.39
10	4.38
11	4.37
12	4.36
13	4.49
15	4.44
16	4.42
17	4.38
18	4.34
19	4.40
20	4.40
25	4.60
32	4.42
33	4.43
34	4.42
35	4.70
DESENSITIZING DYES	$- q\,F$ (eV)
27	4.96
28	4.95
30	5.14
31	5.01

Table 4.4.3 shows the calculated E_{lv}^{em} and E_{ho}^{em} values for all dyes in Tani (2) that were classified with respect to the desensitization effect.

TABLE 4.4.3 The calculated E_{1v}^{em} and E_{ho}^{em} values for some sensitizing and desensitizing dyes (Tani (2)).

SENSITIZING DYES* SHOWING DESENSITIZING EFFECT			
Number	$-E_{1v}^{em}$ (eV)	$-E_{ho}^{em}$ (eV)	Reported Capri Blue Effect
3**	3.44	5.06	√ ***
4	3.53	4.93	√ ***
5	3.60	4.85	
6	3.66	4.78	
9**	3.48	5.29	√ ***
10	3.60	5.15	√ ***
11	3.69	5.04	
12	3.76	4.96	
DESENSITIZING DYES*			
Number	$-E_{1v}^{em}$ (eV)	$-E_{ho}^{em}$ (eV)	Reported Capri Blue Effect
27	4.05	5.86	
28	4.03	5.86	√ ***
30	4.10	6.17	
31	3.84	6.17	√ ***
SENSITIZING DYES* SHOWING NO DESENSITIZING EFFECT			
Number	$-E_{1v}^{em}$ (eV)	$-E_{ho}^{em}$ (eV)	Reported Capri Blue Effect
1	3.22	5.53	
2	3.33	5.24	
7	3.02	5.73	
8	3.30	5.47	
25	3.37	5.83	

* The numbers refer to the dyes structured in Tani (2).
 Dye number 31 is phenosafranine.
** These two entries do not conform to the theory that a dye showing the desensitization effect must have an E_{1v}^{em} value less than—3.50eV.
*** M. Tamura and H. Hada, "Phot. Sci. Eng.," 11, 82 (1967)

Analysis of these results shows that except for dyes 3 and 9 all other dyes having an E_{lv}^{em} value less than the bottom of the conduction band of silver bromide show a desensitization effect (6 other dyes).

All dyes having an E_{lv}^{em} value greater than the bottom of the conduction band of silver bromide show no desensitizing effect (Figures 4.4.7, 4.4.8 and 4.4.9).

A comparison of the calculated and experimental values of $-E_{lv}^{em}$ in Table 4.4.4 shows that the difference between these two quantities ranges from $+0.11$ eV to -0.06 eV.

If the proposition that the E_{lv}^{em} value of a sensitizing dye showing a desensitizing effect must be less than -3.50 eV is correct, then the values of entries 3 and 9 in Table 4.4.3 should be greater than 3.50 eV. However, eleven dyes in Table 4.4.3 conform to the proposition and only two show a slight discrepancy. Since the evidence largely favors this proposition, we may consider these discrepancies to be due to the inaccuracies inherent in the semiempirical Hückel molecular orbital method, an error in the calculation, or the experimental error in the determination of the location of the conduction band of silver bromide.

The data of Tables 4.4.2, 4.4.3 and 4.4.4 show for dyes at normal concentration adsorbed onto either a chemically sensitized or unsensitized emulsion at room temperature:

a) If the quasi-Fermi level of a dye is greater than the Fermi-level of the silver halide in the emulsion, then the dye is a sensitizer in the excited state (Figure 4.4.7).

b) If the quasi-Fermi level of a dye is less than the Fermi level of the silver halide in the emulsion, then the dye is a desensitizer in the excited state

c) If a dye meets the requirements of a) and if its E_{lv}^{em} lies above the conduction band of the silver halide in the emulsion, then this dye is a sensitizer in the excited state and will not show a desensitization effect in the ground state (Figure 4.4.8).

d) If a dye meets the requirements of a) and if its E_{lv}^{em} lies below the bottom of the conduction band of the silver halide in the emulsion, then this dye is a sensitizer in the excited state and a desensitizer in the ground state (Figure 4.4.8).

e) If a dye meets the requirements of b) and if its E_{lv}^{em} lies below the bottom of the conduction band of the silver halide in the emulsion, then this dye is a desensitizer in both the excited and the ground state (Figure 4.4.8).

TABLE 4.4.4

DYE	$E_A^{vac} = - E_{1v}$ calculated*	$E_A^{vac} = \epsilon_{1/2} + 2.67$ experimental*	$- \epsilon_{1/2}$ experimental*	$E_A^{em} = - E_{1v}^{em}$ calculated*	$E_A^{em} = \epsilon_{1/2} + 4.38 = - E_{1v}^{em}$ experimental*
e	1.48	1.57	1.10	3.17	3.28
f	1.63	1.59	1.08	3.32	3.30
g	1.81	1.73	0.94	3.49	3.44
h	1.16	1.08	1.59	2.85	2.79
j	1.55	1.49	1.18	3.24	3.20

* Data obtained from Tani (5)

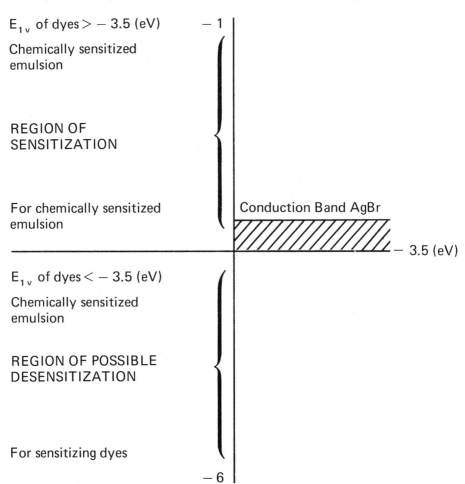

For dyes where quasi-Fermi level of Dye > Fermi level AgBr

E_{1v} of dyes > − 3.5 (eV) − 1

Chemically sensitized
emulsion

REGION OF
SENSITIZATION

For chemically sensitized
emulsion

Conduction Band AgBr

− 3.5 (eV)

E_{1v} of dyes < − 3.5 (eV)

Chemically sensitized
emulsion

REGION OF POSSIBLE
DESENSITIZATION

For sensitizing dyes

− 6

Fig. 4.4.8 *Shows the position of the lowest vacant energy level of dyes relative to the bottom of the conduction band of silver bromide, where all dyes have a quasi-Fermi level greater than the Fermi level of the silver bromide crystal. Although the dyes in both regions are sensitizing dyes, when the E_{1v} of these dyes lies below the conduction band of the silver bromide, and the dye does not absorb radiation, it remains in the ground state and can give a desensitization effect, especially in the blue and ultraviolet regions. This desensitization effect occurs at normal concentration of the dye adsorbed onto a chemically sensitized emulsion at room temperature.*

462

For dyes at low concentration (10^{-6} Molar) adsorbed onto chemically unsensitized emulsions at room temperature.

f) If a dye meets the requirements of c), then this dye is a sensitizer in the excited state and will not show a desensitization effect in the ground state (Figure 4.4.8).

g) If a dye meets the requirements of d), then this dye is a sensitizer in both the excited and the ground state. (Capri blue effect for the ground state, Figure 4.4.9).

h) If a dye meets the requirements of e), then this dye is a desensitizer in the excited state and a sensitizer in the ground state. (Capri blue effect for the ground state, Figure 4.4.9).

For dyes where quasi-Fermi level < F AgBr

— 1

This region not applicable to de-sensitizing dyes

Conduction band AgBr

— 3.5 (eV)

E_{1v} of dyes < − 3.5 (eV)

Region of:
Sensitization effect
for non-chemically
sensitized emulsion
(Capri blue effect)

Desensitization effect
for chemically sensi-tized emulsion

— 6

Fig. 4.4.9 *Shows the position of the lowest vacant energy levels of dyes relative to the bottom of the conduction band of silver bromide, where qF of the dye < Fermi level AgBr. Although the dyes are desensitizing in effect when adsorbed onto a chemically sensitized emulsion at normal concentration* *and at room temperature, they give a sensitization effect for non chemically sensitized emulsions at low concentration of dye ($\sim 10^{-6}$ Molar) at room temperature. This form of sensitization is called the Capri blue effect.*

THE MODIFIED ELECTRON TRANSFER MECHANISM

Tani derives a modified electron transfer mechanism for dye sensitization (Tani (2), (3), (4), (5)).

This mechanism interprets dye sensitization and desensitization in terms of the injection of electrons and positive holes. A sensitizing dye injects more electrons than holes into the silver halide (Figure 4.4.10).

If the level at E_{lv} of a dye lies above the conduction band for a sensitizing dye in the excited state, then electrons will be injected into the conduction band of the silver bromide crystal (Figure 4.4.10).

E_{lv} ⎯⎯⎯⎯ e

Conduction Band AgBr

E_{ho}

Fig. 4.4.10 *Shows a sensitizing dye ($\mu_{Dye} > \mu_{AgBr}$) injecting electrons into the conduction band of the silver bromide crystal.*

A desensitizing dye injects holes into the silver halide.

When a dye is in the excited state, it has one electron in the highest occupied level and one electron in the lowest vacant level. If the partially filled level at E_{ho} lies below the valence band of the silver bromide, it can accept an electron from the silver bromide. This results in the transfer of a hole to the valence band of the AgBr and the reduction of the dye (Figure 4.4.11).

E_{lv}

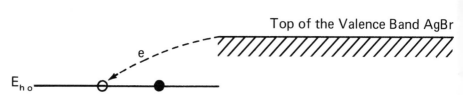

Top of the Valence Band AgBr

e

E_{ho}

Fig. 4.4.11 *Shows the reduction of a dye by the transfer of an electron from the valence band of the silver bromide to the dye,* *resulting in the injection of a hole into the valence band of the silver bromide.*

When the level at E_{lv} for a *sensitizing dye* in the excited state is below the bottom of the conduction band of silver bromide, then the electrons are injected into some intermediate energy level in the silver halide crystal (Figure 4.4.12).

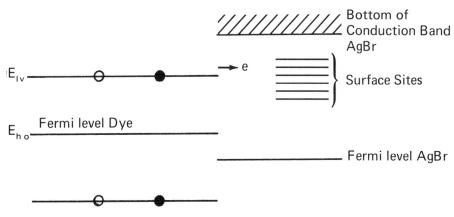

Fig. 4.4.12 *Shows schematically a sensitizing dye in the excited state transferring an electron to some intermediate energy level.*

The modified electron transfer mechanism has the following postulates in air at room temperature:

POSTULATES

a) Electron transfer from dyes in the excited state to the silver halides of an emulsion is responsible for spectral sensitization in photography.

b) The hyper-redox potential and quasi-Fermi level of the dyes determine whether a dye is a sensitizing or desensitizing dye. When the quasi-Fermi level is greater than the Fermi level of the silver bromide, the dye is a sensitizer. If qF less than the AgBr, the dye is a desensitizer.

c) If the concentration and mobility of electrons injected into the silver halide is greater than that of injected holes, the probability for successful nucleation and growth events of latent image formation is greater than the competitive decay events brought about by injected holes.

d) When the lowest vacant energy level of the dye in the excited state is above the bottom of the conduction band of the silver halide, then the dye will inject electrons into the conduction band of the silver halide.

e) When the highest occupied energy level of the dye in the excited state is below the top of the valence band of the silver halide, then hole injection into the valence band can occur.

f) For a series of hypothetical sensitizing dyes *in the excited state* having the characteristics depicted in Figure 4.4.13, we may postulate:

1. The best sensitizer is dye 2, since both the E_{1v} and E_{ho} are above the conduction and valence bands of the silver bromide, respectively.

2. Dye 3 is the next best sensitizer, although the E_{ho} is below the level of the valence band of the silver bromide. This postulate is made on the basis that the quasi-Fermi level of dye 3 is greater than the Fermi level of the crystal but less than the Fermi level of dye 2.

3. Dye 1 is the least efficient sensitizer in this group because its quasi-Fermi level is the lowest with respect to the quasi-Fermi level of dyes 2 and 3.

Fig. 4.4.13 Shows three possible cases for sensitizing dyes in the excited state at room temperature and at normal concentration. According to the modified electron transfer mechanism, the number and mobility of electrons injected into the chemically sensitized silver bromide is greater than the number and mobility of the holes injected.

g) The dyes shown in Figure 4.4.13 may be analyzed *in the ground state* (Figure 4.4.14) and we may postulate:

1. For a chemically sensitized emulsion, dye 1 can trap electrons in its lowest vacant level, thereby desensitizing the emulsion at wavelengths where the dye does not absorb. It has been suggested by Tamura and Hada [Ref: M. Tamura and H. Hada, *Phot. Sci. Eng.*, 11, 82 (1967)] that aggregation of the dye allows the trapped electron to explore the aggregate prior to its recombination with a positive hole, either in the dye or at the dye silver halide interface. The net effect is that such electrons cannot participate in nucleation or growth events of latent image formation. The Tamura and Hada theory is supported by an experiment by Lewis and James [Ref: W.C. Lewis and T.H. James, *Phot. Sci. Eng.*, 13, 54 (1969)]. Lewis and James reported: under evacuation conditions for both chemically sensitized and chemically unsensitized simple mono disperse silver bromide and silver iodiobromide emulsions at high surface coverage by dyes, desensitization was present, while at low surface coverage by dyes desensitization did not occur.

It should be noted that the evacuation of gases, including oxygen and water vapor, did not completely eliminate desensitization at high surface coverage by dyes. The dyes are most likely in a largely aggregated state at high surface coverage.

2. Dyes 2 and 3 cannot act as desensitizers in the ground state because their E_{lv} levels are above the bottom of the conduction band of the silver bromide.

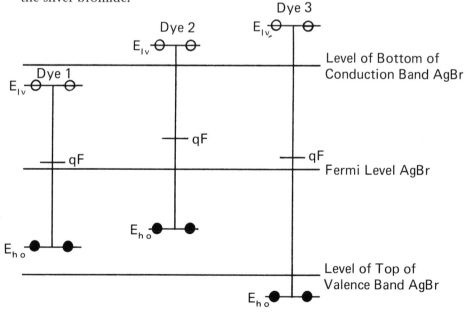

Fig. 4.4.14 *Shows three possible cases for sensitizing dyes in the ground state. According to the modified electron transfer mechanism,* *Dye 1 can trap electrons in its lowest vacant level whereas Dye 2 and Dye 3 cannot.*

h) For a chemically unsensitized emulsion at low surface coverage of a dye ($\sim 10^{-6}$ Molar) having the electronic energy levels similar to those of Dye 1, Figure 4.4.14, the dye can show the Capri blue effect rather than the desensitization effect characteristic of this class of sensitizing dyes in the ground state. The *Capri blue effect* is a sensitization effect that occurs for both sensitizing and desensitizing dyes at low surface coverage of the dyes when adsorbed onto chemically unsensitized emulsions for wavelengths where the dye does not absorb. This effect is not considered spectral sensitization because it is merely the trapping and subsequent release of the electrons from the lowest vacant level of the dye. It is postulated that this trapping and release of the electron takes place quickly because the dye is not aggregated.

The series of hypothetical dyes in the excited state illustrated in Figure 4.4.15 are characterized by the following postulates:

1. Dye 2 is the best desensitizer relative to Dyes 1 and 3 since its quasi-Fermi level is the lowest of these dyes with respect to the Fermi level of the silver bromide.

2. The quasi-Fermi level of Dye 3 is lower than Dye 1 with respect to the Fermi level of the silver bromide, making it the next best desensitizer. Since Dye 3 can inject electrons into the conduction band of the silver bromide and positive holes into the valence band, the number and mobility of the electrons injected into the conduction band is less than the number and mobility of positive holes injected into the valence band, resulting in the destruction of latent image.

3. Dye 2 is the most efficient desensitizer because its quasi-Fermi level is the lowest with respect to the quasi-Fermi level of Dyes 1 and 3 (Figure 4.4.15).

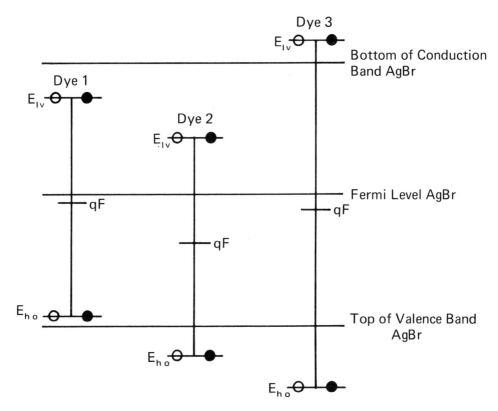

Fig. 4.4.15 Shows three hypothetical cases for desensi- number and mobility of positive holes
tizing dyes in the excited state. According injected into the AgBr because the
to the modified electron transfer mecha- quasi-Fermi level of these dyes is less than
nism, the number and mobility of electrons the Fermi level of the silver bromide in the
injected into the AgBr is less than the emulsion.

The three hypothetical dyes in the *ground state* shown in Figure 4.4.16 are characterized by the postulates:

1. For a chemically unsensitized emulsion and at low concentration of the dye ($\sim 10^{-6}$ Molar), Dyes 1 and 2 can sensitize by the Capri blue effect, whereas Dye 3 cannot.

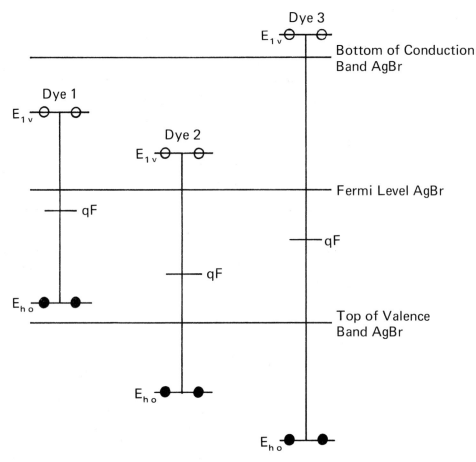

Fig. 4.4.16 *Shows three hypothetical desensitizing modified electron transfer mechanism,*
dyes in the ground state. According to the Dyes 1 and 2 can show a Capri blue effect.

CONCLUSION TO THE PROBLEM OF SPECTRAL SENSITIZATION

A major consideration as to the validity of the Tani theory is whether electrons and holes are actually transferred between the dye and silver halide species. A possible alternate mechanism is resonance energy transfer.

In an attempt to settle the dilemma of whether dye sensitization in photography occurs by electron or energy transfer, Tani performed the following experiment (Tani (4)).

Tani measured the fluorescence spectra of sensitizing and desensitizing dyes adsorbed to silver halides (Table 4.4.5).

TABLE 4.4.5

(1)	Erythrosin
(2)	3,3'—diethyl 2,2'—thiacarbocyanine iodide
(3)	Phenosafranine
(4)	Pinakryptol green

The relation of the electronic energy levels of these dyes to the electronic energy levels of the silver halide of the emulsion is illustrated in Figure 4.4.17.

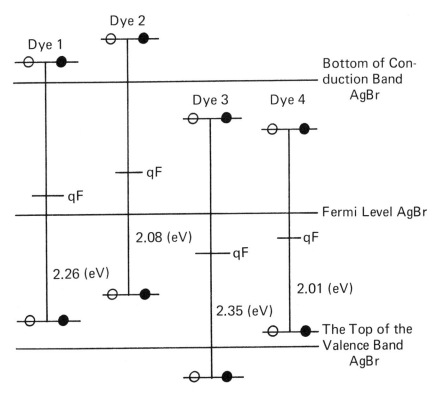

Fig. 4.4.17 *Shows the electronic energy levels of the dyes in Table 4.4.5 in the excited state.*

When the fluorescence of a dye adsorbed onto a silver halide is quenched, this indicates that either electron or energy transfer has occurred (see Appendix 4A).

Tani found that the fluorescence of Dyes 1, 2, 3 was quenched but that the fluorescence of Dye 4 was not quenched. Furthermore, Dyes 1 and 2 sensitized the emulsion, but Dyes 3 and 4 did not. If this were a case of resonance energy transfer, then Dye 3 should also sensitize the emulsion, since it is capable of transferring 2.35(eV) of energy. On the other hand, the sensitizing Dyes 1 and 2 are capable of transferring 2.26(eV) and 2.08(eV) of energy, respectively.

Thus the only reasonable mechanism that can explain these phenomena in air is the modified electron transfer mechanism.

The quenching of the fluorescence in Dye 3 is explained by the transfer of holes and electrons so that the excited dye cannot return to the ground state and fluoresce. (Fluorescence see Appendix 4A).

Since Dye 3 desensitizes the emulsion, the number and mobility of holes injected into the silver halide of the emulsion is greater than the number and mobility of electrons injected into the silver halide.

The theoretical and experimental work done by Tani supports the modified electron transfer mechanism of spectral sensitization in air.

On the other hand, the fact the phenosafranine can spectrally sensitize in a vacuum at low surface coverage [Ref: T.H. James, *Phot. Sci. Eng.*, 14, 84 (1970)] may indicate that the molecule is transferring either energy or more electrons than holes to an intermediate state in the energy gap.

Ordinarily, in air, the amount of electrons supplied to intermediate states in the forbidden gap is smaller due to the quenching action of oxygen and water vapor which is present. When the population of electrons in the intermediate states becomes large enough, a significant fraction may be delivered to the conduction band by thermal excitation.

This seems to be the most likely mechanism operating for phenosafranine adsorbed onto a silver halide emulsion and exposed under conditions of evacuation. Furthermore, Tani calculated and found that the E_{1v} of many sensitizing dyes at room air was below the level of the bottom of the conduction band. Since the quasi-Fermi level of these dyes is greater than the Fermi level of the silver bromide in the emulsion, the evidence supports that they are transferring a sufficiently large population of electrons to intermediate levels such that the fraction of electrons injected into the conduction band of the silver halide can spectrally sensitize the emulsion.

Tani [Ref: T. Tani, *Phot. Sci. Eng.*, 14, 237 (1970)] has further extended the modified electron transfer mechanism of spectral sensitiza-

tion in photography to include non-planar desensitizing dyes whose quasi-Fermi level is greater than the Fermi level of the silver bromide emulsion. Therefore another postulate is required.

Postulate: The necessary condition that a dye be a sensitizing dye is that the dye be planar. This postulate means that all sensitizing dyes are planar.

EXERCISE

What is the sufficient condition for a planar dye to be a sensitizing dye according to the modified electron transfer mechanism?

A corollary to the above postulate is that a non-planar dye cannot be a sensitizing dye and does not conform to the modified electron transfer mechanism.

Evidently the physical reason for non-planar dyes not conforming to the modified electron transfer mechanism is that they do not aggregate on the surface of an AgBr crystal and do not produce a distribution of electrons such that a quasi-Fermi level can exist.

PROBLEM SET 4.1

1. Discuss the modern interpretation of the benzene ring.

2. Using the methods of section 4.1 draw the structures for metol, hydroquinone, pyrogallol, phenidone, ascorbic acid and paraphenylene-diamine.

 (a) Classify these developing agents according to section 4.1.

3. The quinoline molecule is heterocyclic, planar and has sp^2 hybridization. Discuss these terms.

4. Schematically draw the following molecules

 (a) N-ethylquinoline iodide.

 (b) 1,1'—diethyl—2,2'—carbocyanine iodide.

5. Write the general formula for cyanine dyes based on the quinoline ring system.

6. What information determines the prefix naming for cyanine dyes?

7. Discuss the descriptive naming of ethyl red.

8. Why are the two structures shown in Fig. 4.2.9 said to be the major contributors to the ground state?

9. Discuss resonance stabilization.

10. Discuss the excited state structures shown in Fig. 4.2.11.

11. What characterizes the excited state structure shown in Fig. 4.2.11?

12. Utilizing Table 4.2.2 draw schematically six cyanine dye structures having different nuclei.

13. Define the term "unsymmetrical cyanine dye."

14. Draw schematically and descriptively name six unsymmetrical cyanine dye structures.

15. Discuss the amidinium ion system.

16. Discuss the resonance forms of the amidinium ion system.

17. Construct the amidinium linear chain system preserving the angular relationship.

18. What factors influence the absorption characteristics for all cyanine dyes?

19. If the molecule of Figure 4.3.1 absorbs a photon of energy less than $E_2 - E_1$ what transitions may occur?

20. Calculate the energy in electron volts required for the transitions occurring between: two vibrational energy states, two rotational energy states, two electronic energy states, two translational energy states, all transitions taking place at $300°K$.

21. Calculate the photon energy in electron volts for the wavelengths 436nm, 520nm, 580nm, 720nm, 1500nm.

22. Discuss absorption and transmission spectra.

23. Discuss the factors that influence the band spectra of molecules.

24. Discuss the similarities and differences of the equations that represent the bonding and antibonding molecular orbitals.

25. How may the resonance energy for benzene be estimated?

26. Verify the result given in equation 4.3.16.

27. Define an aromatic compound.

28. Discuss the aromaticity of hydroquinone and quinone.

29. Utilizing Figure 4.3.15 explain why hydroquinone is colorless in aqueous solution while quinone is highly colored in aqueous solution.

30. Discuss the electronic molecular orbital energies according to relation 4.3.21.

31. How do the absorption spectra of a cyanine dye vary as a function of dye concentration?

32. Discuss and explain M, H and J molecular aggregation.

33. Verify the absorption in nanometers for the dimer, trimer and tetramer and infinite-mer as given in Figure 4.3.22.

34. Discuss the significance of the 9 ethyl substitution for the methyl group in dye 2 (see Figure 4.3.22).

35. Explain how equation 4.3.28 can be used to classify the sizes of aggregates.

36. Explain why dye 3 forms J aggregates easily while dye 2 does not.

37. Define electron and energy transfer.

38. Discuss the two principal assumptions proposed by Tani that suggests that dye sensitization in photography does not follow either the electron or energy transfer mechanism.

39. Discuss the postulates of the modified electron transfer mechanism for dye sensitization in photography.

40. Describe the Capri blue effect.

41. According to the modified electron transfer mechanism,
 (a) When is a dye a sensitizer in the excited state?
 (b) Desensitizer in the excited state?

42. When can a dye whose quasi-Fermi level is greater than the Fermi level of the silver halide in the emulsion be both a sensitizing and desensitizing dye?

43. Discuss the three possible cases for sensitizing dyes in the excited state according to Figure 4.4.13.

44. Why does the experiment summarized in Table 4.4.5 and Figure 4.4.17 strongly support the modified electron transfer mechanism?

PROBLEM SET 4.2

1. What is the Franck-Condon principle?
2. How can a molecule give up its excitation energy?
3. Discuss Figure 4.A.1.
4. (a) How can the fluorescence wavelength be shorter than the excitation wavelength?

 (b) What is this process called?
5. Discuss low temperature fluorescence.
6. How are absorption and radiation processes important to understanding the photographic process.
7. Verify equation 4.B.12.
8. Discuss Figure 4.B.4.
9. Verify equations 4.B.29 through 4.B.34.
10. Why is the solution to the particle in the box important to the photographic process?
11. A hypothetical conjugated dye molecule contains 18 carbon atoms. If its linear length is approximately 19.5×10^{-8} cm, using the values of m, c, and h given earlier (see 4.C.30), calculate the λ_{max} for this dye.

Appendix 4A
Radiation
Processes

THE FRANCK–CONDON PRINCIPLE

The Franck–Condon principle states that the transitions (4.3.22) take place in a shorter time than the atoms vibrate in the bonds of the molecule. This means that in the first instant after the electronic transition ($\sim 10^{-13}$ seconds) the molecule has its initial configuration with respect to kinetic energy and position of atoms.

Another statement of the Franck–Condon principle is that transitions tend to take place between vibrational levels in which distances between atomic nuclei are the same, and kinetic energies of the atomic nuclei are small in both states.

In the interval following the transition, a number of processes may take place.

When a molecule absorbs quanta and is optically excited, this energy can be given up in any one of the following physical processes:

1. Quenching
2. Fluorescence
3. Phosphorescence
4. Internal Conversion
5. Crossover

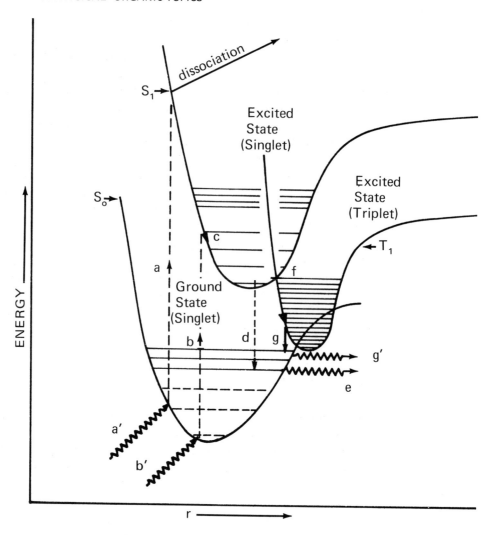

Fig. 4.A.1 *Shows schematically a potential energy
diagram for a hypothetical molecule that
has a singlet ground state S_o, a singlet
excited state S_1, and a triplet excited state
T_1.*

When two electrons have the same spin in this excited state, it is called a *triplet state.*

The triplet state is generally more stable than the corresponding singlet state because the electrons experience less mutual repulsion (Hund's rule). The term 'triplet' means that two unpaired electrons have *three* energy states in an applied magnetic field.

The impinging photon á depicted in Figure 4.A.1 results in an electronic transition from a high enough vibrational ground state to an excited electronic state such that the bond strength of the molecule is lowered sufficiently to result in dissociation of the molecule.

The incoming photon b́ in Figure 4.A.1 produces a transition b that loses vibrational energy to the surroundings in the transition c. This loss of vibrational energy takes place in 10^{-12} sec, and is called vibrational relaxation or internal conversion, which does not result in the emission of a photon. After vibrational relaxation, the molecule may return to the ground state by transition d. This transition results in the emission of photon e and is called *fluorescence.* Fluorescence normally occurs 10^{-9} to 10^{-7} sec after absorption of the original radiation and may have a wavelength longer or shorter than the original excitation photon. If the wavelength of fluorescence is longer than the excitation wavelength, the process is called *Stokes fluorescence* (Stokes, 1852).

On the other hand, if the fluorescent wavelength is shorter than the excitation wavelength, the process is called *anti-Stokes fluorescence.*

The origin of both types of fluorescence comes from the transfer of thermal energy to and from the molecule in the excited state by collisions with other molecules. This transfer of energy takes place during the vibrational relaxation interval time of 10^{-13} sec to 10^{-8} sec. If the molecule is in the liquid or solid state, many collisions occur before the molecule can emit the photon.

In most cases, the excited state loses vibrational energy by thermal interaction with other molecules. Thus the emitted photon is almost always less energetic than the excited photon. However, as the temperature is raised appreciably, more excited state molecules are placed into higher vibrational states before the electronic transition to the ground state.

The difference between the energy of the excitation photon and the emitted photon always appears, or course, as heat.

A number of non-radiative processes (no photon emission) compete with fluorescence.

The electronic excited state may decay by vibrational relaxation to a vibrational excited ground state which subsequently decays by vibrational relaxation to the normal ground state. Three other non-radiative decay

modes are

 a) Chemical reaction with surrounding molecules

 b) Transfer of excess electronic energy to surrounding molecules

 c) The internal conversion designated f, in Figure 4.A.1, to a triplet state that subsequently decays by one of the above non-radiative processes.

The probability of a transition directly from the singlet ground state (S_o) to the triplet excited state (T_1) is zero. Thus the transition $S_o \rightarrow T_1$ is said to be strongly forbidden. However, the transition $S_1 \rightarrow T_1$ is not so strongly forbidden even though transitions between singlet and triplet states are generally forbidden.

The possibility of the transition $S_1 \rightarrow T_1$ arises from the fact that the T_1 state is more stable than the S_1 state. The S_1 potential energy curve crosses over the T_1 potential energy curve. Thus the internal conversion marked f in Figure 4.A.1 can take place and some of the molecules will be in the T_1 state.

Once in the T_1 state, the molecule must either wait a time (10^{-4} sec to 10 sec) before it can make the forbidden transition $T_1 \rightarrow S_o$ and emit a photon, or acquire enough energy through collision to go back to the S_1 state by internal conversion.

This corresponds to the transition $S_1 \rightarrow S_o$ coupled with the emission of a photon of the same wavelength as the normal fluorescent photon. Both processes are much longer in duration than normal fluorescence, but the former process occurs at low temperatures whereas the latter process occurs at high temperatures.

The former process of long lifetime is the transition labeled g that produces the long wavelength photon g′ in Figure 4.A.1. This $T_1 \rightarrow S_o$ emission is generally referred to as *phosphorescence.*

This text refers to this process as low temperature phosphorescence. The emission produced by the sequence of reactions

$$h\nu \; + \; S_o \longrightarrow S_1$$

<div align="right">(4.A.1)</div>

$$S_1 \longrightarrow T_1 \; + \; heat$$

<div align="right">(4.A.2)</div>

$$heat \; + \; T_1 \longrightarrow S_1$$

<div align="right">(4.A.3)</div>

$$S_1 \longrightarrow S_o \; + \; h\nu$$

<div align="right">(4.A.4)</div>

is called *high temperature phosphorescence.*

There is considerable disagreement as to the naming of these emissions. For instance, some workers refer to the emission of equations 4.A.1 through 4.A.4 as fluorescence, while others call the emission labeled g in Figure 4.A.1 slow fluorescence.

The advantage in the names given by this text to these emissions is that they are directly related to the experimental results. It is found experimentally that when almost any unsaturated or aromatic compound is dissolved in a rigid solvent (that tends to prevent collisions) and excited with suitable radiation, the phosphorescence changes gradually from the wavelength of normal fluorescence to a longer wavelength as the temperature varies from high to low. At the high end of temperature, the spectral characteristics of the phosphorescence are exactly the same as the normal fluorescence, but at the low temperature shift to a longer wavelength and its lifetime becomes independent of temperature.

The study of fluorescence and phosphorescence is very important to the understanding of the mechanism of spectral sensitization of the photographic emulsion. Internal conversion also may play a part in spectral sensitization.

INTERNAL CONVERSION

Internal conversion is a process where part of all of the energy of an absorbed photon is converted into heat. This process is sometimes called *energy transfer.* When a photon is completely converted to heat, the process is thought to occur in the following manner.

A polyatomic molecule such as a cyanine dye has a complex potential energy surface. The potential energy surfaces of both the excited state and the ground state being complex may cross one another. Thus several molecular configurations of both states would be identical.

When such a molecule absorbs a photon, it can be raised to a high vibrational level of the excited state. However, this vibrational level would initiate a complicated vibration that would pass many times through one of the ground state molecular configurations.

Each time the vibrating molecule passed through one of the ground state configurations an opportunity would exist for a non-radiative transition to one of the high vibrational levels of the ground state that had an energy identical to one of the low lying vibrational levels of the excited state. Since this transition has a finite probability, it will occur for some molecules.

Once the transition to the high vibrational level of the ground state

of the molecule has occurred, energy could be lost by collisions with other molecules until the lowest vibrational level of the ground state was reached.

The process of internal conversion occurs quite often in the higher excited states of most molecules.

Many molecules show a fluorescence emission wavelength that is independent of the excitation wavelength. This result indicates that although the molecule may be excited to any electronic level, it always rearranges itself to a unique low vibrational level of a particular excited state from which a fluorescent transition to the ground state takes place. This phenomenon is depicted in Figure 4.A.2.

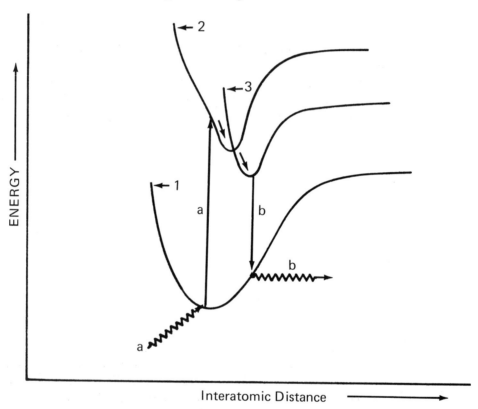

Interatomic Distance

Fig. 4.A.2 Shows schematically the process of internal conversion. Photon a produces the transition a from state 1 to state 2. The energy of the transition passes from state 2 to state 3 by internal conversion at the cross-over points of the potential energy curves. The energy returns from state 3 by the transition b emitting photon b. The figure shows that the transition b is independent of the transition a because the process of internal conversion always brings the molecule to the same vibrational level of state 3.

When fluorescent molecules are adsorbed to molecules containing heavy atoms, transitions between singlet and triplet states become more probable (the heavy-atom effect).

Another phenomenon that is important to photography is *quenching*. This term means that the fluorescence or phosphorescence can be diminished or prevented by a substance that *quenches* the emission.

Quenching is produced in two ways:

1) A molecule A may form a complex with the fluorescent molecule B before photon absorption takes place and we write

$$A + B \rightleftharpoons A B$$

(4.A.5)

where the complex AB does not fluoresce when excited. This process is called *static quenching*.

2) The quencher A may react with the excited molecule B* before fluorescence takes place. The product is a complex AB* that dissociates to give heat and A + B. This process is called *dynamic quenching* (4.A.6 to 4.A.8).

$$h\nu + B \longrightarrow B^*$$

(4.A.6)

$$A + B^* \longrightarrow A^*B$$

(4.A.7)

$$A^*B \longrightarrow A + B + heat$$

(4.A.8)

One may distinguish between these two mechanisms experimentally. The excited molecule B* has a very short life time so that a collision between A and B* must take place rapidly in order to quench the emission. Thus a highly viscous solvent will restrict the movement of A and prevent dynamic quenching. However, the viscosity of the solvent will not affect the equilibrium of reaction 4.A.5, all other things being equal.

Static and dynamic quenching have opposite temperature effects. Low temperatures favor association of A and B so that static quenching is increased. Dynamic quenching, on the other hand, is diminished at low temperatures because of the increase of viscosity of the solvent.

If increasing the concentration of quencher decreases the intensity

but not the lifetime of the fluorescence, then the mechanism is static quenching. This fact is true because increasing the concentration of quencher for a static quencher just decreases the number of potential fluorescent molecules but does not affect the lifetime of the fluorescence. On the other hand, if both the intensity and lifetime decrease, then the mechanism is dynamic quenching because the increase in the concentration of quencher increases the rate of deactivating collisions.

It may happen that the complex A*B in reaction 4.A.8 dissociates and we write

$$A*B \longrightarrow A* + B$$

(4.A.9)

When reaction 4.A.9 occurs, the excited quencher A* may be able to initiate a chemical reaction. In photography this is called *supersensitization* and the quencher A is actually a supersensitizer.

A phenomenon called self-quenching seems to occur by the static mechanism. In this case, as the concentration of fluorescent molecules is increased, the fluorescence is diminished in intensity but not lifetime. The fluorescent molecules form dimers and polymers in solution by complexing with each other. The dimers and polymers are probably unable to fluoresce because of complete internal conversion.

Appendix 4B
Orbitals and Hybridization

When we assume that covalent chemical bonding involves the sharing of electrons donated by each of the atoms, then an atomic orbital representation can be used to show the bond formation (also see Section 2.1).

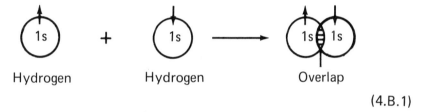

| Hydrogen | + | Hydrogen | → | Overlap |

(4.B.1)

The paired electrons ⬆⬇ exert attractive forces which pull both atomic nuclei closer, thereby forming a single bond.

Single bonds formed by two paired electrons in a manner as shown in 4.B.1 are referred to in molecular-orbital theory as a σ *bond*. A useful postulate relating to covalent bonding is: As the degree of overlapping of the orbitals reaches its maximum, the bonds formed are strongest.

Electrons may be described by wave functions.

The 1s atomic orbital for the hydrogen atom can be written as

$$\psi_{1s} = \text{The 1s wave function of the hydrogen atom}$$

The probability per unit length of finding an electron in the 1s orbital at any distance r from the nucleus of the hydrogen atom is written as

$$\left| \Psi_{1s} \right|^2 \, 4\pi r^2 = \frac{\text{Probability}}{\text{Unit Length}}$$

(4.B.2)

where the unit length is a_0.

The value of a_0 is the radius of the first Bohr orbit

$$a_0 = \frac{h^2}{4\pi^2 \, \mu e^2} = 0.53 \text{ Å}$$

$$(4.B.3)$$

Equation 4.B.2 is the probability density of the 1s electron for the hydrogen atom.

Since the probability of finding the electron somewhere between $r = 0$ and $r = \infty$ is equal to 1, we write

$$\int_0^\infty \left| \Psi_{1s} \right|^2 4\pi r^2 \, dr = 1$$

$$(4.B.4)$$

In the event that we have a wave function ψ_{1s} that does not conform to the above condition but still gives a finite integral, then the wave function is said to be *un-normalized*.

An un-normalized wave function may be represented as

$$\int \left| \Psi_{1s} \right|^2 4\pi r^2 \, dr = N$$

$$(4.B.5)$$

where $N \neq 1$ and $0 < N < \infty$.

An un-normalized wave function can be normalized by multiplying the wave function by $1/\sqrt{N}$.

We may prove this as follows:

Let us assume that we have a 1s un-normalized wave function represented as

$$\phi_{1s}$$

$$(4.B.6)$$

Since ϕ_{1s} is un-normalized, we may write

$$\int \left| \phi_{1s} \right|^2 \, 4\pi r^2 \, dr \;=\; N$$

$$(4.B.7)$$

Now we must prove that $1/\sqrt{N}\, \phi_{1s}$ integrates to unity. Taking the absolute value, we write

$$\left| \frac{1}{\sqrt{N}} \, \phi_{1s} \right| \;=\; \frac{1}{\sqrt{N}} \left| \phi_{1s} \right|$$

$$(4.B.8)$$

Squaring both sides, we have

$$\left| \frac{1}{\sqrt{N}} \, \phi_{1s} \right|^2 \;=\; \frac{1}{N} \left| \phi_{1s} \right|^2$$

$$(4.B.9)$$

The normalization integral can now be written as

$$\int_0^\infty \left| \frac{1}{\sqrt{N}} \, \phi_{1s} \right|^2 \, 4\pi r^2 \, dr$$

$$(4.B.10)$$

Substituting equation 4.B.9 into 4.B.10, we have

$$\frac{1}{N} \int_0^\infty \left| \phi_{1s} \right|^2 \, 4\pi r^2 \, dr$$

$$(4.B.11)$$

Using equation 4.B.7 and 4.B.10, we may write

$$\int_0^\infty \left| \frac{1}{\sqrt{N}} \phi_{1s} \right|^2 4\pi r^2 \, d r \ = \ \frac{1}{N} \times N \ = \ 1$$

(4.B.12)

Thus the normalized wave function is $1/\sqrt{N} \, \phi_{1s}$ Q.E.D. As an example of a normalization calculation, we write

$$\phi_{1s} \ = \ e^{-r/a_o} \ ;$$

$$\text{where } a_o \ = \ 0.53 \text{ Å}$$

(4.B.13)

The 1s orbital of the hydrogen atom is spherically symmetrical. Thus the quantity 4π that appears in the integral expression 4.B.4 comes about by the integration over the angles θ and ϕ in spherical coordinates. With these facts in mind, we may write equation 4.B.7 as

$$\int_0^{2\pi} \int_0^{\pi} \int_0^\infty \left| \phi_{1s} \right|^2 r^2 \sin\theta \, d r \, d\theta \, d\phi \ = \ N$$

(4.B.14)

Since ϕ_{1s} is not a complex variable, we may write

$$\left| \phi_{1s} \right|^2 \ = \ e^{-2r/a_o}$$

(4.B.15)

Substituting 4.B.15 into equation 4.B.14 and after integrating over the angles, we write

$$4\pi \int_0^\infty e^{-2r/a_o} r^2 \, d r \ = \ N$$

(4.B.16)

Since the value of the integral

$$\int_0^\infty r^2 \, e^{-br} \, dr = \frac{2}{b^3}$$

(4.B.17)

Then we may write

$$N = 4\pi \frac{2}{\left(\dfrac{2}{a_o}\right)^3} = \frac{8\pi a_o^3}{8} = \pi a_o^3$$

(4.B.18)

Therefore our normalization constant is

$$\frac{1}{\sqrt{N}} = \frac{1}{\sqrt{\pi a_o^3}}$$

(4.B.19)

and the normalized wave function is written as

$$\Psi_{1s} = \frac{1}{\sqrt{\pi a_o^3}} e^{-r/a_o}$$

(4.B.20)

Using equation 4.B.2, we may write the probability density for the 1s electron of the hydrogen atom as

$$\frac{1}{\pi a_o^3} e^{-2r/a_o} \, 4\pi r^2 = \frac{4r^2}{a_o^3} e^{-2r/a_o}$$

(4.B.21)

Finally, since the unit length for equation 4.B.21 is a_o, we may write the probability of finding the 1s electron at a radial distance r from the nucleus of the hydrogen atom as

$$F(r) = \frac{a_o\, 4\, r^2}{a_o^3}\, e^{-2r/a_o} = \frac{4r^2}{a_o^2}\, e^{-2r/a_o}$$

(4.B.22)

A plot of $F(r)$ versus r/a_o is shown in Figure 4.B.1

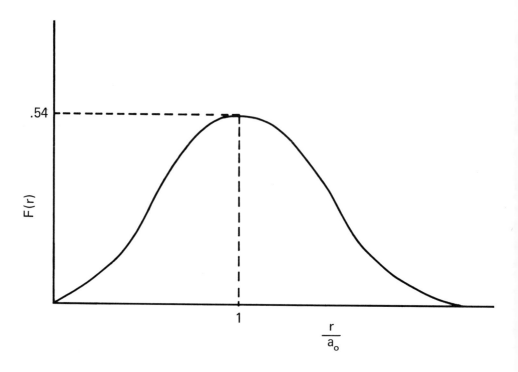

Fig. 4.B.1 *Shows a plot of F(r) versus r/a_o.*

THE p ATOMIC ORBITALS

The p atomic orbitals are not centered on the nucleus of the hydrogen atom (Figure 4.B.2)

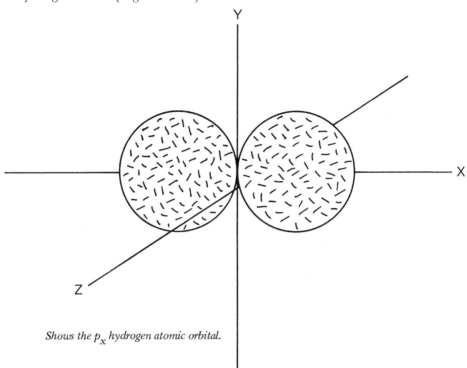

Fig. 4.B.2 *Shows the p_x hydrogen atomic orbital.*

EXERCISE

Draw the p_y and p_z atomic orbitals.

THE ELECTRONIC STRUCTURE OF THE CARBON ATOM

The ground state configuration of the carbon atom is $1s^2$, $2s^2$, $2p^2$. This configuration is schematically shown in Figure 4.B.3

Fig. 4.B.3 *Shows the ground state configuration of the carbon atom.*

Figure 4.B.3 shows that the only electrons available for bonding are the unpaired p_x and p_y electrons. Since these orbitals are at right angles to each other, we should expect that carbon could have a valence of two and bond with two other atoms forming a 90° planar configuration. On the other hand, experimental evidence indicates that methane CH_4, CCl_4, etc., are tetrahedral in structure and that carbon has a valence of four.

This discrepancy between the ground state configuration and the experimental results was resolved by L. Pauling and J. Slater [Ref: L. Pauling, *The Nature of the Chemical Bond*, Cornell University Press (1940)].

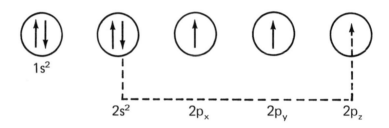

Fig. 4.B.4 *Shows an excited state configuration for the carbon atom.*

These men introduced the concept of *orbital hybridization* which led to agreement between theory and experiment.

The first step in orbital hybridization is to promote one of the paired electrons in the **2s** orbital to the empty **2p$_z$** orbital (see Figure 4.B.4). This promotion has been measured experimentally (spectroscopically) to require an energy of 65 kilocalories per mole. However, the fact that carbon can now form 4 bonds instead of 2 more than makes up for the 65 kilocalories per mole because the amount of energy given off during the formation of the four bonds is much greater than 65 kilocalories per mole per bond. In fact, the amount of energy given off during the formation of a carbon hydrogen bond is 99 kilocalories per mole [Ref: L. Pauling, *The Nature of the Chemical Bond*, Cornell University Press, Ithaca, N.Y., 3rd ed., (1960)].

The second step in orbital hybridization is to form a linear combination of the one **2s** and the three **2p** orbitals.

These linear combinations produce four new atomic orbitals which correctly describe the carbon atom in its bonded state.

We may write these four new atomic orbitals as

$$\Psi_1 = a_{11}(2s) + a_{21}(2p_x) + a_{31}(2p_y) + a_{41}(2p_z)$$

Atomic
Orbital

(4.B.23)

$$\Psi_2 = a_{12}(2s) + a_{22}(2p_x) + a_{32}(2p_y) + a_{42}(2p_z)$$

(4.B.24)

$$\Psi_3 = a_{13}(2s) + a_{23}(2p_x) + a_{33}(2p_y) + a_{43}(2p_z)$$

(4.B.25)

$$\Psi_4 = a_{14}(2s) + a_{24}(2p_x) + a_{34}(2p_y) + a_{44}(2p_z)$$

(4.B.26)

The a_{ij} terms are constants to be determined such that they fulfill the requirements that the ψ 's are normalized, mutually orthogonal, and have the largest possible magnitude along some arbitrary direction in space.

The condition for orbitals to be both orthogonal and normal is

$$\int_{-\infty}^{\infty} \Psi_i \Psi_j \, d\tau = \delta_{ij} = \begin{cases} 0, & i \neq j \\ 1, & i = j \end{cases}$$

(4.B.27)

where i, j = 1, 2, 3, 4 independently, $\delta_{ij} = 1$ when i = j and $\delta_{ij} = 0$ when i \neq j and d τ is the volume element for all space.

Since the 2s, $2p_x$, $2p_y$ and $2p_z$ orbitals are normalized and mutually orthogonal, we may write

$$1 \; = \; \int_{-\infty}^{\infty} (2s)^2 \, d\tau \; = \; \int_{-\infty}^{\infty} (2p_x)^2 \, d\tau$$

$$= \; \int_{-\infty}^{\infty} (2p_y)^2 \, d\tau \; = \; \int_{-\infty}^{\infty} (2p_z)^2 \, d\tau$$

(4.B.28)

and the integral factors of the cross terms are written as

$$\int_{-\infty}^{\infty} (2s)(2p_x) \, dr = 0$$

(4.B.29)

$$\int_{-\infty}^{\infty} (2s)(2p_y) \, dr = 0$$

(4.B.30)

$$\int_{-\infty}^{\infty} (2s)(2p_z) \, dr = 0$$

(4.B.31)

$$\int_{-\infty}^{\infty} (2p_y)(2p_y) \, dr = 0$$

(4.B.32)

$$\int_{-\infty}^{\infty} (2p_x)\,(2p_z)\,dr = 0$$

$$(4.B.33)$$

$$\int_{-\infty}^{\infty} (2p_y)\,(2p_z)\,dr = 0$$

$$(4.B.34)$$

If we let any two ψi's be represented as

$$\Psi_i = a_{1i}\,(2s) + a_{2i}\,(2p_x) + a_{31}\,(2p_y) + a_{4i}\,(2p_z)$$

$$(4.B.35)$$

$$\Psi_j = a_{1j}\,(2s) + a_{2j}\,(2p_x) + a_{3j}\,(2p_y) + a_{4j}\,(2p_z)$$

$$(4.B.36)$$

then we may write

$$\int_{-\infty}^{\infty} \Psi_i \, \Psi_j \, d\tau \;=\; a_{1i} \, a_{1j} \overbrace{\int_{-\infty}^{\infty} (2s)^2 \, d\tau}^{1} \;+$$

$$a_{2i} \, a_{2j} \overbrace{\int_{-\infty}^{\infty} (2p_x)^2 \, d\tau}^{1} \;+\; a_{3i} \, a_{3j} \overbrace{\int_{-\infty}^{\infty} (2p_y)^2 \, d\tau}^{1} \;+$$

$$a_{4i} \, a_{4j} \overbrace{\int_{-\infty}^{\infty} (2p_z)^2 \, d\tau}^{1} \;+\; \underbrace{\text{Cross Terms}}_{\underset{0}{\|}} \;=\; \delta_{ij}$$

(4.B.37)

The result is

$$a_{1i} \, a_{1j} \;+\; a_{2i} \, a_{2j} \;+\; a_{3i} \, a_{3j} \;+\; a_{4i} \, a_{4j} \;=\; \delta_{ij}$$

(4.B.38)

or

$$a_{11}^2 \;+\; a_{21}^2 \;+\; a_{31}^2 \;+\; a_{41}^2 \;=\; 1$$

$$a_{12}^2 \;+\; a_{22}^2 \;+\; a_{32}^2 \;+\; a_{42}^2 \;=\; 1$$

$$a_{13}^2 \;+\; a_{23}^2 \;+\; a_{33}^2 \;+\; a_{43}^2 \;=\; 1$$

$$a_{14}^2 \;+\; a_{24}^2 \;+\; a_{34}^2 \;+\; a_{44}^2 \;=\; 1$$

(4.B.39)

We may show that the coefficients a_{2i}, a_{3i}, a_{4i} are equal to the same value except for the sign. Consistent with experiment we may assume that

the bonds of greatest magnitude are directed towards the corners of a tetrahedran within a cube of arbitrary side length 2 as shown in Figure 4.B.5.

Since the axes for the $2p_x$, $2p_y$, $2p_z$ orbitals are along the X, Y and Z axes, respectively, the formation of a new orbital directed toward the (1,1,1) position of the cube requires that each of the 2p orbitals give equal contribution in order to arrive at this spatial coordinate.

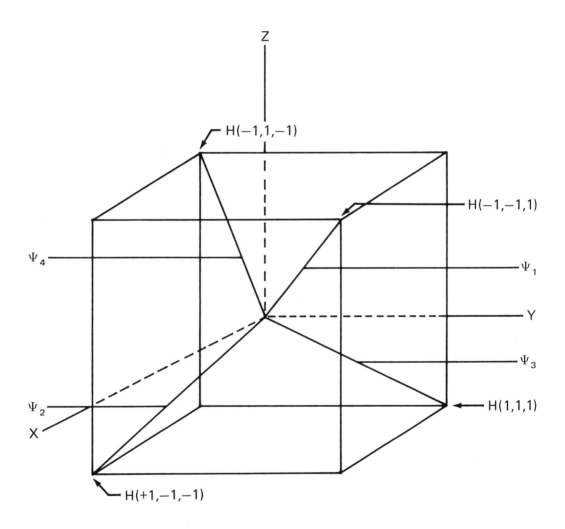

Fig. 4.B.5 *Shows that the bonds of greatest magnitude are directed towards the corners of a tetrahedran within a cube of arbitrary side length 2.*

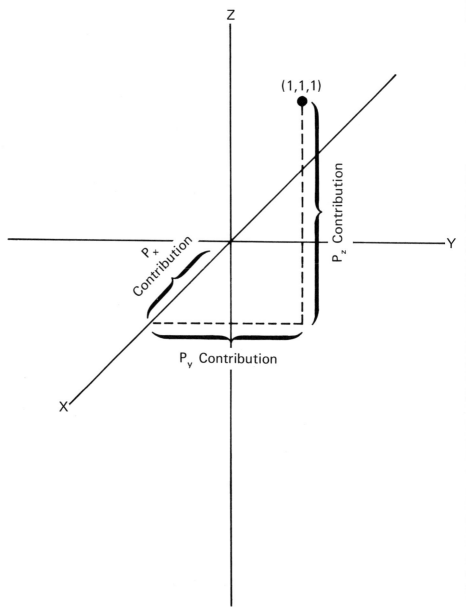

Fig. 4.B.6 *Shows that $a_{21} = a_{31} = a_{41}$.*

If we let $a_{21} = b$, then the normalization condition for ψ_1 can be written as

$$a_{11}^2 \; + \; 3b^2 \; = \; 1$$

(4.B.40)

$$b^2 = \frac{1 - a_{11}^2}{3}$$

(4.B.41)

$$b = \sqrt{\frac{1 - a_{11}^2}{3}}$$

(4.B.42)

Substituting the result of 4.B.42 into equation 4.B.23, we have

$$\Psi_1 = a_{11}(2s) + b(2p_x) + b(2p_y) + b(2p_z)$$

(4.B.43)

Since the coefficients determine the magnitude of the atomic orbital, the sum of the coefficients can be defined as the bond forming strength. Thus the bond forming strength is

$$a_{11} + 3b$$

(4.B.44)

From 4.B.42

$$b = \frac{\sqrt{1 - a_{11}^2}}{\sqrt{3}}$$

(4.B.45)

Utilizing equations 4.B.45 and 4.B.44, we write

$$a_{11} + \frac{3\sqrt{1 - a_{11}^2}}{\sqrt{3}} = a_{11} + \sqrt{3}\sqrt{1 - a_{11}^2}$$

(4.B.46)

Taking the derivative of $a_{11} + \sqrt{3}\sqrt{1-a_{11}^2}$ with respect to a_{11} and setting it to zero to find the maximum a_{11}, we have

$$\frac{d}{d\,a_{11}}\left\{a_{11} + \sqrt{3}\,\sqrt{1 - a_{11}^2}\right\} = 1 + \sqrt{3}\,\frac{1}{2}(1 - a_{11}^2)^{-\frac{1}{2}}(-2a_{11}) = 0$$

(4.B.47)

$$\frac{1}{\sqrt{3}} = \frac{a_{11}}{\sqrt{1 - a_{11}^2}}$$

(4.B.48)

$$\frac{1}{3} = \frac{a_{11}^2}{1 - a_{11}^2}$$

(4.B.49)

$$\frac{1}{3} = \frac{1}{\dfrac{1}{a_{11}^2} - 1}$$

(4.B.50)

$$\frac{1}{a_{11}^2} - 1 = 3$$

(4.B.51)

$$\frac{1}{a_{11}^2} = 4$$

(4.B.52)

Thus

$$a_{11} = 1/2$$

(4.B.53)

Substituting 4.B.53 into 4.B.40 we obtain

$$\frac{1}{4} + 3\,b^2 = 1 \quad \text{or} \quad b = \frac{1}{2}$$

(4.B.54)

Thus we may write

$$\Psi_1 = \frac{1}{2}\left\{(2s) + (2p_x) + (2p_y) + (2p_z)\right\}$$

(4.B.55)

Similarly, we find for the other points on the tetrahedron

$$\Psi_2 = \frac{1}{2}\left\{(2s) + (2p_x) - (2p_y) - (2p_z)\right\}$$

(4.B.56)

$$\Psi_3 = \frac{1}{2}\left\{(2s) - (2p_x) + (2p_y) - (2p_z)\right\}$$

(4.B.57)

$$\Psi_4 = \frac{1}{2}\left\{(2s) - (2p_x) - (2p_y) + (2p_z)\right\}$$

(4.B.58)

The Ψ_i equations above represent sp^3 hybridization.

Appendix 4C
Particle
in a Box

The electronic transitions that are responsible for the absorption of radiation in conjugated molecules such as the cyanine dyes involve the transition energy required to promote a electron to an antibonding state. When the number of conjugated double bonds increases for a given dye system, there is a corresponding bathochromic shift of the absorption maxima.

The treatment of π electrons is based on the premise that these electrons are not localized to a bond position or atom but are free to explore the envelope function of the molecule.

For simplicity, we consider a model where the potential energy outside the envelope of the molecule is infinitely high.

Although simple, this particle-in-the-box model yields results that are satisfactory from the standpoint of a first approximation.

Recalling that

$$H \psi = E \psi$$

$$(4.C.1)$$

where the Hamiltonian contains a kinetic and potential energy term, we have

$$H = \frac{P^2}{2m} + V(X)$$

$$(4.C.2)$$

Substituting, we may write

$$\left\{ \frac{P^2}{2m} + V(X) \right\} \psi = E\psi$$

(4.C.3)

where P is defined as

$$- i\hbar \frac{\partial}{\partial X}$$

(4.C.4)

The boundaries of the box are

$$V(0 < X < a) = 0$$

(4.C.5)

$$V(0) = \infty = V(a)$$

(4.C.6)

The Schrödinger equation representing the region within the box is written as

$$- \frac{\hbar^2}{2m} \frac{\partial^2 \psi}{\partial X^2} = E\psi(X)$$

(4.C.7)

Since V = 0 inside the box, then

$$V(X) = 0$$

(4.C.8)

Looking for a general solution, we assume

$$\psi(X) = A\sin(kX) + B\cos(kX)$$

(4.C.9)

Differentiating twice, we write

$$\frac{d^2\psi}{dX^2} = - k^2(A\sin(kX) + B\cos(kX))$$

(4.C.10)

Applying the 1st boundary condition, we have

$$\psi(X) \ = \ A \sin k X \ + \ B \cos k X$$

(4.C.11)

$$\psi(0) \ = \ A \sin 0 \ + \ B \cos 0$$

(4.C.12)

$$B \ = \ 0$$

(4.C.13)

Applying the second boundary condition, we find

$$0 \ = \ \psi(a) \ = \ A \sin k a \ = \ 0$$

(4.C.14)

$$A \sin k a \ = \ 0$$

(4.C.15)

$$\sin k a \ = \ 0$$

(4.C.16)

therefore

$$k \ = \ \frac{n\pi}{a} \quad \text{where} \quad n \ = \ 1, 2, 3, \dots$$

(4.C.17)

Since

$$\sin \pi \ = \ \sin 2\pi \ = \ \sin n\pi \ = \ 0$$

(4.C.18)

where n = 1, 2, 3, then

$$\sin ka \ = \ 0 \quad \text{when} \quad k \ = \ \frac{n\pi}{a}$$

(4.C.19)

where n = 1, 2, 3, and because sin nπa/a = sin nπ

$$\psi\,(X) \;=\; A \sin \frac{n\pi}{a}\, X$$

(4.C.20)

Taking the first derivative

$$\frac{d\,\psi}{d\,X} \;=\; \frac{n\pi}{a}\, A \cos \frac{n\pi}{a}\, X$$

(4.C.21)

Taking the second derivative

$$\frac{d^2\,\psi}{d\,X^2} \;=\; -\,\frac{n^2\,\pi^2}{a^2}\, A \sin \frac{n\pi}{a}\, X$$

(4.C.22)

Substituting equations 4.C.20 and 4.C.22 into equation 4.C.7, we may write

$$\frac{-\,\hbar^2}{2_m}\;\frac{-\,n^2\,\pi^2}{a^2}\,A \sin \frac{n\pi}{a}\, X \;\bigg|\;=\; E\,A \sin \frac{n\pi}{a}\, X$$

(4.C.23)

Simplifying, we have

$$E_n \;=\; \frac{n^2\,\pi^2\,\hbar^2}{2\ ma^2}$$

(4.C.24)

where

$$\hbar \;=\; \frac{h}{2\pi}$$

(4.C.24a)

and the subscript n indicates that E is a function of n.

$$E_n = \frac{n^2 \pi^2 \frac{h^2}{4\pi^2}}{2\ ma^2}$$

(4.C.25)

$$E_n = \frac{n^2 h^2}{8\ ma^2}$$

(4.C.26)

Therefore the energies of the solutions representing the wave functions for this idealized particle-in-the-box model are

$$E_n = \frac{n^2 h^2}{8\ ma^2}$$

(4.C.27)

$$E_n = \frac{hC}{\lambda_n}$$

(4.C.28)

$$E_{max} = E_{n_2} - E_{n_1} = \frac{hC}{\lambda_{max}}$$

(4.C.29)

$$\lambda_{max} = \frac{8\ ma^2 C}{(n_2^2 - n_1^2)h}$$

(4.C.30)

where
m = 9.1×10^{-28} erg sec^2/cm^2
a = linear length of molecule
c = 2.9×10^{10} cm/sec
h = 6.6×10^{-27} erg sec

EXERCISE

> Given a conjugated molecular system containing eight carbon atoms which can be described by sp^2 hybridization if a = 9.5 x 10^{-8} cm, using the values of m, c, h given previously, calculate the λ_{max} for this system.

The amidinium ion system of the cyanine dyes having the two resonance forms of Figures 4.2.15 and 4.2.16 have the same energy. A very useful assumption is that the π electrons in the long conjugated chain of these molecules move along the chain in an approximately constant potential field. [Ref: N.S. Bayliss, *Quant. Revs (London)*, **6**, 319 (1952); H. Kuhn, *J. Chem. Phys.*, **17**, 1198 (1949); W.T. Simpson, *J. Chem. Phys.*, **16**, 1124 (1948).]

Analysis of the structure of Figure 4.2.15 shows that $2N\pi$ electrons are contained in the N double bonds plus the 2π electrons of the neutral nitrogen atom. Since this system has a total of $2(N + 1)\pi$ electrons, these π electrons in each of the N + 1 molecular orbitals are paired, i.e., 2 paired π electrons in each orbital.

Kuhn assumed that the total length L through which the π electrons are free to move from one end of the conjugated chain to the other is composed of the sum of the individual bond lengths between each carbon atom plus the sum of the bond lengths before and after each nitrogen atom.

Due to the conjugation and delocalization of electrons (Figures 4.2.15 and 4.2.16), the bond character is analogous to the bond length in the benzene ring.

Thus Kuhn [Ref: H. Kuhn, *J. Chem. Phys.*, **17**, 1198 (1949)] used a bond length of 1.39 Å for the calculation of L, and we may write

$$L = 2(N + 1) \ 1.39\text{Å}$$

(4.C.31)

The potential field that the π electrons explore is taken to be zero in the interval

$$0 < X < L$$

(4.C.32)

and infinity

$$X < 0$$

$$X > L$$

(4.C.33)

In other words, these π electrons move along a one-dimensional box of length L with infinitely high walls of potential energy barrier (Figure 4.C.1).

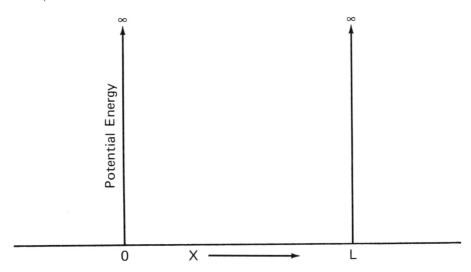

Fig. 4.C.1

Shows the potential curve for the π electrons confined to a one dimensional box of length L.

The one dimensional molecular orbitals $\psi(X)$ and the energy states E inside the box result from the solution of the Schrödinger equation 4.C.7.

EXERCISE

Verify by substitution that equation 4.C.9 is the solution to equation 4.C.7.

Using equation 4.C.20 where both $\psi(X)$ and E are a function of n, we write

$$\psi_n(X) \quad = \quad A \sin(n\pi X/L)$$

(4.C.34)

and using equation 4.C.26, we have

$$E_n = \frac{n^2 \; h^2}{8 \; mL^2}$$

(4.C.35)

The value of A can be found from the normalization requirement

$$\int_0^L \left| \psi_n \, (X) \right|^2 \; d \, X = 1$$

(4.C.36)

Substitution of equation 4.C.34 into equation 4.C.36 results in

$$A^2 \int_0^L \sin^2 (n\pi X/L) \; d \, X = 1$$

(4.C.37)

After integration, we have

$$A^2 \left(\frac{L}{2} \right) = 1$$

(4.C.38)

or

$$A = \left(\frac{2}{L} \right)^{1/2}$$

(4.C.39)

Thus the molecular orbitals are written as

$$\psi_n \ (X) \ = \ \left(\frac{2}{L}\right)^{\frac{1}{2}} \ \sin \ \left(\frac{n\pi \ X}{L}\right)$$

(4.C.40)

where n = 1, 2, 3 . . . ,N + 1 for the doubly occupied molecular orbitals, and n = N + 2, N + 3, . . . , for the unoccupied molecular orbitals or excited states.

Absorption of radiation may occur for the transition

$$N \ + \ 1 \rightarrow N \ + \ 2$$

(4.C.40a)

The change in energy for this transition is

$$\Delta E \ = \ E_{N+2} \ - \ E_{N-1} \ = \ \frac{(N+2)^2 h^2}{8mL^2} \ - \ \frac{(N+1)^2 h^2}{8mL^2}$$

(4.C.41)

Substituting equation 4.C.31 into equation 4.C.41, we write

$$\Delta E \ = \ \frac{h^2}{8m} \left\{ \frac{(N+2)^2 \ - \ (N+1)^2}{4(N+1)^2 \ (1.39 \times 10^{-8})^2} \right\}$$

(4.C.42)

Expanding the numerator of equation 4.C.42, we have

$$\Delta E \ = \ \frac{h^2 \ (2N+3) \ 10^{16}}{m \ 61.8 \ (N+1)^2}$$

(4.C.43)

In Cgs. units ΔE becomes

$$\Delta E \ = \ \frac{h^2 \ (2N+3) \ 10^{16}}{9.11 \times 10^{-28} \ \times \ 61.8 \ (N+1)^2}$$

(4.C.44)

Using relation 4.C.29, we write

$$\frac{h\ C}{\lambda_{max}} = \frac{h^2\ (2N+3)\ 10^{16}}{9.11\ \times\ 10^{-28}}$$

(4.C.45)

and

$$\lambda_{max} = \frac{9.11\ \times\ 10^{-28}\ \times\ 61.8\ (N+1)^2\ \times\ 3\ \times\ 10^{10}}{6.63\ \times\ 10^{-27}(2N+3)\ 10^{16}}$$

(4.C.46)

Converting to nanometers, we write $(10^{-7}\ cm = 1\ nm)$

$$\lambda_{max} = 255\ \frac{(N+1)^2}{(2N+3)}\ nm$$

(4.C.47)

Equation 4.C.47 is related to the structure of Figure 4.2.15 depicted on page 395. The value of N is equal to the number of double bonds in the amidinium ion system. When λ_{max} is calculated by the use of equation 4.C.47 the results are very close to the measured values.

This method of calculating λ_{max} is restricted to linear chains and provides a good first approximation for these systems. The perturbations caused by nuclei and the atoms other than carbon in the nuclei of cyanine dyes are neglected by this calculation.

The concept of tunneling is a further application of a particle in a box where the walls are considered finite.

Since tunneling plays a part in photographic development and in the dye sensitization process the particle in a box gives insight and preparation for the more complicated finite wall problem.

During the initiation period of photographic chemical development it is useful to hypothesize that electrons tunnel through a charge barrier surrounding the silver halide crystal. Depending upon the nature of the chemical agents, pH and type of emulsion system this barrier function approaches zero during development. Silver aggregates formed during latent image formation are responsible for depression in the barrier function in the neighborhood of these atom aggregates. Probabilistically we

expect a greater population of electrons to tunnel through regions where the barrier function has been depressed due to latent image formation.

The resulting energy transfer as a function of tunneling continues to reduce the barrier with a corresponding increase in the rate of development. Finally, as the process shifts to the diffusion limiting process and the developing agent is easily adsorbed to the silver halide, we think of a semisolid state condition as described in both Section 3 of Chapter 1 and in Section 4 of Chapter 4.

Now we may ascribe a quasi Fermi level to silver aggregates as a function of the number of atoms of silver contained per aggregate. As the aggregate becomes large relative to the bulk material the change in chemical potential between these quantities approaches zero. This type of thinking may lead to an experiment where the number of photons absorbed per grain on the average in order to render the grain developable, and the corresponding change in chemical potential as the developable aggregate grows (according to Section 2 of Chapter 2) may be utilized to establish a functional equivalence between these quantities and the output optical transmission density.

5 Color Coupling

This chapter treats the mechanism and kinetics of color coupling.
Appendices include a list of color couplers and developing agents.

5.1 Introduction

Early in the chemistry of dye coupling it was believed that the semiquinone molecule of the coupler coupled with oxidized developing agent to form the dye. In the 1940's, Michaelis, Mees and others began to gather evidence that a quinonediimine was present prior to the formation of the dye.

A series of classical papers done independently by L.K.J. Tong and M.C.Glesmann [Ref: L.K.J.Tong and M.C.Glesmann, *J. Am. Chem. Soc.,* **79**, 583 (1957)–Paper read at the International Conference for Scientific Photography, Cologne, Germany, Sept. 24-27 (1956)], and J. Eggers and H. Frieser [Ref: J. Eggers and H. Frieser, *Z. Elektrochem.,* **60**, 372 (1956)] conclusively established the modern concepts of the mechanism and kinetics of dye formation. Other studies [Ref: S. Hunig and P. Richters, *Ann. Chem.,* **612**, 282 (1958)] showed a relationship between the half-wave potential of the reversible redox reaction of the N,N-dialkylparaphenylenediamine and the wavelength of maximum absorption of the dye formed from the N,N-dialkyl PPD and the coupler.

This chapter discusses the subtractive method of color formation and includes a discussion of dye formation which leads the reader to an understanding of color coupling in terms of the quinonediimine intermediate.

This chapter concludes with a derivation of the functional relationship between the half-wave potential and the λ_{max} for organic compounds.

The chapters on thermodynamics and organic chemistry that support Chapter 5 have been written in sufficient detail to act either as review material or as new material for the reader. The reader who has never studied these disciplines should find it possible to comprehend these chapters and apply them to Chapter 5.

The method of abstracting and expanding the more profound papers of color coupling was chosen to enable the reader to achieve a high degree of competence in understanding and reading the literature. The authors

have attempted to remove the stumbling blocks which plague the average reader.

There are three principal methods by which colored images may be produced photographically. These are the Polaroid or diffusion transfer process, the dye bleach process, and multilayer negative or reversal color processes. The dye bleach process and the Polaroid process are not treated in this textbook. The majority of reversal films use incorporated couplers in the emulsion and a single color development. The latter of these processes depends on the formation of dyes by the oxidation of AgBr and subsequent coupling of oxidized developing agent with the appropriate dye former. Multilayer processes depend on the production of dyes in fixed layers. The chemistry of dye formation is treated in this chapter, and the method of forming a color image is illustrated by an incorporated coupler reversal type process.

Each emulsion layer must be sensitized individually to red, green or blue, and the processing of this emulsion must be established in the appropriate layer with minimal sideways wandering. The reaction that produces the dyes must be proportional to the amount of developed silver, and the dye forming reaction must be free from colored by-products or by-products that will produce color upon storage. The dyes formed must be stable. The method of forming the appropriate color in this process is dependent on the subtraction of unwanted colors.

The term *"color"* must be carefully defined in order to avoid the indiscriminate use of this term. Two observers may look at a color reflected from a surface but they may not be able to match this color when they are asked to choose the same color from a graded series of colors from which the original color was chosen. This experiment is most easily performed by placing a colored sample into a colorimeter (where the illumination is carefully controlled) so that one-half of the viewing field is represented by the sample and the remaining half can be varied by means of a dial to produce a visual color match (Figure 5.1.1).

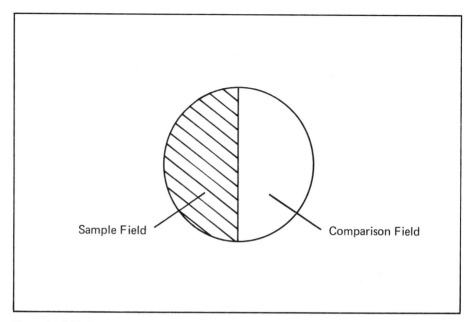

Sample Field Comparison Field

Fig. 5.1.1 *Shows the field that an observer sees when*
 looking into a colorimeter.

When a large number of observers attempt to obtain a color match, an average reading is obtained. This average reading then defines a particular color based on the original colors introduced into the machine.

This method of defining color is a useful operational scheme that enables observers to match and categorize colors.

Therefore this text takes the position that when matter is illuminated, its intrinsic properties give rise to reflected or transmitted radiation which appears to viewers to have a particular color. This color is a condition of operational agreement in the above sense among many observers. For further amplification of colorimetry see *Handbook of Colorimetry*, A.C. Hardy, The Technology Press, Mass. Inst. of Technology, Cambridge, Mass. 1936, and Bell Telephone System Monograph 1910, *Color Television and Colorimetry* by W.T. Wintringham published in Proceedings of the Institute of Radio Engineers, Vol. 39, pp 1135-1172 October 1951.

The subtractive color process utilizes three primary colors: yellow, magenta and cyan (see Figure 5.1.2). The sensation of yellow (red + green) is achieved when blue light is subtracted from a white light source. In a similar way when green light is subtracted, the observer sees magenta (red + blue). If red light is subtracted, the result is cyan (blue + green).

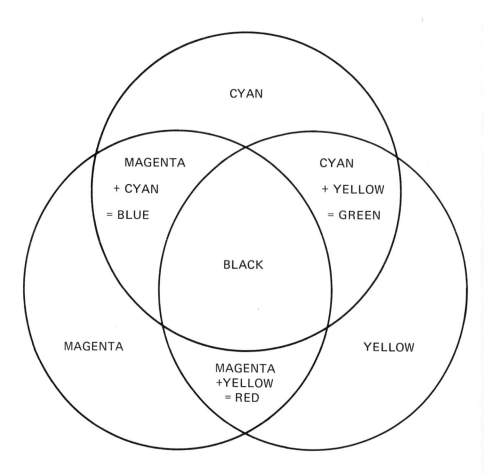

Fig. 5.1.2 *Shows subtractive primaries and how they*
combine to produce red, green, blue and
black.

Another way of producing these colors is to add combinations of red, green and blue additive primaries.

If a red light is projected together with a green light onto a screen, the observer sees a yellow color. The projection of red and blue onto a screen produces magenta. The projection of green and blue onto a screen produces cyan.

Finally, if red, green and blue are projected at the same spot on the screen, the observer sees white (see Figure 5.1.3).

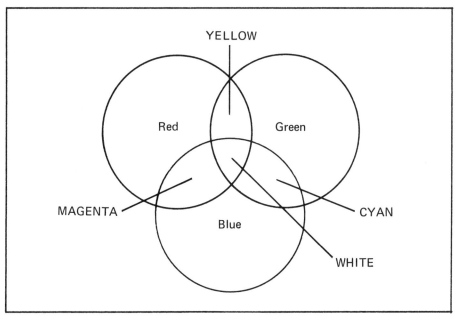

Fig. 5.1.3 *Additive mixture of red, green and blue*
colored light.

If a yellow filter is placed over a surface, it will absorb blue light and transmit red and green (see Figure 5.1.4).

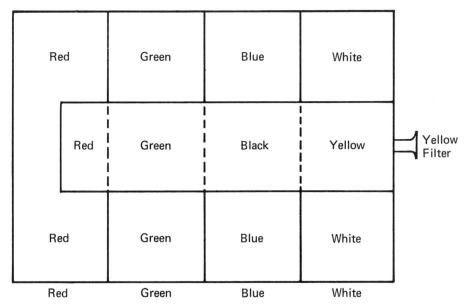

Fig. 5.1.4 *Shows a yellow filter absorbing blue radi-*
ation while transmitting the green and red.

Similarly, if a magenta or cyan filter is substituted for the yellow filter in Figure 5.1.4, we have the results as shown in Figures 5.1.5 and 5.1.6.

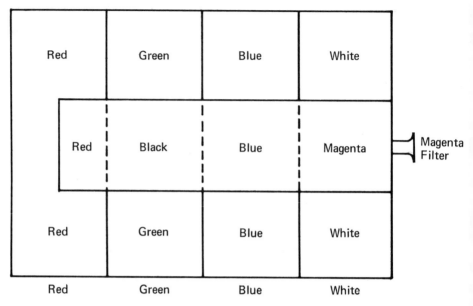

Fig. 5.1.5 *A magenta filter shown absorbing green while transmitting red and blue radiation.*

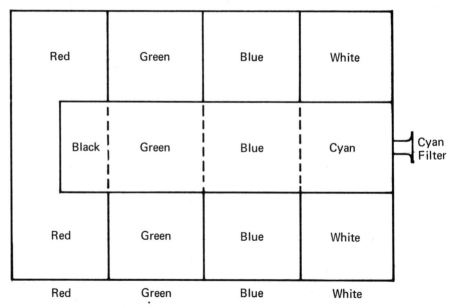

Fig. 5.1.6 *Shows a cyan filter absorbing red while transmitting green and blue.*

The subtractive primary yellow, which is produced by subtraction of radiation between 400 and 500 nm, is shown schematically as an ideal yellow dye in Figure 5.1.7.

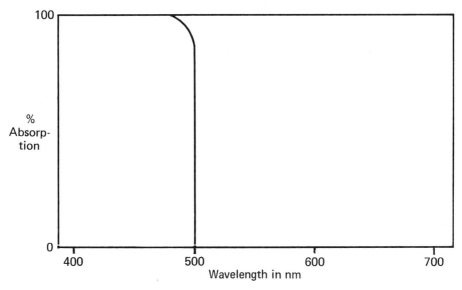

Fig. 5.1.7 *The absorption spectrum of an idealized*
 yellow dye.

Similarly, Figures 5.1.8 and 5.1.9 characterize idealized magenta and cyan dyes.

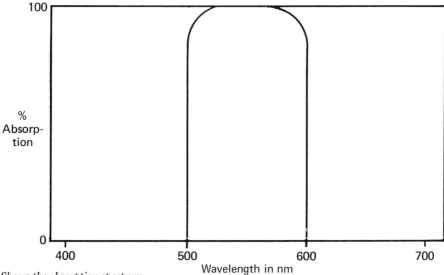

Fig. 5.1.8 *Shows the absorption spectrum*
 of an idealized magenta dye.

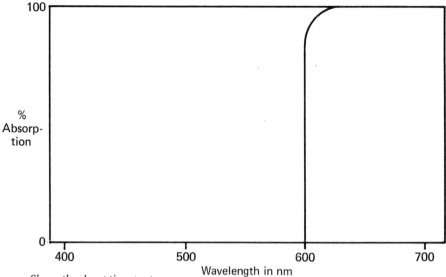

Fig. 5.1.9 *Shows the absorption spectrum*
of an idealized cyan dye.

The curves shown in Figures 5.1.7, 5.1.8 and 5.1.9 are idealized to the extent that they show the radiation absorbed very sharply between 400 to 500 nm, 500 to 600 nm, and 600 to 700 nm, respectively.

The absorption curves for real photographic dyes are shown in Figures 5.1.10, 5.1.11 and 5.1.12. These curves of typical dyes were obtained with a Bausch & Lomb 505 spectrophotometer.

These dyes were produced by coupling Kodak CD-3 color developing agent with typical dye couplers (2′, 5′—Dichloro-acetoacetanilide, yellow coupler; 2,4—Dichloro—1—naphthol, magenta coupler; P—Nitrophenyl acetonitrile, cyan coupler) using Kodak aerographic duplicating film.

The yellow dye shows an absorption maximum of 450 nanometers for steps 2, 6, and 11 for a yellow dyed sensitometric strip.

The magenta dye shows an absorption maximum of 520 nanometers for steps 3, 6, and 9.

The cyan dye exhibits an absorption maximum at 640 nanometers for steps 5, 9, and 11.

Fig. 5.1.10 Shows the actual absorption spectrum 2',5'—dichloroacetoacetanilide with the
 of a yellow dye produced by coupling developing agent CD-3.

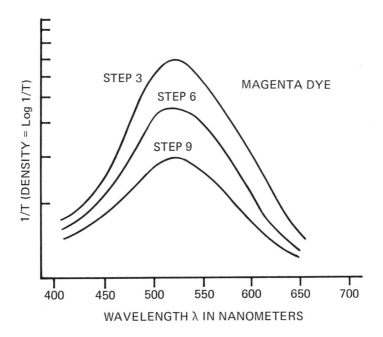

Fig. 5.1.11 The actual absorption spectrum 2,4—dichloro—1—naphthol with the
 of a magenta dye produced by coupling developing agent CD-3.

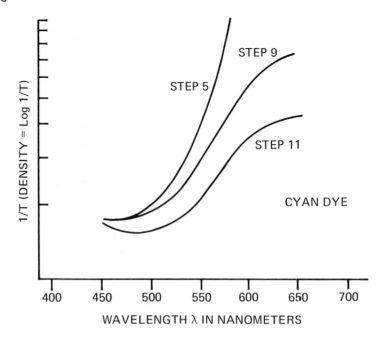

Fig. 5.1.12 *The actual absorption spectrum of a cyan*
dye produced by coupling P–nitrophenyl
acetonitrile with the developing agent CD-3.

Typically, a multilayer color reversal process can be represented by the following:

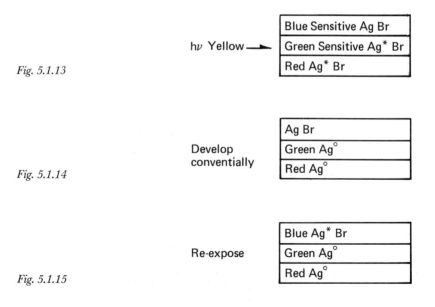

Fig. 5.1.13

Fig. 5.1.14

Fig. 5.1.15

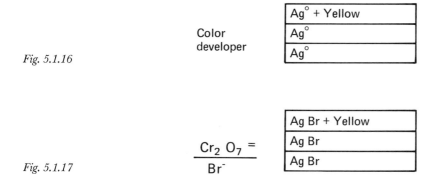

Fig. 5.1.16

| Ag° + Yellow |
| Ag° |
| Ag° |

Color developer

Fig. 5.1.17

| Ag Br + Yellow |
| Ag Br |
| Ag Br |

$$\frac{Cr_2 O_7 \,^=}{Br^-}$$

The dichromate ion oxidizes the silver metal, forming silver ions, which then react with the bromide ion, reforming silver bromide.

Fig. 5.1.18

$Na_2S_2O_2$
(Silver Halide Solvent

| Yellow |
| Clear |
| Clear |

If we expose to red and blue light (magenta), simultaneously, we have

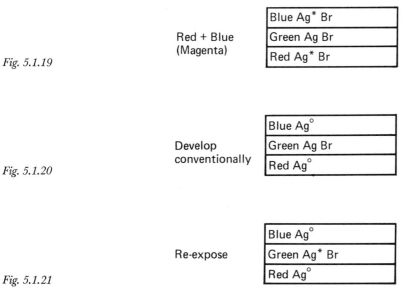

Fig. 5.1.19

Red + Blue (Magenta)

| Blue Ag* Br |
| Green Ag Br |
| Red Ag* Br |

Fig. 5.1.20

Develop conventionally

| Blue Ag° |
| Green Ag Br |
| Red Ag° |

Fig. 5.1.21

Re-expose

| Blue Ag° |
| Green Ag* Br |
| Red Ag° |

* radiation activated silver

Ag°
Ag° + Magenta
Ag°

Color
Develop

Fig. 5.1.22

Ag Br
Ag Br + Magenta
Ag Br

$$\frac{Cr_2O_7^{=}}{Br^{=}}$$

Fig. 5.1.23

Clear
Magenta
Clear

$Na_2S_2O_3$
(Silver Halide
Solvent)

Fig. 5.1.24

The exposure of the multilayer sensitized material to blue and red radiation affects the blue and red sensitive areas. Subsequent processing in a conventional developer containing metol, hydroquinone or other such developing agents yields a black and white negative record.

The film is washed and re-exposed to light, which activates the remaining silver bromide. The activated silver bromide is reduced with a color developer, usually N,N-diethyl–p–phenylenediamine, in the presence of a color former.

The amount of activated silver bromide in the emulsion is directly proportional to the amount of dye formed in the reaction:

$$C_2H_5 \diagdown N \diagup C_6H_4 - NH_2 + \text{Color Coupler} + 4\,Ag^*Br$$
$$\longrightarrow \text{Dye} + 4\,Ag° + 4\,Br^-$$

(5.1.1)

Reaction 5.1.1 is illustrated for a color coupler that requires four equivalents of AgBr (4-equivalent coupler). Some couplers require only two equivalents of AgBr (2-equivalent coupler).

Since a different color coupler is used for each layer of the emulsion, the color image is formed at this point in the process, but the presence of metallic silver veils the colors until it is removed. In the next step, dichro-

mate and bromide solution is used such that the dichromate can oxidize the silver metal, thus forming silver ions. These ions then quickly react with the available bromide ions, forming silver bromide. Finally, a silver halide solvent such as sodium thiosulfate is used to treat the film, removing the silver bromide by forming a water soluble complex and allowing us to view the colored image.

The sensitivity of a primitive unsensitized emulsion (U.V. & Blue) composed of silver halide crystals can be extended easily to the green and red region by the use of sensitizing dyes. These sensitizing dyes absorb radiation and transfer energy to the silver halide (see Chapter 4—Dye Sensitization).

Similar to black & white emulsions, sensitized silver salts are precipitated in the presence of gelatin. Following the predetermined prescriptions, three separate emulsions are prepared. These emulsions are coated as separate layers in order to analyze a scene into its three color components.

Typically, a cross section of a color photographic material is schematically shown in Fig. 5.1.25.

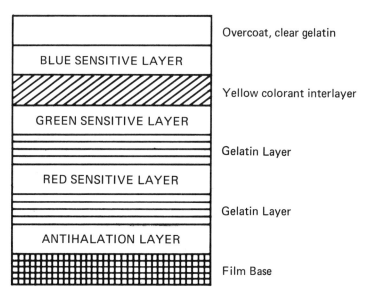

Fig. 5.1.25 The cross section of a typical multilayer color film.

The yellow filter (colorant) prevents blue light from reaching the green and red layers. The yellow colorant is dissolved during processing.

Exposure of these emulsions produces a color negative or positive, depending on the processing procedure.

Oxidative condensation or coupling, as described by R. Fisher [German Pat. 253,335 (Nov. 12, 1912), R. Fisher] in 1912, is characteristic of the majority of subtractive color processes.

The process of dye formation may involve couplers that are incorporated into the emulsion, such that a single color developer can produce the three dye images. In another case, the developers and the couplers are incorporated in three different processing solutions, one for each dye image.

To ensure success for this process, the color forming reactions must be constrained by the requirements for permanence or stability of the dyes, reproducibility, yield, color rendition relative to the original scene and rate of reaction.

5.2 Color Coupling Chemistry

Many of the color coupling reactions involve couplers which have an active methylene or methine group. This group is shown in the dotted lines below:

Fig. 5.2.1

where

Fig. 5.2.2

The R and R' groups attached to the methylene group (Figure 5.2.1) must have sufficient electron attractive power to cause the formation of the following ion (Figure 5.2.3) in alkaline media such that it can couple with the color coupler to form a dye.

Fig. 5.2.3

The active methylene group can be schematically derived from methane (Figure 5.2.4).

Fig. 5.2.4

The structure shown in Figure 5.2.1 can be drawn using dots instead of the lines for representing paired electron bonds (Figure 5.2.5).

Fig. 5.2.5

Prior to any coupling reaction, the quinonediimine intermediate is formed (to be discussed in detail later in the chapter). The formation of the quinonediimine intermediate is shown in equation 5.2.1.

$$C_2 H_5$$

$$\ddot{N}\!-\!\!\langle\ \rangle\!-\!\ddot{N}H_2 \ + \ 2\ Ag^* \ Br$$

$$C_2 H_5$$

$$\longrightarrow \ 2\ Ag^\circ \ + \quad \overset{C_2 H_5}{\underset{C_2 H_5}{>}}\overset{\oplus}{N}\!=\!\!\langle\ \rangle\!=\!\ddot{N}H \ + \ 2\ Br$$

coupling point

Quinonediimine

(5.2.1)

The quinonediimine molecule resonates between the equivalent forms:

(5.2.2)

The arrows show how the double bonds move back and forth between the two extreme forms (a) and (b). Actually the positive charge + spends some time at all the points of the benzene ring. However, the fact that this molecule couples at the hydrogen substituted nitrogen (shown with the + charge in form (b) of equation 5.2.2) with nucleophilic groups (groups attracted to positive ions) implies at least that the hydrogen atom is easier to eliminate at the hydrogen substituted nitrogen. A complete theoretical treatment is beyond the scope of this book.

When the R groups have sufficient electron attracting power, one of the hydrogens leaves as H^+ ion (in alkaline media), leaving the negatively charged ion shown in Figure 5.2.6.

2 paired electrons

Fig. 5.2.6

Fisher introduced a concept of using N,N-dialkyl-p-phenylenediamines as useful developing agents whose oxidation products in conjunction with a dye coupler formed dyes in proportion to the amount of exposure to a given spectral region.

Diethylparaphenylenediamine (see Figure 5.2.7) is a developing agent that

Fig. 5.2.7

reacts with 4 silver bromide molecules and a coupler to form a dye at the active group shown in Figure 5.2.8.

Fig. 5.2.8

Considering a typical yellow dye coupler, $RCOCH_2CONHR$ (Figure 5.2.9), diphenylacylacetamide, and a specific developing agent, N,N—diethyl—p—phenylenediamine (Figure 5.2.10), the overall reaction can be written as (neglecting Ag^+ ion) shown in equation 5.2.3.

Yellow
Dye
Coupler

Fig. 5.2.9

Developing
Agent

Fig. 5.2.10

Reacting the molecules shown in Figures 5.2.9 and 5.2.10 together, we form Yellow dye.*

Dye
Coupler

Developing
Agent

Yellow Dye

* Where the dotted rectangles represent the coupling points. (5.2.3)

In a similar manner, the N,N—diethyl—p—phenylenediamine reacts with a—naphthol:

$$(5.2.4)$$

to form Cyan dye of the indoaniline class.

Another example is when $COCH_2C = N -$ is part of a ring called pyrazolone. The pyrazolone shown in Figure 5.2.11 is 1-phenyl-3-methylpyrazolone.

Where

Fig. 5.2.11

PYRAZOLONE

Fig. 5.2.12 *Shows the Magenta dye coupler portion or group in the form of the ring that is more common.*

The reaction of the Magenta coupler with the developing agent (equation 5.2.5) to form Magenta dye follows:

COUPLER + DEVELOPING AGENT

MAGENTA DYE

(5.2.5)

Variations of the reactions cited by Fisher involve couplers that contain various substituents in the coupling position. If the substituents are alkoxy, sulfo, halogens, etc., they are eliminated during dye formation. For a comprehensive listing of Dye Couplers and Developing Agents see Appendices 5A, B, C and D.

QUINONE
DIIMINE (QDI)

COUPLER

INTERMEDIATE
LEUCO DYE

DYE

(5.2.6)

Equation 5.2.6 is an example of a two equivalent reaction where X is a substituent such as CH_3O^-, Cl^-, $SO_3^=$, Br^- [Ref: G. W. Sawdey, M. K. Ruoff, and P. W. Vittum, *J. Amer. Chem. Soc.*, **73**, 4947 (1950)] etc., which can be eliminated as an anion. In such color coupling reactions, 2 equivalents of oxidant are always used to oxidize the developing agent to quinonediimine.

If the coupler contains a substituent, at the coupling position, designated as X as shown in equation 5.2.6, which can be eliminated as an anion, then no further oxidation is required for dye formation.

The sequential elimination of the anion and a positive hydrogen ion balances the electronic charge so that further oxidant is not required. This type of dye forming reaction is called a two-equivalent reaction.

Another example of a two-equivalent coupling reaction is

COUPLER QDI INTERMEDIATE

(5.2.7)

+ HCl

(5.2.8)

If the coupler has an H in place of a Cl, then the H is eliminated as H^+. Since another hydrogen is eliminated as H^+ (from the nitrogen which couples), then a total of 2 positive charges are eliminated during the formation of the dye.

Elimination of both hydrogens as $2H^+$ is accomplished by addition of 2 more equivalents of oxidizing agent which gain 2 electrons in the process.

An example of the 4-equivalent coupling reaction is

COUPLER + (QDI) → INTERMEDIATE

(5.2.9)

OXIDIZING AGENT

OXIDIZING AGENT

INTERMEDIATE DYE → DYE + 2H⁺ + 2 Electrons

Removed by 2 equivalents of oxidizing agent

(5.2.10)

When considering the kinetics of reactions 5.2.6 through 5.2.10, it is very important to distinguish between the two and four-equivalent cases. The kinetics of these reactions will be considered later in this chapter.

Color-forming photographic products based on oxidative coupling chemistry impose severe requirements on the couplers. Incorporated coup-

lers must be compatible with the emulsion system, must not diffuse, and must form dyes that do not diffuse. Couplers used in Ansco Color, Ansco-chrome (General Aniline and Film Corp.), Gevacolor (Gavaert Ltd.), Adox Color (C. Schleussner Fotowerke GmbH), Agfa Inc. color-reversal and color-negative products, Ferraniacolor (Ferrania SPA), are water soluble due to a hydrophilic group, i.e., COOH and SO_3H, maintaining non-diffusibility by addition of a long aliphatic chain.

Eastman Kodak Co. incorporates non-diffusible couplers by use of combinations of aromatic systems and short aliphatic chains or long aliphatic chains. By use of non-polar solvents, these couplers become evenly dispersed in small hydrophobic globules throughout the respective emulsion layers.

For many years the exact course of the coupling reactions was unknown. The following section will discuss the most probable reactions that occur during color coupling.

The rate controlling factors and competing reactions will also be considered.

Relations between λ_{max}, half-wave potential, and ionization potential of the dyes and the developing agents will be discussed in the latter portion of the chapter. Properties of color developing agents and their effects on the hue of the dye, substituents choice and their effect on hue will be discussed at the end of this chapter, with supporting organic chemistry developed in Chapter 4.

5.3 Important Reactions

Oxidative condensation reactions as depicted by equation 5.2.3, 5.2.4 and 5.2.5 can be schematically written as:

Fig. 5.3.1

The reaction of N,N–dialkylanilines with couplers containing active groups as shown in Figure 5.3.1 is complex when silver ions are used as the oxidant. This multiple phase system is best described by a heterogeneous reaction (see Equation 5.3.1).

When ferricyanide is used as an oxidizing agent in place of silver halides, then the coupler reacting with the oxidized form of the dialkylaniline type developing agent can be considered as a *homogeneous reaction*. [Ref: L.K.J. Tong and M.C. Glesmann, *J. Amer. Chem. Soc.*, **79**,583 (1957)] (see Equation 5.3.2).

$$[PPD + Coupler + Ag^+ \rightarrow DYE + Ag^\circ] \text{ HETEROGENEOUS REACTION}$$

$$(5.3.1)$$

$$[PPD + Coupler + Ferricyanide \rightarrow DYE] \text{ HOMOGENEOUS REACTION}$$

$$(5.3.2)$$

Previous research where silver halide was utilized as the oxidizing agent has been reported by other investigators. [Ref: P.W. Vittum and A.

Weissberger, *J. Phot. Sci.*, **2**, 81 (1954); K.S. Lyalikov, B.A. Tsarev, Ya. Lileibov, and V. N. Kurnakov, *Otd. Khim. Nauk*, **2**, 38 (1954)].

L.K.J. Tong and M. Glesmann used ferricyanide as the oxidant in their experiment in order to maintain homogeneity of the reaction. These are very fast reactions that cannot be studied using standard techniques. Tong utilized the flow machine designed by Ruby, for rapid reactions [Ref: W.R. Ruby, *Rev. Sci. Instruments*, **26**, 460 (1955)].

The oxidation of the developing agent takes place in two separate steps as shown in reaction 5.3.3.

$$\text{Developing Agent} - e \rightarrow \text{Semiquinone} - e \rightarrow \text{Quinonediimine}$$

(5.3.3)

The developing agent loses one electron, producing the semiquinone. The semiquinone loses an electron and the quinonediimine is produced as follows:

(5.3.4)

A = N, N—diethyl paraphenylenediamine
B = semiquinone
C = quinonediimine

Michaelis [Ref: L. Michaelis, *Ann. N.Y. Acad. Sci.*, **40**, 39 (1940)] studied the two-step oxidation of paraphenylenediamines, where the semiquinone is produced upon the removal of one electron and where the quinonediimine is produced after the removal of the second electron.

We ask the following question: Is the *semiquinone* or the *quinonediimine* (QDI) involved in the coupling rate reactions? The answer will be found in the development of this section.

The following coupling reaction (see Chapter 4, Dimerization) is possible for the semiquinone:

$$(5.3.5)$$

The formation of the semiquinone dimer on the right side of equation 5.3.5 depends upon the concentration of the semiquinone in solution.

The higher the concentration of semiquinone in solution, the higher the probability for a favorable collision which will result in equation 5.3.5. In order to minimize the formation of this dimer, it is necessary to use dilute solutions. In order to determine whether the semiquinone or quinonediimine is involved in the oxidative condensation (coupling) reaction, it is necessary to study the dismutation reaction where

$$2B \;=\; A + C$$

$$(5.3.6)$$

$$(5.3.7)$$

The dismutation reaction is highly pH dependent. In acid media, the resonance (see Chapter 4, Organic Chemistry) between the two equivalent forms stabilizes the molecule from dismutating, as seen in 5.3.8.

:NH₂ ⊕.NH₂

⊕.N(CH₃)₂ :N(CH₃)₂

$$(5.3.8)$$

Above pH of eight studies [Ref: L.K.J. Tong, *J. Phys. Chem.* 58, 1090 (1954)] show dismutation is almost instantaneous and complete.

Another reaction which occurs at high pH or when the coupler is non-reactive is the deamination reaction 5.3.9. This reaction is irreversible and competes with the coupling reaction (sulfonation is another important competing reaction, see Section 2.1).

:NH :NH

+ OH⁻ ⟶ + HN̈(CH₃)₂

⊕ N(CH₃)₂ O

QUINONEDIIMINE QUINONEMONOIMINE

DEAMINATION REACTION

$$(5.3.9)$$

Equation 5.3.9 is a deamination reaction. (The amine group is replaced by an oxygen atom and coupling is no longer possible.)

This reaction must be borne in mind to prevent the experimenter's coming to false conclusions.

Therefore, the first thing that must be established is a study of the deamination reaction and how it competes with the coupling reaction.

In order to study both the deamination reaction and the coupling reaction, the following assumptions were made by L.K.J. Tong and M.C. Glesmann [Ref: *J. Amer. Chem. Soc.*, 79, 583 (1957)].

1. Ferricyanide oxidizes the developing agent to QDI, if added in stoichimetric quantity.

2. The coupling rate is proportional to either the semiquinone concentration or to the QDI concentration.

The first assumption is well supported in the region of high pH, and two experiments were performed to validate this assumption. In both experiments, the coupler concentration and ferricyanide concentration

were kept constant, but in experiment one, half the concentration of developing agent was used relative to experiment two. It was found that the rate of dye formation was identical in both experiments. We analyze this result by the method of thought experiments or analytic possibilities.

We can write the dismutation reaction as

$$2\,S\,Q \rightleftharpoons D\,A \;+\; Q\,D\,I$$

$$(5.3.10)$$

The equilibrium expression for 5.3.10 can be written as

$$\frac{[SQ]^2}{[DA]\;[QDI]} = K$$

$$(5.3.11)$$

Two separate possibilities arise from equation 5.3.11.
1. K is large (numerator large) and the dismutation is small.
2. K is small (denominator large) and dismutation is large.

Each of these possibilities is considered in two separate experiments which differ only in the concentration of developing agent (DA).

Experiment 1. The initial concentration of the developing agent, $[DA]_o$, is q/2 where q is some convenient concentration.

Experiment 2. The $[DA]_o$ is q.

We are simply saying here that the $[DA]_o$ in Experiment 1 is half that of the $[DA]_o$ in Experiment 2.

In both experiments the concentration of the Ferricyanide oxidant is q.

We may write

$$2\,S\,Q \rightleftharpoons D\,A \;+\; Q\,D\,I, \text{ Exp. 1}$$
$$q/2$$

$$(5.3.12)$$

$$2\,S\,Q \rightleftharpoons D\,A \;+\; Q\,D\,I, \text{ Exp. 2}$$
$$q$$

$$(5.3.13)$$

where only the initial concentration of the DA is written in. The other concentrations are obtained by the following analysis for each possibility or thought experiment.

Recalling that the source of the semiquinone (SQ) and QDI is the developing agent itself, these molecules result from a two-step oxidation process which can be schematically written as

$$DA \xrightarrow{-e^-} SQ \xrightarrow{-e^-} QDI + H^+$$

(5.3.14)

Equation 5.3.14 shows that two electrons are lost by the developing agent before reaching the QDI state. Therefore, the concentration of the ferricyanide oxidation agent must be twice that of the developing agent in order for the developing agent to go completely to the QDI state.

Possibility 1. For this possibility, K is large and very little dismutation takes place, so that reaction 5.3.14 predominates. In Experiment 1, there is sufficient ferricyanide present to oxidize the DA to the QDI state, i.e., $[\text{ferricyanide}]_o = q$ and $[DA]_o = q/2$.

Thus the [DA] and the [SQ] are very small and the $[QDI] \sim q/2$.

In Experiment 2, where $[DA]_o = q$, there is not enough ferricyanide to oxidize the DA to the QDI state, so the [DA] and the [QDI] are very small and $[SQ] \sim q$. The possibilities are summarized in Table 5.3.1

TABLE 5.3.1 K Large

Exp. 1. Exp. 2.

	Exp. 1.		Exp. 2.	
[DA]	– very small	[DA]	– very small	
[SQ]	– very small	[SQ]	–	$\simeq q$
[QDI]	– $\simeq q/2$	[QDI]	– very small	

If the rate of the reaction is proportional to [SQ], then Table 5.3.1 shows that

Rate 1 < Rate 2

(5.3.15)

However, if the rate of the reaction is proportional to QDI, then Table 5.3.1 shows that

Rate 1 > Rate 2

(5.3.16)

In both inequalities 5.3.15 and 5.3.16, the subscripts 1 and 2 refer respectively to the thought experiments 1 and 2. Inequalities 5.3.15 and

5.3.16 do not support the experimental results that the rate of formation of the dye was identical in both actual experiments. Thus we must examine the second possibility.

Possibility 2. For this possibility, K is small and dismutation is large, so that either equation 5.3.10 or 5.3.14 may predominate, depending on the $[DA]_o$. In experiment 1 there is enough ferricyanide to oxidize the developing agent to QDI. Equation 5.3.14 predominates and [DA] is very small; [SQ] is small; [QDI] is approximately q/2. In experiment 2, there is only enough ferricyanide present to form q moles/liter of SQ, but since the dismutation is extensive, equation 5.3.10 shows that approximately q/2 moles/liter of DA and QDI will be produced from q moles/liter of SQ. The reaction is

$$2\,S\,Q \rightleftharpoons D\,A \;+\; Q\,D\,I$$

$$q-X \qquad \frac{X}{2} \qquad \frac{X}{2}$$

$$(5.3.17)$$

and since in this case the equilibrium is far to the right, X must be approximately equal to q. This possibility is summarized in Table 5.3.2.

TABLE 5.3.2 K Small

	Exp. 1		Exp. 2	
$[DA_1]$	very small	$[DA_2]$	~ q/2	
$[SQ_1]$	very small	$[SQ_2]$	small	
$[QDI_1]$	~ q/2	$[QDI_2]$	~ q/2	

It is evident from Table 5.3.2 that if the rate is proportional to [QDI], then

$$Rate_1 \;=\; Rate_2$$

$$(5.3.18)$$

Now if the rate is proportional to [SQ], then

$$Rate_1 \;<\; Rate_2$$

$$(5.3.19)$$

We analyze this situation as follows: Since the table indicates that

$$[DA_1] \ll [DA_2]$$

(5.3.20)

we may write

$$2SQ_1 \rightleftharpoons DA_1 + QDI_1$$

very
small q/2

(5.3.21)

$$2SQ_2 \rightleftharpoons DA_2 + QDI_2$$

q/2 q/2

(5.3.22)

Equations 5.3.21 and 5.3.22 indicate that

$$[SQ_1] \ll [SQ_2]$$

(5.3.23)

so that if the rate of dye formation is proportional to $[SQ]$,

$$Rate_1 \ll Rate_2$$

(5.3.24)

The experimental results are consistent only with equation 5.3.18, so we have shown with use of this analysis that the rate of dye formation is proportional to the $[QDI]$.

5.4 Kinetic Equations

Since the rate of dye formation is proportional to the [QDI], we may write

$$\text{QDI} + \text{Coupler} \xrightarrow{k_1} \text{Leuco dye}$$

$$\xrightarrow{k_3 \text{ (fast)}} \text{dye (a)}$$

(5.4.1)

$$\text{QDI} \xrightarrow{k_2} \text{quinonemonoimine (QMI)}$$

(5.4.2)

Equations 5.4.1 and 5.4.2 result in the rate equation:

$$\frac{d\,[\text{QDI}]}{dt} = -k_1\,[\text{C}]\,[\text{QDI}] - k_2\,[\text{QDI}]$$

(5.4.3)

$$= -(k_1\,[\text{C}] + k_2)\,[\text{QDI}]$$

(5.4.4)

where [C] is the concentration of coupler.

Now we must write an equation describing the rate of formation of the dye. This equation is dependent only upon the formation of the leuco dye governed by the rate constant k_1. Since the rate going from the leuco dye to the dye itself is governed by the rate constant k_3, which is much faster, the controlling factor is the rate of formation of the leuco dye (colorless, reduced form of the dye). By studying equation 5.4.1, we see that the rate of formation of the dye is equal to the rate of disappearance

of the coupler and it is also proportional to the product of the concentration of the coupler multiplied by the concentration of the QDI.

Thus we may write

$$\underbrace{\frac{d\,[X]}{dt}}_{\text{dye}} = \frac{-d\,[C]}{dt} = k_1\,[C]\,[QDI]$$

(5.4.5)

where [X] is the concentration of the dye.

Equations 5.4.4 and 5.4.5 may be written in the differential form as

$$d\,[C] = -k_1\,[C]\,[QDI]\,dt$$

(5.4.6)

$$d\,[QDI] = -(k_1\,[C] + k_2)\,[QDI]\,dt$$

(5.4.7)

(Note that the concentration of dye formed at the completion of the reaction is equal to the initial concentration of the coupler.)

Dividing 5.4.7 by 5.4.6 we find

$$\frac{d\,[QDI]}{d\,[C]} = 1 + \frac{k_2}{k_1\,[C]}$$

(5.4.8)

To integrate equation 5.4.8, we use the limits

$$[QDI] = [QDI]_o$$

(5.4.9)

$$[C] = [C]_o$$

(5.4.10)

Rewriting equation 5.4.8 after transforming to differential form, we find

$$d\,[QDI] = d\,[C] + \frac{k_2\,d\,[C]}{k_1\,[C]}$$

(5.4.11)

Integrating equation 5.4.11 to find the $[QDI]$ as a function of $[C]$, we write

$$\int_{[QDI]_o}^{[QDI]} d[QDI] = \int_{[C]_o}^{[C]} \left\{ d[C] + \frac{k_2\, d[C]}{k_1\, [C]} \right\}$$

(5.4.12)

Remembering that

$$\frac{k_2}{k_1} \ln [C] \Bigg|_{[C]_o}^{[C]} = \frac{k_2}{k_1} \ln [C] - \frac{k_2}{k_1} \ln [C]_o$$

(5.4.13)

we may write

$$[QDI] - [QDI]_o = [C] - [C]_o + \frac{k_2}{k_1} \ln \frac{[C]}{[C]_o}$$

(5.4.14)

Inspection of equation 5.4.1 shows that the concentration of the dye at the completion of the reaction is equal to the initial concentration of the coupler.

Furthermore, for every mole of coupler that couples, one mole of dye is formed. Utilizing these facts, we may write

$$[X] = [C]_o - [C]$$

(5.4.15)

Substituting equation 5.4.15 into 5.4.14 and using simple algebraic manipulations, we can write

$$[QDI] = [QDI]_o - [X] + \frac{k_2}{k_1} \ln \frac{[C]_o - [X]}{[C]_o}$$

(5.4.16)

We continue in our efforts to solve for the rate constant k_1.

A Taylor's expansion of ln $(1 - X)$ around the point $X = 0$ produces the following series:

$$\ln (1 - X) \; = \; -X - \frac{1}{2} (-X)^2 + \frac{1}{3} (-X)^3 - \ldots$$

(5.4.17)

where the limits of convergence for the series is

$$\boxed{-1 < X < 1}$$

(5.4.18)

Inspection of the right hand side of equation 5.4.16 shows

$$\ln \left(1 - \frac{[X]}{[C]_o} \right)$$

(5.4.19)

From equation 5.4.17,

$$\ln (1 - X) \; = \; -\left(X + \frac{1}{2} (-X)^2 + \frac{1}{3} X^3 + \ldots \right)$$

(5.4.20)

The term ln $(1 - [X]/[C]_o)$ which appears on the right hand side of equation 5.4.16 can be approximated for small values of $[X]/[C]_o$ as

$$\ln \left(1 - \frac{[X]}{[C]_o} \right) \approx - \frac{[X]}{[C]_o}$$

(5.4.21)

This approximation results from the fact that the first term in the Taylor-MacLaurin series of ln $(1 - X)$ is $-X$ and the other terms contain higher powers of X (see equation 5.4.20).

Rewriting equation 5.4.16, we find

$$[QDI] = [QDI]_o - [X] + \frac{k_2}{k_1} \ln\left(1 - \frac{[X]}{[C]_o}\right)$$

(5.4.22)

At the early part of development or when the coupler concentration is high, $[X]/[C]_o$ is a small quantity and the left side of equation 5.4.21 can be approximated by the right hand side. Using the result of 5.4.21 and substituting into equation 5.4.22 we write

$$[QDI] = [QDI]_o - [X] - \frac{k_2}{k_1} \frac{[X]}{[C]_o}$$

(5.4.23)

We now define the following quantity:

$$1 + \frac{k_2}{k_1 [C]_o} = m$$

(5.4.24)

From 5.4.5 we write

$$\frac{d[X]}{dt} = k_1 [C] [QDI]$$

(5.4.25)

Substituting 5.4.24 into 5.4.23, we write

$$[QDI] = [QDI]_o - [X] \left(1 + \frac{k_2}{k_1 [C]_o}\right)$$

(5.4.26)

$$= [QDI]_o - m [X]$$

(5.4.27)

Substituting 5.4.27 into 5.4.25, we write

$$\frac{d[X]}{dt} = k_1 [C] \left([QDI]_o - m [X] \right)$$

$$(5.4.28)$$

In order to integrate equation 5.4.28, the concentration of coupler must be placed in terms of the concentration of the dye. The expression which relates the concentration of the coupler to that of the dye, transformed from equation 5.4.15, is

$$[C] = [C]_o - [X]$$

$$(5.4.29)$$

Substituting equation 5.4.29 into 5.4.28, we write

$$\frac{d[X]}{dt} = k_1 \left([C]_o - [X] \right) \left([QDI]_o - m [X] \right)$$

$$(5.4.30)$$

For convenience, we rewrite 5.4.30 as

$$\frac{d[X]}{dt} = m k_1 \left([C]_o - [X] \right) \left(\frac{[QDI]_o}{m} - [X] \right)$$

$$(5.4.31)$$

Rewriting 5.4.31 in the differential form and integrating, we write

$$\int_0^{[X]} \frac{d[X]}{\left([C]_o - [X] \right) \left(\frac{[QDI]_o}{m} - [X] \right)} = \int_0^t m k_1 \, dt$$

$$(5.4.32)$$

The limits are dye concentration from 0 to concentration X and 0 time to time t.

This integral is in the standard form:

$$\int \frac{dX}{(a-X)(b-X)}$$

$(5.4.33)$

The indefinite integral for 5.4.33 is written as

$$\int \frac{dX}{(a+bX)(a'+b'X)} = \frac{1}{ab' - a'b} \ln\left(\frac{a'+b'X}{a+bX}\right)$$

$(5.4.34)$

$$\left.\begin{array}{rcl} b &=& -1 \\ b' &=& -1 \\ a &=& [C]_o \\ a' &=& \dfrac{[QDI]_o}{m} \end{array}\right\}$$

$(5.4.35)$

$$\frac{1}{\dfrac{[QDI]_o}{m} - [C]_o} \ln\left(\frac{\dfrac{[QDI]_o}{m} - [X]}{[C]_o - [X]}\right)\Bigg|_0^X$$

$(5.4.36)$

$$= \frac{1}{\dfrac{[QDI]_o}{m} - [C]_o} \left\{ \ln\left(\frac{\dfrac{[QDI]_o}{m} - [X]}{[C]_o - [X]}\right) - \ln \frac{[QDI]_o}{[C]_o m} \right\}$$

$(5.4.37)$

Rearranging, we get

$$\frac{1}{\dfrac{[QDI]_o}{m} - [C]_o} \ \ln \frac{[C]_o([QDI]_o - m[X])}{[QDI]_o([C]_o - [X])} = m\,k_1\,t$$

$$(5.4.38)$$

Since we are interested in the rate constant, we go on to solve for k_1:

$$k_1 = \frac{1}{t([QDI]_o - m[C]_o)} \ln \frac{[C]_o([QDI]_o - m[X])}{[QDI]_o([C]_o - [X])}$$

$$(5.4.39)$$

Rewriting 5.4.39, we obtain

$$k_1 = \frac{1}{m\,t\left(\dfrac{[QDI]_o}{m} - [C]_o\right)} \ln \frac{m[C]_o\left(\dfrac{[QDI]_o}{m} - [X]\right)}{[QDI]_o([C]_o - [X])}$$

$$(5.4.40)$$

Equation 5.4.40 can be written in the slope intercept form of the equation of a straight line; $y = Cx + b$, where C is the slope and $b = 0$. Equation 5.4.41 is the slope intercept form of the rate equation where the rate constant k_1 is the slope.

$$\frac{t}{x} \ \frac{k_1}{C} = \frac{1}{m\left(\dfrac{[QDI]_o}{m} - [C]_o\right)} \underbrace{\ln \frac{m[C]_o\left(\dfrac{[QDI]_o}{m} - [X]\right)}{[QDI]_o([C]_o - [X])}}_{y}$$

$$(5.4.41)$$

A plot of $\ln m[C]_o([QDI]_o/m - [X])/[QDI]_o([C]_o - [X])$ versus t should yield straight lines passing through the origin in cases where equation 5.4.40 is valid.

In the case of four-equivalent couplers, equation 5.4.40 is valid only when the concentration of the oxidizing agent is greater than or equal to four times the concentration of the developing agent.

For two-equivalent couplers, equation 5.4.40 is valid at any concentration of the oxidizing agent. Equation 5.4.40 is valid for the two and four-equivalent couplers when the concentration of coupler is either in large excess or at the early part of the reaction.

When the proper conditions are present and straight lines passing through the origin are obtained, then we can say with reasonable certainty that the mechanism specified by equations 5.4.1 and 5.4.2 is valid.

Equation 5.4.40 indicates that a plot of t versus the logarithm of $[QDI]_o/m - [X]/[C]_o - [X]$ will produce a straight line.

We can derive a useful expression when $[QDI]_o/m$ is equal to $[C]_o$ as follows:

Rewriting 5.4.39, we obtain

$$k_1 = \frac{1}{mt(X - [C]_o)} \ln \frac{1 - \dfrac{[X]}{X}}{1 - \dfrac{[X]}{[C]_o}}$$

(5.4.42)

$$\text{where } X = \frac{[QDI]_o}{m}$$

(5.4.43)

$$\text{Find the limit of the function as } X \longrightarrow [C]_o$$

(5.4.44)

We note that equation 5.4.42 is in the form of 0/0 when we take the limit of X as it goes to $[C]_o$.

Therefore, we may invoke L'Hospital's rule to find the limit. First we take the derivative of the numerator because the derivative of the denominator is clearly mt.

Derivative of the numerator follows:

$$\frac{d}{dX} \left(\ln \frac{1 - \dfrac{[X]}{X}}{1 - \dfrac{[X]}{[C]_o}} \right)$$

(5.4.45)

$$= \frac{d \left(1 - \dfrac{[X]}{X} \middle/ 1 - \dfrac{[X]}{[C]_o} \right)}{dX}$$
$$\frac{}{1 - \dfrac{[X]}{X} \middle/ 1 - \dfrac{[X]}{[C]_o}}$$

(5.4.46)

$$\frac{\dfrac{[X]\,X^{-2}}{1 - \dfrac{[X]}{[C]_o}}}{1 - \dfrac{[X]}{X}\bigg/1 - \dfrac{[X]}{[C]_o}} = \frac{[X]\,X^{-2}}{1 - \dfrac{[X]}{X}}$$

$$(5.4.47)$$

$$= \frac{[X]}{X^2 - X[X]}$$

$$(5.4.48)$$

We now divide the derivative of the numerator by the derivative of the denominator and we write

$$\frac{1}{mt}\ \frac{[X]}{X^2 - X\,[X]}$$

$$(5.4.49)$$

Taking the limit as $X \to [C]_o$, we may write

$$\lim_{X \to [C]_o}\left\{\frac{[X]}{mt\,X\,(X - [X])}\right\}$$

$$(5.4.50)$$

and

$$k_1 = \frac{[X]}{mt\,[C]_o\,([C]_o - [X])}$$

$$(5.4.51)$$

Equation 5.4.51 can be used to calculate k_1 when the experimental conditions are chosen such that $[QDI]_o/m = [C]_o$.

The development of the kinetic equations is based upon two equivalent couplers, i.e., couplers that require two equivalents of oxidant to form one equivalent of dye. 4-Chloro-1-naphthol is such a coupler, and its reaction is

(5.4.52)

1–Naphthol is a 4 equivalent coupler and its reaction is

(5.4.53)

With four-equivalent couplers of the type shown in equation 5.4.53, two more equivalents of oxidant are needed to convert the leuco dye to the dye. When there is an excess of the ferricyanide oxidizing agent present, the ferricyanide is reduced and the equations are identical to those for two-equivalent couplers. When the initial concentration of oxidant is less than or equal to twice the initial developing agent concentration, the quinonediimine is reduced and it disappears twice as fast as dye is formed. (The QDI serves as an oxidizing agent where the leuco dye is oxidized to form dye.)

This is the only significant case for four-equivalent couplers as cited in equation 5.4.53. No further information can be obtained from the more complex case where the concentration of oxidant is greater than twice the initial concentration of the developing agent while still being less than the amount required for complete oxidation.

Analysis of equation 5.4.1 for the formation of the leuco dye and the dye for the case when the QDI acts as the oxidant is given in the following sequence of reactions.

$$QDI \ + \ C \xrightarrow{\ k_1\ } Leuco\ Dye$$

(5.4.54)

$$\underbrace{Leuco\ Dye}_{becomes\ oxidized} \ + \ \underbrace{QDI}_{reduced} \xrightarrow{\ k_3\ fast\ } Dye$$

(5.4.55)

The deamination reaction that competes with the coupling reaction is the same as equation 5.3.9

$$QDI \xrightarrow{\ k_2\ } QMI$$

(5.4.56)

The rate equations which can now be written for equations 5.4.54, 5.4.55, 5.4.56, respectively, follow

$$\frac{d\ [QDI]}{dt} \ = \ - \ 2\,k_1\ [C]\ [QDI] \ - \ k_2\ [QDI]$$

(5.4.57)

Initially, the p-phenylenediamine developing agent in the presence of ferricyanide oxidant goes rapidly to QDI,

$$\text{P.P.D.} \quad + \quad \underset{\text{Oxidant}}{\text{O.A.}} \xrightarrow{\text{fast}} \text{QDI} \quad + \quad \underset{\substack{\text{reduced form} \\ \text{of oxidant}}}{\text{O.A}'.}$$

(5.4.58)

The QDI and the coupler then form the leuco dye, equation 5.4.54. Since we do not have an excess of oxidant available in equation 5.4.55, the QDI acts as the oxidizing agent and disappears as dye is formed by the oxidation of the leuco dye (LD). The QDI is used first in equation 5.4.54 to form the LD, and then again in equation 5.4.55 as the oxidant to form the dye. Thus we obtain the factor 2 which appears in equation 5.4.57.

For the rate of increase of the dye, we rewrite equation 5.4.5

$$\frac{d\,[X]}{dt} = -\frac{d\,[C]}{dt} = k_1\,[C]\,[QDI]$$

(5.4.59)

The appearance of the dye depends only on equation 5.4.54. The subsequent reaction of the leuco dye is so fast that it can be neglected. However, it cannot be neglected for the disappearance of the QDI, which appears in equation 5.4.57 as the factor 2.

Dividing equation 5.4.57 by equation 5.4.59, after putting them into differential form, we write

$$\frac{d\,[QDI]}{d\,[C]} = 2 + \frac{k_2}{k_1\,[C]}$$

(5.4.60)

Integrating equation 5.4.60 (see equation 5.4.12) we write

$$[QDI] = [QDI]_o - 2\,[X] + \frac{k_2}{k_1} \ln \frac{[C]_o - [X]}{[C]_o}$$

(5.4.61)

Solving equation 5.4.61 for k_1 (see equation 5.4.8–5.4.39)

$$\text{where } m' = 1 + \frac{k_2}{k_1 \ [C]_o} \text{ we find,}$$

$$(5.4.62)$$

$$k_1 = \frac{1}{t(2m'[C]_o - [QDI]_o)} \ \ln \frac{[QDI]_o}{2m'[C]_o} \frac{([C]_o - [X])}{\left(\frac{[QDI]_o}{2m'} - [X]\right)}$$

$$(5.4.63)$$

Using L'Hospital's rule (see equation 5.4.44), taking the limit as

$$[QDI]_o \longrightarrow 2m' \ [C]_o$$

$$(5.4.64)$$

we write

$$k_1 = \frac{[X]}{2m'[C]_o \ ([C]_o - [X]) \ t}$$

$$(5.4.65)$$

When the deamination rate is slow compared to coupling, k_2 is small and both m' and m are approximately equal to 1 and the rate constants (equations 5.4.63 and 5.4.40) for both the two and four-equivalent couplers reduce to second order rate equations.

5.5 Determination of Rate Constants

If we first determine k_2 in a given buffer, by reacting P.P.D. at pH > 11 in the presence of an oxidizing agent to form the QDI, then we may determine k_1 as follows. In the same buffer, QDI and a coupler are reacted at a given initial concentration until the QDI is exhausted. The dye concentration is then determined and all the previous data; i.e., $[QDI]_o$ $[C]_o$, and $[X]$ are introduced into equations 5.4.23 and 5.4.61; k_1 can be determined by setting $[QDI] = 0$.

Validity of Equations. Now that we have developed various equations, the next step is to determine the validity of these equations.

This can be done by determining how well our experimental points agree with graphs of theoretical straight lines.

TEST 1, when looking at

$$k_1 = \frac{1}{t(2m'[C]_o - [QDI]_o)} \ln \frac{[QDI]_o}{2m'[C]_o} \frac{([C]_o - [X])}{\left(\dfrac{[QDI]_o}{2m'} - [X]\right)}$$

(5.5.1)

When:
$$a_1 = 2m'[C]_o - [QDI]_o$$
$$a_2 = [C]_o [QDI]_o$$
$$a_3 = [QDI]_o$$
$$a_4 = 2m'[C]_o$$

Rewriting equation 5.5.1, we find

$$k_1 = \frac{1}{t \; a_1} \ln \frac{(a_2 - a_3 [X])}{(a_2 - a_4 [X])}$$

(5.5.2)

$$t = \frac{1}{k_1 \, a_1} \, y \quad \text{where } y = \text{In} \frac{(a_2 - a_3 \, [X])}{(a_2 - a_4 \, [X])}$$

(5.5.3)

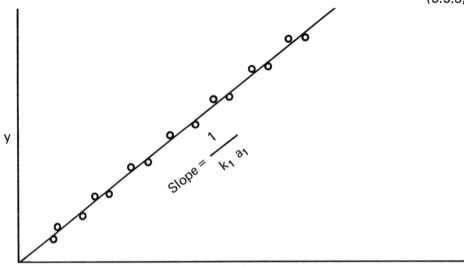

Fig. 5.5.1 *Shows a plot of y versus t as given by equation 5.5.3. The initial conditions for test 1 were:*

The points established in test 1 approximate a theoretical straight line.

$$a = [c]_0 = 1.25 \times 10^{-4} \, M$$
$$m = 1.013$$

The points on Figure 5.5.1 were established by reacting the following:

where $a = b = [C]_0 = 1.25 \times 10^{-4}$ M

and $m = 1.013$

(5.5.4)

564

The best approximation for the points established in TEST 1 was the theoretical straight line Figure 5.5.1.

The next test of the equation was obtained from the reaction of

D.A. Coupler

(5.5.5)

TEST 2. With the use of equation 5.4.39, if we choose values of pH where $m = 1$, i.e., where deamination is negligible, equation 5.4.39 becomes

$$k_1 = \frac{1}{t\,([QDI]_o - [C]_o)}\, \ln \frac{[C]_o\,([QDI]_o - [X])}{[QDI]_o\,([C]_o - [X])}$$

(5.5.6)

When we plot

$$\ln \frac{[C]_o\,([QDI]_o - [X])}{[QDI]_o\,([C]_o - [X])}$$

(5.5.7)

versus time, we arrive at straight lines passing through the origin with a slope (see Figure 5.5.2)

$$\frac{1}{k_1\,([QDI]_o - [C]_o)}$$

(5.5.8)

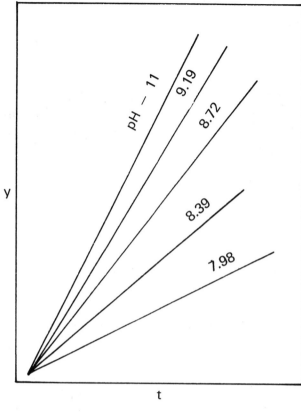

Where y = equation (5.5.7)

Fig. 5.5.2

Shows a plot of y versus t where y is equal to expression 5.5.7. The initial conditions for test 2 were:

$[QDI]_o$ = 2.5 x 10^{-4} M
$[C]_o$ = 1.25 x 10^{-4} M

Once again experimental points agreed very well with the theoretical lines.

Other tests, made by L.K.J. Tong and M.C. Glesmann at Kodak Research Labs., agreed very well with the theory.

Their research established the following:

(1) The coupler anion is the reactive species in the condensation reaction where the anion for α naphthol is

Fig. 5.5.3

and the total reaction is

$$\text{QDI} \qquad\qquad \alpha \text{ naphthol} \qquad\qquad \text{Dye}$$

(5.5.9)

(2) The anions of various couplers vary in reactivity.

(3) The reactivity is higher the greater the electron density at the active methine or methylene group.

(4) The reactive species of the oxidized developer in the reaction with the coupler anion is the quinonediimine cation. [This fact was established by L.K.J. Tong and M.C. Glesmann, *J. Amer. Chem Soc.*, **79**, 583 (1957), and independently by J. Eggers and H. Frieser, *Z. Elecktrochem.*, **60**, 372 (1956)] (see Figure 5.5.4).

Fig. 5.5.4

PROBLEM SET 5.1

1. Explain the reasons for using a homogeneous system rather than a heterogeneous system for studying color coupling reactions.

2. Show a typical reaction for the formation of a QDI.

3. Show a reaction for the formation of a semiquinone dimer.

4. Show a dismutation reaction. Why is it pH dependent?

5. Show the resonance forms of a semiquinone molecule.

6. Show a typical deamination reaction.

7. Which of the reactions in questions 10 to 14 are reversible?

8. (a) What assumptions did Tong and Glesmann make in order to study the color coupling reaction?

(b) Why did they make these assumptions?

(c) What is a thought experiment, and why must it sometimes be used rather than an actual experiment?

9. A student will sometimes say:

"I know that there is not enough ferricyanide oxidizing agent to completely oxidize all the DA to the QDI state, but since this is a statistical process, isn't it true that some QDI will be formed and invalidate your results?"

Answer this student to show that the text is correct.

10. Explain why equation 5.4.1 is consistent with the analysis or thought experiment in Chapter V.

11. Explain the results of Table 5.3.1, K Large, Table 5.3.2, K Small.

12. Write a paragraph explaining how the rate equation 5.4.4 is consistent with equations 5.4.1 and 5.4.2.

13. Write a paragraph explaining how the rate equation 5.4.5 is consistent with equation 5.4.1.

14. Derive equation 5.4.14 and 5.4.26.

15. Why do we integrate equation 5.4.31?

16. Derive equation 5.4.40.

17. What is the purpose of equation 5.4.51?

18. Explain the factor 2 in equation 5.4.57.

19. Derive equation 5.4.63.

20. What conclusions resulted from the 1957 Tong and Glesmann paper?

21. Prior to equation 5.4.54 it is stated that no further information can be obtained from the more complex case where the concentration of oxidant is greater than twice the initial concentration of the developing agent, while still being less than the amount required for complete oxidation. Give an explanation for this statement. (Hint: Consider the reactions that can occur.)

5.6 Structural Influence on Color

By means of oxidative coupling of N,N-dialkyl P.P.D. with ortho-cresol, Figure 5.6.1

Fig. 5.6.1

a series of indoaniline dyes (as shown in Table 5.6.1) have been made [Ref: S. Hunig and P. Richters, *Ann. Chem.*, **612**, 282 (1958)].

A typical reaction of this type is

$$\text{P.P.D.} + \text{Ortho Cresol} + OH^- + \text{Oxidant} \longrightarrow \text{Dye}$$

(5.6.1)

Table 5.6.1 also shows the P.P.D.'s and the half-wave potentials associated with each different P.P.D. (For derivation of half-wave potentials and their relation to the redox potential, see Thermodynamics,

Chapter 3) in strongly alkaline solution. The measurement of the half-wave potential corresponds to the following reversible redox reaction, forming the QDI.

Reduced Form

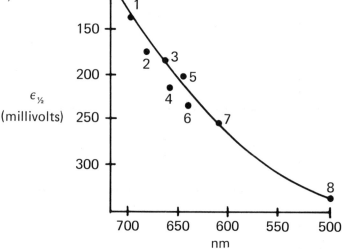

$$ + \ 2e \ + \ H^{\oplus} $$

$$(5.6.2)$$

As derived in the Thermodynamics Chapter, the half-wave potential of this reversible reaction is actually the redox potential for this reaction.

The actual reaction that takes place at the interface of an emulsion with a solution is heterogeneous. This means that one would have to use heterogeneous kinetics; this would complicate the process and we would probably lose information. Thus we simplify the problem in order to get more information. This information is very carefully delineated with all its assumptions. The knowledge acquired in the simple case can then be applied to the more complicated process of color development.

When the absorption maximum of the indoaniline dyes is plotted versus the $\epsilon_{1/2}$ of the P.P.D. developing agent, we find:

As the λ_{max} decreases, the half-wave potential increases (see Figure 5.6.2).

Fig. 5.6.2 *Shows that as the λ_{max} of the indoaniline dyes decreases, the corresponding half-* *wave potential of the P.P.D. developing agent increases in a non-linear manner.*

TABLE 5.6.1

Number	λ_{max} of Dye	DYE $R = -N=\!\!\!\bigcirc\!\!\!=O$	P.P.D.	$\epsilon_{1/2}$ (mv) of P.P.D.
1	700	(julolidine-type tricyclic ring, R)	(julolidine-type tricyclic ring, NH_2)	142
2	680	(tetrahydroquinoline ring, H_5C_2–N, R)	(tetrahydroquinoline ring, H_5C_2–N, NH_2)	182
3	655	(H_3C, H_3C)N–C$_6$H$_3$(CH$_3$)–R	(H_3C, H_3C)N–C$_6$H$_4$–NH_2	190
4	648	(H_5C_2, H_5C_2)N–C$_6$H$_4$–R	(H_5C_2, H_5C_2)N–C$_6$H$_4$–NH_2	222

Number	λ_{max} of Dye	DYE $R = -N\langle\bigcirc\rangle=O$	P.P.D.	$\epsilon_{1/2}$ (mv) of P.P.D.
5	635	H_5C_2, HOH_4C_2 on N—(phenyl)—R	H_5C_2, HOH_4C_2 on N—(phenyl)—NH_2	202
6	630	H_3C, H_3C on N—(phenyl)—R	H_3C, HOH_4C_2 on N—(phenyl)—NH_2	235
7	595	(S-ring) N—(phenyl)—R	(S-ring) N—(phenyl)—NH_2	254
8	505	H_3C, H_3C on N—(phenyl)—R	H_3C, H_3C on N—(phenyl with H_3C)—NH_2	330

The plot of wavelength versus half-wave potential indicates a non-linear relationship [S. Hunig and P. Richters, *Ann. Chem.*, **612**, 282 (1958)]. However, careful examination of the plot shows that the non-linearity results mainly from one point, which consists of the values for 4—amino—N,N-dimethyl—2—methylaniline (Figure 5.6.3) and its dye in the buffered acetonitrile solvent.

Fig. 5.6.3

This is an unusual molecule due to the presence of the methyl group in the 2 position, which prevents the free rotation of the nitrogen containing the two methyl groups. Therefore the methyl substituent in the 2 position increases the benzenoid character of the molecule, bringing it closer to the unpolarized form, with a corresponding hypsochromic shift producing a bend in the curve to the shorter wavelengths.

This is an example of a sterically enforced hypsochromic shift.

The indoaniline dye has the following resonance forms:

Unpolarized Form

Polarized Form (5.6.3)

Kuhn [Ref: H. Kuhn, *Z. Elektrochem. Angew. Chem.*, **53**, 165 (1949)] has shown that molecules of this type absorb radiation at the longest possible wavelength when the pi electrons are evenly distributed between the end key atoms.

Inspection of the unpolarized form shows that the left end key atom, nitrogen, does not participate in the conjugated system whereas the right end key atom, oxygen, does participate. On the other hand, the polarized form shows the opposite case where the nitrogen has a double bond and the oxygen does not.

Since long-wave absorption would require an even distribution of pi electrons between both end key atoms, this suggests that the resonance equilibrium point (resonance equilibrium point—see Chapter 4) must lie in the middle between both the polarized and unpolarized structures.

A displacement of the ground state from the unpolarized to the polarized form produces a color shift which is easily found experimentally.

One can experimentally determine whether the ground state lies predominantly in either the unpolarized or polarized form by placing the indoaniline dye into a polar solvent (water, methanol, etc.). If a color shift does not occur, we know it is in the polar form. If we see a color shift, then we know it was originally in the unpolar form.

It was found experimentally that the resonance equilibrium point lies closer to the unpolarized form. [Ref: P.W. Vittum, G.H. Brown, *J. Amer. Chem. Soc.*, **68**, 2235 (1946).]

This leads to the following theorem which concerns the influence of the substituents on the position of the absorption maxima of indoaniline dyes. If the substituents increase either the quinonoid character of the P.P.D. portion or the benzenoid character of the quinonoid part of the dye molecule, then a *bathochromic* shift (shift to longer wavelength) is produced.

P.P.D. Region Quinonoid Region

Fig. 5.6.4

For purposes of illustration, we now increase both the benzenoid and quinonoid character to the limit according to the theorem, and we write

Originally P.P.D.
region—now
Quinonoid Region

Originally Quinonoid
region — now
Benzoid Region

Fig. 5.6.5

It can now be seen from Figure 5.6.4 and Figure 5.6.5 that the effect of this change is to move the ground state farther away from the unpolarized resonant structure. We have shown the extreme limiting case in going from Figures 5.6.4 to 5.6.5.

The converse of this theorem is that the effect of opposite substituents, i.e., substituents which move the dye molecule in the direction of the unpolarized form, produces a hypsochromic shift. [P.W. Vittum and G.H. Brown, *J. Amer. Chem. Soc.*, **68**, 2235 (1946)] (Shift to shorter λ).

Indoaniline dye studies with particular emphasis on the effect of substituents on the dyes have been made by P.W. Vittum [P.W. Vittum and G.H. Brown, *J. Amer. Chem. Soc.*, **69**, 152 (1947)] and G.H. Brown [P.W. Vittum and G.H. Brown, *J. Amer. Chem. Soc.*, **71**, 2287 (1949)].

Thus, the curvilinear relationship found by Hünig and Richters is a special case which results when the 4-amino-N,N-dimethyl-2-methylaniline is considered with the other anilines.

The physical and chemical properties of substituted paraphenylenediamines and their derivatives are very important for understanding the process of dye formation by color coupling.

There is a linear correlation between the deamination rates and coupling rates of the oxidized paraphenylenediamines and frequency of maximum absorption of dyes derived from the paraphenylenediamines [Ref: R.L. Bent, A. Weissberger, *et al., Photo. Sci. Eng.*, **8**, 125 (1964)]. This type of correlation can be important in designing emulsions. For example, one must make a compromise by minimizing the deamination rate, maximizing the coupling rate, while obtaining the desired maximum frequency of absorption from the dye.

We have seen in the previous section that the half-wave potentials of the paraphenylenediamines are related to the absorption maximum of the dyes formed by the oxidative condensation of the couplers and the paraphenylenediamines.

The availability of electrons, [Ref: D.B. Julians, W.R. Ruby, *J. Am. Chem. Soc.*, **72**, 4719 (1950)] from the (P.P.D.) paraamino dialkylaniline

is readily measured by the half wave oxidation potential and is a measure of the activity of the developing agent. The availability of electrons also determines the absorption of the dyes formed [Ref: (a) L.G.S. Brooker and P.W. Vittum, *J. Phot. Sci.*, **5**, 71 (1957), (b) R.L. Bent *et al.*, *J. Am. Chem. Soc.*, **73**, 3100 (1951)].

The reaction of paraaminodialkylaniline in the presence of silver ion is written as

$$(5.6.4)$$

Looking at equation 5.6.4, we see that the availability of electrons from the paraphenylenediamine type developing agent determines how quickly silver can be reduced. Therefore there is a relationship between the half wave oxidation potential and the activity of developing agents. On the other hand, the equation for the absorption of energy of a representative dye formed from a paraaminodialkylaniline is

$$(5.6.5)$$

Equation 5.6.5 clearly shows that the ease of absorption is directly related to the availability of electrons in the paraminodialkylaniline portion of the dye.

The ease with which the paraminodialkylaniline part of the dye releases electrons (becomes oxidized) to the coupler portion of the dye is measured by the λ_{max}. The ease with which the developing agents release electrons is measured by the half-wave potential. That there is a relationship between the half-wave potential of the developing agents and the λ_{max} of the dyes formed is not surprising since both the λ_{max} of the dye

and the activity of the developing agent depend on the release of electrons from the paraphenylenediamine system.

Measurements of the coupling reactivity k_i and deamination k/OH of the oxidized paraphenylenediamines are given in Table 5.6.2, expressed as logarithms. The half-wave potential, structures and names are also included in this table. It was found (see Figure 5.6.6) by plotting log k/OH versus log k_i that there was a strong linear relationship between these two quantities [Ref: R. L. Bent, A. Weissberger *et al.*, *Phot. Sci. Eng.*, **8**, 125 (1964)].

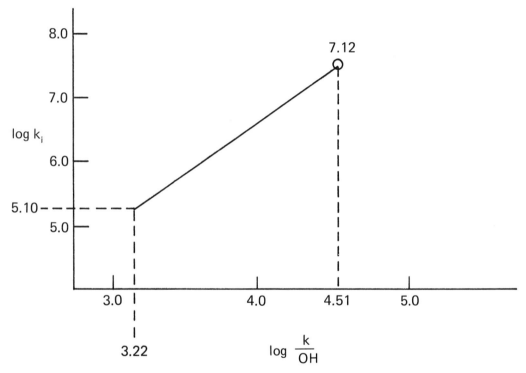

Fig. 5.6.6 *Shows a linear relationship between log k_i and log k/OH.*

TABLE 5.6.2

DEVELOPING AGENT STRUCTURE	NAME	$E_{1/2}$, pH 11	DEAMINATION RATE LOG (k/OH)	COUPLING REACTIVITY LOG k_1
	4Amino-3-methyl-N,N di-ethylaniline	− 190	3.22	5.10
	4Amino-3 methyl-N,-Hydroxyethyl-N-ethylaniline	− 188	3.59	5.72
		− 256	3.83	6.06

TABLE 5.6.2, continued

4Amino-N,N-diethyl aniline	— 216	3.99	6.58
4Amino-N-ethyl-N-β-Hydroxyethyl aniline	— 2.06	4.24	7.04
4Amino-N,N-di-methyl-aniline	— 228	4.40	6.83
4Amino-N-ethyl-N-β-sulfoethyl aniline		4.51	7.12

5.7 Half Wave Potential and λ_{max}

It has been shown by A. Stanienda [Ref: A. Stanienda, *Z. Physik. Chem. Neue Folge* **33**, 170 (1962)] that there is a linear relation between the half-wave potential and the minimum wave number of absorption of radiation $(1/\lambda_{max})$ for organic compounds.

This relation is of the form

$$\epsilon_{\frac{1}{2}} \;=\; a \;+\; b\, \tilde{\nu}_{max}$$

$$(5.7.1)$$

where a and b are constants, $\bar{\nu}_{max} = 1/\lambda_{max}$, and $\epsilon_{\frac{1}{2}}$ = half-wave potential. This section treats the derivation of equation 5.7.1 and discusses its scope and validity.

We may write the ionization potential in electron volts as follows:

$$E_I \;=\; E_1 \;+\; E_2$$

$$(5.7.2)$$

where E_1 = the energy difference between the ground state and the first excited state of the molecule, and E_2 = the energy difference between the beginning of the free electron state (complete ionization) and the first excited state. Figure 5.7.1 shows the simple term scheme for equation 5.7.2.

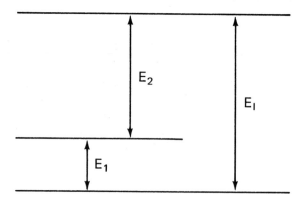

Fig. 5.7.1 *Shows schematically an energy level diagram of the ionization energy E_I; the energy difference between the ground state* *and the first excited state E_1; the energy difference between the first excited state and the free electron state E_2.*

The major contributor to the first excited state of organic dye molecules is the polarized resonance form. An example of this is given by the polarized form in equation 5.6.3. A sequential shifting of double bonds produces other forms, some of which are

Fig. 5.7.2

Fig. 5.7.3

582

Fig. 5.7.4

Fig. 5.7.5

All of these forms and others contribute to the resonance hybrid (Resonance Hybrid—see Chapter 4, Organic Chemistry) of the first excited state.

Since E_1 represents the energy required to raise the molecule to the first excited state, it corresponds to the photon energy of absorption for the molecule (see Absorption of Radiation—Chapter 4).

$$\text{Since } E \;=\; h\nu \qquad \text{where } \nu \;=\; \frac{C}{\lambda}$$

$$\text{and } \tilde{\nu}_{max} \;=\; 1/\lambda_{max}$$

$$(5.7.3)$$

$$\text{thus } E_1 \;=\; h\nu_{max} \;=\; \frac{h\,C}{\lambda_{max}} \;=\; hC\,\bar{\nu}_{max}$$

$$(5.7.4)$$

The quantity $\bar{\nu}$ in units of cm^{-1} is called the wave number. The value of h C in electron volts is 1.24×10^{-4} e V, so that equation 5.7.4 becomes

$$E_1 = 1.24 \times 10^{-4} \bar{\nu}_{max} \text{ (eV)}$$

$$(5.7.5)$$

From the Hückel approximation, in the quantum mechanics of organic compounds we may write

$$E_1 = a_1 + \beta_1 n^{\gamma_1}$$

$$(5.7.6)$$

$$E_2 = a_2 - \beta_2 n^{\gamma_2}$$

$$(5.7.7)$$

where a_i, β_i and γ_i are constants for a homologous series of compounds and n is equal to the number of π electrons in the molecules. In most cases, $\gamma_1 = \gamma_2$, so that we may write

$$n^{\gamma_1} = n^{\gamma_2} = \left(\frac{E_1 - a_1}{\beta_1} \right)$$

$$(5.7.8)$$

Substituting equation 5.7.8 into equation 5.7.7, we find

$$E_2 = a_2 - \beta_2 \left(\frac{E_1 - a_1}{\beta_1} \right) = a_2 + \frac{\beta_2}{\beta_1} a_1 - \frac{\beta_2}{\beta_1} E_1$$

$$(5.7.9)$$

Adding E_1 to both sides of equation 5.7.9, we find

$$E_1 + E_2 = a_2 + \frac{\beta_2}{\beta_1} a_1 + \left(1 - \frac{\beta_2}{\beta_1} \right) E_1$$

$$(5.7.10)$$

From equation 5.7.2 and equation 5.7.4, we write

$$E_I = a_2 + \frac{\beta_2 \cdot}{\beta_1} a_1 + \left(1 - \frac{\beta_2}{\beta_1}\right) h C \bar{\nu}_{max}$$

(5.7.11)

It is known that the equation

$$Z\epsilon_{1/2} = E_1 + K \text{ (eV)}$$

(5.7.12)

is true [Ref: A. Stanienda, Z. *Physik. Neue Folge* 33, 170 (1962)] for a homologous series where Z = the number of electrons exchanged in the redox reaction, $\epsilon_{1/2}$ = the half-wave potential of the redox reaction, and K is a constant. If we substitute equation 5.7.11 into equation 5.7.12, we find

$$Z\epsilon_{1/2} = a_2 + \frac{\beta_2}{\beta_1} a_1 + \left(1 - \frac{\beta_2}{\beta_1}\right) h C \bar{\nu}_{max} + K$$

(5.7.13)

After dividing both sides of equation 5.7.13 by Z, the constants can be defined as

$$a = \left(a_2 + \frac{\beta_2}{\beta_1} a_1 + K\right) \Big/ Z$$

(5.7.14)

$$b = (1 - \frac{\beta_2}{\beta_1}) / Z$$

(5.7.15)

so that equation 5.7.13 becomes

$$\boxed{\epsilon_{1/2} = a + b h C \bar{\nu}_{max}}$$

(5.7.16)

585

and we have obtained the linear relation sought.

We have derived equation 5.7.16 for a homologous series of organic compounds for which the number of π electrons remains constant.

5.8 Cost and Quality

An important consideration in color photography is the control or adjustment of such subjective and objective parameters as graininess, granularity, color quality and cost. The first three parameters relate to the overall quality of the color film and the last relates to the amount of silver in the film and other factors to be considered below.

Cost of Color Film. The cost of the color film can be divided into two parts:

1. The cost of manufacturing.
2. The cost of materials.

The cost of manufacturing is primarily dependent on the number of layers that must be coated on the film substrate.

If only one side of the substrate is coated, each layer requires a certain amount of coating machine time which is approximately constant from layer to layer. Therefore n layers require n x (coating time of one layer), and consequently n x (cost of one layer). The product development engineer is then faced with the problem of keeping the number of layers as few as possible.

The cost of materials can be immediately reduced by half by using only 2-equivalent couplers. The previous sections show that 2-equivalent couplers require 2 equivalents of silver for each mole of dye formed; whereas 4-equivalent couplers need twice as much silver per mole of dye formed. The cost of the couplers generally depends on the cost of the starting compounds used in their synthesis and the number of steps in the synthesis. Once a coupler is chosen, the product development engineer must choose the cheapest way of producing it. The solution of this problem requires a good knowledge of synthetic organic chemistry and chemical engineering.

Often compounds are cheaper to buy than to synthesize.

Quality of Color Film. The quality of color film depends on factors:

1. Within a layer (intralayer effects).

2. Between layers (interlayer effects).

The Intralayer Effects are graininess, sharpness, smearing and hue. The graininess of a color film depends on the size distribution of silver halide grains in the film and the mode of development of the film. If the film contains a large number of silver halide grains of small size, the graininess is reduced. However, each developed silver grain is surrounded by a dye cloud which is larger than the silver grain, producing a dye image which is grainier than the silver image. The solution to this problem is to reduce the size of the developed silver grain so that a proportional reduction takes place in the surrounding dye cloud. The size of the developed silver grain can be reduced by including a development inhibitor in the layer which is released during development [Ref: C. R. Barr, J. R. Thirtle, and P. W. Vittum, *Phot. Sci. Eng.*, **13**, 74 (1969)] have shown how development–inhibitor–releasing (DIR) couplers can be used to reduce the size of developed silver grains in color emulsion layers. The coupler contains a group such as

Fig. 5.8.1

or

Fig. 5.8.2

which is connected at the coupling point.

A typical reaction is

DIR COUPLER INDOANILINE DYE

DEVELOPMENT INHIBITOR

(5.8.1)

Benzotriazole and other molecules have been described by R.J. New-miller and R. B. Pontuis [Ref: R. J. Newmiller and R. B. Pontuis, *Phot. Sci. Eng.,* **5**, 283 (1961)] as development restrainers which act like bromide and iodide ions as they are released during development. The DIR couplers produce much larger inhibiting or restraint effects.

DIR couplers have been shown to produce a good edge effect [Ref: C.E.K. Mees and T.H. James, *The Theory of the Photographic Process,* 3rd ed., Macmillan, New York, 1966, p. 521], thereby increasing the sharpness of the image. The edge effect is ordinarily due to the diffusion of bromide or iodide ions and fresh developer at the boundary of maximum to minimum exposure area. Fresh developer diffuses from the minimum

exposure area to the maximum exposure area while development-inhibiting by-products such as bromide and iodide ion diffuse in the opposite direction.

Since the DIR coupler produces a larger inhibiting effect, the sharpness is markedly increased without loss of contrast. In most cases, without DIR couplers, the edge effect is produced with loss of contrast by diluting the developing solution. Intralayer smearing is caused by horizontal diffusion of the dye. Horizontal diffusion of the dye can be prevented by attaching to the coupler either a long chain aliphatic group or a group which forms covalent bonds to the gelatin. Numerous illustrations of this method of preventing diffusion can be found in the patent literature listed in Appendix 5.

A practical example of the former method is the Yellow Coupler.

Fig. 5.8.3

where the 18 carbon group in the dotted lines acts like an anchor.

A practical example of the latter method is the Cyan Coupler.

Fig. 5.8.4

where the dichloropyrimidinyl group in the dotted lines forms bonds with amino or hydroxyl groups of gelatin, polyvinyl alcohol, etc. These methods of preventing horizontal diffusion are also used to prevent vertical diffusion which is an *interlayer effect*.

The hue of a dye is dependent on the presence or lack of electron-donating or electron-accepting substituent groups on the dye and the steric effect of the substituent group. These factors produce bathochromic (shifts to longer wavelengths) or hypsochromic (shifts to shorter wavelength) shifts from the λ_{max} of the dye.

In many cases the dye may also have side absorptions which may or may not help to produce the desired hue. The patent literature, as listed in Appendix 5, shows many practical examples of couplers which have been modified by substituent groups to produce the desired hue in the resultant dye.

The interlayer effects are vertical diffusion of dyes and vertical diffusion of by-products. Vertical diffusion of dyes can be prevented in the same way as cited in the previous section for the horizontal diffusion of dyes. Vertical diffusion of by-products affects the development in the other layers of the film and can be adjusted to correct for hue. [Ref: W.T. Hanson, Jr., and C.A. Horton, *J. Opt. Soc. Am.*, 42, 663 (1952).] The incorporation of a DIR coupler in one or more layers of the color film can compensate for unwanted side absorptions of dyes in other layers by inhibiting development in these layers.

PROBLEM SET 5.2

1. What type of molecule was first believed to couple and form the dye?

2. What factors must be considered in the manufacture of color film materials?

3. After exposing color film material, describe the process that takes place during the subsequent development steps.

4. Describe a methylene group and explain how it can be made into an active methylene group.

5. Show the resonance forms of the QDI molecule.

6. Give typical structure of cyan, magenta and yellow dye couplers.

7. Show typical reactions of:

(a) 2-equivalent coupler + color developer to form a dye in the presence of an oxidizing agent.

(b) 4-equivalent coupler + color developer to form a dye in the presence of an oxidizing agent.

(c) Explain how a coupler can only require 2 equivalents for oxidation to a dye in the presence of a developing agent.

8. An experimenter found that he could not form a dye image while trying to react a new coupler with a new developing agent in the presence of an oxidizing agent. Suggest experiments that could be performed to establish whether the combination can produce a colored dye.

9. Hunig & Richters claim that a plot of the wavelength of PPD's versus the λ_{max} of the dye formed from the PPD and orthocresol is non-linear. What is the reason for the non-linearity?

10. Under what conditions is the $\epsilon_{1/2}$ equal to the redox potential?

11. What is the meaning of "free rotation", as discussed in this Chapter?

(a) Construct a scale model of a molecule which illustrates free rotation.

(b) Construct a scale model of a molecule which illustrates lack of free rotation.

12. Explain, in terms of energy, the theorem and its converse illustrated by Figure 5.6.4.

13. Look up the references P.W. Vittum and G.H. Brown, *J. Amer. Chem. Soc.* **68**, 2235 (1946); *ibid.* **69**, 152 (1957); *ibid.*, **71**, 2287 (1949), and discuss the influence of substituents on dyes.

14. What is the criterion which determines:

(a) The ease with which a PPD releases electrons.

(b) The ease with which the PPD portion of the dye release electrons to the dye portion.

(c) The linear relationship between the λ_{max} of the dye and the $\epsilon_{1/2}$ of the D.A.

15. Discuss the reasons for the strong linear relation between the deamination rate and the coupling reactivity of oxidized PPD's.

16. What is meant by the statement, "The major contributor to the first excited state of an organic dye molecule is the polarized resonance form?"

17. From an energy standpoint, explain why a bathochromic shift occurs if a substituent increases the benzenoid character of the quinonoid part of the dye molecule?

18. How might one experimentally determine whether the ground state of an indoaniline dye lies predominantly in either the polarized or unpolarized form?

19. If a substituent moves the dye molecule in the direction of the unpolarized form, what resultant wavelength shift can be expected?

20. What relation exists between deamination and coupling rates of the oxidized paraphenylenediamines?

21. How can the availability of electrons from paraaminodialkyl-aniline be measured?

(a) What does this measurement express?

(b) How is this measurement related to dye absorption?

22. What equation shows the relationship between the availability of electrons from a PPD type developing agent and the rate at which silver is reduced?

23. The ease with which developing agents release electrons can be accomplished by what measurement?

24. What fundamental relation is expressed by equation 5.7.16?

25. How can the size of a developed silver grain in color emulsions be reduced?

26. Describe DIR couplers.

(a) How does a DIR coupler increase sharpness of the developed image?

27. The hue of a dye is dependent upon what factors?

LIST OF ABBREVIATIONS USED IN APPENDICES

A	=	Application, as in Patent Application
Ag	=	Agfa
Belg } BP }	=	Belgian Patent
Can	=	Canadian Patent
D	=	Dufay Color Inc.
DAS } DDR } DRP }	=	German Patent Designations
DP	=	Du Pont
F	=	French Patent
FP	=	Fuji Photo Film Co.
FS	=	Fuji Shashin Co.
G	=	Gevaert
GAF	=	General Aniline and Film
GB	=	British Patent
I	=	Ilford
ICI	=	Imperial Chemical Industries
Jap	=	Japanese Patent
K	=	Kodak
Swiss	=	Swiss Patent
US	=	United States Patent
USSR	=	Russian Patent
V	=	Veracol Film

Appendix 5A
Yellow
Couplers

	STRUCTURE	NAME	REFERENCE	COMPANY OR INDIVIDUAL
1.	$CO\,CH_2\,CO\,\ddot{N}H$	Benzoylacetanilide	DRP 253 335	R. Fischer
2.	RCH_2COCH_2COOR	Acetoaceticacid derivatives	US 2,206,142 US 2,113,330	K
3.	$RCH_2COCH_2COCH_3$	Acetylacetone derivatives	GB 525,765	K
4.	$COCH_2COCH_2R$	Hexahydrobenzoyl acetone derivatives	F 867,413	K
5.	$\ddot{N}CCH_2CO\ddot{N}HR$	Cyanacetamide derivatives	GB 458,664	K
6.	Replace C=O with C=N̈H, C=N̈OH, C=S	Substituents for carbonyl group	GB 648907	G
7.	$COCH_2CO$	Benzoylacetophenone derivatives	GB 525,874	K
8.	CH_3CSCH_2CSR	Thioacetone derivatives	FP 804472	K
9.	RCH_2CSNHR	Thioacetamide derivatives	GB 576855	I

595

STRUCTURE	NAME	REFERENCE	COMPANY OR INDIVIDUAL
10. X'—⟨ ⟩—CO CH$_2$CO ṄH—⟨ ⟩—X' I = Benzoyl part II = Amine part	αBenzoylacetanilide derivatives	J. Am. Chem. Soc. 79,2919 (1957)	
11. R—⟨ ⟩—COCH$_2$COCH$_2$COOH	αBenzoylacetoacetic— acid derivatives	DRP 744265	Ag
12.	Impurities in malonicdiamines	Soc. Ind. Photogr. 23,386 (1952)	
13.	Protected couplers	Jap 42-5,582 Belg 659109 GB 1,052,488	FP
14.	Sulfonamide contain- ing benzoylacetaril- ides	US 2,271,238	K
15.	α—Acyl—α—Aryl Oxyacetanilide derivatives	DRP 1,236,332 F 1,411,384 Belg 653,722	K
16.	Aminoisphthalic acid residues for solubil- ity	US 2,652,329	K
17. RṄHCOCH$_2$COṄHR' where R or R' = thiazol or benzothiazole		Soc. Ind. Photogr. 23,386 (1952)	
18.	4,4'—diaminodi- phenyl or 1,5—dia- minonapthaline	GB 544189	DP
19. R—CH=CHCH$_2$COX		DRP 746530 US 2,214483	Ag GAF

	STRUCTURE	NAME	REFERENCE	COMPANY OR INDIVIDUAL
20.		Acid Yellow Couplers	DRP 1,235,324 GB 977,044 F 1,325,411	

21.

$$\begin{matrix} X \\ \diagdown \\ \diagup \\ Y \end{matrix} C=\ddot{N}HCOCH_2CO\ddot{N}H\ddot{N}H_2$$

Soc. Ind. Photogr. 23,173 (1952)

or

$$\begin{matrix} X \\ \diagdown \\ \diagup \\ Y \end{matrix} C=\ddot{N}-\ddot{N}HCOCH_2CO\ddot{N}H-\ddot{N}=C \begin{matrix} X' \\ \diagup \\ \diagdown \\ Y' \end{matrix}$$

Bul. Soc. Belg. 61,243 (1952)

Where X, Y, X', Y', are the same or different groups. These molecules give an intense yellow.

		NAME	REFERENCE	COMPANY OR INDIVIDUAL
22.		N—acetoacetylpip- eridine and ben- zoylacetylmorpholine	US 2,378,266	K

23.

$$C=\ddot{N}-\ddot{N}HCOCH_2C\ddot{N}$$

GB 590637 G

		NAME	REFERENCE	COMPANY OR INDIVIDUAL
24.		Phenylenediamine residues for amineparts	GB 493952 GB 566880	K K

25.

US 2,507110 DP

		NAME	REFERENCE	COMPANY OR INDIVIDUAL
26.		Morpholine substi- tuted arylamine in the amine parts. (See #10)	BPA 4686 (1938)	DP

	STRUCTURE	NAME	REFERENCE	COMPANY OR INDIVIDUAL
27.	RCH (CH$_2$COOH) CONH arylene – COCH$_2$CONH arylene (O–OR') COOH R = aliphiatic containing 10-18 carbons R' = alkyl containing 1-3 carbons		GB 1,045,633	FP
28.	 X=CH$_2$,CO,NH,S,SO$_2$, N=N		GB 544120	DP
29.	CHCH$_2$CONHR or (CNCH$_2$CONH–N=)$_n$X Where X = an organic molecule. These couplers give yellow to orange dyes.		US 2,375,344	G
30.		Bis–(benzoylacet-anilide) with diamines	GB 544189	DP
31.	CH$_3$ CO CH$_2$CO N	N,N–diphenyl-acetylacetamide	GB 521550	G
32.			US 2,547,307 US 2,500,487	GAF GAF
33.		1,2,4–Oxodiazole – 3 R	GB 648,907 GB 638039 GB 540760	G G G
34.			GB 663550	G

	STRUCTURE	NAME	REFERENCE	COMPANY OR INDIVIDUAL

35.

	US 2,435173	GAF
	US 2,323,504	DP
	US 2,323,503	DP

The dotted ring in the first compound indicates a pyridine, quinoline or isoquinoline ring. The dotted ring in the second compound indicates a benzo-thia or oxazole ring. The second compound couples yellow to magenta.

36.

Heterocyclic amine	GB 493952	K
substituents in the	US 2108602	K
amine parts (see	US 2395776	GAF
#10).	US 2406654	GAF
	FR 804472	K
	GB 493952	K

37.

Compounds with two	US 2406654	GAF
active methylene	US 2395776	GAF
groups, allowing		
the possibility of		
faster coupling by		
splitting.		

38.

	US 2,387,145	D
	GB 648 907	G

The S "bridge" breaks so coupling can take place at the arrows.

US 2,340,763	DP
(This patent describes an *S-S— bridge.)	

39.

F 869169	G
F 978156	G

Coupling here is to the strongest methylene group.

STRUCTURE	NAME	REFERENCE	COMPANY OR INDIVIDUAL

40.

where X = $\ddot{N}NH_2$,

\ddot{N}HOH, \ddot{N}H \ddot{N}=CH R,

Y = O,S,\ddot{N}H

		F 969826	G
		GB 578666	DP
		GB 674103	G

41.

	Sulfonic acid sub—stituted Aroylacet—arylide couplers.	US 3,393,040	G
		Belg 634,669	G
		GB 1,062,203	G
		Can 758,619	G

42.

	Derivatives of Polyenic aldehydes		D. Bellone, A. Gazzi, Ann Chim Rome 53, 1269 (1963)

43.

		F 869169	G
		F 978156	G

44. $RSO_2CH_2-C-\ddot{N}$

		DAS 1045230	G

45. R–CO–CH–COX

R–CO–CH–COX

Arrows show two active methylene groups.

	This methylene group can be sub-stituted with halogens or alkyl groups to facilitate splitting.	US 2,368,302	DP

	STRUCTURE	NAME	REFERENCE	COMPANY OR INDIVIDUAL
46.		Yellow couplers from the reaction of P — aminebenzylacetanilide or P — aminoanilide of benzylacetic acid with a copolymer of styrol and maleic anhydride.		G. N. Lapshin S. I. Dikii M. A. Al'perovic Zh Nauchn i Priklad Fot i Kinemativ 8, 304 (1963)

47.

$$RO \longrightarrow CO\ CH_2\ CO\ \ddot{N}H \longrightarrow C \begin{cases} \ddot{N}-C-COOC_2H_5 \\ \quad\ \|\ \\ S-C-COOC_2H_5 \end{cases}$$

		REFERENCE	
Where R is a diffusion hindering group, and this combination increases the coupling ability.		DRP 1,038,916	G

48.

		REFERENCE	
		US 2,427,910	I

49. $\ddot{N}H_2COCH_2CO\ddot{N}H_2$

$HOOCCH_2CO\ddot{N}H_2$

	NAME	REFERENCE	COMPANY
	Malonic acid diamide	DDR 5194	Ag
	Malonic acid monoamide	US 2186735	GAF

	NAME	REFERENCE	COMPANY
50.	Thiazole couplers.	US 3,393,041	G
		Belg 634,670	G
		GB 1,075,084	G
		F 1,415,573	G
		Jap 43-16,188	G
		DRP 1,213,739	G

	NAME	REFERENCE	
51.	Triazinyl Diazo couplers	DRP 1,156,311	

	STRUCTURE	NAME	REFERENCE	COMPANY OR INDIVIDUAL

52.

US 2,283,276 DP

53.

BP 819,827 ICI

54.

Dialkyl–Morpholino–phenel diazotype couplers GB 948,965

55.

Nondiffusing yellow couplers

Belg 659109 FS
GB 1,052,488 FS
Swiss 436,984 FS
Jap 42-5,582 FS

56.

Nondiffusing couplers

US 3,138,604 G

57.

F 808,390 Ag

58.

DRP Anm. K146235 K
F 804,472 K
US 2,875,057 K
DAS 1,036,639 G
US 2,376,679 GAF
GB 627,353 DP
GB 566,880 K
GB 537,921 K
GB 537,696 K

STRUCTURE	NAME	REFERENCE	COMPANY OR INDIVIDUAL
58A. [structure] CO CH$_2$CO ṄH— R		DDR 10538	
59. [structure] CO CH$_2$COR	Furoylaceticacid derivatives	US 2,184,303 GB 478,933 GB 507,611	DP K V
60. [structure] C—CH$_2$-C		US 2,323,503 US 2,377,302	DP DP

This is a yellow
to red coupler.

Appendix 5B
Magenta Couplers

STRUCTURE	NAME	REFERENCE	COMPANY OR INDIVIDUAL
1. (phenyl)$C \equiv C - COCH_2C\ddot{N}$	1–phenyl–2–cyan-acetacetylene	GB 902939 GB 908446 GB 705950 US 2680732	Ag Ag DP Ag

(The λ max of dye obtained from this coupler is 530 nm.)

STRUCTURE	NAME	REFERENCE	COMPANY OR INDIVIDUAL
1A. (phenyl)$\overset{H}{C} = \underset{H}{C} - COCH_2C\ddot{N}$	1–phenyl–2–cyan acetethylene	GB 902939 GB 908446 GB 705950 US 2680732	Ag Ag DP Ag
2. (phenyl)$\ddot{N} - SO_2 -$ (ring) $\overset{CH}{\underset{O}{\|}} C - COCH_2C\ddot{N}$, $i\text{-}C_5H_{11}$		US 2338677 US 2350127 US 2359332	K K K
3. (benzimidazole ring) $\overset{\ddot{N}=}{\underset{\ddot{N}-H}{}} C - CH_2 - C\ddot{N}$	2–cyanomethylbanzoimidazole	DDR 4267	Ag
4. $COCH_2C\ddot{N}$ / (phenyl) / CH_2COOH / $\ddot{N}H - CO\overset{}{\underset{H}{C}} - C_{17}H_{35}$	Cyanoceto derivative	GB 902939 GB 905094	Ag Ag

(The λ max is between 480 and 530 nm.)

	STRUCTURE	NAME	REFERENCE	COMPANY OR INDIVIDUAL
5.	HC——CH / ‖ ‖ / ·HC˷O˳C–CH–CHCOCH$_2$CN	2–cyanacetrinyl-furan	GB 902939	Ag
6.	(benzopyran) COCH$_2$CN / C=CH / C=O / O	2–keto–4–cyan-acetbenzopyran	GB 902939	Ag
7.	(phenyl) CH$_2$ ‖ C—COCH$_2$CN	1–phenyl–1–cyanacet ethyline	GB 902939	Ag
8.	H C–O CH–CH$_2$CH$_2$O—(benzofuran, CH$_3$)—COCH$_2$CN C–O H		US 2680733	DP
9.	CH$_3$CSCH$_2$CSR	Dithio–β–diketone derivatives	F 804472	K
10.	CNCH$_2$CONH–C(benzothiazole ring system)S C–NHCOCH$_2$CN:	(This coupler produces orange to magenta dyes depending on the substituent R.)		
		heterocyclic diamines with cyanoacetamide substituents	US 2182815	DP
11.	CO–NH–N=C–CH$_2$COOR \| \| / CH$_2$ CH$_3$ \| \| / CH$_2$ CH$_3$ \| \| / CO–NH–N=C–CH$_2$COOR		GB 590637	G

606

	STRUCTURE	NAME	REFERENCE	COMPANY OR INDIVIDUAL

12. $R - \overset{\overset{H}{|}}{C} = \ddot{N} - \ddot{N}HCOCH_2C\ddot{N}$

Where R is an alkyl or aryl group having no active methylene groups.

cyanacethydar-zones (Reaction products of $H_2\ddot{N}\ddot{N}HCOCH_2C\ddot{N}$ cyanacethydrazine with compounds containing the group C = 0).

GB 615218 G

13. OH — [ring with OCH$_3$] — $CH = \ddot{N} - \ddot{N}HCOCH_2C\ddot{N}$

(3—methoxy—4—hydroxybenza-ldehyde) cyan-acethydrazone

GB 615218 G

This entry is an example of the compounds in entry number 12. Compounds formed by reacting an aldehyde or ketone with a substituted hydrazine are well known in Organic Chemistry as a means of isolating and identifying aldehydes and ketones. These hydrazones are usually solid and many compounds of wide ranging melting points may easily be prepared as hydrazones. These couplers, when coupled with PPD type developing agents, have a λ max between 480 and 550 nm.

14. $Z - \overset{\overset{Y}{||}}{C} - \overset{\overset{R}{|}}{N} - COCH_2X$

where R = H, alkyl, aryl;

F 897483
Supplement
54847 K

15. $R - \overset{\overset{H}{|}}{\underset{..}{N}} -$ [ring with COCH$_2$CN and COCH$_2$CN]

N—substituted 3,5 dicyanacet-anilines

GB 878891 Ag
US 2563375 GAF
US 2563376 GAF

16. [benzofuran ring with CH and C-COCH$_2$CN]

2—cyanacet-benzofuran

US 2115394 K
GB 908466 Ag

(λ max between 515 to 520 nm)

	STRUCTURE	NAME	REFERENCE	COMPANY OR INDIVIDUAL

17.

1–substituted–3-
methylpyrazolones

US 1969479

K

When R = (phenyl) λ max is 525 nm with a small secondary
maximum at 445 nm.

18.

N–(2'–benzothia-
zolyl)–N–3'–
[1'–R–pyrazolonyl])
amine

GB 636988

G

19.

NHSO$_2$R

1–(β-R sulfonamid-
ophenyl)–β-R' pyra-
zolone

US 2353205

K

20.

1–R–3 alkylpyra-
zolone

GB 902820

Ag

21.

derivatives of
pyrazolones

US 2865748

K

Where R' = H, acyl;
R'' = acyl,
R''' = H, alkyl,
aryl,
RIV = H, acyl

STRUCTURE	NAME	REFERENCE	COMPANY OR INDIVIDUAL
22. [3-amino-bispyrazolone structure with R', R substituents]	3—amino—bispyraz-olones	US 2691659	K
23. [bispyrazolone structure with R']	Bispyrazolones	US 2013181 GB 503941	GAF K
24. $ROOC(CH_2)_n$—[pyrazolone ring with R]	1,3 substituted pyrazolones	GB 532726	I
25. $C_{16}H_{23}$—CH—CONH—[pyrazolone structure] SO_3H ... SO_2—[morpholine ring N S O]	1,3 substituted pyrazolones	US 2829975 DAS 1051638	GAF GAF
26. R—C[pyrazolone with NH$_2$ phenyl] R—C[benzimidazole-fused structure]	1,3 substituted pyrazolones	DAS 1070030 DAS 1046496	Ag Ag
27. [R O—C pyrazolone ring with R']	1,3 substituted pyrazolones	US 2376380 US 2439098 US 2472581 GB 478990 GB 599919	K K K K K

	STRUCTURE	NAME	REFERENCE	COMPANY OR INDIVIDUAL
28.		1,3 substituted pyrazolones	US 2899443	GAF
29.		1,3 substituted pyrazolones	US 2899443	GAF
30.		1,3 substituted pyrazolones	F 965998 F 930289	K K
31.		1,3 substituted pyrazolones	GB 759642 GB 902821	Ag Ag
32.		1,3 substituted pyrazolones	US 2200306 GB 736876 US 2354552	GAF Ag GAF

STRUCTURE	NAME	REFERENCE	COMPANY OR INDIVIDUAL

33. 1,3 substituted pyrazolones — GB 681915 — G

34. 1,3 substituted pyrazolones — GB 737105 — K

35. 1,3,4 substituted pyrazolones — GB 542149 — I

36. 3–R′–1–(2′–Benz-imidazolyl) – pyra-zolone — GB 813866 — I

37. DAS 1002199 — VEB Wolfen

STRUCTURE	NAME	REFERENCE	COMPANY OR INDIVIDUAL

38. where X = 0, or S — bispyrazolones — US 2200924 / US 2637732 — DP / Ciba

39. oxodiazoles — US 2473166 / DAS 1045230 — G / G

$R-C\underset{S}{\overset{N-N}{\underset{\ }{C}}}CH_2CN:$

40. $1-(2-[5-sulfoben-zothiazole])-3-R$ pyrazolone — GB 904137 — Ag

41. $C_2F_5CONH-C\ ...$ — $1-R-3-(\beta-perfluoro-propionylamide)$ pyrazolone — US 2895826 — K

These compounds are heat and light stable.

42. $R-C\ ...\ CH_2-CH_2SO_3H$ — 1-ethylsulfonic-acid-3-R-pyrazolone — DRP 699710 / US 2265221 / US 2309562 — Ag / GAF / GAF

43. — US 2593890 — GAF

STRUCTURE	NAME	REFERENCE	COMPANY OR INDIVIDUAL
44.	1−trichlorophenyl− 3−R−pyrazolone	US 2933391	K
45.	1−R′−3−alkysulfon- amido-pyrazolone	GB 737700	ICI
46.	1−R−3−hydroxy- pyrazolone	GB 577260	I
47.	1−R−3−hydroxy- pyrazolone	GB 577260	I
48.		GB 670746	I
49.	polymerized pyrazolones	US 254621	K

613

STRUCTURE	NAME	REFERENCE	COMPANY OR INDIVIDUAL
50.	1—phenyl—3—hydroxy—5—ketimin-opyrazolone	Conrad and Zart, Berichte 39,2287 (1906)	
51.	1—R—3—amino-pyrazolone	US 2600788	K
52.	Coupling with aminopyrazolones	GB 737692	ICI
53.	Reactions of pyrazolones	US 2593890	GAF
54.	1—R—3—hydroxy—5(4—methoxy-phenylketiminyl) pyrazolone	US 2311081 GB 547064 US 2343702 GB 553506 US 2343707 GB 553507	K K K K K K
55.	5—acyloxypyra-zolones	US 2436130 US 2575182 US 2865748	K DP K
56.	1—R'—5—(R''guanid-ino) pyrazolone	GB 737700	ICI
57.	1—R—3—Acylamino-pyrazolones	US 2511231	K

	STRUCTURE	NAME	REFERENCE	COMPANY OR INDIVIDUAL
58.		1,3 substituted pyrazolones	US 2348463	GAF
59.		1–cyano–1–alkyl-amido–3–phenyl-propene	US 2436007	I
60.		1–nitro–3–phenyl-propene	US 2436007	I
61.		Methods of preventing diffusion in pyrazolones	US 2437063 US 2200306	GAF GAF
62.		Diazocompounds	GB 617233	G
63.		1,3 substituted pyrazolones	US 2343703 US 2927928 GB 558855 GB 737692	K GAF K ICI
64.			US 2481466 US 2403329	GAF GAF
65.			US 2403040 US 2368302	GAF GAF

Structures:
- 58: $C_{17}H_{35}C$ pyrazolone ring with CH_2, $C=O$, N, N; attached to phenyl with SO_3H and O-phenyl.
- 59: phenyl–CH_2–$CH=C$ with CN and $CONHR$.
- 60: phenyl–CH_2–$CH=CHNO_2$.
- 62: NO_2–phenyl–CH_2–$N=N$–phenyl–SO_3H.
- 64: $O=C$–$N=C$–CH_2 fused ring with HC, C, N, N, $C=O$, CH_3.
- 65: bis-chromone structure with OR, $C=C$–CH_2, O, $C=O$.

STRUCTURE	NAME	REFERENCE	COMPANY OR INDIVIDUAL

66.

1—phenyl—3— [3—(4—
tert—amylphenoxy)
benzamido] pyra-
zolone

US 2369489 K

67.

1— [4—(3,5—Dimethyl—
phenoxy) phenyl]
—3—(4—tert—amyloxy-
—3—methyl-benzamido)
pyrazolone

US 2369489 K

68.

1,3,5 substituted
pyrazolones

US 2706685 K

69.

3—R amino—isoxa-
zolone

GB 576890 I

616

STRUCTURE	NAME	REFERENCE	COMPANY OR INDIVIDUAL

70.

| | Substituted Bispyrozolones | US 2435550 | GAF |

71.

| | Bridged Bispyra-zolones | US 2671021 US 2592303 US 2340763 | GAF K DP |

72.

| | Unsymmetrical bridged Bispyra-zolones | US 2706683 | K |

73.

| | Derivatives of Indazolinones | US 2866706 US 2881167 GB 729505 | ICI ICI ICI |

Also

This is an example of a coupler with no active methylene group.

It couples with $H_2\ddot{N}$—⟨⟩—$\ddot{N}R_2$ to form

, an azo dye.

STRUCTURE	NAME	REFERENCE	COMPANY OR INDIVIDUAL

74.

λ max = 579 nm

| | 4,6 Dimethyl–
5–aza–indazolinone | GB 663190 | G |

75.

| | 2–Chloroacetyl–
indazolinone | GB 685061 | G |

76.

| | Substituted 2–
Thiazolylhyd–
razone | DDR 14668

DAS 1040372 | VEB
Wolfen
VEB
Wolfen |

77.

| | | DDR 14668

DAS 1040372 | VEB
Wolfen
VEB
Wolfen |

78.

| | Substituted
Imidazolones | US 2421693 | GAF |

79.

| | | US 2376192 | K |

STRUCTURE	NAME	REFERENCE	COMPANY OR INDIVIDUAL
80.		US 2328652	DP
81.	2—Propionyl— —6—octadecenyl— succinyl—amino— indazolon	GB 720284	G
82.	N—substituted Rhodanines	GB 509707	K
83.	α—Napthol—β— carb—onamides	F 956226	Ag
84.	Indandion	US 1102028	R. Fischer
85.		US 2036546	GAF
86.	Substituted 2—methylpyroles	DRP 738080	Ag

	STRUCTURE	NAME	REFERENCE	COMPANY OR INDIVIDUAL
87.		Oxindole	GB 511790	Ag
88.		Thiohydantion	US 2551134	DP
89.		Imidazolone—4	GB 782545	I
90.			US 2632702	K
91.			GB 1035959	I

where R = alkyl group of at least 12 C atoms, R_1 is p-sulfophenyl ($-SO_3M$) or p-sulfophenoxyphenyl ($-O-SO_3M$), X = H,

or $-N=N-$ R_3 , R_2 = H, or alkoxy group of 1—4 C atoms,

R_3 = alkoxy of 1—4 C atoms , M = H , alkali metal or NH_4^+.

STRUCTURE	NAME	REFERENCE	COMPANY OR INDIVIDUAL

92.

where B = pyrazolone ring, X = H, or alkyl of 1 – 3 C atoms Y = CO when X = H
and Y = $-SO_2-$ when X = alkyl, R = alkyl of 12 or more C atoms or some other
group which contains an alkyl of 12 or more C atoms. Molecules I and II are
examples of types that can be made into cyan or yellow couplers by the correct B.

For example, when B = $-COCH_2CONH$ ⟨ ⟩ then I and II are yellow

couplers; when B = ⟨ ⟩ OH, then I and II are cyan couplers.

93.

1,3 substituted
pyrazolones

GB 1039880

Ag

Where R is a saturated or unsaturated alkyl or olefin group with 8-20C atoms,
R_1 = 4–ethoxy–3 sulfophenyl. These couplers possess especially favorable
absorption properties and they are added to AgX emulsions in quantities of
15–100g/g mole of AgX.

94.

GB 1044778

I

Where R = phenyl, monochlorophenyl, dichlorophenyl or trichlorophenyl
group; R_1 = halogen, R_2 = acyl group containing an alkyl group of at least 10 C
atoms and at least one COOH group; R_3 = alkoxy group or – NHCO – alkyl
group in which the alkyl group contains 1 – 4 C atoms; R_4 = H, or alkoxy
group of 1 – 4 C atoms.

STRUCTURE	NAME	REFERENCE	COMPANY OR INDIVIDUAL

95.

$D-(X)_{n-1}-Y-\ddot{N}-\ddot{N}$

A : SO$_3$H or SO$_3$H salt

Where A = SO$_3$H or SO$_3$H salt, Z the atoms to complete an aromatic substituted nucleus; Y = divalent aromatic radical (for example); X = 0, S, SO$_2$, −

−SO$_2$NH− or Y ← −SO$_2$N − R$_2$; D = acyclic aliphatic radical for minimizing diffusion about 5−20 C atoms and n = 1, or 2. These dyes are low in blue absorption and cut off sharply on long wavelength side.

GB 1044959 — G

96.

I II

East German Patent 46,633
W. Schindler, H. Pietrzok,
E. M. Marx.

Where R is a magenta coupler. Molecules I and II are examples of types which form covalent bonds with gelatin so that diffusion is prevented. They may also be made into cyan and yellow couplers by the correct R substituent.

97.

Jap. 42-11,309
Konishiroku Photo
Industry Co. Ltd.

Where R$_1$ = substituted on nonsubstituted aryl or heterocyclic group; R$_2$ = alkyl of 12-17 C atoms plus many others. This coupler is claimed to automatically produce a yellow mask during development with PPD type DA.

STRUCTURE	NAME	REFERENCE	COMPANY OR INDIVIDUAL

98. Q – T – X

Jap. 42-11,302 FP
Fuji Photo Film Co.

Where Q = magenta coupler; T = linking group; X = dichloro or trichloropyrimidinyl group. The diffusion hindering group is X, which forms covalent bonds with gelatin.

H_2C —— C — NHCONHR

GB 1066334 G
GB 1007847 G

Where R = alkyl of 5-20 C atoms;
R_1 = phenyl or substituted phenyl

99.

Fluoroalkyl–2–Pyrazolone GB 1069533 G

These couplers have improved light stability.

100.

Cyanoacetyl derivatives. USSR 184619

Appendix 5C
Cyan
Couplers

	STRUCTURE	NAME	REFERENCE	COMPANY OR INDIVIDUAL
1.		5–cyanacetylamine– 1–napthol	US 2507180	K
2.			DAS 1009923	GAF
3.			DRP 165126 DDR 5567 US 2373821 US 2530349 DDR 5906	Ag GAF GAF
4.		N–phenyl–homo- phthalimide	US 2328652	DP

	STRUCTURE	NAME	REFERENCE	COMPANY OR INDIVIDUAL
5.	OH / $CON\ddot{H}_2$ (naphthalene)		GB 519208	I
6.	OH / CON: R', R' / SO_3H (naphthalene)		GB 727693	ICI
7.	—S— bis-naphthalene, HO / HO	Thio—bis—α— napthole	GB 567224	Dufay Chromex
8.	OH / $CON\ddot{H}$— / :NH / $COC_{17}H_{35}$ (naphthalene + dibenzofuran)		DB 939313	Ag
9.	OH / CON: R', R'' / X (naphthalene)		GB 519208	I
10.	OH / CH=R (benzene)	p—hydroxy- benzal R	US 216337	K
11.	OH / N / $N=C-\ddot{N}H_2$ / :NH_2 (pyrimidine)	2,6—Diamino- pyrimidinderiv- atives	US 2355691	K

626

STRUCTURE	NAME	REFERENCE	COMPANY OR INDIVIDUAL
12.	2,4–Diarylpyrole derivatives	GB 562960	ICI
13.		DRP 745046	Zeiss Ikon
14.	2–propene–5– methyl phenol	F 956732	K
15.		GB 506224	G
16.		US 2474293	K
17.		US 2472910	DP
18.		US 2357395	GAF

STRUCTURE	NAME	REFERENCE	COMPANY OR INDIVIDUAL

19.

OH ... OH
CH=N̈[(CH₂)₂N̈H]₂–(CH₂)₂–N̈=CH

US 2418747 — GAF

20.

OH ... OH
CON̈H—CH₂N̈HCO
SO₃H ... SO₃H

US 2498466 — DP

21.

H . R′
 N̈
OH |
 C
 ‖
 O
—O—...—OH

US 2189817 — DP

22.

OH
:NH SO₃H
|
COR

DDR 7213 — Ag
US 2312004 — GAF

23.

OH OH
SO₂N̈H–AN̈HSO₂

DDR 7213
US 2312004
US 2313586
GB 717698
US 2435629 — DP
US 2395484 — DP

24.

HO

3–hydroxy pyridine

US 2293004 — GAF

25. CH₃

OH

1–phenyl–4–methyl–6–hydroxy–α–pyridone

US 2293004 — GAF

STRUCTURE	NAME	REFERENCE	COMPANY OR INDIVIDUAL
26.		GB 615477	G
27.		GB 615477	G
28.		US 2376192	K
29.		US 2376192	K
30.		US 2543745	GAF
31.		DAS 1036053	G

26.

OH
CONH–NH
CO
⌋2

27.

OH
CONH–N=CH–⟨phenyl⟩

28.

NHR
H C CH2
R—C
C=O N C=O
H

29.

N—R
H C CH2
R—C
O=C N C=O
⟨phenyl⟩

30.

O CONH–⟨naphthyl-OH⟩

31.

OH
CONH–⟨phenyl with SO3H and OC16H33⟩

629

STRUCTURE	NAME	REFERENCE	COMPANY OR INDIVIDUAL

32.

F 966004 — K

33.

$-O-CH(CH_2)_nCH_3$, R

US 2166181 — DP

34.

SO_2N-R, H

J. Allg. Chem. (Russian), 26,2537 (1936)

US 2306410 — K
US 2356475 — K
US 2362598 — K

35.

US 2313138 — GAF

36.

(t) C_5H_{11} — $O-CH-CONH$ — $NHCOC_3F_7$
(t) C_5H_{11}

US 2895826 — K

37.

CON, CH_3

US 2313586 — K
GB 538914 — K

38.

$CONH$ — N: CH_3, $C_{18}H_{37}$, SO_3H

US 2324832 — GAF

STRUCTURE	NAME	REFERENCE	COMPANY OR INDIVIDUAL

39.

GB 566772 — Dufay Chromex

40.

GB 623622 — I

41.

DDR 5906
F 878943 — Ag

42.

US 2373821 — GAF
US 2545687 — GAF
US 2547307 — GAF
US 2530349 — GAF

43.

US 2389575 — DP

44.

US 2476559 — GAF

	STRUCTURE	NAME	REFERENCE	COMPANY OR INDIVIDUAL

45.

GB 562205 — K
US 2242337 — K
US 2367531 — K

46.

GB 576963 — I

47.

GB 747628 — ICI

48.

GB 747628 — ICI

49.

F 932479 — K

50.

F 932479 — K

632

STRUCTURE	NAME	REFERENCE	COMPANY OR INDIVIDUAL
51.		F 932479	K
52.		F 932479	K
53.	1,8–Dihydroxy-napthalene	Can 440776	GAF
54.	2–alkyl–5–methyl phenol	US 2338676	K
55.		US 2465067	DP
56.		US 2350812	K
57.		GB 458665	K

STRUCTURE	NAME	REFERENCE	COMPANY OR INDIVIDUAL
58.		GB 458665 US 2039730	K K
59.	α–Dinapthol	GB 566772	Dufay Chromex
60.		US 2394527	DP
61.		US 2366324	GAF
62.		US 2366324	GAF
63.		US 2445252	GAF

634

STRUCTURE	NAME	REFERENCE	COMPANY OR INDIVIDUAL

64.

US 24880815 — GAF

65.

US 2423730 — K
US 2367531 — K
US 2772162 — K
US 2369929 — K

66.

US 2728660 — K

67.

Jap 42-11304 — FP
F 1455447 — FS
GB 1070768 — FS

68.

$n = 12 - 18$

Jap 42-11,303 — FP

69. $Q - T - X$

Jap 42-11,303 — FP

Where Q = cyan coupler, T = linking group, and X = dichloro — or trichloro — pyrimidinyl group which forms covalent bonds with amino or hydroxyl group of gelatin, polyvinyl alcohol, etc.

STRUCTURE	NAME	REFERENCE	COMPANY OR INDIVIDUAL

70. $1,2-HOC_{10}H_6CONHCH_2CH_2C_6H_4NHCOR_x$ — Belg 672255 FP / GB 1062190 FP

$X = 2, R = C_2H_5$

$X = 2, R = CH_3$

$X = 4, R = C_2H_5$

71.

Where R = cyan coupler

East German 46,633

72.

GB 1039452 I

Where B = cyan coupler and other difinitions are found in section on magenta couplers entry #91.

Appendix 5D
PPD
Developing
Agents

PARAPHENYLENEDIAMINE

$$R_1, R_2 - N - \text{(ring: 6, 5, 4, 3, 2)} - NH_2$$

R_1, R_2, POSITIONS AND SUBSTITUENTS	NAME	HALF WAVE POTENTIAL
1. CH_3CH_2-, CH_3CH_2-, $3-NHCH_2CH_3$	4 Amino—3—ethylamino—N,N—diethylaniline	$E_{1/2} = -17$
2. CH_3CH_2-, CH_3CH_2-, $3-NHSO_2CH_3$	4 Amino—3—methylsulfon—amido—N,N—diethylaniline	$E_{1/2} = -81$
3. CH_3CH_2-, CH_3CH_2-, $3-N\begin{cases}CH_3\\CH_3\end{cases}$	4 Amino—3—dimethylamino—N,N—diethylaniline	$E_{1/2} = -110$
4. CH_3CH_2-, CH_3CH_2-, $3-OCH_2CH_3$	4 Amino—3—ethoxy—N,N—diethylaniline	$E_{1/2} = -153$
5. CH_3CH_2-, CH_3CH_2-, $3-OCH_3$	4 Amino—methoxy—N,N,—diethylaniline	$E_{1/2} = -159$
6. CH_3CH_2-, $-CH_2CH_3\overset{..}{N}HSO_2CH_3$, $3-OCH_2CH_3$	4 Amino—ethoxy—N—ethyl—N—(β—methylsulfonamidoethyl) aniline	$E_{1/2} = -163$

R_1, R_2, POSITIONS AND SUBSTITUENTS	NAME	HALF WAVE POTENTIAL
7. CH_3CH_2-, CH_3CH_2-, 3,5–CH_3	4 Amino–3,5–dimethyl–N,N–diethylaniline	$E_{1/2} = -167$
8. CH_3CH_2-, $CH_3SO_2-N-CH_2CH_2-$, $\quad\quad\quad\quad\quad\quad\mid$ $\quad\quad\quad\quad\quad\quad CH_3$ 3–OCH_2CH_3	4 Amino–3–ethoxy–N–ethyl–N–(N–methyl–β–methylsulfon–amidoethyl) aniline	$E_{1/2} = -176$
9. CH_3CH_2-, CH_3CH_2-, 3–$C(CH_3)_3$,	4 Amino–3–tert–butyl–N,N–diethylaniline	$E_{1/2} = -179$
10. CH_3CH_2-, CH_3CH_2-, 2–OCH_3, 5–OCH_3	4 Amino–2,5–dimethoxy–N,N,diethylaniline	$E_{1/2} = -187$
11. CH_3CH_2-, $HOCH_2CH_2-$, 3–CH_3	4 Amino–3–methyl–N–ethyl–N–(β–Hydroxyethl) aniline	$E_{1/2} = -188$
12. CH_3CH_2-, CH_3CH_2-, 3–CH_3	4 Amino–3–methyl–N,N–diethylaniline	$E_{1/2} = -190$
13. CH_3CH_2-, $CH_3SO_2\ddot{N}HCH_2CH_2$, 3–$CH_3$,	4 Amino–3–methyl–N–ethyl–N–(β–methylsulfonamidoethyl) aniline	$E_{1/2} = -190$
14. CH_3CH_2-, CH_3CH_2-, 3–$CH_2CH_2CH_3$,	4 Amino–3–(n–propyl)–N,N–diethylaniline	$E_{1/2} = -193$
15. CH_3CH_2-, CH_3CH_2-, 3–$\ddot{N}COCH_3$	4 Amino–3–acetamido–N,N–diethylaniline	$E_{1/2} = -199$
16. CH_3CH_2-, CH_3CH_2-, 3–$CH_2CH_2\ddot{N}HSO_2CH_3$	4 Amino–3–(β–methylsulfon–amidoethyl)–N,N–diethylaniline	$E_{1/2} = -200$
17. CH_3CH_2-, 3–CH_3	4 Amino–3–methyl–N–ethyl–N–(tetrahydrofurfurylaniline)	$E_{1/2} = -201$

R_1, R_2, POSITIONS AND SUBSTITUENTS	NAME	HALF WAVE POTENTIAL
18. CH_3CH_2-, CH_3CH_2-, $3-CH_2CH_2$ $\overset{..}{N}-SO_2CH_3$ \vert CH_3	4 Amino$-3-$(N$-$methyl$-\beta-$methylsulfon$-$amidoethyl)$-$N,N$-$diethylaniline	$E_{1/2} = -202$
19. CH_3CH_2-, CH_3CH_2-, $3-CH_2CH_3$	4 Amino$-3-$ethyl$-$N,N$-$diethylaniline	$E_{1/2} = -203$
20. CH_3-, $CH_3SO_2\overset{..}{N}HCH_2CH_2-$, $3-CH_3$	4 Amino$-3-$methyl$-$N$-$methyl$-$N$-(\beta-$methylsulfonamidoethyl) aniline	$E_{1/2} = -204$
21. CH_3CH_2-, $\overset{..}{N}H_2CH_2CH_2-$	4 Amino$-$N$-$ethyl$-$N$-(\beta-$amino$-$ethyl) aniline	$E_{1/2} = -204$
22. $CH_3CH_2CH_2-$, $CH_3 CH_2CH_2-$, $-$,	4 Amino$-$N,N$-$di (n$-$propyl) aniline	$E_{1/2} = -204$
23. CH_3CH_2-, $HOCH_2CH_2-$	4 Amino$-$N$-$ethyl$-$N$-(\beta-$hydroxyethyl) aniline	$E_{1/2} = -206$
24. CH_3CH_2-, CH_3CH_2-, $3-CH_2CH_2\overset{..}{N}H_2$	4 Amino$-3-(\beta-$aminoethyl)$-$N,N$-$diethylaniline	$E_{1/2} = -210$
25. CH_3CH_2-, CH_3CH_2-, $3-SCH_3$,	4 Amino$-$N,N diethyl$-3-$methy$-$thioaniline	$E_{1/2} = -210$
26. CH_3CH_2-, CH_3CH_2-, $3-CH_2CH_2OH$	4 Amino$-3-(\beta-$hydroxyethyl)$-$N,N$-$diethylaniline	$E_{1/2} = -211$
27. CH_3CH_2-, CH_3CH_2-, $3-CH_2CH_3COCH_3$	4 Amino$-3-(\beta-$acetamido$-$ethyl)$-$N,N$-$diethylaniline	$E_{1/2} = -211$
28. CH_3CH_2-, $CH_3CH_2CH_2-$	4 Amino$-3-$N$-($n$-$propyl) aniline	$E_{1/2} = -217$
29. CH_3CH_2-, CH_3CH_2-, $3-CH_2OH$	4 Amino$-3-$hydroxymethyl$-$N,N$-$diethylaniline	$E_{1/2} = -219$

R_1, R_2, POSITIONS AND SUBSTITUENTS	NAME	HALF WAVE POTENTIAL
30. CH_3CH_2-, $CH_3SO_2\overset{..}{N}HCH_2CH_2-$	4 Amino—N—ethyl—N—(β—methylsulfonamidoethyl) aniline	$E_{\frac{1}{2}} = -219$
31. CH_3CH_2-, CH_3CH_2-, $3-CH_2CH_2\overset{..}{N}HSO_2CH_3$	4 Amino—3—β—methylsulfon—amidoethyl—N,N—diethylaniline	$E_{\frac{1}{2}} = -221$
32. CH_3CH_2-, CH_3CH_2-	4 Amino—N,N—deithylaniline	$E_{\frac{1}{2}} = -222$
33. CH_3CH_2-, $CH_3SO_2-\overset{..}{\underset{CH_3}{N}}-CH_2CH_2-$, $3-CH_3$	4 Amino—3—methyl—N—ethyl—N—(N—methyl—β—methylsulfon—amidoethyl) aniline	$E_{\frac{1}{2}} = -222$
34. CH_3-, $CH_3CH_2CH_2-$	4 Amino—N—methyl—N—(n—propyl) aniline	$E_{\frac{1}{2}} = -225$
35. CH_3-, $CH_3CH_2CH_2CH_2-$	4 Amino—N—methyl—N—(n—butyl) aniline	$E_{\frac{1}{2}} = -229$
36. CH_3, CH_3CH_2-	4 Amino—N—methyl—N—ethylaniline	$E_{\frac{1}{2}} = -231$
37. CH_3-,	4 Amino—N—methyl—N—tetrahydrofurfurylaniline	$E_{\frac{1}{2}} = -233$
38. CH_3-, CH_3-	4 Amino—N,N—dimethylaniline	$E_{\frac{1}{2}} = -235$
39. CH_3CH_2-, CH_3CH_2-, $2-OCH_3$, $5-CH_3$	4 Amino—2—methoxy—5—methyl—N,N—diethylaniline	$E_{\frac{1}{2}} = -239$
40. CH_3CH_2-, $CH_3CH_2OCH_2CH_2-$	4 Amino—N—ethyl—N—(β—ethoxyethyl) aniline	$E_{\frac{1}{2}} = -242$
41. CH_3CH_2-, $CH_3SO_2-\overset{..}{\underset{CH_3}{N}}-CH_2CH_2-$	4 Amino—N—ethyl—N—(N—methyl—β—methyl—sulfon—amidoethyl) aniline	$E_{\frac{1}{2}} = -247$
42. CH_3CH_2-, $CH_3C\overset{..}{O}NHCH_2CH_2-$	4 Amino—N—ethyl—N—(β—acetamidoethyl) aniline	$E_{\frac{1}{2}} = -251$

Bibliography

BOOKS

Barrow, G. M., *Physical Chemistry,* McGraw-Hill Book Company, New York (1966), 2nd ed.

Brandt, R. C., *Infra Red Absorption by Localized Polarons in the Silver Halides,* Thesis, University of Illinois, Urbana (1967).

Burton, P. C., *In Fundamental Mechanisms of Photographic Sensitivity,* edited by J. W. Mitchell, Butterworth, London (1951), p. 188.

Eyring H., Walter, J., and Kimbal, G. E., *Quantum Chemistry,* John Wiley & Sons, Inc., New York (1965).

Frenkel, J., *Kinetic Theory of Liquids,* Oxford University Press, New York (1946).

Glasstone, S., Laidler, K. J. and Eyring, H., *The Theory of Rate Processes,* McGraw-Hill Book Company, New York (1941).

Haist, G., *Monobath Manual,* Morgan & Morgan, Inc., Hastings-on-Hudson, N.Y. (1966).

Halliday D. and Resnick, R., *Physics for Students of Science and Engineering,* John Wiley & Sons, Inc., 1963.

Hardy, A. C., *Handbook of Colorimetry,* The Technology Press, MIT, Cambridge, Mass. (1936).

Hodgeman, C. D., *Handbook of Chemistry and Physics,* 43rd ed., Chemical Rubber Publishing, (1962).

Ince, E. L., *Ordinary Differential Equations,* Dover Publications, Inc., New York (1956).

James, T. H., and Higgins, G. C. *Fundamentals of Photographic Theory,* Morgan & Morgan, Inc., Hastings-on-Hudson, N.Y. (1960).

Kaplan W., *Advanced Calculus,* Addison-Wesley Publishing Company, Reading, Mass. (1959).

Kittel, C., *Introduction to Solid State Physics,* 3rd ed., John Wiley & Sons, New York (1967).

Klotz, I. M., *Chemical Thermodynamics Basic Theory and Methods,* Prentice-Hall, Inc., Englewood Cliffs, N.J. (1962).

Lang's Handbook of Chemistry 10th ed., McGraw-Hill Book Company, New York (1961).

McRae, E. G., and Kasha, M., in Augenstein, Rosenberg, and Mason, eds., *Physical Process in Radiation Biology,* Academic Press, New York (1964).

Mees, C. E. K., and James, T. H., *The Theory of the Photographic Process,* 3rd ed., Macmillan Company, New York (1966).

Mizuki, E., *Kaimengensho, Hoshikekkan,* Kyoritsu-Shuppan, Tokyo (1963), p. 350.

Mott, N. F., and Gurney, R. W., *Electronic Process in Ionic Crystals,* 2nd ed., Oxford University Press, New York (1948).

Pauling, L., *The Nature of the Chemical Bond,* 3rd ed., Cornell University Press, Ithaca, N.Y. (1960).

Planck, M., *Thermodynamik,* 3rd ed., Veit and Co., Leipzig (1911).

Roberts, J. D., *Notes on Molecular Orbital Calculations,* W. A. Benjamin, New York (1961).

Thomas, G. B., Jr., *Calculus and Analytic Geometry,* 3rd ed., Addison-Wesley Publishing Company, Reading, Mass. (1962).

Todd, H. N., and Zakia, R. D., *Photographic Sensitometry,* Morgan & Morgan, Inc., Hastings-on-Hudson, N.Y. (1969).

Wall, F. T., *Chemical Thermodynamics,* 2nd ed., W. H. Freeman and Company, San Francisco (1965).

PAPERS

Anderson, M., *Phot. Mitt.,* **28**, 124, 286, 296, 340 (1891, 1892).

Arrhenius, S., *Z. Physik. Chem. (Leipzig),* **4**, 226 (1889).

Bayer, B. E., and Hamilton, J. F., *J. Opt. Soc. Am.,* **55**, 439 (1965).

Barr, C. R., Thirtle, J. R. and Vittum, P. W., *Phot. Sci. Eng.,* **13**, 74 (1969).

Bent, R. L., et al., *J. Amer. Chem., Soc.,* **73**, 3100 (1951).

Bent, R. L., Weissberger, A., et al., *Phot. Sci. Eng.,* **8**, 125 (1964).

Bichowsky R., and Urey, H. C., *Proc. Nat. Acad. Sci. U.S.,* **12**, 80 (1926).

Bird, G., Norland, K., Rosenoff, A. and Michaud, H., *Phot. Sci. Eng.,* **12**, 196 (1968).

Biusson, H., and Fabry, C., *Rev. Opt.,* **3**, 1 (1924).

Brezina, M., Jaenicke, W. and Taithel, H., *Phot. Sci. Eng.,* **13**, 320 (1969).

Brooker, L. G. S., and Vittum, P. W., *J. Phot. Sci.,* **5**, 71 (1957).

Brooker, L. G. S., White, F., Heseltine, D., Keyes, G., Dent, S. Jr., and Van Lare, E., *J. Phot. Sci.,* **1**, 173 (1953).

Bucher, H., Kuhn, H., Mann, B., Mobius, D., von Szentapaly L., and Tillman, P. *Phot. Sci. Eng.,* **11**, 233 (1967).

Burton P. C., and Berg, W. F., *Phot. J.*, **86B**, 2 (1946).

Clementi, E., *J. Chem. Phys.*, **49**, 4916 (1968).

Dyba, R. V., and Smith, T. D., *Phot. Eng.*, **7**, 98 (1956).

Eggers, J., and Frieser, H. *Z. Elektrochem.*, **60**, 372 (1956).

Eggert, J., and Noddack, W. *Sitzber. Preuss. Akad. Wiss.*, **1921**, 631; **1923**, 116; **31**, 922; (1925) **43**, 222 (1927); **58**, 861 (1929).

Evjen, H. M., *Phys. Rev.*, **39**, 675 (1932).

Ewald, P. P., *Ann. Physik*, **64**, 253 (1921).

Frank, F. C., *Phil. Mag.*, **41**, 1287 (1950).

Frieser, H., and Klein, E., *Z. Elektrochem.*, **62**, 874 (1958).

Frieser, H., and Klein, E., *Phot. Sci. Eng.*, **4**, 264 (1960).

Goudsmit, S., and Uhlenbeck, G., *Naturwiss.*, **13**, 953 (1925).

Grimly, T. B., *Proc. Roy. Soc., (London)*, **B201**, 40 (1950).

Grimly, T. B., and Mott, N. F., *Discussions Faraday Soc.*, **1**, 3 (1947).

Gurney, R. W., and Mott, N. F., *Proc. Roy. Soc. (London)*, Ser. A **164**, 151 (1938).

Hada, H. and Tamura, M., *Bull. Soc. Sci. Phot. Japan*, p. 1 (No. 7, 1957).

Hamilton, J. F., *Phot. Sci. Eng.*, **13**, 331 (1969).

Hamilton, J. F., and Bayer, B. E. *J. Opt. Soc. Am.*, **56**, 1088 (1966).

Hamilton, J. F., and Brady, L. E., *J. Appl. Phys.*, **30**, 1893 (1959).

Hamilton, J. F., and Brady, L. E., *J. Phys. Chem.*, **66**, 2384 (1962).

Hamilton, J. F., Hamm, F. A., and Brady, L. E., *J. Appl. Phys.*, **27**, 874 (1956).

Hanson, W. T., Jr., and Horton, C. A., *J. Opt. Soc. Am.*, **42**, 663 (1952).

Hautot, A., *Inventaire des Travaux Menes dans le Champ de la Photographie Scientifique*, Establissements Ceuterick Louvain, Belgium (1958).

Haynes, J. R., and Shockley, W., *Phys. Rev.*, **82**, 935 (1951).

Hedges, J. M., and Mitchell, J. W., *Phil. Mag.*, **44**, 223, 357 (1953).

Hirschfelder, J. O., *J. Chem. Phys.*, **6**, 795 (1938).

Hochstrasser, R. M., and Kasha, M., *Phot. Chem. Phot. Biol.*, **3**, 317 (1964).

Hunig, S., and Richters, P. *Ann. Chem.*, **612**, 282 (1958).

Jahn, H. A., and Teller, E., *Proc. Roy. Soc. (London)*, **A161**, 220 (1937).

James, T. H., *J. Phot. Sci.,* **6**, 49 (1958).

James, T. H., *Phot. Sci. Eng.,* **7**, 304 (1963).

James, T. H., *Phot. Sci. Eng.,* **14**, 84 (1970).

James, T. H., and Weissberger, A., *J. Amer., Chem. Soc.,* **61**, 442 (1939).

James, T. H., Snell, J. M. and Weissberger, A., *J. Am. Chem. Soc.,* **60**, 2084 (1938).

James, T. H., Vanselow, W. and Quirk, R. F., *Phot. Sci. Tech.,* **19B**, 170 (1953).

Julians, D. B., and Ruby, W. R., *J. Amer. Chem. Soc.,* **72**, 4719 (1950).

Kapteyn, J. C., and van Uven, M. J., *Skew Frequency Curves in Biology and Statistics,* 2nd paper, Hoitsems Brothers, Groningen, Netherlands (1916).

Kasha, M., Rawls, and El-Bayoumi, *Pure Appl. Chem.,* **11**, 317 (1965).

Katz, E., *J. Chem. Phys.* **17**, 1132 (1949).

Kendall, J. D., *Proc. Congr. Intern. Phot. 9th, Paris* (1935) p. 227.

Kuhn, H., *Z. Elektrochem. Angew. Chem.* **53**, 165 (1949).

Kurbaton, B. L., and Vilesov, F. I., *Dohl. Akad. Nauk. SSSR,* **132**, 532 (1960).

Lehovec, K., *J. Chem. Phys.,* **21**, 1123 (1953).

Levison, G. S., Simpson, W. T. and Curtis, W., *J. Amer. Chem. Soc.,* **79**, 4314 (1957).

Lewis, W. C., and James, T. H., *Phot. Sci. Eng.,* **13**, 54 (1969).

Loveland, R. P., and Trivelli, A. P. H., *J. Phys. Collection Chem.,* **51**, 1004 (1947).

Lumiére, A. and Lumiére, L., *Bull. Soc. Franc. Phot.,* **7**, 310 (1891).

Lyalikov, K. S., Tsarev, B. A., Lileibove, Ya. and Kurnakov, V. N., *Otd. Khim. Nauk,* **2**, 38 (1954).

McRae, E. G., and Kasha, M., *J. Chem. Phys.,* **28**, 721 (1958).

Madelung, E., *Physik. Z.,* **19**, 524 (1918).

Marriage, A., *J. Phot. Sci.,* **9**, 93 (1961).

Matsen, F. A., *J. Chem. Phys.,* **24**, 602 (1956).

Meiklyar, P. V., *Zh. Nauchn. Prikl. Fotogr. Kinematogr.* **4**, 62 (1959).

Michaelis, L., *Ann. N.Y. Acad. Sci.,* **40**, 39 (1940).

Mitchell, J. W., *Rept Progr. Phys.,* **20**, 433 (1957).

Mitchell, J. W., and Mott, N. F., *Phil. Mag.,* **2**, 1149 (1957).

Mott, N. F., *Phot. J.,* **88B**, 119 (1948).

644

Mulliken, R. S., *J. Chem. Phys.*, **2**, 782 (1934).

Mutter, R., *Z. Wiss. Phot.*, **26**, 193 (1929).

Nelson, R. C., *J. Phys. Chem.*, **71**, 2517 (1967).

Nelson, R. C., *J. Mol. Spectroscopy*, **23**, 213 (1967).

Newmiller, R. J., and Pontius, R. B., *Phot. Sci. Eng.*, **5**, 283 (1961).

Pelz, W., *Angew. Chem.*, **66**, 231 (1954).

Pitzer, K. S., *J. Amer. Chem. Soc.*, **70**, 2140 (1948).

Porter, R. N., and Karplus, M., *J. Chem. Phys.*, **40**, 2358 (1964).

Ruby, W. R., *Rev. Sci. Instr.*, **26**, 460 (1955).

Saunders, V. I., Tyler, R. W., and West, W., *Phot. Sci. Eng.*, **12**, 90 (1968).

Sawdey, G. W., Ruoff, M. K., and Vittum, P. W., *J. Amer. Chem. Soc.*, **73**, 4947 (1950).

Seitz, F., *Rev. Mod. Phys.*, **23**, 328 (1951).

Silberstein, L., *J. Opt. Soc. Am.*, **32**, 326 (1942).

Slifkin, L., McGowan, W., Fukai, A., and Kim, J. S., *Phot. Sci. Eng.*, **11**, 79 (1967).

Spencer, H. E., and Atwell, R. E., *J. Opt. Soc. Am.*, **54**, 498 (1964).

Sprague, G., *J. Appl. Phys.*, **32**, 2410 (1961).

Stanienda, A., *Z. Physik. Chem.*, **33**, 170 (1962).

Stern, O., and Gerlach, W., *Z. Physik*, **8**, 110; **9**, 349 (1922).

Stevens, G. W. W., *Phot. J.*, **82**, 42 (1942).

Storch, L., *Ber.*, **27**, Ref. 77 (1894).

Tamura, M., and Hada, H., *Phot. Sci. Eng.*, **11**, 82 (1967).

Tamura, M., and Tutichasi, S., *Sci. and Appl. Phot. Proc. R.P.S. Centenary Conf. London,* 1953, p. 103 (pub. 1955).

Tani, T., *Phot. Sci. Eng.*, **13**, 231 (1969).

Tani, T., *Phot. Sci. Eng.*, **14**, 63 (1970).

Tani, T., *Phot. Sci. Eng.*, **14**, 72 (1970).

Tani, T., and Kikuchi, S., *Phot. Sci. Eng.*, **11**, 129 (1967).

Tani, T., Kikuchi, S., and Honda, K., *Phot. Sci. Eng.*, **12**, 80 (1968).

Tong, L. K. J., *J. Phys. Chem.*, **58**, 1090 (1954).

Tong, L. K. J., and Glesmann, M. C., *J. Amer. Chem. Soc.*, **79**, 583 (1957).

Trautweiler, F., *Phot. Sci. Eng.*, **12**, 98 (1968).

Trautweiler, F., *Phot. Sci. Eng.*, **12**, 138 (1968).

Uhlenbeck, G., and Goudsmit, S., *Nature* **117**, 264 (1926).

Van Heyningen, R. S., and Brown, F. C., *Phys. Rev.*, **111**, 462 (1958).

Vittum, P. W., and Brown, G. H., *J. Amer., Chem. Soc.*, **68**, 2235 (1946).

Vittum, P. W., and Brown, G. H., *J. Amer., Chem. Soc.*, **69**, 152 (1947).

Vittum, P. W., and Brown, G. H., *J. Amer. Chem. Soc.*, **71**, 2287 (1949).

Vittum, P. W., and Weissberger, A. *J. Phot. Sci.*, **2**, 81 (1954).

Vogel, H. W., *Ber.*, **6**, 1302 (1873).

Webb, J. H., *J. Opt. Soc. Am.*, **38**, 27 (1948).

Webb, J. H., *J. Opt. Soc. Am.*, **40**, 3 (1950).

Webb, J. H., *J. Opt. Soc. Am.*, **40**, 197 (1950).

West, W., Lovell, S. P., and Cooper, W., *Phot. Sci. Eng.*, **14**, 52 (1970).

West, W., *Phot. Sci. Eng.*, **6**, 92 (1962).

Wheatley, P. J., *J. Chem. Soc.*, 1959, 3245 4096.

Willems, J., and Van Veelan, G., *Phot. Sci. Eng.*, **6**, 49 (1962).

Wintringham, W. T., *Color Television and Colorimetry*, Bell Telephone System Monagraph 1910, *Proc. IRE*, **39**, 1135-1172 (1951).

Index

A

ABSORPTION
band spectra of a cyanine dye 417
band spectra of photographic sensitizing
materials 416
elementary layer 227
optical 67
photon, in surface latent image 150
of radiation 397
rate of, in surface latent image 151
spectra 401
spectrum of emulsion 421
spectrum of magenta dye 526
spectrum of yellow dye 526
Activated complex 94, 116, 120, 121
average frequency at which breaks up 119
equilibrium constant for 118
Activation
energy 123, 223
energy barrier 65, 121
energy for a developer film combination
122
entropy barrier 121
Active center 85, 111, 121, 125
concentration of 112
SO_3^- is 85, 110
SO_5^- is 85, 110
$SO_5^=$ is not 111
Activity 342
coefficient 343
Actors 129
position of 129
symbol of 130
Aggregate
growth 72, 77
growth stage 66
H 418
J 418
minimum size 60
negatively charged 75, 77

neutral 73, 75
neutral silver 75
number above critical size 155
positively charged 62
silver 42
silver atom 73
size 63
three silver atom 59, 60
two atom 59, 60
Aggregates
determination of α for J 431
H 422
J molecular 422
theory of 422
Angular momentum, of electron 87
spin 88
Antibonding
molecular orbital 70
Aqueous
media 85
solution 85
Aromatic
compound 410
resonance energy of 410
Assumptions
of the latent image model 132-134
Atomic
orbital 56
Auxochrome 402
groups 402

B

BAND
benzenoid 414
conduction 53, 57, 63, 75
valence 3, 57

F

2012-28
22-95